ALEUT AND ESKIMO ART

Aleut and

Tradition and Innovation

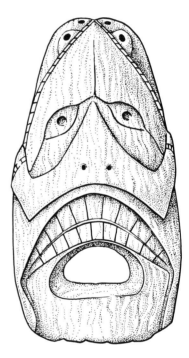

University of Washington Press Seattle

Eskimo Art

in South Alaska

Dorothy Jean Ray

Copyright © 1981 by Dorothy Jean Ray
Printed in the United States of America
Designed by Audrey Meyer

Library of Congress Cataloging in Publication Data

Ray, Dorothy Jean.
 Aleut and Eskimo art.

 Bibliography: p.
 Includes index.
 1. Eskimos—Alaska—Art. 2. Aleuts—Art.
I. Title.
E99.E7R24 745'.08997 79-56591
ISBN 0-295-95709-3

Preface

The subject matter of this book is the decorative and sculptural arts of the Eskimos living south of Saint Michael, Alaska—the Aleut, Yupik, and Pacific Eskimos—from the time of first European contact to 1979. *Eskimo Art: Tradition and Innovation in North Alaska,* published in 1977, dealt with the arts of the people living north of Saint Michael—the Inupiat—and on Saint Lawrence Island (Ray 1977).

These volumes are concerned with art of the historical and contemporary periods; therefore, it is important to understand the historical and cultural events that contributed to the character and degree of change in art forms and styles in the various areas. The changes that occurred in Yupik art made it as different from Aleut or Pacific Eskimo art in this southern area as it was from Inupiak art of the north. To clarify these differences I have devoted a chapter to a summary of historical events in the southern areas as related to the north.

Both volumes are divided into two parts: a discussion and interpretation of traditional and market art, and illustrations with descriptive captions. Much of what I wrote about the differences and similarities of traditional and market arts in *Eskimo Art* also applies to the southern area where a souvenir market developed—and has been sustained—from the first contact with the white man. The south differed, however, in the kinds and quantities of objects made within more localized marketing situations.

Market art in the south (especially in the Kuskokwim-Nunivak area) was produced in a more subtle fashion than in the north, and a strange misconception has developed whereby the Eskimos of southwest Alaska are thought not to have indulged in the indelicate occupation of making objects for sale until recent times. As a matter of fact, the southwest Eskimos went joyfully to their knives and their needles at the first opportunity to sell their "art." But souvenir-making was so unobtrusive that when Hans Himmelheber was studying Eskimo art on the Kuskokwim in 1936, he said that the younger generation was just then beginning to earn money from the souvenir business. The Kuskokwim and Nunivak people had been making souvenirs, however, long before the 1930s and almost as long as the Saint Michael and Yukon people, as is illustrated in figures 113-17 and 122-26. This activity did not have the appearance of an "industry," or commercialization, as in the north— especially at Nome, Teller, and Saint Michael—but was nevertheless a very important cottage industry that dated from the 1790s in the Pacific Eskimo area, where model kayaks and dolls were staple souvenirs.

This volume includes Aleut and Pacific Eskimo (Koniag, Chugach, Peninsula Eskimo) art, which, though not as well known as Yupik and Inupiak art, was a vital activity, and for which there is no general description or summary in any language. The Aleut occupied the Aleutian Islands and part of the Alaska Peninsula; the Koniag, the Kodiak Islands and part of the Alaska Peninsula;

and the Chugach, Prince William Sound. Although the majority of artifacts collected from this area during the eighteenth and early nineteenth centuries are in European museums, I have been able to outline, and illustrate, the principal forms of art from old published accounts, present-day monographs, and information supplied by Soviet ethnographers. I hope that one day someone can make an intensive study of historical Aleut and Pacific Eskimo art in all media, utilizing world-wide collections at first hand. By also including the art of prehistoric times, which has been described in various American archeological reports, such a study would give the art of the Aleut and Pacific Eskimos the attention it deserves.

The Saint Michael area is included in both volumes, because of a blend of northern and southern Eskimo cultures there. During the nineteenth century, a number of Inupiat Eskimos moved permanently to the Yupik area of Saint Michael and Unalakleet. During the 1880s and 1890s especially, collections made in this area contained objects in both traditions.

Besides the acknowledgments, there are two appendixes and a glossary of special terms at the end of the book. Appendix A provides additional material on certain illustrations and appendix B is a "village identification." The significance of ethnological facts often rests upon specific and accurate identification of provenience. This is markedly the case in the field of native arts, but, with respect to southern Alaska, there is great confusion as to the locales where collections were made. Many more villages are represented in collections of traditional art from the south than from the north, where there were fewer villages, and where the Eskimos went to the trader and the trading ships more often than the trader or the collector to the villages, as in southwest Alaska. The trading pattern in the Aleutians was similar to that of the north.

In order to counteract and correct some of this confusion, and to provide salient information, I have listed in appendix B sites and localities mentioned in this publication, except for such well-known places as Bethel, Nome, Saint Michael, and Teller, or prominent bays and rivers. Three places where numerous objects were collected in the 1880s and 1890s—Andreafsky, Rasboinsky, and Sabotnisky—are discussed at length so as to clarify many puzzling historical questions. The spellings of the Eskimo villages in both this list and the captions to the illustrations are presented as they were originally recorded (with the exception of Kashunuk and Tununak), or as used on present-day maps. I have also written a brief description of the Aleutian Islands for purposes of general orientation, which I have placed at the beginning of the list. This description will permit the reader to localize the most important places without the use of a map.

In most cases I have used the specific names, Aleut, Chugach, Eskimo, Koniag, and Yupik, but occasionally, the term "native," when referring to the people collectively. This usage, which is peculiar to Alaska, identifies a person of Alaskan Indian, Eskimo, or Aleut ancestry. An Alaskan-born person of another race is not an Alaskan native in that sense.

January 1979

Contents

PART ONE

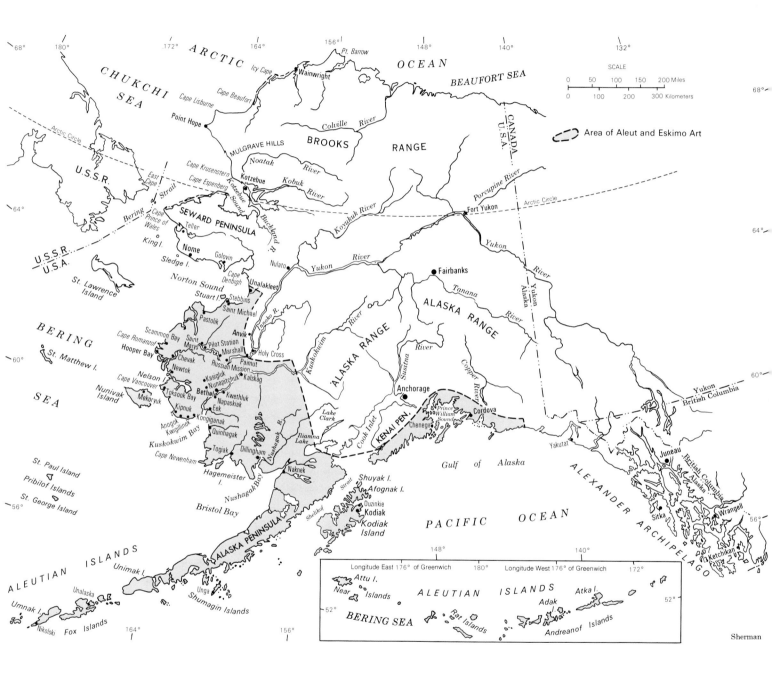

ARCTIC OCEAN

CHUKCHI BEAUFORT SEA
SEA

68° 180° 172° 164° 156° Pt. Barrow 148° 140° 132° SCALE
 0 50 100 150 200 Miles
 Icy Cape 0 100 200 300 Kilometers
 Cape Lisburne Wainwright

 Area of Aleut and Eskimo Art
 Point Hope
 Cape Beaufort

 MULGRAVE HILLS Colville River BROOKS RANGE
 Arctic Circle
USSR Cape Krusenstern Noatak River CANADA
 Kotzebue Kobuk U.S.A.
 East Cape Espenberg Kotzebue River Kovukuk River Porcupine River
64° Cape Sound Fort Yukon Arctic Circle
 Bering Prince of SEWARD PENINSULA Buckland R. Yukon
 Strait Wales Teller 64°
 King I. Yukon River
 Nome Golovin Alaska
 Sledge I. Nulato Yukon River Fairbanks
USSR Cape Denbigh Tanana River
U.S.A. St. Lawrence Unalakleet ALASKA RANGE
 Island Norton Sound Stuart I. Stebbins River
 Saint Michael ALASKA RANGE
 Pastolik Innoko R.
BERING Scammon Bay Saint Mary's Pilot Station River
 Cape Romanzof Anvik Marshall River
60° St. Matthew I. Hooper Bay Chevak Russian Mission Holy Cross Siustna Anchorage Yukon
SEA Newtok Kasigluk Paimut Kuskokwim British Columbia 60°
 Nunivak Nelson I. Kwigillingok Nunapitchuk Kalskag Copper River
 Island Cape Vancouver Bethel Kwethluk Prince Cordova
 Mekoryuk Toksook Bay Napaskiak Lake KENAI PEN. William
 Kipnuk Eek Clark Cook Inlet Chenega Sound
 Anogok Kwigillinok Kongiganak Iliamna Yakutat
 Quinhagak Lake
 Cape Newenham Togiak Dillingham Nushagak R. Gulf of Alaska
St. Paul Island ALEXANDER
Pribilof Islands Hagemeister Naknek Shuyak I. Juneau
St. George Island I. Nushagak Bay Afognak I. Strait Sitka
56° Bristol Bay Ouzinkie Kodiak Wrangell 56°
 Shelikof Kodiak PACIFIC OCEAN ARCHIPELAGO Ketchikan
 Island

 ALASKA PENINSULA

ALEUTIAN ISLANDS Unimak I.
Umnak I. Unalaska Unga Shumagin Islands
Nikolski Fox Islands 164° 156°

 ┌──┐
 │ Longitude East 176° of Greenwich 180° Longitude West 176° of Greenwich 172° │
 │ Attu I. │
 │ Near Islands ALEUTIAN ISLANDS Atka I. │
 │ Adak 52° │
 │ 52° BERING SEA Rat Islands Andreanof Islands │
 └──┘

 Sherman

1. Historical Background

The Aleut and the Eskimo are related culturally, linguistically, and physically, so much so that the Aleuts could have been called Eskimos from the very first meeting with Europeans in 1741. The name "Eskimo," however, was not in use for the natives of Alaska at that time (and not definitely until the 1820s), so the accident of being called "Aleut" by the Russians has popularly set them apart as a distinct ethnic group despite the fact that the Aleuts and the Bering Strait Eskimos in Alaska are as much alike as are the Bering Strait Eskimos and the Labrador Eskimos in Canada.

The course of aboriginal art in all of Eskimo territory was changed by the arrival of Europeans. Through the acquisition of both material goods and new attitudes, the identifiable ethnic arts either took different directions or died out completely. The Eskimos stopped using their own ornamented or sculptured tools and implements whenever the new ones worked better than the old, and they no longer relied on charms and amulets when they accepted new religious ideas and scientific explanations of the unknown.

The flow of creativity did not stop with the changes, however, because if the Eskimos no longer needed their art, the newcomers did, either as ethnological examples of the so-called "exotic peoples," who had become popular subjects for writers during the nineteenth century, or as souvenirs to be taken back home as mementos of their visits.

The new market art made for nonnatives developed later in the north than it did in the Aleutian Islands and the Gulf of Alaska, where contacts with Europeans occurred much earlier and with greater frequency. By 1816, only four sailing vessels had been north of the Aleutians in contrast to at least a hundred Russian vessels, five Spanish, two French, and untold British and American explorers and traders in the Aleut and Pacific Eskimo area.[1] This disparity explains, in part, the differences in the development of the arts in the southern and northern areas.

The Aleuts saw their first Europeans in 1741 during Vitus Bering's voyage of discovery, but, except for a brief encounter at King Island in 1732, the people north of the Aleutians did not meet a European, James Cook, until 1778. By that date, the Aleuts had already experienced a long, intensive, and often tragic, firsthand relationship with the Russians. In contrast, the meetings between northern Eskimos and explorers were generally short and peaceful. Even between 1778 and 1833, when the Saint Michael trading post was established at the extreme southern end of the northern Eskimo territory, very few foreign ships had sailed north of Saint Michael, and the time spent by

1. Besides the many Russian vessels that had gone to Alaska from Kamchatka between 1741 and 1816, there had been 8 French, 10 Portuguese, 43 Spanish, 93 British, and 258 American vessels on the Northwest Coast, which included British Columbia and the state of Washington (W. Cook 1973:551).

Europeans at any one place could be counted in days, or only hours, usually at anchor offshore.

Until 1848, when commercial whaling and the search for John Franklin's third expedition began simultaneously north of Bering Strait, the foreign vessels could be counted on two hands. Except for the Russians at Saint Michael, the northern Eskimos' first intensive contact with nonnatives was between 1848 and 1854 when a dozen ships searched the Bering and Chukchi seas between Saint Michael and Point Barrow for Franklin's expedition. The English seamen made many overland trips, chasing rumors about Franklin and exploring unknown territory. The Eskimos' second intensive acquaintance with nonnatives was between 1865 and 1867 when 120 young men of the Western Union Telegraph Company explored extensively and dug postholes between Saint Michael and Port Clarence for a proposed telegraph line to Siberia (for details, see Ray 1975).

The commercial whalers spent most of the brief whaling season on the high seas, and even after the establishment of shore whaling stations in the 1880s, their activities affected only a few hundred Eskimos. Not until 1898, 114 years after the Shelikhov Company had established the first Russian settlement at Three Saints Bay on Kodiak Island, did a permanent white town—Nome—come into being north of Saint Michael.

The first descriptions of Alaskan Eskimo artifacts were written by Georg W. Steller, the scientist of Bering's expedition in 1741.[2] He described an encounter with two men, each in a kayak, who came out to the *Saint Peter* from the shore of Bird Island in the Shumagins (the Aleutian Islands) on 4 September of that year. The two men began to speak loudly in unison, and after much gesturing on the part of both Russians and Aleuts, one man approached them, "reached into his bosom, pulled out some iron- or lead-colored shiny earth, and with this he painted himself from the wings of the nose across the cheeks in the form of two pears, stuffed the nostrils full of grass (the nose wings on each side, however, were pierced with fine pieces of bone)." He then took a long stick, painted red, to which he attached "two falcon wings," and threw it toward them into the water (Golder 1925:90, 92). This man has been preserved in a drawing by Sven Waxel, who took over command of the expedition after Bering's death (see fig. 1).

Steller also described nine persons standing on the shore of the island, who wore "whale-gut shirts with sleeves, very neatly sewed together, which reach to the calf of the leg. Some had the shirts tied below the navel with a string, but others wore them loose. Two of them had on boots and trousers . . .

2. Although this is the first *description,* it is not the first record of the meeting of an Alaskan Eskimo by a European. In 1732, the expedition of Mikhail Gvozdev and Ivan Fedorov in the *Gabriel,* sighted land in the vicinity of Wales on Seward Peninsula. On their way home to Kamchatka, according to Gvozdev's journal, a man came out to them from an island (King Island) "in a leather boat which had room for but one man. He was dressed in a shirt of whale intestines which was fastened about the opening of the boat in such a manner that no water could enter even if a big wave should strike it" (Golder 1914:162).

Likewise, on 21 July 1741, Steller had gone ashore on Kayak Island, in the northeast part of the Gulf of Alaska, which was the hunting territory of the Chugach Eskimos. He did not meet any people, but saw their campsites, and mentioned—but did not describe—the following man-made objects: bark containers, a wooden basket, a shovel, seaweed rope, arrows, a hollow clay ball with a pebble enclosed, and a paddle (Golder 1922:99; 1925:48-53).

made of seal leather and dyed brownish-red with alder bark. . . ." They had holes pierced "anywhere in their faces," and wore pieces of bone through the nasal septum, in the wings of the nose, in the chin, or in the forehead. The Aleuts gave them presents of "iron-colored paint" (ibid.:94, 96-97, 103).

The next day nine persons in one-man kayaks paddled toward them in single file; two approached the *Saint Peter* and presented gifts of "sticks with falcon feathers and of iron-colored face paint. On their heads they had hats made of the bark of trees, colored green and red, that resembled in shape the eye shades that are usually worn around the head; the crown was uncovered [and] between the hat and the forehead some had placed a few variegated falcon feathers, others tufts of grass. . . ." They traded "a rusty iron kettle, five sewing needles, and some thread" for two wooden hats, on one of which was fastened "a small carved image, or sitting idol, of bone, with a feather sticking out from behind, intended no doubt to represent the tail" (ibid.:102, 103). Waxel, apparently reporting the same two hats, wrote that they were made of "sea-lion skin," and although the ivory human images were sent to the Admiralty College (in Russia), the hats were lost (Golder 1922:275; Waxel 1962:96). It should be pointed out that Waxel's reporting may have been due to a faulty memory (since no skin hats are known to have come from the Aleut area), because he finished his manuscript about 1756, whereas Steller's information was taken from his journal written in 1741.

The second vessel of the expedition, the *Saint Paul,* under Alexei Chirikov, also met similar boats and men dressed in similar garments near Adak Island. Chirikov noticed that they used animal bladders to carry water, and were extremely eager to obtain knives. As on the Shumagins, more than seven hundred miles away, these men, too, were reported to "stuff roots into their noses," wear wooden hats, and present visitors with "some kind of mineral." The hats were "made of thin birch boards . . . decorated with various colors and feathers. Some of these dippers (hats) had in the top small ivory statues" (Golder 1922:304-5).

After the *Saint Peter* took sea otter skins back to Kamchatka, Amelian Basov, with Andrei Serebrennikov, built a boat to sail to Bering Island to hunt sea otters. After his first trip in 1743, Basov returned several times with such success that by 1753 at least twelve expeditions had left Kamchatka for Bering Island, Copper Island, and the Near Islands (Attu, Agattu) to hunt.

Another dozen ships had sailed to the Aleutians by the time Kodiak Island was discovered by Stepan Glotov in September 1763. Glotov was the first to describe the artistic products of the Koniag people:

Amongst other wares the Russians procured two small carpets, worked or platted in a curious manner, and on one side set close with beaver-wool like velvet: they [Glotov and his men] could not however learn whether these carpets were wrought by the islanders. . . . Their caps had surprising and sometimes very ornamental decorations: some of them had on the forepart combs adorned with manes like an helmet; others, seemingly peculiar to the females, were made of intestines stitched together with rein-deer-hair and sinews in a most elegant taste, and ornamented on the crown with long streamers of hair died of a beautiful red. Of all these curiosities Glottoff carried samples to Kamchatka [reported by Coxe 1780:114-15].[3]

3. In a footnote at this point, William Coxe, the historian, wrote, "These and several other ornaments of a similar kind are preserved in the cabinet of curiosities at the Academy of Sciences

These headdresses were probably similar to those illustrated in figures 18 and 19.

In 1764, from the journal of Ivan M. Soloviev, who purportedly killed two hundred Aleuts on Umnak Island in supposed revenge for earlier murders of his countrymen, we read about Aleut masks, dancing caps, and other forms of art in the first detailed description of Unalaska and the Fox Islands (ibid.:131-55). A few years later, the secret expedition of Petr K. Krenitsyn and Mikhail D. Levashev added to the knowledge of the Aleutians. Krenitsyn spent the winter of 1768-69 on Unimak Island, and Levashev, on Unalaska. (Captains Bay on Unalaska was named for him.) Levashev wrote copious notes about Unalaska and drew numerous sketches, some of which were published by Frank A. Golder for the first time in an English publication in 1922. The sketches show an Aleut dwelling, tools, dishes, a drum, a man in a one-cockpit kayak, a "belt used when they dance," two visor hats, a grass sleeping mat, and a round basket with a handle and a pointed bottom. This is the first sketch of an Aleut basket known to have been made (Golder 1922:facing 149, 304, 305).[4]

Ten years before James Cook discovered Prince William Sound and sailed, as the first European, almost the whole length of western Alaska, Levashev wrote that the Russians paid the Aleuts for furs with "beads, false pearls, goat's wool, copper kettles, hatchets, etc.," and that they had suffered from "a change in their way of life. No longer contented with their original simplicity, they long for Russian luxuries" (Masterson and Brower 1948:58, 60-61).

Cook's expedition arrived in Prince William Sound on 12 May 1778, where people approached, using ceremonial gestures similar to those described by Steller thirty-seven years before in the Shumagins. Three men in two kayaks came to the ship, each holding a stick, three feet long, "with the large feathers or wing of birds tied to it," which Cook interpreted as a peace gesture. Although the inhabitants already had beads and many metal knives and daggers in various sizes and shapes, Cook was sure that they had never seen Europeans before, because, as he rightly observed, "had [the Russians been amongst them] we should hardly have found them clothed in such valuable skins as those of the sea-otter" (Cook 1784, 2:356, 357, 373, 401).

Cook sailed north through the Aleutians and discovered and named Bristol Bay and Cape Newenham at the southern end of Kuskokwim Bay where he met twenty-seven kayaks, each with a man wearing "a hood of skins, and a bonnet which appeared to be of wood." They, too, were "wholly unacquainted with people like us," although they had foreign knives obtained from an unknown source. Unfortunately for our knowledge of the arts in 1778, Cook did not tarry before continuing northward to Sledge Island; and despite a brisk trade in clothing, bows, darts, and wooden dishes, and an interest shown by John Webber, the artist, in a man in his kayak wearing a "bonnet," Cook

of St. Petersburg [Leningrad]: a cabinet which well merits the attention of the curious traveller; for it contains a large collection of the dresses of the Eastern nations. Amongst the rest one compartment is entirely filled with the dresses, arms, and implements, brought from the New-discovered islands [the Aleutians and Kodiak]."

4. These drawings are also illustrated by I. V. Glushankov (1973). The sketches of an Unalaska man in his baidarka (the Russian name for kayak) are different in Golder and Glushankov, however, although posed alike.

described only one other object, a fur "girdle . . . with trappings depending from them" (ibid.:437).[5]

The date 1783 has a two-fold importance in the history of the Pacific Eskimos, for in that year Grigorii I. Shelikhov sailed from Okhotsk in Siberia to establish the first permanent European settlement in Russian America, and Potap Zaikov took charge of the first fur-hunting expedition to Prince William Sound. In 1784, Shelikhov chose a site and began building at Three Saints Bay on Kodiak Island, but Zaikov was unable to remain in Prince William Sound more than one winter because of the strong opposition of the Chugach. Yet, only two years later, in 1786, one French ship and three English ships, besides another Russian contingent, were exploring and briskly trading in the sound.

By the time Joseph Billings' expedition arrived in the Aleutians and North Pacific in 1790, and George Vancouver's expedition in 1794, the Aleuts and Pacific Eskimos were very well acquainted with Europeans indeed. It is not surprising, therefore, that the model kayaks collected by Vancouver at Cape Elizabeth at the southern tip of Kenai Peninsula and many of the objects sold by Kodiak men hunting that summer at Yakutat Bay, were made and offered for sale as souvenirs.

In 1799, the headquarters of Shelikhov's company (which had been renamed the Russian-American Company) was moved from Kodiak to Sitka, but the fur hunting continued unabated until about the 1820s. Father Ivan Veniaminov, the Aleut's first ethnographer, did not arrive (as the first permanently stationed Russian Orthodox priest in the Aleutians) until 1824 when the sea otters and many other treasures of the northern waters were already disappearing. By that time the Aleuts were three generations removed from their aboriginal life, and great changes, especially in subsistence and settlement patterns, had occurred. The dispersion of Aleut and Kodiak hunters, who were forced to work for the Russians almost from the beginning of the fur exploitation, has led to confusion as to the identity of many persons in the North Pacific area. The hunters were sent in large flotillas of kayaks to hunt in alien territory: Prince William Sound, Yakutat Bay, Sitka, and even to Fort Ross in California. Some of the Aleuts remained in Prince William Sound and on Kodiak Island, but confusion has been compounded by the fact that the Russians also called the true Koniag and Chugach Eskimos "Aleuts," a name that some of the Koniag and Chugach descendants have retained to this day.

After Cook's brief visit in 1778, the Yupik people of southwest Alaska living between Bristol Bay and the Yukon River had no more European visitors until 1818 when the Russian-American Company explored the Nushagak River and the mouth of the Kuskokwim. During the summers of 1820 to 1822, five Russian vessels explored the coast of western Alaska, during which time Nunivak Island, Cape Romanzof, and Golovnin Bay were discovered and the existence of the Yukon River became definitely known. Russian-American Company posts were built at Saint Michael in 1833, at Ikogmiut in 1836, and at Unalakleet in 1837.

The people living on the vast Yukon-Kuskokwim delta were the last to feel the effects of the coming of a new way of life. In 1878-79, the three

5. The original drawing of the Cape Newenham man is in the Photography Collection, University of Washington Library.

thousand "pure-blooded Eskimos" of this area were "among the most primitive people found in Alaska," according to Edward William Nelson, who made a sledge trip there when stationed as a signal corps officer at Saint Michael. They still retained "their ancient customs [and] their character is but slightly modified by contact with whites. . . . They retain their complicated system of religious festivals and other ceremonies from ancient times. Their work in ivory and bone bears evidence of great skill, and all their weapons and utensils are well made" (Nelson 1882:670).[6] At that same time, in Unalaska, however, nearly half of the adults could read and write the Aleut language, and some were literate in Russian; on Sundays they dressed up in silk dresses, dainty slippers, well-cut suits, and leather shoes as for any Russian holiday. By that time, also, in the Aleutians, the Aleut no longer had native names—almost all had Russian first and last names—but in the Yukon–Kuskokwim delta and in the area north of Saint Michael, the Eskimos were still using the one-name Eskimo system, and there were few, if any, European or American names in use (Hooper 1897:17-35; Petroff 1884:20; Ray field notes).

6. For biographical information about Nelson, see Lantis 1954.

2. Materials and Coloring Agents

All Alaskan Eskimos generally used the same materials for their handicrafts—
ivory, bone, caribou antler, clay, stone, wood, grass, skins, and fur. The use
of specific materials, however, has often been associated with one group or
area almost to the exclusion of others, for instance, ivory and the Bering Strait
carvers, whose work in walrus ivory is widely known, or wood and the south-
west Alaskan Eskimos. But these are one-sided notions, for ivory was used
by Eskimos everywhere from Kodiak to Point Barrow, and wood was also a
favorite material of the northerners. As demonstrated in *Eskimo Art,* the Point
Hope artists were among the best wood sculptors in all Alaska (Ray 1977:figs.
57-59).

Stone was rarely used for art in the south during the historical period, al-
though stone artifacts, such as lamps with sculptured human figures, have
been found in archeological sites, especially in the Aleut and Kodiak areas.
Small pebbles were also used for incising various designs, and many petroglyphs
have been discovered on out-of-the-way rock cliffs and boulders, probably
dating back to prehistoric times. The few nephrite objects collected in the
south had been traded from the Kobuk River in the north.

Prehistoric Eskimos made rather poor clay pottery, which was quickly aban-
doned as soon as metal and crockery containers became available through trade.
Generally, little care was expended either in the shape or ornamentation of
the pots. The Aleut and Chugach did not make pottery.[1]

Bone, antler, and ivory were used by the southern Eskimos for many weapons
and tools, but ivory was the preferred material for most sculptured and deco-
rated objects. Mountain goat horn was sometimes used for spoons, especially
by the Chugach who carved handles in a style somewhat similar to the North-
west Coast Indian style (see illustrations in Birket-Smith 1953:63). From reading
Russian-language publications and translations pertaining to artifacts of the
Aleuts and Alaskan Eskimos, it often appears that the people used more bone
than ivory. This, however, is a matter of semantics rather than choice of materi-
als, because the word "kost" in Russian refers to both ivory and bone, and
unless the specific material under discussion is definitely established, there
can be considerable ambiguity. A good example of this is in the original, pub-
lished caption to figure 36 a and b: "iz kosti" (of bone), but the text reads
walrus ivory, which is evident in the present photographs.

Traditional ivory objects were obtained by nineteenth-century collectors
from almost all southwest coastal villages, but some villages had greater supplies
than others. At E. W. Nelson's time (between 1877 and 1881), the Eskimos
living between Norton Sound and Cape Vancouver generally obtained their
ivory through trade, but walruses were "taken more or less commonly" all

1. A summary and bibliography of pottery in southwest Alaska, including Kodiak, are given
in Dumond 1969.

along the coast between Cape Vancouver and Kongiganak on Kuskokwim Bay, where Nunivak Islanders also hunted walrus. Unlike the walrus hunters of Bering Strait, who hunted on the ice or along the ice pack that carried the walrus, flotillas of hunters in their kayaks tried to surprise walrus herds in shallow bays at the Kuskokwim mouth, driving them to shore by lining up their boats end to end. Thirty animals were obtained once in such a drive south of Cape Vancouver, according to Nelson (1882:669; 1899:166).

Walruses were also hunted during the breeding season in certain bays and islands of the entire shoreline of Bristol Bay, including Unimak Island and the north shore of the Alaska Peninsula, where Ivan Veniaminov said the Aleut obtained between three hundred and two thousand walruses each year (1840, 2:385). According to Ivan Petroff, the census taker, walrus tusks were "the common currency" of the Bristol Bay area in the 1870s, the trader at Alexander Redoubt at Nushagak asserting that "he did as much business in walrus tusks from the coast as in furs from the interior" (Petroff 1884:15, 16, 24). In the 1880s and 1890s, large quantities of walrus tusks were taken from Nushagak, as well as from the Bering Strait herds, to Saint Michael for making souvenirs.

The Kodiak people, who were said to be skillful ivory carvers, and some Aleut, got their ivory either by trade or by an occasional hunting trip to the south coast of Bristol Bay. Strangely enough, few pieces of historical ivory work from Kodiak Island have been preserved, but numerous ivory figurines and other objects have been excavated from archeological sites on Kodiak and the Aleutians.[2]

During the 1970s, ivory was scarce in southern Alaska, the carvers getting their ivory from stores for about ten dollars a pound in 1976 (but the price had doubled or tripled by 1979) or from walruses that washed up on shore. (Occasionally a mammoth tusk is found.) I was told that the Nunivak people got only one walrus in 1975, a startling contrast to the 1,700 walruses harvested farther north—mainly for the tusks—during the same year (*Alaska,* March 1976, p. 26; see also Rearden 1973:13).

Driftwood, which was abundant almost everywhere in the southern coastal areas, was used for houses, boat frames, utensils, and art objects. Wood drifted down the Yukon and the Kuskokwim rivers from the forests farther upstream, and small stands of stunted alder and spruce grew near some of the lower river villages. Driftwood was also plentiful on the Alaska Peninsula and on many of the Aleutian Islands, where it was gathered both as an individual and a community effort. In both northern and southwest Alaska, however, wood was considered to be private property, and was gathered and arranged in round or conical piles by the family who found the wood. Nunivak Island families spent most of December transporting wood supplies from their coastal

2. The following list contains selected publications on the archeology of the Aleut and Eskimo areas south of Saint Michael. Other references can be found in the bibliography of each publication, as well as in the specialized bibliographies listed at the end of "References Used."

Ackerman 1967; Aigner 1976; Clark 1974, 1976; Collins, Clark, and Walker 1945; Dumond 1964, 1969, 1977; Dumond, Henn, and Stuckenrath 1976; Giddings 1964; Heizer 1956; Hrdlička 1944, 1945; Jochelson 1925, 1933; de Laguna 1934, 1956; Larsen 1950; Laughlin 1963; Laughlin and Marsh 1951; Laughlin and Reeder 1966; McCartney 1969, 1977; Nowak 1970; Oswalt 1952; Oswalt and VanStone 1967; Quimby 1948; Reger 1977; Stein 1977; Townsend and Townsend 1961; and VanStone 1957.

piles to the village by sled (Athearn 1949:56; Berreman 1953:87-88; Lantis 1946:181).

As in the north, special parts of the spruce—the roots and lowest part of the trunk—were eagerly sought for masks, dishes, hunting hats, and sculpture, but other kinds of wood, like cottonwood, were also used. In the Aleutians, yellow cedar was supposed to be best for halibut hooks, and the drifted California oak was preferred for the elaborate bentwood hunting hats. Peter Simon Pallas, in his 1781 account of the discoveries between Siberia and America, said that the Russians had noticed "all kinds of foreign wood [in the Aleutians], and they have brought back to Siberia pieces of Japanese camphor-wood, still recognizable by its odor," as well as cypress and mahogany (Masterson and Brower 1948:41; Jochelson 1933:6).

In the Chugach area, wood for most manufactures was obtained from the huge supply growing almost at their doorsteps. For example, the frame of a kayak was made of hemlock, and the stem, stern, and crosspieces were of spruce. The Chugach also used driftwood, preferably cedar. Kodiak Islanders drew upon both driftwood and the large groves of alder, birch, and spruce, especially at the north end of Kodiak and on the nearby islands of Shuyak and Afognak.

Paints made from mineral and vegetal materials were used in all Eskimo areas. Red, black, and white were the most common colors for wooden objects, and black for ivory; but various shades of blue were also used extensively in the south, besides an array of lavenders and pinks by the Aleut and Pacific Eskimos.

Red color, especially from minerals, appears to have had a magical meaning for all arctic peoples. Red paint was applied to innumerable hunting and ceremonial objects by every Eskimo and Aleut group in Alaska: kayak frames, implements, and boxes; the back sides of many nineteenth-century masks; the front human side of the half-man–half-animal mask from Nunivak Island; and the reverse side of skin clothing. Many pieces of wood with traces of red have been found in archeological sites. An unusual drill bow, collected at Port Clarence in 1854, portrays Eskimo activities in red, and those of English sailors in black (Ray 1977:fig. 238). In the Aleut and Pacific Eskimo area, men painted their faces red (sometimes black) for important undertakings, and pieces of a red mineral were presented as gifts and used as amulets, especially to attract sea mammals. Among the gifts presented to Bering's men in 1741 was "iron-colored face paint."

As an example of the pigments used by one group—the Chugach—the sources of colors were as follows, from information obtained in 1933:

Red and purple came from a sort of swamp grass. Dark red they got by boiling hemlock bark, and another variety of red from cranberry and blueberry juice. Mineral dyes were made by crushing rocks of different colours in a hollow stone (mortar?) and mixing the dust with seal-oil or water. After the dyeing process, spruce roots for making basketry were soaked in stale urine to make the colour stick, and red to be used for painting wooden vessels or the like was mixed with blood from the nose. A grayish colour which was mixed with other colours was produced from copper ore. Black came from a black rock on Kayak Island, red and yellow from other rocks, probably ochre; red ochre is only found at Nuchek. Other minerals used were blue, brown, and a dark-coloured stone. Spruce roots were dyed before weaving; only the basketry hats had designs painted afterwards [Birket-Smith 1953:78].

Natural dyes were still a popular source of paint for masks and wooden dishes on Nunivak Island in the 1970s. Black color was obtained from coal, preferably from pieces that had rolled in the water for several years, leaving a hard core. In 1976 Peter L. Smith, a leading Nunivak mask maker, gave me samples of minerals that he uses for white, red, and blue colors, and which were analyzed by Walter E. Gnagy of the Alaska Bureau of Mines, Juneau, in 1978. The red mineral was found to be goethite (not hematite, which has been said to be the source for most red color); the white, kalium, altered in part to sericite and kaolin, and the blue, vivianite. The use of vivianite was an eye-opener to me because almost all printed sources have attributed the blue color to some copper derivative. Nevertheless, by comparing the colors of masks with that produced from vivianite, it is apparent that the blue on almost all nineteenth-century masks now in museums was obtained from this mineral.[3] To make a light blue, the vivianite is mixed with water, but for blue black, it is mixed with seal oil.

The goethite, which came from Nelson Island, was said by Peter Smith to be the "best red in Alaska" (it is a darker red than that found on Nunivak Island) and was an important trade item long ago. In 1936 Hans Himmelheber learned the mythical origin of the "cache of red" on Nelson Island, which legend dates from the old raven's time. The raven's daughter, as was the custom, had to leave her parent's home to live alone in a hut for a year when she became of marriageable age. Her cliff house can be seen to this day, and near it, the ground where her toilet had been, colored red from her menstrual blood (1953:101).

The leading mask makers of Nunivak Island use a variety of applicators for their colors: Peter Smith uses timber wolf or red fox fur; Edward Kiokan prefers the tip of ground squirrel tail; but Andrew Noatak sometimes paints with his fingers, after he has smoothed the surface with wood shavings and polished it with his fingers and palms. E. W. Nelson said that on the lower Yukon designs were sometimes painted on wooden dishes with brushes made of human hair (Nelson n.d.:66).

Dyes used for grass basketry are now obtained from a variety of sources. Some women use commercially packaged dyes almost exclusively, but others, like Rita Pitka Blumenstein, a basketry teacher from Nelson Island, use natural dyes as much as possible, at the same time taking advantage of several unique store-bought products: "Onion skins dye the grass yellow. Iris petals or fresh beets turn the blades rich purple. From stink weed and coffee grounds comes brown, from blueberries comes royal blue. . . . Crepe paper and construction paper are bled for their dyes as is a new sweatshirt. Hershey bar wrappers give up a deep brown dye" (*Tundra Drums,* 15 May 1976, p. 25).

Fur and grass materials are discussed in the basketry and sewing sections.

3. Samples of blue rock in the Alaska State Museum, which were collected by George T. Emmons in the early twentieth century, also tested as vivianite by Gnagy.

3. The Traditional Arts

SCULPTURE AS AMULETS AND CHARMS

Eskimo art was basically religious and ceremonial, although there seems to be no doubt that the manipulation of materials was an enjoyable creative activity in the making of objects that we now call art. Objects were not owned by families or villages, but were individual products that belonged to the person who made them or to whom they were given, despite their frequent use in ceremonies held for the public welfare. This art in traditional southern Alaska culture was employed for either ceremonial or utilitarian purposes, that is, sculpture and masks for various festivities, or utensils, such as shuttles, toggles, fish spears, and sinkers in the shape of protective spirits or game animals, for everyday occupations. Sometimes these objects were ornamented with geometric designs that suggested animal anatomy, usually the skeleton (figs. 101-3, 105, 107).

Amulets and charms of wood or ivory were made in abundance by the shamans and even by ordinary people for supernatural protection or aid. An amulet was worn for protection or to bring luck, and a charm was used to influence a tutelary (helping spirit) or animal. An amulet was occasionally carved as sculpture, but more often it was a natural object—part of a human or animal body, a piece of mineral, a feather, or almost anything thought to contain power. A charm could also be a natural object, but it was usually a carving. Charms were used by the shamans in curing and magical performances, and were often hung in ceremonial houses and individual dwellings, or attached to boats.

The information that we have about charms and amulets of Nunivak Island is applicable more or less generally to the whole of Alaskan Eskimo culture during traditional times. On Nunivak, a person might have as many as two dozen amulets, or *inogos,* representing two dozen spirit helpers. These amulets were acquired either from shamans or through inheritance, and were so important to Nunivak religion that nothing could be accomplished without their help. More than three-fourths of the amulets were small "full-round naturalistic" figurines of ivory in human or animal form. Most important to each person was one specific, powerful *inogo* that a son inherited from his father, which was painted on umiaks and dishes and carved as sculpture, especially the stylized ivory figure placed on each side of a man's sacred hunting hat (Lantis 1946:204, 239). *Inogos* were also painted on kayaks, masks, and weapons. We do not know definitely whether the Aleut and Pacific Eskimos used as many individual amulets as the northern Eskimos, but the similarities in Aleut and Eskimo religion suggest that they did.

Hans Himmelheber has said that in 1936 he collected numerous ivory human and animal figures "made and sold by the shamans as means to a successful hunt" from the area north of Norton Sound, but that he did not encounter

"a single such piece on the Kuskokwim." Most of the people he talked to had never heard of them. A few thought they had once existed, but none could describe their "appearance or use" (1953:61). It is significant for the history of souvenir and traditional arts that Himmelheber was able to get information about old amulets and charms as late as the 1930s in the north, where souvenirs had been made since the 1870s and where, he categorically stated, "an art study [of traditional objects was] no longer possible" (ibid.:7); yet he was unable to learn anything about them in the south, where it had been assumed—wrongly, as it turned out—that souvenirs had not been made until recently. Another anomaly is that masks, which had similar religious and ceremonial uses as amulets and charms, were made in various southwest Alaska villages in the 1930s. Himmelheber's data, however, may have been slanted by his Bethel informants who had joined the Moravian church, which opposed traditional Eskimo religious practices. It is known furthermore that almost all masks collected in the 1930s were made in outlying villages where Moravian influence was weaker than in Bethel.

Besides *inogos,* two other powerful charms used by the Nunivak shaman were a life-size wooden human face and a big wooden doll "with one eye scratched." Huge human statues of wood were made as charms and oracles all the way from the Aleutians to Siberia. One of the best-known oracles was a wooden doll used in the Yukon "doll festival," which was reported by E. W. Nelson. At Ikogmiut, this doll was displayed during all the ceremonies and entertainments of the festival, but at the end the shaman wrapped it in birchbark and hung it in a secret tree. During the ensuing year he fed food to the doll, which he consulted "to ascertain what success will attend the season's hunting or fishing. If the year is to be a good one for deer [caribou] hunting, the shamans pretend to find a deer hair within the wrappings of the image." For good fishing, they claimed to find fish scales (Nelson 1899:494). (On Seward Peninsula, farther north, success in caribou hunting was foretold by blood running from the mouth of a wooden face placed on a pole.)

Large statues also had other uses. According to Ivan Veniaminov, on Atka Island there were images of human shape and size called *taiiaguliguk,* to whom the people offered sacrifices. These figures, which were located in places difficult of access, were considered to be so dangerous that they could kill people. On a bay called Usaamkukh, a wooden statue that had been erected by a shaman was supposed to have killed every passerby on sight, until finally it was destroyed by nearby villagers. In 1814, a similar statue, also showing signs of life, was found on Kanaga Island, and in 1827, another one, on Adak. Both were destroyed (Veniaminov 1840, 3:2-5).[1] Nearly life-size wooden figures were also found in a cave on Unga Island by both William H. Dall and Alphonse Pinart in the 1870s (Lantis 1947:79).

Small human figurines were among the earliest objects collected by members of Vitus Bering's expedition in 1741 and James Cook's in 1778. At Prince William Sound, Cook bought a "good many" figurines, four or five inches high, made of wood or stuffed skin, and dressed in miniature fur clothing, but he was unable to learn whether they were toys or religious objects (1784, 2:372-73).

1. Dolls relative to "evil spirits" in other Eskimo and Indian cultures are compared in Birket-Smith and de Laguna 1938:502-3.

There is much that we do not know about wood and ivory figurines in human form. Unless they were made as children's dolls, each may have had a distinct meaning and purpose, no longer known, such as a shaman's helper, amulet, or fertility doll, which a barren woman treated like a baby (figs. 99, 100, 169, 170). For example, Margaret Lantis stated that a shaman had told her that he had caught a human soul, which he showed to people, possibly in the form of a doll (personal communication, 1954).

Hans Himmelheber wrote that animal figures were never used as toys on the Kuskokwim River, but Nelson said that "birds, seals, and other animals" were made for the children by their fathers (1899:342). We do not know what the animals in figures 101, 102, and 105 were used for, although even in 1877-81, when they were collected, I suspect that some were being made for sale.

In the Aleutians, a much-used charm was a small ivory sea otter, which was often attached to the kayak, either on the outside or on the inside framework, as illustrated in the model kayak in figure 33. (Attaching a charm inside the kayak was also a northern practice. Nelson unsuccessfully tried to buy a wooden beluga-like image hanging from the framework of a kayak at Kotzebue Sound in 1881, since its owner said that he would die if he parted with it [Nelson 1899:436; Ray 1977:fig. 9]). Not only was success in hunting dependent on the ivory sea otter amulets, but, according to Veniaminov, hunting equipment and clothing were made as beautiful as possible to please the hunted animals. New and handsome clothing was also made for seal hunting on Nunivak Island and for whale hunting in the north. Being clean and neat for hunting was a requirement for all Alaskan Eskimos. The Chugach, for example, who did not make sea otter figures to help in their hunting, were required to dress neatly for the hunt.

Sea otter carvings have been collected all the way from the Aleutians to Saint Michael, but very little is known about them. Even Waldemar Jochelson, who did anthropological research on the Aleutians during 1909 and 1910, does not give any information about these charms except to say that a sea otter figurine "with a hole filled with hematite was worn" to attract sea otters and whales. Although the sea otter figurine itself was thought to have power, the magical part of this particular amulet was the hematite (Jochelson 1933:77).

There are many ivory sea otter figurines that look almost alike in American and European museums. Because of their similarity, they apparently were not amulets in the sense of *inogos* and other tutelaries of Eskimos to the north, which were made in various forms to represent individual spirits.

Ivory sea otters were carved with their paws to ears, cheeks, or chin, as illustrated in figures 33, 34, 103, and 105. We do not know the meanings attached to the various positions; they may only represent characteristic poses of this interesting creature, which uses its front paws in many expressive ways, even to covering its eyes when frightened by a blow (Jochelson 1933:38). The sea otter was believed to have been a transformed human being, but then, all animals and birds in Aleut-Eskimo mythology were thought to have a human counterpart, a basic belief that has been made especially visible in masks and some ivory carvings.

Although the usual portrayal of a sea otter was a small ivory figurine, it was occasionally made in other forms, such as the elongated bas-relief figures

on seal-dart foreshafts from the Alaska Peninsula and the lower Kuskokwim, or the stylized forms on Aleut throwing boards (Liapunova 1967b:pl. IV; Collins 1929:pl. 21). Two unusual objects with sea otter motifs, which were obtained from Kodiak Island in the 1850s, are a small round bowl made of bone in the shape of a sea otter, and a long, square awl of ivory with a metal point. Two carved birds, side by side, are on top of the awl's handle, and below them are four sea otters with front paws to their faces, one on each of the square sides. On the bottom of the sea otter bowl is a small sea otter sculpture similar to the Aleut carving in figure 34 (Birket-Smith 1941:fig. 33 a and h).

Many other figurines with special uses have been made—and the knowledge of their use lost—by the Aleuts and Pacific Eskimos. In 1805 G. H. von Langsdorff, who was a member of the Krusenstern-Lisianskii expedition, observed that "many Aleutians employ themselves, in their leisure hours, with cutting out from the teeth of the sea-cow little figures of men, fish, sea-otters, sea-dogs, sea-cows, birds, and other objects," but he did not suppose them to be religious objects (1814, 2:46). Yet, they were probably quite like the figurines illustrated in figures 5-7, 8-11, and 33-36, many of which were undoubtedly used as amulets or charms.

A human figurine of ivory, 14.5 centimeters high, which is not represented in ethnological collections, was found by archeologists in the early period of the Chaluka mound at Nikolski, the oldest Aleut site on record. This object, which could be as old as four thousand years, was identified by an Aleut man as being "the Deity," called "Kaadaraadar." This archeological figurine has ethnographic importance, because it has been asserted that "modern people [Aleuts], though Christians for over a hundred years, retain memory of the name and its use" (Laughlin and Marsh 1951:82). It seems doubtful, however, whether any peoples without written records could identify the use and provide the name for a four thousand-year-old object. The Eskimos of the north, who retained the use of amulets and charms much longer than the Aleuts, do not recognize objects used only a hundred years ago, much less the many unique "winged objects" and other "unidentified objects" of Old Bering Sea, Okvik, and Punuk times, a thousand to two thousand years old.

Another Chaluka figurine, made of sperm whale tooth, from the recent levels, was likewise considered to be "the Deity," but it does not resemble the one from the older level. The two quite probably represent different charms—two among the many used by Eskimos—since Eskimo-Aleut religion had no single unifying deity. (Kaadaraadar is illustrated in Aigner 1966:fig. 25, and Laughlin and Marsh 1951:facing 75.)

Like the northern peoples, the Aleut believed that a charm in the shape of a human face would insure successful hunting. In the north, such a face, used as a plug in a sealskin float, led the owner to the game. Among the Aleut, human faces on casting weapons "were intended as guardians of the weapons and to help them in striking animals," according to Jochelson, who illustrated three bone "war-harpoon heads" with faces carved on them (Jochelson 1925:95, 96; Jochelson 1933:78; Ray 1977:94; Bockstoce 1977:69). Human faces were also used on the inside frames of Nunivak kayaks, and simple mask-like faces were mounted on slats of wooden armor, which the Cook expedition saw at Prince William Sound in 1778 (Beaglehole 1967, 3:1112; Kaeppler 1978:fig. 589).

Ivory guards that were placed on the deck of a kayak to prevent spears and paddles from falling off were often amulets made in human and animal shapes. One of these from the Kuskokwim delta is illustrated in figure 105 *(top left),* and two others from Kaialigamut, in figure 106. The two guards from Kaialigamut are as complicated conceptually as the masks made in that area. The broad sides of the guards are carved as mask-like faces, and the narrow sides, as whole animals in low relief: the top guard in figure 106 has white whales, and the bottom guard, seals. The upper ends of both—where the two faces converge at the top of their heads—are seals' heads carved in relief (Nelson 1899:227).

The guards from Nunivak Island were often made in the shape of an entire animal, which was lashed through a hole cut diagonally in the side. E. W. Nelson illustrated a land otter, about six inches long, used in this way (1899:pl. LXXVIII-14). The Nunivak men also placed bas-relief faces as amulets in their kayaks. The faces of a man and a woman were attached in pairs on the two cockpit supports, just under the rim facing the paddler, to complement each other and to keep the kayak from swaying (fig. 168). A woman's breast, stylized as a circle with a dot in the center, was sometimes substituted for a woman's face (Himmelheber 1953:62).

The elegant Aleut hunting hats (figs. 5-11) had numerous attached ivory amulets and charms, as did hunting hats from southwest Alaska. The first ivory object that Europeans saw in Alaska (1741) was a seated human figurine attached to a wooden hunting hat (see chap. 1). Figurines in a seated position are rather rare in both archeological and ethnological collections, and their use probably differed from area to area. The Russian ethnologist, S. V. Ivanov, devoted a paper to discussing six such human figurines from Soviet museums (Ivanov 1949b).[2] Three of the six figurines came from the Aleutian Islands, and one from Kodiak. Two are of indefinite provenience, but are obviously from the Aleut-Kodiak area. One, a very spare-looking individual, only 3.5 centimeters high, is attached to a section of a hunting hat with sinew. This figurine, which is mostly head and neck, has a body shaped like a square frame formed by arms resting on drawn-up legs. In profile, it appears to be staring into the distance, as it might well be, looking for sea otters. Since this was the only example of its kind in the Soviet Union, Ivanov supposed that it was the only seated figurine still attached to an Aleut hunting hat in the entire world. However, the little man in the John Webber drawing (fig. 5) is still firmly attached to the hat, now in the British Museum (Ivanov 1930:494; King, forthcoming).

Despite the rarity of seated figurines in collections, they apparently once had a wide geographic spread. One was found in the lower levels of the Uyak site on Kodiak Island, and several are known to have come from northern Alaska during the nineteenth century: from Little Diomede Island, Kauwerak on Seward Peninsula, and Point Barrow (Heizer 1956:pl. 82-p; Ray 1977:fig. 49). Lavrentii Zagoskin collected a seated figurine from southwest Alaska (but Ivanov did not illustrate it in his paper of 1949), and Johan Jacobsen illustrated

2. Three of the same figurines are also illustrated in Orlova 1964:figure 54, and one is illustrated in this book, figure 35.

three seated figures that he collected on the Kuskokwim River in 1882 (Jacobsen 1884:351; 1977:185; Zagoskin 1967:fig. 16).[3]

MASKS AND OTHER WOOD SCULPTURE

When E. W. Nelson collected masks from the Yukon-Kuskokwim delta area on his long winter sled trip during 1878-79, he regretted that he had "failed to secure the data by which the entire significance of customs and beliefs connected with masks can be solved satisfactorily. I trust, however, that the present notes [in *The Eskimo about Bering Strait*] with the explanations and descriptions of the masks, may serve as a foundation for more successful study of these subjects in the future; the field is now open, but in a few years the customs of this people will be so modified that it will be difficult to obtain reliable data" (1899:395).

Unfortunately, no one did follow through with serious inquiry, and it was not until 1913 that the first description of a masked ceremony was published by E. W. Hawkes, who attended the "Inviting-In Feast" of 1911 at Saint Michael where he was teaching school. Many years had elapsed without such a celebration, mainly because of pressure brought by religious groups, but when the Saint Michael people invited the entire village of Unalakleet to a messenger feast in 1911, the Unalakleet people readily accepted (Hawkes 1913).

By the time I began inquiring among the Eskimos about masks, in the 1960s, I learned that most of their information was secondhand, and even the few persons who had attended semi-traditional ceremonies in the 1910s could remember very little of what they saw or did. They were unable to tell me why the masks were made, nor could they repeat the songs and stories. But the spirit of mask-making had not died, and as with basketry, there were always some persons who had kept the tradition alive, usually by copying the old designs.

In the days of traditional ceremonies, probably no people with equivalent degree of cultural similarities made such a variety of masks as did the Eskimos (including the Aleuts) of Alaska. There were many one-of-a-kind masks, which came into being through dreams and visions of individual shamans. Yet despite this highly individualistic approach to mask-making, the carvers worked within a stylistic pattern, so that it is possible to identify masks from certain areas and even villages. Styles were also borrowed, as might be expected during intervillage festivities, and some of the dreams and visions represented in the masks were based on themes common to all Aleuts and Eskimos. For example, the half-man–half-animal (or half-man–half-spirit) mask was made from Prince William Sound to Point Hope. Such masks from the Aleut, the Chugach, and Nunivak Island are illustrated in figures 39 *(lower middle)*, 46 (*middle left* and *lower right*), 47, 48, and 154. (Also see depictions in ivory, figs. 97 [16] and 137.)

3. Recently, several seated figures, which date back at least fifteen hundred years, were found in the Ekven burials on the Chukchi Peninsula in Siberia. One of these figures serves as the handle of a comb, and two other small "statues of dancers" undoubtedly represent shamans sitting on the ground. Both figures have a slit part way down the back and in the back of the head (Arutiunov and Sergeev 1975:figs. 54 [5], 78 [7], and 80 [11]).

Masks ranged from a simple piece of wood with eye holes, which covered only the upper half of the face, to those that extended almost the length of a man's body. The largest one that I have seen is 49½ inches high, from Goodnews Bay, illustrated in figure 144a. Simple masks in realistic human (portrait) or animal style, without distortion or spirit faces, were generally made by Eskimos living north of Saint Michael, and on Kodiak Island and Prince William Sound. Simple one-piece portrait masks were also used by the Yukon and Kuskokwim people in certain ceremonies. Although the Pacific Eskimo masks were structurally simple, they differed from those of the north by a lavish use of paint, feathers, grasses, and geometric pieces of wood radiating from the masks (figs. 44, 45).

The majority of large complex masks with spirit faces or of surrealistic design were made by the Eskimos living on the mainland coast from Nushagak to Scammon Bay. Wooden appendages that represented whole figurines or parts of animal or bird bodies were attached, and halos of caribou hair, feathers, and roots encircled the masks. Almost all masks south of Saint Michael were painted in various colors, especially black, blue, red, and white. Some Pacific Eskimo masks were painted an unusual shade of rose pink (see also chap. 2).

Many masks were visual reports of a shaman's supernatural adventure or a representation of his tutelary. He carved his own masks or hired a skilled carver to make them under his direction, but certain secular masks, made for fun, could be carved by any man. In Alaskan Eskimo festivals, masks were not worn as concealment or disguise, but for visual and psychological transformation into the animal or supernatural being represented by the mask. During the wearing of a mask, the dancer or performer was suffused with its spirit; and in dances that called for the transformation of an animal, bird, or inanimate object into its human counterpart, "doors" built into the mask were sometimes pulled open to reveal a carved human face.

A shaman sometimes used a mask when doctoring, or during a seance performed to avert a disaster that threatened a village. On Nunivak Island, a shaman was not transformed when he drummed, sang, and wore a mask of a certain spirit in a seance; he only portrayed that spirit (Lantis 1946:200-1). During a hunting festival, a shaman often donned a mask for a visit to the spirit world, where he sought assurance for a good hunting season. Masks were never used in warfare.

Since there is a considerable body of information about the masks of southwest Alaska, I would like to elaborate on the masks and ceremonies of the Aleuts and Koniags. Almost all of the masks in present-day collections are of human faces, although the Aleut and Koniag were supposed to have worn animal masks in their festivities. Yet, S. V. Ivanov wrote that Russian museums have no zoomorphic masks, and I have seen only one published illustration (Ivanov 1930:488; see Ray and Blaker 1967:pl. 70, from a plate in Lot-Falck 1957).

Before the Russians came to the Aleutian Islands, the Aleuts had elaborate masked ceremonies, which were still performed during the latter part of the eighteenth century, but had ceased several decades later, and masks were no longer made. Potap Zaikov reported for the years 1775-78 that in the winter, "the [Aleut] men and women foregather in a hut to pass the time away, don painted wooden masks, and crown these with wooden figures representing

human beings, birds, or sea animals." In 1781, Peter Simon Pallas, describing intervillage festivities, wrote: "The men dance entirely nude, some of them wearing painted wooden masks, representing all kinds of sea animals and covering their heads to the shoulders. The women follow, clothed. After the festival the masks are broken to pieces or deposited in distant holes in the rocks, and are not used the next year" (Masterson and Brower 1948:46, 91). At Unalaska, in 1790, the Billings expedition collected (or saw) a number of Aleut masks, which were illustrated by both Martin Sauer and Gavriil Sarychev of the expedition. Sauer lamented, however, that the expedition's "illiterate and . . . savage priest . . . upon hearing that some of our gentlemen had seen a cave in their walks, where many carved masks were deposited, went and burnt them all" (fig. 39; Sauer 1802:160; Sarychev, Atlas 1802). In 1805 G. H. von Langsdorff observed that "the masks, which earlier travellers observed these people to wear at their festivals, seem now entirely laid aside," and from 1824 to 1834, according to Ivan Veniaminov, the people no longer had formal festivals—only informal get-togethers (Langsdorff 1814, 2:49; Veniaminov 1840, 2:93).

The Koniags also participated in numerous festivities, apparently long after the Russians had arrived, because we have information from 1802 and the 1840s about elaborate hunting ceremonials in which masks were used. In 1802 Gavriil I. Davydov witnessed hunting festivals in three separate ceremonial houses on 8, 18, and 30 December. In the first ceremony, no participants wore masks, although two men had helmets made of bent twigs. The dancers carried puffin-beak rattles and kayak paddles painted with sea mammals and fish figures (see figs. 13 and 17 for puffin-beak rattles). A kayak, fur pelts, and hunting weapons and decoys hung from the ceiling, and were kept in motion by one of the actors, who wore a kamleika (the Russian name for a gut parka). The entire ceiling was covered with dry grass.

The second ceremony began with the entrance of five masked men. Two wore fur parkas; one, a kamleika; and two were nude, the body of one painted red, and the other, black. The three not wearing fur parkas wore a bird skin object that hung to their knees. The five dancers performed, and then departed. After they had left, another man appeared "in a kamleika and an exquisite mask with rattles in his hands representing the evil spirit." Davydov was unable to learn the meaning of any of the activities.

On 30 December, Davydov was invited to the "wooded islet" where the ceremonial house was also decorated with hanging figurines, paddles, and pelts, and the dome-like ceiling was covered with dry grass. Four naked men, painted with red stripes all over their bodies, wore masks from curved sticks, made in such a way that the man's face, which was painted red and white, could be seen between them.[4] Arrows, kayaks, decoys, and implements hung from the ceiling, and, as before, all were kept in motion by one man. After the four naked men had danced, another man "with a painted body, in a mask

4. Both the Aleut and Pacific Eskimo men painted their faces with various designs for different occasions, but the early explorers apparently thought that the details and descriptions were not important; therefore, our information is rather sketchy in this regard (figs. 3, 4, and 13). There are only hints as to how this activity related to their religion, but it is known that paints were presented as gifts to spirits as well as to human beings, and Waldemar Jochelson recorded a folk tale on Umnak Island in 1910 in which a "corpse [in a burial] was provided with paints of

around which small painted planks and eagle's feathers were glued in a semicircle," also danced. The spectators wore their best clothes, including cloth parkas (Davydov 1810-12, 1:201-11 [the translation is from the original]; 1977:107-11).

In 1842 Ilia G. Voznesenskii saw a masked performance at Kodiak called the "Six-Act Mystery." He obtained several of the masks used in this ceremony, three of which are illustrated in figures 43-45. These masks were not made of "bent twigs," as some were described in 1802, but were carved of wood, and had considerable artistic merit. "Small painted planks," however, also encircled most of these masks.

The Aleut masks that the Billings expedition saw at Unalaska were quite different from the heavy, massive masks found in the Kagamil Island caves, although both kinds were apparently used for dancing (figs. 40, 41; see also Ray and Blaker 1967:pl. 70). The cave masks did not have eyeholes, but were made so that a dancer looked out of the nostrils to the ground. W. H. Dall suggests that this narrow vision was imposed because a human being was not permitted to look at the spirits supposedly standing in front of him (Dall 1878:4-5). Dall said that similar masks were placed on faces of the dead in some rock shelters (though not in the Kagamil caves), which he thought were used to protect the corpse from the glances of spirits, but masks have never been found lying on a skull.

Very little is known about Chugach masks, and, according to Kaj Birket-Smith, the only Chugach masks in existence are the seven specimens illustrated in figure 46. Others, however, have subsequently been identified as Chugach, for example, the masks in figures 47 and 48. The Chugach at Nuchek in Prince William Sound used masks for both shamanistic and ceremonial performances, especially when visitors came from Kodiak Island or Yakutat. The masks were made in both animal and human shape, had feather ornaments, and were painted. Women also wore masks. As on Nunivak Island, there were no finger masks (Birket-Smith 1953:109-10).

Eskimos and Aleuts wore various woven, sewed, or carved ornaments on their heads or held them while dancing. No one in southern Alaska danced without something in the hands. The women waved wands, fans, or blown bladders (the Aleut, see fig. 2), and the men wore gloves or held rattles or wands. Hand fans (the so-called finger masks) were a local development of the southwest Alaska mainland, and were traditionally made of wood, sometimes as miniatures of a large face mask. A recent innovation is a hand fan made of woven grass.

Many carved wood and ivory models of animals, birds, human figures, and boats were used in all ceremonies. Some, especially birds, were hung as protective figures in the *kazgi,* or ceremonial house. Others were puppet-like figures that were built to move in clever ways during the festivities. Few of these objects have been preserved, but we have some firsthand descriptions. I have

four colors in order that he might paint his face in the future life" (Jochelson 1933:20). Women in the Aleutian Islands tattooed "various figures on their faces, the backs of their hands, and lower parts of their arms" in the 1760s, but by Veniaminov's time in the 1840s, the practice had died out. Veniaminov said that some of the designs had displayed the hunting or war exploits of their ancestors (Coxe 1780:151; Veniaminov 1840, 2:113).

already mentioned the many hanging objects in the Kodiak ceremonies. In 1878 (the original text erroneously reads 1879), E. W. Nelson saw "a fantastic bird-shape image, said to represent a sea gull," hanging from the ceiling of a ceremonial house at Kashunuk during a bladder festival. It was rigged so that it could "be made to glide up and down" on a rawhide thong (Nelson 1899:382-83).

On Nunivak Island, various figurines were a part of seal hunting and seal-hunting ceremonies. For example, at the beginning of the bladder festival, a man carved a seal from a piece of wood that had been carried into the *kazgi* on a kayak seat. A boy then took the seal outside, where it remained until the men took it to the top of a cliff during the first spring seal hunt. They were then ready to make their new kayaks. On the fourth day of the bladder festival when a shaman was preparing to dive under the ice to check on the seals, the same boy who had taken the seal outside the *kazgi* put a "little figure of a seal in the hole" to lead the shaman under water. Then the shaman, with a sealskin float tied to his back, left the ceremonial house through the skylight to enter the sea. The other men remained inside to sing three songs, after which the little seal figurine dropped from the skylight, verifying the shaman's "journey." Soon after, the shaman himself reappeared (Lantis 1946:182, 184-85, 193).

A large wooden cross-like frame, now called a dance stick, was used in the Nunivak Island messenger feast. Margaret Lantis has written the only description of this unusual piece of sculpture: On the second evening of the messenger feast, when all of the guests had left the *kazgi*, several men who were

unofficial heads of the lineages brought in large flat wooden frames (a kind of tray) on each of which there were many, possibly two dozen, wooden carvings of seals, caribou, birds, kayaks and kayak men, and other things. A frame was constructed as follows: one long stick served as handle and a kind of tongue, with crosspieces fastened to it at one end (front end). Pegged onto the crosspieces, hence in rows one behind the other, were the simple, stylized, painted wooden figures. On the handle itself were the more elaborate compositions, such as a seal popping out of a hole in the ice or a flying bird perched at the end of a quill (hence quite fluttery whenever the "tray" was moved). Each one of these contraptions, called kani'gax͡'oa'tăt, was about six feet long, too large to be held by one man; so the heavy front end was sustained by a rope from the kazigi roof. The owner and carver sat on the floor or on the bench at the rear of the clubhouse, holding his kani'gax͡'oa'tăx by the handle, and pushed it forward and back. (Thus it might also be called a shuttle.) As there was not room to suspend them all side by side, usually there were two just above the floor and two at bench level. The figures on the frame commemorated spectacular hunting achievements of the ancestors of the family. Sticking into the animals were highly conventionalized models of harpoons or arrows. Everyone knew the meaning and the legend of each figure. Although they were proprietary, they were not secret. [After the guests returned] the headmen sang and "danced" sitting down, pushing their trays forward and back and shaking them so that all the animals seemed to quiver and move.

After the "dance" with the sticks, several of the hosts danced, wearing elaborate masks, all different, but singing the same song and dancing the same dance. The masks were broken up and thrown away, or else burned, and the dance stick was dismantled. The figures of the stick were given to the children as

"a kind of talisman," and the handle was kept for the next messenger feast (figs. 160, 161; Lantis 1946:191-92, and figs. 31, 32).

The apex of wooden boxes as sculpture was reached in southwest Alaska during the nineteenth century. In no other area was there such exquisite workmanship and variety of forms and ornamentation. Some of the boxes were, in themselves, fine pieces of sculpture; some were foundations for the figure painter, and others, models of ingenious inlay techniques.

The many fine examples not only show unusual artistry, but suggest that the sculptors were trying to make something out of the ordinary and to provide conspicuous surprises: for example, the boxes in animal shape, which give no hint of the interior until the lid is opened and a feast of painted figures meets the eye (fig. 176); or lids that are cleverly devised and neatly fitted— the sea mammals (figs. 176 [7], 177, and 178 [12, 17, 26]), human faces (fig. 178 [21, 22]), or the lower jaws of animals, the front of the mandibles serving as lifters (fig. 178 [16, 24]); or the painstaking, meticulous work that went into the grooving and inlays on the *bottoms* of boxes.

One of the most unusual boxes ever collected (that is, if it *is* a box) is illustrated in a book about Northwest Coast Indian art by Erna Siebert and Werner Forman (1967:pls. 74-76). This object, which is in the Museum of Anthropology and Ethnography, Leningrad, is undoubtedly of Eskimo origin, and was included in the book with that suggestion. The only information provided by the museum catalog was that it was "from the collection of the Admiralty Department, 1829."

This box, or dish, has been a topic of lively conjecture since the book was published in 1967.[5] The consensus is that it most likely is Eskimo—but from where, and for what use? The wing-like side boards, which do not close, and the mask-like face in the bottom of the bowl, suggest that it may not have been used as a box or a dish, but as a piece of sculpture to hang during a ceremony, or as a mask for dancing. It is possible that this piece came from the Nushagak or Kuskokwim rivers, where Russian traders had been active since 1818. The workmanship is similar to that of Yukon River snuff boxes collected by Zagoskin in the 1840s (figs. 174, 175).

The shape of two small oval boxes in figure 178 (5, 6) is found fairly universally throughout the north, ranging from Siberia to Prince William Sound. The Sheldon Jackson Museum has several well-made ones from Siberia very similar to these, and the Washington State Museum has one made of baleen from Prince William Sound, but with only one overlapping zig-zag flap (also see Ray 1977:fig. 224). Very few snuff or tobacco boxes of any kind, however, appear to have been made in the Aleutian or Kodiak islands.

The antiquity of wooden tool and work boxes has not been definitely established, but tobacco boxes were not made until the tobacco trade began across the Bering Strait at the end of the eighteenth century, or with the Russian-American Company after their Bering Sea posts were established after the 1820s (Ray 1975:97–102). The high regard in which tobacco, a much sought-after commodity, was held seems obvious in the care lavished on the containers

5. I wish to thank Erna Siebert, Leningrad, and James W. VanStone for information concerning correspondence about this box between the Museum of Anthropology and Ethnography, Leningrad and the Rijksmuseum voor Volkenkunde, Leiden, the Netherlands.

made to hold snuff or quids of tobacco. Similar care was taken in making small boxes that held paints and arrowheads, but the designs were usually not so intricate.

This attitude toward making boxes beautiful had evaporated by the time Hans Himmelheber went to the Kuskokwim River in 1936. When he asked a Kuskokwim man why the people did not decorate their tobacco tins, which were treasured objects that they took out of their pockets in pleasant moments and turned playfully in their hands, the man answered, for what reason? All they needed was a container in which to put the quids between chews (1953:14-15).

HUNTING HATS

Eskimo hunters as far north as Kotzebue Sound wore visors or hats when they were on the sea in their kayaks. From Norton Sound to Kotzebue Sound, the hats were open-crowned visors of wood or stiff skin (fig. 59; Ray 1977:figs. 7a and 7b); in southwest Alaska and the Aleutian Islands, they were either open- or closed-crown of wood (figs. 1, 5-11, 59 and 60), but north of Kotzebue Sound the Eskimos wore wooden goggles instead.[6] The Pacific Eskimos wore a different type of hat woven of straw or roots (figs. 3 and 4).

On these utilitarian hats, which effectively protected the eyes from glare, were attached various carved bone and ivory amulets: human figurines, bird heads, walrus heads, and sea mammals. The most elaborate ones also had grass, feathers, bristles, and beads.

The Aleut style of closed-crown hat was the most dazzling of all. The "classic" Aleut hat in profile was formed like an acute triangle, and the usual Kuskokwim hat, like a cone (figs. 7, 59, 60); but the earliest drawing of a closed pointed hat (earlier than any known closed Aleut hat) is shaped like the triangular Aleut hat, yet was worn by an Eskimo in Kuskokwim Bay (see page 14).

The earliest known Aleut wooden hats were large visors, open at the top. From the few discussions in print about these hats, it has been assumed that from the earliest days the visor and closed triangular hats had coexisted, signifying a difference in rank. As I examined the illustrations and explorers' accounts for the hundred years following Bering's voyage of 1741, it became quite clear, however, that the open-crowned visor was the *only* style worn until the closed hat and its unusual ornamentation appeared on the scene during the early nineteenth century.[7] The development of the ornate, closed hat, which became a symbol of rank and privilege, has a remarkable parallel with the changes in attitudes toward chieftainship by the Aleuts and the Russians. Ivan Veniaminov wrote in 1840, that the early Russian fur hunters had drawn no class lines between the traditional "chiefs and ordinary Aleuts, in their labors, punishments, or other respects." But toward the end of the eighteenth century,

6. There has been speculation that the prehistoric Ipiutak people might have used visors because of the presence of several ornamental bands (conceivably used on such objects) in the site, although there is no direct evidence (Larsen and Rainey 1948:113 and pl. 51). In historic times, the farthest north range for the conical hat was Norton Sound, and for the broad visor, Kotzebue Sound.

7. See chap. 1 and figs. 1, 5, and 6; Beaglehole 1967, 3:1142, 1442; Choris 1822:pl. V; Cook 1784, 2:510, and Atlas:pl. 48; Glushankov 1973; Golder 1922:facing 149, 304, 305; Lisianskii 1947:171; Sarychev 1806-7, 2:facing 8; and Sauer 1802:facing 155.

the government wanted a distinction made so that the chief's authority could work to the advantage of the Russian-American Company. Consequently, between 1792 and 1823, the commanders of naval expeditions were instructed to distribute bronze, silver, and gold medals to the chiefs (Veniaminov 1840, 2:171). It was sometime during these years that the first expensive, ornate, closed hat was made, becoming a badge of office and establishing identity of rank.[8]

The Aleut leaders were comparatively wealthy, and could afford the expensive hats. From 1824 to 1834, according to Veniaminov, a hat cost from one to three slaves, which was more expensive than an umiak, usually worth only one slave. (Veniaminov said that rich Aleuts had from five to twenty slaves, who were taken as prisoners of war.) This kind of hat was an Aleut man's prized possession, which is evident by the care taken in the native repairing and patching of hats now in the Museum of Anthropology and Ethnography, Leningrad. It was also a dangerous possession, for if a strong wind caught under the hat, both man and kayak could capsize (ibid.:165, 218, 329).

Both the visor hats and the closed hats of the Aleut were made of a single piece of wood, the two ends bent to join in the back, and fastened together with sinew. In the visor hat, this seam was usually left uncovered, but in the closed hat, it was covered with a long plate of bone or ivory, incised with blue, green, black, or red geometric designs, into which sea lion whiskers were inserted. At the top was an ivory bird, animal, or thimble-like carving. The early visor hats were sparsely ornamented with a small amulet, a few grasses or feathers, and red or green paint. Later, sea lion bristles and beads were added (figs. 5, 6). The closed hats were much fancier. Besides the long seam plate, it was ornamented with several ivory amulets, side pieces in the shape of bird beaks, many beads, and painted geometric designs (figs. 7-11). The usual pattern of these hats with elaborate geometric motifs was symmetrical, each half divided in the middle front by a row or cluster of beads or small carvings. The size of the closed hats from the tip of the top peak to the front edge varied from thirty-nine to fifty-three centimeters (Ivanov 1930:478).

Bending wood for the hats was hard work. G. H. von Langsdorff said that a man would frequently be occupied a whole week in turning a good piece of driftwood into a plank and rendering it pliable by "lying in the water" (perhaps hot water, a method used by the Chugach), although Waldemar Jochelson said that Aleut hats were bent by steaming as follows: "A wooden board (mostly of drifted California oak) of a required form and size is planed as thin as possible by a knife, and keeping the board over the steam of boiling water it is carefully bent until the edges come together to be sewn [with sinew],"

8. In his paper of 1930, S. I. Ivanov postulates that the closed, cone-shaped hats were derived from animal masks, and had a religious purpose, "which was overlooked by Veniaminov and other visitors to the Aleutian Islands." He cites as evidence of "animal prototypes"—mainly from inspection of hats—the beak-like ivories at the sides as "ears," the painted rosettes or spirals as eyes, and a line for a mouth. He wrote, "We take for granted that these wooden hats were originally masks of a religious and magic character," yet he also wrote that "Aleut hats are most unlike their animal prototypes." He assumes that the beak-like pieces at the side are ears, yet asserts: "There is no explanation for the fact that bird heads appeared in place of the ears" (1930:483-88, 495). I can recommend this paper for the information about objects in Soviet museums, but his sweeping generalities and conclusions should be read critically.

a material also used to attach the ornaments (Langsdorff 1814, 2:38; Birket-Smith 1953:73; Jochelson 1933:26n).

The closed Aleut hats were painted in three styles: (1) simple, parallel bands of color; (2) geometric designs of many colors, usually stripes, and parallel and curved lines, as well as medallion and floral motifs of European origin; (3) realistic animals and scenes.

Jochelson, in 1909, was probably the last person to photograph Aleut men wearing the elaborate closed hunting hats and fancy kamleikas as they sat in a two-holed kayak (Jochelson 1933:figs. 15-17; compare these photographs with one taken of a Nunivak man wearing his hunting hat and gut parka as he sat in his kayak in 1928 [Curtis 1930:facing 54]).

We have no contemporary information about the painted bands and geometric designs; perhaps they were purely decorative. On Nunivak Island, however, the white and light blue paints of the hunting hat not only disguised the hunter in the blue and white of sea and ice floes, but was thought to please the seals, "which were supposed to like cleanliness." A man's most important animal protector was also painted on such a hat, which was worn at certain times during the Nunivak bladder feast and in ceremonies before spring hunting (Lantis 1946:172, 184, 185, 194, 205). At Kashunuk, E. W. Nelson said that he saw many conical hats painted white with "various phallic pictures in red; these pictures had a certain significance connected with the religious beliefs of the people, which I failed to ascertain." Although he did not describe the phallic pictures, he illustrated a paddle painted with a similar symbol (Nelson 1899:167 and pl. LXXX-8; also see section on representational painting).

One of the striking aspects of the Aleut hat was the placement of sea lion bristles, feathers, and beads so that movement enhanced the beauty of the hat, something akin to masks with their feathers and springy appendages, yet these hats were worn only for hunting on the sea. The sea lion bristles were not for beauty alone, however, according to Langsdorff, but were regarded "as trophies which indicate a good hunter, since each animal has only four [long] bristles, consequently any number of them together must be a testimony of having captured a great many. I have in my possession a hat which must be ornamented with the beards of at least thirty-seven sea-lions . . ." (Langsdorff 1814, 2:38-39). To hold 148 bristles, the style of hat that he describes was undoubtedly like the one illustrated in figure 6.

Beads were probably adopted as ornaments at their first appearance. They were a plentiful trade item in the 1760s, and James Cook said that Unalaska hats were decorated with "two or three sorts of glass beads" by 1778 (1784, 2:423). Beads of various sizes were threaded on sea lion whiskers or placed at the base where each whisker was attached to the wood. Large beads were strung in rows or clusters in the middle of the hat, and small seed beads were imbedded into the hat itself (figs. 5-7, 9).

Some of the ivory side pieces are said to be stylized bird beaks, and they may well be, although no firsthand information about these designs was ever recorded. They were usually placed on the peaked closed hats, although Frederick Litke illustrated a man in a one-cockpit kayak wearing a large open-crowned visor hat with side pieces and sea lion whiskers in the 1820s (Litke, Atlas, 1835:pl. 11). Side pieces of different shapes were also an important part of both the open and closed hats of the Kuskokwim River and Norton Sound

areas, and some of the elongated attachments seem definitely to represent bird beads and beaks (for examples see figs. 9, 11, 59; *The Far North:* figs. 63, 64, 66, 71, 72; Feder 1971:fig. 64; Hoffman 1897:pl. 54; Ivanov 1930:pls. II, IV; Nelson 1899:pl. LXIV and fig. 45).

Pacific Eskimo hats differed from those of the Aleutians and southwest Alaska. In his paper on Aleut hunting headgear, S. V. Ivanov said that there are no "sharp-pointed [wooden] hats from the Alaskan Konjag [Peninsula Eskimo] and Kadiak Island" in Russian museums, but G. I. Davydov, who was on Kodiak Island in 1805, said that the Koniags wore "wooden bonnets, which are sharply pointed and painted" and eyeshades set with "various stones." An elaborately decorated eyeshade, collected in 1857, supposedly from Kodiak, is illustrated by Birket-Smith (1941:fig. 9). Father Gideon, who wrote an ethnography of Kodiak Island in 1805-7, said that when the Kodiak men went into battle, they wore hats "made either of poplar wood or from thick animal skin," but he did not describe them.

The Eskimos of the Alaska Peninsula wore wooden hats of a different style— rather flat on top, and without a long forward projection. Little is known about these hats. A rare record of a Naknek River man wearing such a hat was painted by Pavel Mikhailov, an artist who visited the northern shore of the Alaska Peninsula in 1827-28. The hat is undecorated except for several stripes of paint. The hats from Katmai (on the south side of the peninsula and opposite Kodiak Island) differed somewhat by being more square, and ornamented with beads, bristles, and ivory side pieces. These Katmai hats, which Ivanov calls "Konjag" (apparently referring to Alaska Peninsula Eskimos, although Kodiak Eskimos may also have worn this style), were painted black and tan on white, and were almost identical to the hat worn by a Kuskokwim man in figure 58 (Black 1977:92; Davydov 1977:153; Hoffman 1897:pl. 53; Ivanov 1930:pl. III; and Shur and Pierce 1978:362).

Decoy hats in the shape of a seal's head were used in seal hunting by both the Chugach and the Koniag. Cook was the first to report such a hat for the Chugach, a "well painted" one at Prince William Sound (Cook 1784, 2:369). Both Davydov and Gideon wrote that the use of the wooden seal hats was very common on Kodiak Island. Gideon explained that for hunting, a man placed a blown-up sealskin *(shuak)* in shallows that were exposed at high tide, near where the "seals like to go ashore. . . . The hunter sits behind the decoy, dressed in a wooden hat which resembles a seal head and utters cries resembling the noises made by these animals" (Black 1977:97-98; Davydov 1977:153; for a decoy hat, see *The Far North* 1967:figs. 68, 70).

The Chugach and Koniag also had hunting hats woven from roots. These hats apparently are the ones that David Samwell of Cook's expedition described, for the first time, at Prince William Sound: "They wear two sorts of Caps, one of which is exactly like those of George's Sound [Nootka] & variously painted, the other sort have a kind of Pyramid built on the top of them & are worn only by the Men of the first Consequence among them; they paint all their Caps with various figures and some who can afford it have them ornamented with beads of different Colours" (Beaglehole 1967, 3:1112).

The designs of four woven Chugach hats in the Museum of Anthropology and Ethnography, Leningrad, are illustrated by R. S. Razumovskaia (1967:pl. VII). Three have stylized eyes, reminiscent of those in figure 4, coupled with

numerous geometric motifs of both Tlingit and Eskimo origin. The ornamentation of the fourth hat is composed only of five parallel rows of triangles around the hat. (Figure 1 in Razumovskaia's article is very similar to a hat provisionally ascribed to Kodiak in Birket-Smith 1941:fig. 7.)

It is not certain which hats the Koniags made themselves or obtained in trade. G. I. Shelikhov said that in the 1780s the Koniag traded wooden hats at trade fairs, and Ilia Voznesenskii wrote that the conical cedar root hats worn by the Kodiak paddlers in one of his drawings, "A View of Pavlovsk Harbor on Kodiak Island" (1842-44), were not made on the island, but were obtained from their neighbors on the mainland, the Chugach (Blomkvist 1951:164; Ivanov 1930:484; Pierce 1975:12).[9]

Although neither the Aleuts nor the Koniags usually wore hats for everyday use, they had elaborate headcoverings for ceremonial wear as well as for hunting. Their ornate and intricately designed hats for ceremonial occasions are discussed under "Sewing."

EFFIGY MONUMENTS

Large effigy monuments, also called grave or memorial monuments, were erected in the graveyards of southwest Alaska in memory of the dead. These monuments, which were found mainly on the Kuskokwim River and in the delta area between Hooper Bay and Kuskokwim Bay, were of two kinds: a pole monument with a human face integral with the pole or an animal sculpture attached separately; and a board monument, on which were hung carved human faces or whole human figures. The pole monument was the most widely erected one of the two, the board monument apparently being a local development of the lower Kuskokwim River area (figs. 162-66). The two kinds were supposedly not erected in the same village, although a photograph taken by Aleš Hrdlička in 1930 shows an effigy post and two board monuments in a "small recent graveyard" at Lomavik on the lower Kuskokwim River (1943:303 and fig. 173).

The record of the pole monument farthest south appears to have been made at Togiak in Bristol Bay, where Ivan Petroff sketched a burial with a large post painted with two schematic faces. Another pole was in the background, and two smaller poles had a wooden fish mounted on each (Petroff 1884:pl. IV).[10] The pole monument farthest north was recorded at Solomon on the north shore of Norton Sound, which is now inhabited by Inupiak speakers, but in earlier times was in a problematical borderland of Yupik-Inupiak people. This record is a photograph, taken during the Nome gold rush (1900), of a

9. Two Aleut hats, which are illustrated in *The Far North* (figs. 63, 64) are designated as being from the "Aleutian Islands or Kodiak," but no others like these have been attributed to Kodiak Island.

10. Petroff said of the Togiak people in 1880: "This tribe [had] never been visited by white men in their own country until the year 1880. . . . An absence of the elaborate carvings found among the Kuskokvagmute is very noticeable here; the crudest images of fish and the human head and face being all they possess in this line." The Nushagak men, on the other hand, who lived only some eighty miles away, "are all skillful carvers in ivory. . . . Great care and pains are bestowed upon their masks," and puppets figured prominently in their festivals (Petroff 1884:134, 135).

life-sized man of wood, holding a rifle and surrounded by his possessions, including a paddle and what appears to be a wood carving of a caribou atop a pole (McElwaine 1901:122). It should be remembered, however, that throughout northern Alaska, a person's own mask was often hung on a frame over the grave; mask-like images were placed on poles to prognosticate hunting success; and bird and animal carvings, representing protective spirits, were placed on posts in summer camps.[11]

There were no effigy monuments on Nunivak Island, nor in the Pacific Eskimo and Aleut areas, although the Atka Aleut were said to put "colored posts" in front of the entrance to caves where the bodies of noted hunters, especially whale hunters, were placed after embalmment. The entrance was also painted in different colors (Jochelson 1925:44).

The information that we have about the meaning and function of these monuments is relatively generalized. Hans Himmelheber, who was on the Kuskokwim in 1936, said that the "purpose of the figures is exclusively to mark the grave." The poles were erected during a memorial feast about a year after death. Clark M. Garber, district school superintendent of the Yukon-Kuskokwim area in the 1930s, said that these "idols are made by the relatives of the deceased . . . placed on the graves merely as tributes to the dead [so it is] known where the dead one is lying," and could be erected any time. Garber said that he had heard of a grave with two monuments, one placed by the woman's husband shortly after her death, and the other, by her son about fifteen years later.

Himmelheber said that the faces on the monuments were "not meant as a portrait," but were "just supposed to be a dead person, not the person concerned." Garber, in an article on Eskimo mortuary practices, said essentially the same thing; but two years before, in his superintendent's report, he had written the opposite: that the faces were "intended to represent the dead and are as near to an actual image of the deceased as the Eskimo can carve it" (Garber 1932:10; 1934:215, 216; Himmelheber 1953:65).

Pole monuments were made with both human faces and animal sculpture at the top. (No animals were placed on board monuments.) Several explanations have been given for the animal figurines. One was that they were portrayals of tutelaries for memorial ceremonies. E. W. Nelson said that the day before the feast of the dead, "the nearest male relative" planted an unpainted, "simple wooden image" of the deceased's helping spirit near his grave. This animal image supposedly drew the dead person's spirit to the grave where it waited to be called into the ceremonial house for the festivities. A similar procedure was carried out to invite the spirits of the dead to "the great feast to the dead," a much more elaborate ceremony that was held every few years. This invitation was issued a year before the festival by placing at the grave a painted—not unpainted as in the ordinary ceremony—image of an animal or a bird on an invitation stake, four to six feet high, with red rings around it (Nelson 1899:363, 365).

Another explanation for the animal sculpture is that it was a substitute

11. Dates and places where pole and board effigy monuments have been observed in Norton Sound and southwest Alaska are as follows: Akiachak (1930), Big Lake (1879), Hooper Bay (1921, 1927), Kalskag (1879), Kinak (1932), Lomavik (1930), Napakiak (1921), Napaskiak (1930), "Nelson Island" (1921), Nunachuk (1932), Solomon (1900), Togiak (1880), Tununak (1878).

for a human face. Himmelheber was told that poles with carved animals were erected in the same graveyard as poles with human faces for men who had not been well liked. A favorite hunting animal, therefore, substituted for a human likeness, which would have embarrassed the survivors. This differs from yet a third explanation given by Nelson for pole monuments at Tununak. There, monuments with human faces represented persons whose bodies had never been found, and the animal figures and other objects put on poles represented their exploits. The human figure on the left in figure 166 (Nelson's drawing of the Tununak poles) is a woman who had died in a landslide, and the other two are men who had been lost at sea. This kind of statue apparently took the place of a body, which ordinarily would have been placed in a grave box. According to Nelson, "Each year for five years succeeding the death a new fur coat or cloth shirt is put on the figure at the time of invitation to the festival for the dead, and offerings are made to it as though the body of the deceased were in its grave box there. When the shade comes about the village to attend the festival to the dead, or at other times, these posts are supposed to afford it a resting place, and it sees that it has not been forgotten or left unhonored by its relatives" (Nelson 1899:318).

Nelson's explanation for the Tununak poles was corroborated by Johan Jacobsen, who saw them in 1882, five years after Nelson's visit. The poles were still standing during the early part of the twentieth century, but later met a regrettable fate, for, according to Himmelheber, the "entire forest [of poles] . . . this unique monument was destroyed by the white teacher [no date given], 'because he did not like its looks'" (Jacobsen 1884:208-9, 334; 1977:111, 175-76; Himmelheber 1953:66). This is not the sole example of the destruction of native monuments and graveyards. I was told by a nonnative woman, who lived long ago in Old Hamilton, that in the 1920s, a teacher "ordered the many graves thrown into the river." A graveyard at "old Akiachok," which had "carved figure posts . . . with hands" fared slightly better with Aleš Hrdlička in 1930. In his *Alaska Diary* he wrote, "Five [figures] secured and sawed off, for packing. Some physiognomic value; and all had eyes and mouth inlays of ivory" (1943:312; one of these figures is illustrated in *The Far North*:vii and fig. 160, and Feder 1971:fig. 68).

Almost all board monuments had a human face or figure attached, but some, like one photographed at Kwigillingok by Garber, had only the dead person's possessions—belt, dancing cap, basket, etc. (Garber 1934:fig. 8). Nelson was the first to describe and illustrate board monuments, which he saw during his travels in 1879. At Big Lake, there were large headboards, four feet long, erected on two posts, with wooden faces inlaid with ivory eyes and mouths, bead earrings, and valuable necklaces. Although he was not there long enough to examine their "curious ornamentation" carefully, he did make a sketch (Nelson 1899:319).

Board monuments with faces have been illustrated in several publications, but those with a whole body placed entirely on the board were unique to a small area on the lower Kuskokwim, and illustrated only by Garber. Although G. B. Gordon also illustrated a whole figure, only the top half was placed on a board. Gordon said that a complete statue was erected only if a man were important—otherwise, a mask served as well—but this difference is not borne

out from other sources (1917:131, 136). Garber described the board monuments at Kinak as follows:

Two posts are set at the head of the grave about three feet apart and extending to a height of six feet above the ground. Beginning about thirty inches from the ground the two posts are boarded up to within one foot of the tie beam which joins the posts across the top. At the top of the boarded section there extends a roof or canopy for about two feet at right angle to the upper margin of the boarded surface. Under this canopy and fastened to the boarded surface is found a human figure. The head is carved from wood and is made in an oval shape with ivory or bone insets for eyes and mouth. The hands are also of wood and frequently hold some object, such as a spoon, knife, sewing kit, etc. The torso is covered by fur or cloth garments, adorned with pendants, buttons . . . and the cap, belt and other cherished property of the deceased [figs. 163 and 164; Himmelheber 1953:pl. 24; Hrdlička 1943:fig. 173; Garber 1932:10; Garber 1934:215; Gordon 1917:facing 126; Nelson 1899:fig. 105].

At Nunachuk, Garber wrote that "not all the figures are mounted on the canopied frame. . . . The two figures with outstretched arms have their base of support in the ground. The figure at the right is adorned with a bead necklace, supports in one hand a modern kitchen knife" (fig. 165; Garber 1934:215).

Most of the figures on the board monuments were women, although occasionally one depicted a man. In 1882, Jacobsen said that he saw two large grave monuments at a village called "Klekusiremuten" (probably in the vicinity of Kinak, southwest of Bethel): "one figure represented a man whose body was painted red [a universal custom on effigy figures] and whose mouth and eyes were made of bone. Behind this figure was a wooden board, on which all kinds of grave goods and keepsakes were hanging" (Jacobsen 1884:340; 1977:179 [translation omitted "keepsakes"]).

An unusual post monument, placed in front of a ceremonial house, was described to Wendell Oswalt at Crow Village on the Kuskokwim. At the bottom of the post was a carving of a young girl, but at the top was a large bird. The girl represented the dead daughter of the village leader, and the bird, apparently his helping spirit (Oswalt 1963:145-46). Crow Village is not far from "Kaltkhagamute" (Kalskag) where Ivan Petroff described grave monuments in 1880. Among the "grotesquely carved monuments and memorial posts" was a female figure with four arms and hands, two of which held rusty tin plates "upon which offerings of tobacco and scraps of cotton prints have been deposited." It sat with legs crossed, and on its head had human hair, which fell to the shoulders. The entire figure was protected by a little roof (Petroff 1884:133).

REPRESENTATIONAL PAINTING

During the historic period, and apparently to some extent in recent prehistoric times, all Alaskan Eskimos either engraved or painted representational figures or scenes on various materials. The incising of such subjects on ivory was done almost entirely by the Inupiat peoples of the north, but when the Malemiut moved south to the Saint Michael area, others adopted the technique for souvenirs after the 1870s.

Although the people of southwest Alaska used only geometric designs on ivory, they were the best-known and most prolific painters of graphic subjects on wood and skin surfaces. The most frequently used subjects were episodes in family history, legendary heroes, helping spirits, and mythological animals, which were painted on bowls, plates, spoons, drumheads, and other surfaces. Usually the painting of these figures was done at some ceremonial or festive time, such as the messenger feast, the bladder festival, or the launching of a new kayak.[12] Above all, the most popular subjects were unusual experiences. For example, the drumhead in figure 190 illustrates the story of a man who killed seven caribou in one day. (The figures in the center of dishes and drums were records of only one episode.) A painting that belonged to one family was not used by any other family, so if a person recognized a painting and its story in another village, it meant that the artist was related. An Eskimo never painted a story told by a stranger or relating to something that had happened to himself. He would, however, tell his experience to another person, possibly a son, who could paint it in the future (Himmelheber 1953:31, 34-35).

Painting representational figures was a man's prerogative, but family property marks, which were derived from ancestor stories, belonged to both men and women and were inherited through both. Men did not permit women to paint these figures, and even in 1936, one of the Kuskokwim men said that it would be "against the dignity of the man if a woman paints. . . . If we want the women to do something like that, we will let them sew it onto the fur clothing" (ibid.:71). A woman's talent in realistic expression was developed in storyknife illustrations (see section, "The Storyknife"), but those transient designs of childhood play were unrelated to religious or ceremonial activities. As in story-knife drawings, the paintings did not stand alone as pieces of art, and seemed to be in a nonexistent state until the stories were known and retold. It appears, therefore, that a painting was less an artistic endeavor than a mnemonic device or historical document.

Some of the most elaborate paintings were on drumheads, which were painted only for the messenger feast on the Kuskokwim River. A son often used a drumhead to paint his father's adventure for the first time, and if he were a host for a messenger feast, he gave it to a person from another village during the festival. If there were several hosts, many drums were given away during a single celebration. The same stories were also painted on gutskin windows by men from a village that was invited to the festival. Such a painting was taken back to the host village by the messenger as a sign that the village had accepted the invitation, and placed in the skylight of the *kazgi* for the duration of the festivities. If a man could not paint a drumhead to his satisfaction, he paid someone to do it for him (ibid.:35-36, 38; the technique of painting on drumheads in 1936 is described by Himmelheber 1953:109-12, and a gut window is illustrated by Oswalt 1967:between 166-67).

12. Most of the material in my summary of Kuskokwim and Nunivak painting, symbolism, and ivory carving has been acquired from information obtained during the 1930s and before. In the 1970s, I found, as did Janice Gibson, who wrote a dissertation on Nunivak arts, that a large part of the knowledge of traditional arts has been lost. Margaret Lantis is preparing a paper about traditional Nunivak art based on her own field work of the 1940s, and it is to be hoped that the absence of this information herein will not materially alter my interpretations or conclusions.

Property marks were often small and insignificant—almost diagrammatic—on harpoon heads and other bone and ivory implements, but usually large, consisting of animals, people, and small scenes, on wood. The painting of property marks on dishes was a part of the bladder festival on Nunivak Island because it was believed that the spirits of the ancestors, who had originated the symbols, were present while these new wooden utensils were being painted specifically for that festival.

Each family had many property marks, and an artist could use them in arbitrary ways because designs were not limited to any particular kind of object, nor did they have to be placed in any set arrangement. Designs could also be used interchangeably on men's and women's bowls, which were differentiated by a flat rim on the man's, and a slightly concave one on the woman's. Nevertheless, a person usually reserved one mark for a bowl, another, for a spoon, and so on. These marks, or ancestor stories in very simple form, were also painted or carved at the ends of batons, about thirty inches long, which were used to lead the drummers and singers at family dances. Himmelheber said that a painting was always monochromatic, two colors being used only if a unique aspect, such as a rainbow, was presented (thus, parallel black and red lines). Paintings on drumheads and gut windows were usually black or red (although a drumhead collected by Himmelheber, now in the University of Alaska Museum [UA67-290], is painted green); dishes, black; and kayaks, black and blue (Curtis 1930:59-60, 63; Himmelheber 1953:37, 41, 42, 63, 103; Lantis 1946:182-83).

Figures that were painted on spoons, paddles, and the inner box lids seem to have been mainly mythologic animals or grotesque beings in folktales, rather than family episodes (figs. 176, 185, 186, 188, and 189). It is usually thought that the painted ware was never actually used because of the pigments, but many dishes and trays in museums are so dark from grease that it is impossible to see the designs, and E. W. Nelson wrote that the black paint used on the spoon from Chalitmut in figure 186 (no. 24) was "very durable, since it shows no sign of defacement, although the utensil has been used in hot water and in greasy compounds" (1899:67).

The permanence of paint on drumheads and wooden dishes was achieved by mixing the black or red color with blood. Himmelheber said that colors of drumheads were mixed with nose blood, the painter inducing a nosebleed with a small stick about the size of a toothpick. He would prick his nose for several minutes, twisting it if the blood did not flow freely enough. "Charles," one of the prominent painters in Bethel, had to operate on his nose in this manner six times to complete a painting only half as complex as the one illustrated in figure 190. Paints for wood were also treated in the same way, and were subjected to a sweatbath treatment for further hardening (Himmelheber 1953:102).

The southwest Alaskan Eskimos also painted figures on kayaks and kayak paddles. (The northern Eskimos apparently did not paint designs on kayak covers, although the Sheldon Jackson Museum has a model one-cockpit kayak with a mythical creature drawn on the side, said to be from Cape Prince of Wales [II.D.52]). Nelson said that the mythical creature called a *palraiyuk* (a long, alligator-like being with three stomachs, each having a pair of legs) was painted on nearly all of the umiaks (and on wooden dishes) "in the country

of the lower Yukon and to the southward," but he did not explain its meaning, or why almost every umiak had this same creature painted on it almost without variation (1899:444, 445). Since it supposedly was a dangerous being, lying in wait to seize a person, it hardly seems to have been an appropriate tutelary. To my knowledge, there is no record of a *palraiyuk* painted on a full-sized kayak, although the design on the Sheldon Jackson Museum model is similar to this figure.[13]

On Nunivak Island, the kayak figures were *inogos* (amulets), which were painted in linear design on the sides of the kayaks, as well as on paddles, thus transmitting the spirit power (such as speed) to the kayak for help in hunting. Edward S. Curtis illustrated two of these kayak designs—one representing a hybrid bird-mink, and the other, two separate animals, a white fox and a red fox, one above the other. The front half of an animal was drawn at the bow, and the rear half—always with the male genitals showing clearly— at the stern, with the body between the front and the back represented by a long line. Only the married men had such drawings on their kayaks (Curtis 1930:14-16; see other drawings in Nelson 1899:pl. LXXIX). A rainbow was frequently drawn on the kayak "in front of the seat," but no explanation has been given for its use (Himmelheber 1953:90).

Kayak paddles were painted with geometric designs—usually red or black— in almost all of western Alaska, but we rarely have been told what they represented. Nelson explained the meaning of a pair of paddles that he obtained at Kashunuk. Each paddle had half an oval on the edge, which he said was a "female phallic emblem." When the two paddles were joined, the emblem (an oval with an elongated center) was completed.[14] The horizontal hand grip at the end of each paddle was also incised with a "semi-human" face, one with a downturned mouth, the other, upturned; therefore, one represented a woman, the other, a man, further extending the symmetry and balance in kayak charms. The same emblems were painted on hunting hats (see "Hunting Hats"; Nelson 1899:pl. LXXX [8], 167, 225).

The attribution of sexual characteristics in kayaks and kayak paddles was also found in the Aleutians. Waldemar Jochelson said that to the Aleut, the boat was regarded as a living being that pretended to share a polyandrous marriage with his partner, that is, the owner of the kayak (1923:20).

The relationship between a man and his kayak is not understood at all well because so little about it appears in anthropological literature, but apparently there was a systematic relationship between hunting, kayaks, and a man and his wife. It is well-known that women were required to observe many taboos and to behave in special ways during hunting and hunting ceremonies, and the kayak complex is one variation for which we have very little data for interpretation.

In the Yukon-Kuskokwim delta area, grave boxes, which were usually placed above ground, were also ornamented with realistic subjects. Many early travelers saw drawings of caribou, beluga (white whale), and bears painted on the sides of boxes to commemorate a man's hunting exploits. Himmelheber also

13. The *palraiyuk* figure was also a frequently used motif on engraved souvenir pipes and tusks made in Saint Michael during the 1880s and 1890s (Ray 1977:fig. 243).

14. In the 1930s, one of the Kuskokwim kayak charms was a circle with a dot in the middle, representing a woman's breast (see "Sculpture as Amulets and Charms").

reported that these animals were sometimes painted in red on the faces of effigy monuments or on the post beneath the face (1953:67).

The southwest Alaskan Eskimos were not, however, the only ones who painted realistic subjects on wood. The Aleuts and the Eskimos of Barrow—a thousand miles apart—painted whales and related subjects on wood objects connected in some way with whaling or hunting on the sea, the Aleuts on bentwood hats and spears, and the Barrow Eskimos on gorgets and other objects (Ray 1977:fig. 12; see also Hoffman 1897:figs. 1-4). In contrast to the diagrammatic, impressionistic drawings of the southwest Alaskan Eskimos, the Aleut and northern peoples drew their subjects as realistically as possible.

Hunting scenes and other activities completely covered some Aleut hats, but on others they were combined with painted stripes and other geometric motifs. Sometimes the little figures are scarcely noticeable in the boldness of the painted lines. Such a hat, from the Museum of Anthropology and Ethnography, Leningrad, is illustrated in *The Far North* (fig. 63). The diminutive figures are a man shooting a bear *(left middle)*; a man with birds *(middle front)*; and a man in a kayak hunting a sea otter *(bottom front)*.

There has been no explanation for the meaning and use of hats that were painted with representational subjects (figs. 8 and 13 [no. 7]). The hats that were almost covered with figures were apparently rather rare, and S. V. Ivanov, who had all of the holdings of Russian museums at his disposal, illustrated only three such hats in his detailed paper on Aleut hunting headgear. On the basis of these three hats, he divided the subjects as follows: "(a) Aleut hunting forest animals on land, with arrows, throwing spears, harpoons, etc. (b) Aleutian hunters sitting in boats wearing wooden hats and armed with spears. (c) Common scenes of hunting various sea animals. (d) Aleut housework. (e) Various animals on sea and land. (f) Birds. (g) Mythical animals and birds."

Specific scenes painted on the hats were sea otter hunting, communal whale hunting, caribou hunting, and men with upraised clubs killing sea lions. "Aleut housework" was represented by only one scene: black drying racks hung with red meat, and people working around a dwelling with smoke rising from a smoke hole. Only one mythical bird was drawn on any of the hats—an eaglelike bird, daubed with splotches of red, and holding an unidentified creature in each claw (Ivanov 1930:500, 501, pls. VI, VII, IX; see also larger and better illustrations of the same hats in Ivanov 1954:pls. 54, 55, 57-60, 62-64).[15] The Aleuts painted their scenes in numerous colors: green, blue, yellow, gray, and lavender; but the Eskimos usually used only black and red.

The Chugach and Kodiak people painted geometric and representational designs on their twined root hats, sometimes using both kinds of motifs on the same hat. Some of the Chugach and Koniag hat designs were similar to

15. Explanations have been given for Eskimo pictographic writing from time to time, but unfortunately, some of the explanations, which were obtained from only one informant or were representative of only one group, were presented as pertaining to *all* Eskimos. An example of this is the information about various symbols and sign language given to W. J. Hoffman by Vladimir Naomoff, a Russian-Eskimo man from Kodiak Island in 1882. Although Hoffman was aware of the limitations of the material, he let it stand as a more-or-less general explanation for all Eskimo groups. There is considerable doubt whether the majority of answers that Naomoff gave Hoffman in San Francisco, where Naomoff was employed by the Alaska Commercial Company, were even applicable to the *specific* questions asked, and his interpretations of the northern Alaskan drill bows are highly suspect (Hoffman 1897:750, 805, 868, 872, 900, 904, 905, 906, 927, 947-58).

those employed by the Tlingit artist, a sharing of motifs that apparently pre-dated the Russian custom of transporting the Aleut, Chugach, and Koniag hunters in Indian territory for sea otter hunting (figs. 3 and 4). In 1802 G. I. Davydov described the Koniag hats as having "wide brims and a low crown slightly pointed at the top, and they are decorated with various designs. At the top of the hat they draw a crab, seal or some other animal. . . . Some young gallants wear hats with a high crown like a flower pot" (1977:153).

The Chugach also painted designs and figures on other objects—their sea-hunting quivers (fig. 50) and wooden armor. In the first mention of representative drawing in the Aleut and Pacific Eskimo area, David Samwell, of Cook's expedition, wrote that the Chugach armor was "variously Ornamented with Figures of Men &c" (Beaglehole 1967, 3:1112).[16]

A number of petroglyphs have been found on large flat rock surfaces in the North Pacific Eskimo area. Despite their apparent antiquity, no other objects with realistic drawings have been found in archeological sites in the entire southern area, although there are small pebbles and other objects with sketchy incising and geometric designs.[17]

THE STORYKNIFE

The storyknife is an implement used by a girl to trace conventionalized illustrations in mud or snow while she is telling a story. The terms "snow knife" and "storyknife" have been used interchangeably for this object, but storyknife more clearly differentiates its form and use from the traditional snow knife used for cutting snow.

The ivory storyknife developed as a triple art form; that is, as a piece of sculpture used for the simultaneous activities of drawing designs and telling a story (fig. 109). Ivory storyknives have a limited temporal and geographical distribution. They have not been recovered from archeological sites dating before 1700, and were used only in the Yukon and Kuskokwim areas and around Bristol Bay. In his study of storyknife tales, Wendell H. Oswalt places the oldest known storyknife at A.D. 1690 at Hooper Bay Village. This site also contained the largest number of knives—thirty-five—of the five sites that he summarized in his paper. On the other hand, an extensive midden site at Togiak contained none at all, although E. W. Nelson had illustrated two Togiak knives from the 1880s (see caption to fig. 109; Oswalt 1964:310-11).

Although Nelson said that the storyknife was known as far north as Point Barrow, no traditional ivory storyknives have come from there. All of the knives that Nelson illustrated in his plate XCIV are from southwest Alaska. Johan Jacobsen illustrated two ivory storyknives, supposedly from Cape Prince of Wales, but there is a mixup in his identification because these knives were not made at Wales. One is almost a duplicate of one collected by Nelson

16. Although this armor was described as having "figures," apparently the only suit of armor that the Cook expedition collected had sculptured faces of men (see "Sculpture as Amulets and Charms"). For further illustrations of Pacific Eskimo hats, see Birket-Smith 1953:fig. 35; *The Far North*:fig. 252; and Kaeppler 1978:266.

17. Detailed information about petroglyphs, pictographs, and incised figurines can be found in the following references: Aigner 1972; Clark 1964, 1970; Heizer 1947, 1956; de Laguna 1934, 1956; Petersen 1971; Stevens 1974.

from Nulukhtulogumut, and the other is similar to one from Ikogmiut (Jacobsen 1884:295 [nos. 2 and 3]; 1977:141 [nos. 2 and 3]; Nelson 1899:pl. XCIV [nos. 7 and 10]; also see Hoffman 1897:784 and pl. 15).

Storyknives collected by Nelson were made of ivory, bone, and antler, but there were others of wood and baleen. Although today the men and boys usually express ignorance of the stories, and appear to want to disassociate themselves from this "woman's sphere" (no boy ever used the storyknife), the man—usually a girl's father, grandfather, or other male relative—made the knives. The ivory knives are rarely used in the 1970s for drawing, because they are considered to be keepsakes, and any pointed metal object is now substituted.

The classic storyknife has a scimitar-like blade, gradually narrowing to a handle made in various ways for firm grasping. The devices used were circular or lozenge-shaped knobs, tiny birds' heads placed in a series, large bird and fish heads at the handle ends, or serrations. Nelson identified the handle designs on three of the knives in his collection as murre heads and salmon heads, and Hans Himmelheber said that the engraved circles represented drums; the circles with beams, the sun; and the bent lines, animal legs (Nelson 1899:345, 346; Himmelheber 1953:15).

The stories are usually told by girls under sixteen years of age, but formerly grown women sometimes told them, and indeed the figures in one model made by Lucy Berry, appear to be adults, although I never had the opportunity of asking her which she had meant (fig. 74). (Mrs. Berry, who died in 1977, lived in Napaskiak, where Wendell Oswalt gathered the information for a study of storyknife tales in 1956 and 1960.) A girl was not supposed to play with a storyknife during her first menstruation because the river banks would crack and fall off (*Kalikaq Yugnek*, spring 1976, p. 96).

The drawings followed a rather set procedure in the step-by-step development of the story and use of conventionalized elements. For example, the girl always began her story with a house floor plan, which usually included a pathway leading from it. After setting this stage, she was free to draw in the principal characters. A character did not speak before she had sketched the outline of a head and facial features. When a character left the scene, she erased him, but when major changes in action occurred, she wiped out the entire drawing (Oswalt 1964:313-14; see also Ager 1971). Oswalt learned that a storyknife was essential for the telling of storyknife tales because the girls had difficulty with narration if they were not drawing at the same time. The relationship between picture and story was also vital in the painting of representational subjects on wood and skin surfaces, as we have already seen.

Himmelheber, in discussing the transience of much of Eskimo art, said that the storyknife drawings, which were done with the greatest care, survived only a few seconds before the next picture was drawn, and he wondered why the girls had not "hit on the idea" of drawing the stories on birchbark or skin as in a storybook (1953:13). But the purpose was not to draw a permanent picture, even in 1936 when the girls had had many opportunities to see picture books, but to create a miniature performance of changing scenes in symbols, actually a highly specialized animated cartoon; and the action and changing scenes were much more important than a static representation of just one portion of the story.

BASKETRY

Dried grass, usually the wild rye *(Elymus mollis),* was used abundantly for many purposes in all of southern Alaska. It was woven into bags, baskets, socks, and matting that was used as sails, kayak pads, floor coverings, and room dividers. It was used in unwoven bunches for boot insoles, figurines on masks, rings for games, and bound to the body in certain ceremonies. The Aleut also wove cradle-baskets and made big grass figures in human shape for festivals.

Otis T. Mason, in his classic study of Indian and Eskimo baskets published in 1904, said that the term basketry included all products that used the same techniques as those in making baskets. The Alaskan Eskimos made two kinds of basketry, twined and coiled. Twining is a hand weaving, which twists a weft, or filling material, over the warp, or foundation strands. Coiling is a sewing technique, in which the weft is sewed to the adjacent coil.

Twined mats were made by all early Eskimos and Aleuts except possibly those living on the far north arctic coast, and though the coiled technique was principally a historical development, fostered by teachers and traders, coiled basketry apparently dates back to prehistoric times. So far, however, only two archeological sites in Alaska have produced coiled basketry, and only a few coiled baskets were collected during early historic times, mainly from places where traders were active (also see below, "Eskimo Coiled Basketry"). Eskimo baskets now made for sale are usually coiled, but bags and mats for home use are twined. A large part of all basketry production, especially in coiled basketry, has been done in the past forty years; therefore, recent changes are discussed in chapter 4.

Aleut and Pacific Eskimo Twined Basketry

Early Russian sources have very few references to Aleut and Pacific Eskimo basketry. The oldest observations consist of only a few words about woven grass sleeping mats and "plated bags" from two expeditions to the Aleutian Islands in 1763. The first known illustrations of Aleut basketry were drawn by Mikhail D. Levashev during his winter sojourn on Unalaska Island in 1768-69: a grass mat with linear designs, and a stiff, unlidded basket with a handle (Coxe 1780:78, 104; Glushankov 1973:205, 206; Golder 1922: facing 305; Jochelson 1933:6).

In 1778 it was apparent that the Unalaska women were industrious weavers. According to David Samwell, "the Women make very curious Baskets of different kinds variously ornamented & beautiful Matts, some of their Baskets are worked so close with Straw that they will hold Water" (Beaglehole 1967, 3:1146).

In 1776, Dmitri Bragin first noted Kodiak basketry as "grass mats woven like Russian mats" (apparently only a comparative statement), which were used as room dividers; and in 1778, James Cook first mentioned the basketry of Prince William Sound, where he saw "many chequered baskets, so closely wrought as to hold water" (Cook 1784, 2:372; Masterson and Brower 1948:71-72).

Only a few twined spruce-root baskets of the Pacific Eskimos have been

preserved, and only two of definite Chugach provenience have been illustrated. These are among five baskets collected by Johan A. Jacobsen in Chenega in 1883, and examined by Kaj Birket-Smith in the 1940s for his study of the Chugach. Birket-Smith also mentioned the existence of two others from Nuchek, but they were of less interest to him because they imitated "ordinary European bottles" (1953:59). These baskets, which are in the Museum für Völkerkunde, Berlin, were the only ones known with definite provenience until the basket illustrated in figure 29, from the Alaska State Museum, was found to have come from a cave on Knight Island in Prince William Sound. Molly Lee, of Juneau, has subsequently undertaken an examination of baskets in several European museums, and has discovered seven more baskets attributable to the Chugach on the basis of style. Although her conclusions are tentative, and she would prefer that the more general term "Pacific Eskimo" be used at present, certain features can be considered to be characteristic of Chugach baskets. Since the Chugach were close neighbors of the Tlingit, sharing the technique of spruce-root basketmaking, a description is necessarily couched in terms of relationship to the Tlingit. The general features that distinguish both the Chugach baskets with definite provenience and those that are attributable to the Chugach are as follows: (1) absence of decorative style associated with the Tlingit, that is, a difference in orientation of design field; (2) a coarser texture (texture equals stitches per square centimeter times the wall thickness); and (3) the presence of concentric basal reinforcing rings, when found in conjunction with the first two features.

Molly Lee has divided the baskets into two populations: first, the Alaska State Museum basket (illustrated in figure 29) and eight other attributed baskets, and second, the four baskets collected by Jacobsen (one was destroyed during World War II) and one attributed basket. The distinguishing features of the first population are tern tail-shark's tooth design elements; the presence of design elements not shared with the Tlingit; and the presence of a secondary design field. The distinguishing features of the second population are the absence of the tern tail-shark's tooth design elements; no secondary design field; narrow pattern bands in the principal design field, located in the upper one-third of the basket walls; and all design elements shared with the Tlingit (Letters, 5 and 24 July 1979, Juneau).

In contrast to Chugach basketry, that of the Aleut is found in numerous museums world-wide, and is still being made today. All Aleut basketry is twined. The basic technique is a two-strand weaving (that is, a double strand of weft wound around the warp strands) with a few minor variations (Mason 1904:403-4). For his analysis of Aleut basketry in 1904, Mason drew upon the collection of Attu and Atka baskets in the United States National Museum, but Raymond L. Hudson, who has written an analysis of Aleut basketmaking from firsthand experience, said that Mason's lumping of Atka and Attu weaving techniques together should be revised, because the Atka weave originally differed from that of Attu. According to Hudson, the Attu technique was restricted to Attu Island, while that of Atka was the kind of weaving known throughout the rest of the Aleutians, and which he calls the "Unalaska method" (Shapsnikoff and Hudson 1974:51).

Aleut women made some of the most delicately woven baskets in the world, and the Attu women made the finest of all. The term "Attu basket," because

of its renown, is sometimes wrongly applied to all Aleut baskets. Some Attu cigar or card cases have fifty stitches to the inch, and one of the baskets in the Alaska State Museum has 1,980 meshes to the square inch. It has been said that there are some with the fineness of 2,500 (Porcher 1904:578; Keithahn n.d.:48). The card case illustrated in figure 26 has thirty-seven stitches and thirty-two rows to the inch, or 1,184 meshes per square inch.

Baskets are differentiated by the fineness of the weave, shape of the basket, style of corners, and knob styles, but exact provenience—if the individual weaver is not known—is often difficult to determine even by a specialist.

In 1904, Mason considered Aleut basketry to be the finest found anywhere. In contrast, both Eskimo twining and coiling were "more rudely done," and were quite coarse in both materials and style. His admiration of Aleut basketry in general was tempered, however, by his comparison of the old Aleut basketry in the National Museum with that recently acquired (i.e., around 1904): "The weaving does not begin to be so fine as on this later ware. It is the same story of progress. With the possession of better knowledge, of superior tools, of gauges for sizing the straws, and, above all, of such demands for their products as to stimulate emulation to its highest pitch, the Atka and Attu weavers have reached their climax" (1904:396, 405). Yet, despite the coarse material in the National Museum, some fine weaving was done in the late eighteenth century, as reported by Gavriil Sarychev in 1791. At Unalaska, he wrote that for "finer works," the long blades of grass were "split into slips," and G. H. von Langsdorff in 1805 collected an envelope-like bag of fine weave, probably made for sale. Rosa G. Liapunova, of the Institute of Ethnography, Leningrad, has illustrated a number of finely woven mats, envelopes, and carry-ing bags, all of which date before 1867 (Langsdorff bag, see fig. 17 herein; Liapunova 1975b; Sarychev 1806-7, 2:8).

The blades of the wild rye were split with a fingernail to make the finest Aleut baskets. In 1791, Sarychev said that the Unalaska woman let her index fingernail grow "to a great length, until it is as sharp as a lancet" (Sarychev 1806-7, 2:8). Anfesia T. Shapsnikoff, an expert Atka weaver living in Unalaska, explained the techniques of gathering and curing grass to Hudson for his paper on Aleut basketry. Mrs. Shapsnikoff did not use the grass near the beach because it was coarse and became brittle when dry. Instead, she went to favorite localities on the hillsides where the best grass grew in scattered clumps. (C. Gadsden Porcher, writing in 1904 [page 575] said that the women always preferred hillside grass, cut during the first part of July, because it was tough.) After Mrs. Shapsnikoff had cut the stalks with their four to six blades, she bundled them into bags and placed them in a dark, cool place to cure; that is, to dry and turn yellow. She checked them every day or so for mildew, and soaked them in salt water at the beach twice during the curing process. (Other weavers, however, have preferred to leave the grass on the hillside to cure.) After the blades had cured, Shapsnikoff chose certain ones for her bask-etry (Shapsnikoff and Hudson 1974:45-46).

Mason, writing in 1904, said that the two youngest full-grown blades of a stalk were split into three pieces at the time of cutting before they were cured, and the middle part was thrown away. (Porcher, also writing in 1904, said that the splitting was done two weeks after the curing began.) The outer pieces were tied into bunches two inches in diameter and hung, tops down, out-of-

doors, but out of the sun, for more than a month. On Attu, if the weaver wanted white strands for weaving, the grass was cut in November; if it was to be yellow, it was cut in the middle of July. Late fall picking resulted in grass blades six feet long, but only the inner and second blades could be used for delicate baskets. The rest of the blades were woven into mats and fish baskets (Mason 1904:220; Porcher 1904:576).

Aleut baskets were woven upside down, suspended from a string, or placed on a stake. The weaver worked from bottom to top, the fine, silky fringes of the top edge hanging downward. Sometimes a mold was used, for instance, in 1908, a "lard-pail . . . wrapped with two or three layers of newspaper" for a medium-size basket (Jaggar 1908:29). Large baskets often took many months to make. Sophia Pletnikoff, a skilled weaver from Unalaska can make a basket about three inches high and the diameter of a "soup can" (about 2⅝ inches) in a week or a week and a half when she has unlimited time; otherwise, with household chores and other duties at home, it may take her a month (Chandonnet 1975:58). Put into different terms, Eunice Neseth of Kodiak told me that her teacher, Anfesia Shapsnikoff, took thirty-seven minutes to go once around the size of a milk can (diameter: three inches). With twenty-three or twenty-four rows to an inch, it took her fifteen hours to weave an inch.

Unlike the designs of Eskimo coiled basketry, which are generally a part of the weft, most Aleut ornamentation was sewed on with embroidery floss or colored grass after the basket was completed. In 1904, Porcher said that "silks and worsted" were used for decoration in all Aleut villages, but that green and white grass and the white, papery throat skin of the sculpin were also used on Attu. On Umnak, painted seal gut was used, and at Makushin on Unalaska Island and Biorka on Sedanka Island, white eagle down. Neckties were sometimes unravelled for use (Porcher 1904:576; Keithahn n.d.:47).

Most Aleut basketry in American collections was made for the souvenir market, but that does not lessen its beauty or value. The envelope-like packet in Langsdorff's illustration (fig. 17), suggests that basketry products were being made for sale at least as early as 1805, because Langsdorff said that during the winter the women "make fine mats, little baskets, and pocket-books, of straw," all of which made up a large part of the early souvenir trade (Langsdorff 1814, 2:46). Besides the pocketbooks and lidded baskets, the principal items made during the latter nineteenth century were cigar cases (also called card cases, cigarette cases, and holy card cases), covered bottles, napkin rings, capes or "pelerines," place mats, belts, and flared baskets ("May baskets") (figs. 17, 23-28, 30). Harriett N. Wardle, in an article about Aleut basketry in the University of Pennsylvania Museum, made the interesting statement that the lids of the Attu baskets had a knob "like the button on an old-time Russian sailor's hat" (1946:23).

The cigar cases, which are baskets made on two slightly different-sized wooden cylinders so that one can slip over the other after being flattened, were made as early as 1824-34, since Veniaminov mentions them as being one of the articles—along with pocketbooks—which were skillfully made by the women of the western islands, but I have not learned when the covered bottles and May baskets first appeared (Veniaminov 1840, 2:253). Covered bottles probably date back to before the 1880s, and the shape of the barbershop

49 THE TRADITIONAL ARTS

bottle in figure 27 suggests that it was made in the 1890s. I have not found a reference to a May basket in old publications, but two May baskets in the University of Alaska Museum date before 1910. One was made on Attu in 1902, and the other was collected before 1910. The May basket in figure 25 probably dates from that time. Designs were borrowed from many sources— magazine illustrations, Russian and American pictures, and cloth prints. Even wallpaper patterns were used.

Eskimo Coiled Basketry

During the 1930s when Aleut basketry was in a decline, the art of coiled basketry among the southwest Alaska Eskimos was beginning its spectacular rise to the heights of the 1960s and 1970s.

The peak of Aleut basket production was between the 1880s—when the Revenue Marine steamers and other ships made regular stops at Unalaska and other ports—and 1918, when a number of basketmakers died in the influenza epidemic. The gold rushes of the 1890s and subsequent mining in the Klondike and at Nome greatly stimulated the market when thousands of persons stopped at the port of Unalaska en route to the gold fields. Eskimo coiled basketry, on the other hand, reached its peak of technical proficiency, form, and design during the past twenty or thirty years. No longer can we say, as Otis Mason did of the work dating from the end of the nineteenth century, that "the Eskimo basket maker does not prepare her foundations evenly, sews carelessly, passing the thread sometimes through the stitches just below and sometimes between them, and does not work her stitches home." He was convinced that "the art of basket making is not an old one with these people. They have not learned how to begin the work from the center of the foundation, and always leave a circular space, either vacant or to be filled with some other substance." He thought, however, that the art was "improving," because specimens brought home at that date (1904) were "vastly better made than any of the old pieces in the National Museum" (Mason 1904:399, 400).

Matting has been excavated from various sites, but only two examples of coiled basketry have been found: some charred pieces from Bristol Bay, and a "whole coiled basket" from early Nukleet levels at Cape Denbigh. The latter was found in the second season's excavations, but this object and other artifacts were not used in the laboratory for the analysis of Nukleet culture because (among other reasons), "the stratigraphy here was not as easily defined as it was for the test cuts because of numerous house disturbances." This material, furthermore, was not carefully analyzed in the field, nor was it sent to Brown University with other Nukleet artifacts, which makes the age of this basket suspect (Larsen 1950:184; Giddings 1964:26; Oswalt 1964:310). The contrast between problematical archeological examples from only two sites in all of Eskimo Alaska and the huge quantity of baskets produced soon after traders and entrepreneurs of the gold rushes arrived makes the antiquity of coiled basketry debatable.

No coiled baskets were offered for sale to early explorers, and E. W. Nelson said that from 1877 to 1881 coiled grass baskets were being made only between the lower Yukon River and Kotzebue Sound, with the twining technique con-

centrated principally between Norton Sound and the Kuskokwim River.[18] The coiled baskets that he illustrated were of uneven and rough workmanship (1899:pl. LXXIV).

Lieutenant J. C. Cantwell, who was in charge of the U.S. Revenue steamer *Nunivak* on the Yukon River in 1899-1901, said that though the women at Russian Mission made a "very fair quality of basket from the grasses which are found in this region," it was remarkable that "the art of basketry appears to be unknown or to have been long since discontinued among the natives of the interior farther up the river." He recommended that basketmaking be taught to women all along the river (most of whom were "comparatively igno-rant" of basketmaking) so that they could find a "most profitable means of support." He was probably recommending instruction in coiled basketry be-cause, of the six baskets that he illustrated, only one was coiled; the others were twined or made of birchbark (Cantwell 1902:142, 228).[19]

During and after the gold rush on Seward Peninsula, the Eskimo women made coiled baskets by the hundreds in many sizes in response to a growing souvenir industry. The teachers at Wales, Unalakleet, Golovin, and Teller, and the many traders lent a hand and ideas. The northern women abandoned basket-making after the influenza epidemic of 1918 and concentrated on fur sewing, for which they are justly famous, but a few school programs have recently attempted a basketry revival. From Stebbins and southward, however, basketry has been one of the women's main sources of income from handicrafts since the 1930s.

The designs on traditional Eskimo twined work were simple horizontal or vertical patterns in subtle contrasting colors, some apparently having special meanings; for example, the patterns used on Nunivak kayak mats were inherited (Lantis 1946:241). Coiled basketry designs were equally simple at first, consist-ing mainly of a few tufts of yarn, tiny beads, or natural objects such as birds' feet in repetitive designs, or of varying the grasses of the weft to create mottled effects. The use of bold geometric designs on baskets, place mats, hot pads, and other objects began in the 1930s, possibly a little before, on both the mainland of southwestern Alaska and on Nunivak Island. No coiled baskets had been made on Nunivak Island before 1920, when Paul Ivanoff, a Shaktoolik Eskimo who was manager for the Lomen Corporation, a Nome transportation and reindeer-breeding company, began to teach the Nunivak women how to coil. The baskets from Nunivak, photographed by Edward S. Curtis in 1927, have a finer coiling and less pronounced designs than those in the Nelson Island photograph of 1932, illustrated in figure 80. A distinctive motif, copied from nonnative baskets about that same time, is a single- or multiple-warp coiling in an undulating pattern, made on both the Nelson Island and Nunivak baskets (Lomen 1954:179; Curtis 1930:facing 78).[20]

18. Since Nelson's monograph dealt with the people living "about Bering Strait," he did not discuss the large production of twined basketry of Kodiak Island and the Aleutians.

19. Baskets collected by Miner Bruce from Port Clarence in the 1890s were very crude, and copied after imported models (VanStone 1976:pl. 22).

20. I have seen a number of Eskimo baskets with the openwork wave design in private collections. All of the baskets from Quinhagak, which were collected by Flo Hurst in 1936 and illustrated in a recent catalog, have this motif, as does the basketry collected in 1914 at Hamilton Inlet, Labrador, by E. W. Hawkes (Quevillon [1977]:11-13; Hawkes 1916:225, 227).

The women of Nunivak Island and other places in southwest Alaska began using representational designs during the 1930s. Since such designs had been the province of the men, the women borrowed only the idea, not the traditional subject matter, for basketry. The Nunivak women used ordinary subjects like fish, flies, crabs, dogs, sleds, and birds—those that would not have ordinarily been used in ancestor or mythological tales and drawings (Lantis 1950:70). Almost all coiled basketry designs were made of grass or other materials in contrasting colors added to the weft as a part of the basket itself. There were few imbricated or overlaid designs of embroidery floss or raffia until recently.

SEWING

Eskimo women living north of Saint Michael and on the Aleutians were the best-known seamstresses of Alaska, but all Eskimo women were skillful in creating and ornamenting clothing and other objects made of fur and skin. The subject of sewing in the southern Eskimo area is a huge one, for which I can only provide a general outline. Fur sewing has been fairly well covered in anthropological literature, but the making of intestine (gut) garments, which was developed to a high degree in the Aleutians, has been less noticed.[21]

The outer fur garment of the Eskimos (called a parka by the Russians) was not made on the same pattern throughout Alaska. The main differences were in the length, hood, and tailoring details. E. W. Nelson said that this kind of garment was "practically identical in pattern" (that is, knee-length with a hood and ruff) from Point Barrow to the mouth of the Yukon. In the inland delta area and southward from the Kuskokwim River, parkas were usually made without a hood, and were full-length to the ground. For walking, they were drawn up and belted round the waist (fig. 58).

Details of tailoring and ornamentation also differed in the various areas. In the far north, the squirrel parkas made for ceremonial wear had many white gores or oblong insets of white reindeer skin on the shoulder, upper chest, and borders, often in conjunction with parallel welts and hanging strips of wolverine or land otter fur. The white insets, which were also sewn into dress-up mukluks (boots), were cut from the spotted white and brown skins of domesticated Siberian reindeer, obtained in trade from Siberia across the Bering Strait. These rare and expensive skins (wild Alaskan caribou did not produce a white variety) were also used whole for a rich man's parka.

Nelson said that "women's frocks [were] much more handsomely made" north of the Yukon. "Richly ornamented" parkas were something of a rarity in southwest Alaska, and those made of squirrel, muskrat, or mink skins were more likely to be ornamented with tails and strips of fur inserted into the seams than with white insets (fig. 58). Yet, in the 1840s, Lavrentii Zagoskin collected women's parkas from the Kuskokwim, which were ornamented with numerous white patterns on the front, back, and shoulder, and trimmed with valuable furs "such as wolverine, wolf, or black or white otter." One of these, however, he attributed to the "Malegmiut" (Malemiut), or northern Eskimos, who had come to the Kuskokwim. The ordinary, full-length, hoodless Kusko-

21. See Ray 1977:51-55 for northern sewing and additional references.

kwim parkas were ornamented only with the paws, strips, and tails of squirrels.

Other materials were sometimes substituted for fur. According to Nelson, "very poor people [on the lower Yukon] utilize even the skins of salmon for making their frocks," yet, fish skin was also used generally for parka snow covers at Zagoskin's time, and quite fancy jackets, boots, hoods, and pouches were made of salmon and other fish skins on the Yukon and the Kuskokwim, and even by the neighboring Ingalik in the 1890s and later (figs. 63, 64, and 66; *The Far North*:fig. 83; Lipton 1977:fig. 77; Nelson 1899:30-36; Osgood 1940:155-59; Sheldon Jackson Museum 1976:148; Zagoskin 1967:111,211-12, and figs. 5-8).

The Chugach also wore garments, which reached to the ground, from bird skins and sea otter, squirrel, marten, fox, raccoon, and seal fur. A Chugach chief and his family wore coats made of sea otter or ground squirrel skins, sealskin being considered "too cheap for clothing." According to James Cook in 1778 the parkas were made with "a kind of cape or collar," but some had a hood (Birket-Smith 1953:64-68; Cook 1784, 2:367-68).

Aleut garments, also made without hoods, were originally sewed of bird, seal, and sea otter skins. According to Ivan Korovin and Ivan Soloviev, both of whom were on Umnak and Unalaska in the 1760s, men wore clothing made of bird skins, but women, of sea mammals. Andreian Tolstykh, however, speaking of the Andreanof Aleuts, said that men and women both wore bird skin garments, but the wives of prominent men wore sea otter skins (Coxe 1780:104, 152; Jochelson 1933:10-11). About seventy-five years later, Ivan Veniaminov said that the principal furs used for the hoodless parka were fur seal, sea otter, and bird skins, but that sealskin was used if other fur was not available. Little children wore garments made from "eagle skin with down." A few adult eagle-skin garments from Prince William Sound have been preserved in European museums. The long feathers had been pulled off the skin, leaving the down. According to Veniaminov, a bird skin parka, worn constantly, would last a year, and even more, if special care were taken. G. H. von Langsdorff has said that it sometimes took a woman a year to make such a parka (Birket-Smith 1953:65, fig. 33; Langsdorff 1814, 2:36; Veniaminov 1840, 2:212).

The Kodiak Island people made their clothes from the skins of birds, otters, squirrels, caribou, and other animals, according to G. I. Davydov, but the squirrels were imported from the Kenai area, and the caribou parkas were obtained from the Alaska Peninsula people, who sold ready-made kamleikas and tanned skins (1810-12, 2:14; 1977:152).

Davydov said that the cormorant was considered to be the softest and most handsome skin for a Kodiak woman's parka. To make a large parka, 140 birds were required because only the soft small necks were used. A cormorant parka looked so much like fur that it was "difficult to recognize as birdskins at first," and was decorated with threads ravelled from red and green wool cloth, caribou or goat hair (often imported from Siberia), thin strips of ermine or otter fur, and other articles such as puffins' beaks and eagles' feathers, all of which were suspended from the parka (Davydov 1810-12, 2:12; 1977:151).[22]

A beautiful cormorant-skin gown, collected in 1847 by Arvid A. Etolin, is

22. The 1977 translation of Davydov has a typographical error of 40 cormorant necks instead of 140, and reads "strips of cloth," rather than ravelled threads.

illustrated in *The Far North* (figures 78 and 79) and the Unalaska woman in figure 14 may also be wearing such a garment. Puffins (fig. 20) and guillemots ranked next in bird skin popularity. Murres were least liked. The guillemots were usually captured in the spring when white feathers appeared on their necks, thus affording a natural ornamentation.

Though Davydov said that clothes were still being made from sea otters in 1802, Father Gideon, who lived on Kodiak Island from 1804 to 1807, said that only bird skins were used for clothing, since the sea otter and fox furs had been prohibited for individual use since 1792 by the Russian-American Company, who "let [it] be known, with the strictest order, that if anyone were to do so, such clothing would be torn off his back and taken as Company property without compensation. . . . This is why all local inhabitants nowadays wear bird skin parkas which in the old days were worn only by the poor or by *kalgi* (prisoners)" (Black 1977:101).

The Eskimo women of the north expended a great deal of time decorating mukluks with fancy and intricate designs in historic times, but footgear was of relatively little importance in the Aleut and Pacific Eskimo areas, since the people went barefoot a large part of the time. What boots they did make were usually of sealskin, and mostly undecorated, though dyed a brownish red.

Everywhere in southern Alaska, soft headgear was important because most of the garments did not have hoods. Many varieties of everyday and ceremonial hats were worn, ranging from bird skin hats with attached wings and tails worn by the Aleut, to the snugly fitting hood-hats and earflaps made of caribou head fur, squirrel bellies, or mink in southwest Alaska. Each area had its distinctive style of ceremonial hat. Those of southwest Alaska were made with delicate white insets and welts in conjunction with hanging pieces of fur. On Nunivak Island, hats of squirrel fur were made by sewing coils of the fur round and round until the right size was attained (fig. 67; Curtis 1930:10; Nelson 1899:32, 33, 37; Zagoskin 1967:212, fig. 8).

The Aleut women made the most ornate ceremonial hats of all—some made of many small slips of seal and caribou skin, and ornamented with feathers, twisted and braided sinew, and long chest hairs of the caribou. These hats had all disappeared by Veniaminov's time (1824-34) on the Aleutians (Veniaminov 1840, 2:219). Thus the seventeen hats, which are preserved in the Museum of Anthropology and Ethnography in Leningrad, are especially valuable. Ten of the hats are illustrated in a preliminary paper by Rosa G. Liapunova, and two appear in figures 18 and 19 (this book), each illustrating a distinctive Aleut style (Liapunova 1976). The tall pointed hat in figure 18 is the style considered to be typical of the western Aleutians (the Andreanof Islands), and the round hat, of the eastern Aleutians (the Fox Islands). The workmanship is obviously superior in both styles, yet Veniaminov wrote that the women of the western islands were less skillful in embroidery than those of the eastern islands, while the women of the western islands were more skilled in basketry than the eastern women (Liapunova 1976:163; Veniaminov 1840, 2:253).

Few descriptions of these hats were written at the time they were in use. Even Langsdorff described the beautiful hat illustrated in figure 17 as only "a head-dress with a great deal of embroidery"! The most detailed description is from the writings of Peter Simon Pallas in 1781:

[The Aleut women] make themselves very elegant, neatly embroidered headgear, some like skullcaps with a tassel of reindeer hair colored red, others like grenadiers' caps, still others like helmets with a projecting painted point. Such handsome head ornaments have been brought [to Russia] particularly from Kadiak, where the islanders also receive from the mainland an abundance of reindeer [caribou] skins and hair. The needlework in these caps, for which woven sinews and reindeer hair are used, is wonderfully fine and neat for a people having only bone needles [Masterson and Brower 1948:44].[23]

Other examples of these intricately embroidered hats have been recorded by early artists, as seen in figures 2 and 17. A well-known drawing by John Webber, "Caps of the Natives of Oonalashka" (Cook's Atlas 1784:pl. 56), which illustrates some incredibly fine embroidery from the eastern Aleutians, has been reprinted a number of times in other publications, for example, Hulbert (1976:43) and Kaeppler (1978:270). Other kinds of ceremonial headdresses, both Kodiak and Aleut, are illustrated in figures 12, 13, 15, and 16 (see also Liapunova 1975a:fig. 31 [in color]; and Liapunova 1976:pls. 1-3).

As trade goods became more plentiful, many foreign objects, such as buttons, clock wheels, and beads augmented the Aleut and Eskimo woman's native materials. Beads of all sizes were attached to, or imbedded in, almost everything made of fur, wood, basketry, or ivory, but not gut sewing. They became important materials for facial jewelry: singly, in clusters, in strands, or strung with bits of metal, dentalium shells, and pieces of ivory or leather for the ears, nose, and chin. Hundreds were sewed together to make ceremonial hats, bands, and trains. For example, a bead hat of a Chugach chief's daughter had a train (perhaps like that of the Aleut woman in figure 15), which reached to her heels. The Chugach women also made belts, neck bands, and arm bands composed entirely of beads on a leather backing (figs. 3-7, 9, 11, 13-17, 30, 35, 36, 39, 49, 61, 62, 67-69, 73, 75, 97, 163-65, 174-78, 196; Birket-Smith 1953:68-70; see Curtis 1930:30, 32, 38, and Quevillon [1977]:14, 15 for buttons used as ornamentation on clothing).

A bone needle with a knob on the end, usually from a bird wing, was used for sewing in the south. By 1790, when steel needles were becoming common, Gavriil Sarychev said that the Unalaska woman would break off the eye of a steel needle, and scrape it against a stone to make a notch so that the thread could be attached in the accustomed way (Sarychev 1806-7, 2:8). "Thread" was usually caribou or sea mammal sinew, but other materials were also used, for example, dried nettles or strips of muskrat tails in the Kuskokwim area (*Kalikaq Yugnek,* fall-winter 1975:49).

Sea mammal intestines were used for waterproof parkas, bags, and windows. Even the Russians had adopted gut for windows. As late as 1861, Hieromonk Illarion said that in the Kolmakov barracks on the Kuskokwim River, the Russians used sea mammal intestines instead of glass for their windows (Illarion 1861-63). All Eskimos made the gut parka in almost the same basic pattern, except the northern seamstress who often placed the strips vertically rather than horizontally, and rarely decorated the seams. The Saint Lawrence Island women made a parka of "cold tanned" (almost opaque) intestine, which was ornamented with auklet and cormorant feathers and beaks, and strips of skin,

23. A tall headdress, similar to the one in figure 18, is said to have come from Kodiak about 1862, but it possibly is Aleut (Birket-Smith 1941:fig. 6).

but they did not begin to approach the exquisite workmanship of the Aleut and Kodiak women. The "kamleika," or gut parka, was one of their greatest accomplishments.[24]

The word kamleika, like parka, was introduced into Alaska from Siberia by the Russians. All Eskimo gut parkas had hoods and were worn by both sexes, especially by a man in his kayak. Besides serving as a raincoat, the gut parka was also used as a ceremonial and religious garment. Almost all shamans wore one when curing as well as when performing miracles beneath the sea and in other secret places. On Nunivak Island and in other parts of southwest Alaska, a woman wore a gut parka while cutting sealskins for use as kayak covers in order "to prevent any evil influence from entering or afflicting the new kaiaks." The men also wore waterproof parkas and mittens while handling sea nets "to prevent any evil influence passing from them to the nets and keeping the seal away" (Curtis 1930:13, 29). Women everywhere wore them for dancing, naked, and some men, too, as witnessed by Davydov on Kodiak Island (see "Masks and Other Wood Sculpture").

Davydov said that Kodiak kamleikas were made from the intestines and throats of whales, seals, sea lions, and bears. The tongue and liver of the whale were also used—the skin of one large tongue producing eight kamleikas—but whale was the least favorite material since it was heavy and tore easily (Davydov 1977:152). According to Veniaminov, the Aleuts used the intestines of the largest sea lions, but also of bears, walruses, and whales. The Russian-American Company made kamleikas from sea lion throats, but they were not commonly used because of the expense. Sea lion intestines made the strongest parkas, but bear intestines were most handsome (Veniaminov 1840, 2:213-14). An active man needed two or three kamleikas a year. North of the Aleutians, seal intestine was the most popular material, but walrus intestines, and even fish skins, were used.

The kamleika illustrated in figures 21 and 22 is an example of the intricate work done by the Aleut woman. This parka, which is in the Washington State Museum, is 116.5 centimeters long (45⅜ inches) from the top of the hood to the bottom of the garment, and weighs only ten ounces. The body is 88 centimeters long and the horizontal strips average 3.8 centimeters wide. It is made of seal intestines, and the tiny braided strips and loops are composed of caribou hair, seal parchment dyed red, bird quills, fox hairs, and red, green, and some brown and black wool yarn. Every other horizontal seam is ornamented, and the sequence of motifs is the same in the back as in the front. The design is so symmetrical that when the parka is folded down the middle of the back or the front, each design is superimposed on another as its mirror image. One can get an idea of the minute proportions of the motifs from the size of the all-white loop, six of which are visible in the close-up in figure 22. This loop, which is a four-strand braid of flattened quill, measures only 0.4 centimeter from one outer edge to the other outer edge where it is sewed into the seam. The widest single braid strand is a tenth of a centimeter wide (Ray 1954).[25]

24. For illustrations of the Saint Lawrence style, see Coe 1977:fig. 238; *The Far North:*fig. 82; Lipton 1977:fig. 129.

25. For other illustrations of parkas and other objects made of intestines, see Birket-Smith 1941:figs. 3, 4, 5, 26, and 27; Birket Smith 1953:fig. 34; Coe 1977:fig. 238; Curtis 1930:24; *The Far*

Belts were an important part of both the southern and the northern woman's wardrobe. A belt worn by a pubescent girl or a widow in the Aleutians had curative powers. So did the caribou tooth belt, which was made in western Alaska wherever the Eskimos hunted caribou. The first record of a caribou tooth belt was made in 1791 at Cape Rodney at Bering Strait by Carl Heinrich Merck, the naturalist of the Joseph Billings' expedition. This kind of belt was usually made in a single row of overlapping incisor sets, but sometimes there were double and even triple rows. Besides having curative powers, this kind of belt also secured a baby to the mother's back, and publicized the hunting skills of a woman's husband. Many of these belts had ivory fasteners incised with designs or made as small sculpture. The Ingalik Indians, neighbors to the Eskimos, also made the caribou belt, but considered the teeth to be only "esthetic" (fig. 98; Jacobi 1937:134; Osgood 1940:264 and pl. 9; Johan Jacobsen illustrated a doll wearing a parka and miniature caribou-tooth belt [1884:27, 349; 1977:figs. 40, 59]).

North:figs. 58-61 and frontispiece; Holtved 1947:57, 60; Hulbert 1976:ill. 42; Jochelson 1933:57; Lipton 1977:fig. 158; Sheldon Jackson Museum catalog 1976:79, 81; Zagoskin 1967:fig. 10; and Zerries 1978:fig. 48.

4. The New Arts

In past years, Eskimo art was collected as mementos of adventures to far places or as a contribution to knowledge. At the present time, the late 1970s, its acquisition is based on its merit as art more than ever before. Many of the objects, bought as ethnological objects, and later as mere souvenirs, are now looked upon as esthetically significant works of art, even in terms of contemporary criteria and critical evaluation.

This applies to the products of southern Alaska, as well as the more celebrated north. In the south—as well as in the north—carving, mask-making, painting of designs, and sewing were once important activities in every village, no matter how small, but production in the arts is now limited to only a few villages. Also, in the south and the north, some new and original work is being done by the younger generation who have taken art training, combining it with their heritage to join the mainstream of art. The largest proportion of objects made to sell in the south, however, has shifted to the women. Market art of the twentieth century in the north consisted mainly of ivory objects made by the men, although at first, women's sewing and basketry had a fairly prominent place. In the 1970s, the ivory carvings and graphic art of the men (painting and drawings on paper and skin) were definitely the largest output in the north, but in the south, basketry made by the women overshadowed all other categories of salable commodities.

The production of the arts varies greatly from place to place in southern Alaska today. Scarcely any ethnic handicrafts come from the Aleutians, Kodiak Island, or Prince William Sound despite the earliest souvenirs (baskets and model kayaks) having come from there as long ago as the 1790s. By the early nineteenth century—before the indigenous art of the Kuskokwim River and Nunivak Island had even been seen—the Aleut and Pacific Eskimos had effectively abandoned their traditional arts. The men had been making *Russian* handicrafts for a hundred years before the gold rushes of the 1890s, which virtually created the northern souvenir market. Only the Aleut women had maintained traditional techniques in their basketry. Ivan Veniaminov wrote in 1840 that "the [Unalaska] Aleuts in nearly all respects are very imitative. They prove this by the fact that very soon they took over from the Russians all the handicrafts that they had the chance to see, so that there are among them now [between 1824 and 1834] good cabinet makers, carpenters, coopers, locksmiths, blacksmiths and shoemakers" (Veniaminov 1840, 2:15, from Hrdlička 1945:197).

The Aleut and Pacific Eskimo development of arts during postcontact times is akin to that of American pioneer days. During the early twentieth century, when Eskimos of the north were making vast quantities of native artifacts from ivory and furs to sell, the Kodiak people were making nonnative objects for their own use—cribs, doll furniture, tables, boats, storage chests, wheelbarrows, shoulder yokes for water buckets, potato and berry mashers, and crosses for graves, although a few women made baskets both in an Aleut-style twining

and an Eskimo coiling, and men made a few model kayaks, which they sold to the old Alaska Commercial Company store. Eunice Neseth of Kodiak, whose own observations go back toward the beginning of the twentieth century, said that in her grandmother's time, the people of Afognak and Ouzinkie made tubs, pails, milk containers, and barnyard tools from carefully selected standing trees to trade in Kodiak for manufactured goods brought in from the states. Locally-made icon and picture frames were also deeply carved with floral, leaf, and religious motifs. Local fireweed was a popular subject (Eunice Neseth, letter, Kodiak, 20 October 1977; and interviews, Kodiak, 2-3 August 1978).

The Chugach, likewise, had very little that could be termed "Eskimo handicrafts" after the advent of the Russians. In 1933, Kaj Birket-Smith observed that "all Chugach women crochet and knit. Socks are mended by knitting, not by darning. The women also make sealskin moccasins (tourist style), and crêpe-paper flowers for the church and for gifts." They had not kept up their former basketmaking or fur sewing, and the men had not continued any of their traditional manufacturing, with the exception of a few kayaks that were then under construction because the depression of the 1930s had made wooden boats too expensive. Even so, very few kayaks were made, because "even in former times but a few persons knew how to build them" (Birket-Smith 1953:46, 78).

On the Aleutian Islands, the women were making many baskets to sell by the end of the nineteenth and beginning of the twentieth centuries, but the artistic endeavors of the men were directed toward utilitarian work based on European models, except for model kayaks and a little ivory work. For example, the Unalaska men, like the Kodiak people, made wood carvings of floral and leaf designs, crosses, and birds—such as the dove in the Cathedral of the Holy Ascension of Christ. Vassilii Kriukov, an Aleut, also painted an icon for the church, probably in the 1820s.[1] In Akutan, the village men also finished the interiors of their churches, and in the latest one built in 1917, "all of the interior wooden fixtures, such as the candelabra, iconostasis, and bannisters, were hand carved by the men of the village" (Lydia Black, letter, Providence, R. I., 26 June 1978; Spaulding 1955:135).[2]

Traditional objects that still existed in mid-twentieth century were looked upon as treasured heirlooms, but they had to be left behind when the Aleuts were evacuated after the Japanese attacked Attu in 1942. The forty-five Attuans (only twenty-four of whom survived) were interred in Japan and the Aleuts of the other islands and the Pribilofs were taken to southeast Alaska. By the

1. Ivan Veniaminov said of Kriukov that he was so talented that he had learned to paint icons and watercolor portraits with great skill without instruction, and had to see a man only two or three times to remember his features (1840, 2:16).

2. Alaska's flag was designed by an Aleut boy, Benny Benson, born in Chignik of an Aleut-Russian mother. When the American Legion sponsored a contest for flag designs for students in grades seven to twelve in 1926, Benson was living at the Jesse Lee Home in Seward. As a thirteen-year-old seventh grader, his drawing of the Big Dipper and the north star in gold on a blue background won first prize in a field of 142 finalists in May 1927. His original entry is now in the Alaska State Museum, Juneau. His simple drawing of the flag is explained in his handwriting on a piece of paper, 7½ by 11 inches: "The blue field is for the Alaskan sky and the for-get-me-not, an Alaskan flower.

"The north star is for the future state of Alaska the most northerly of the Union. The dipper is for the Great Bear as Symbolizing strenth [sic]."

time they returned home after the war, many of their traditional treasures had disappeared (Stein 1977, 1:55-57; Berreman 1953:260). Some of the Aleut women made dolls, moccasins, and knitted gloves of non-Aleut design during the war and later, but the few articles that they now make—including baskets—are rarely found in retail stores because they are usually sold to local visitors.

These facts relating to the nineteenth and twentieth century handicrafts of the Aleuts and Pacific Eskimos help explain why only eleven men and women from Kodiak and the Aleutian Islands (none from Prince William Sound) have entered their works—among the hundreds accepted—in the eleven juried Alaska Festival of Native Arts competitions that have been held annually in Anchorage. In the 1978 festival, which was an invitational, non-juried show, a non-resident Alaskan native artist—John Hoover, an Aleut—was asked to exhibit for the first time.

As in the north, several kinds of objects have developed to become characteristic of one locality or village in the south, and include model kayaks, certain basketry forms, the so-called "Nunivak tusk," ivory and wood mask sculpture, and "ring sculpture." All have been made in response to a nonnative market.

MODEL KAYAKS

Model skin kayaks, decorated skin bags, and twined baskets were about the only souvenir items based on native techniques made by the Aleut and Pacific Eskimos, although the Aleuts and Koniags occasionally carved some ivory during the 1800s (for example, see figs. 33-38, and Orlova 1964:figs. 52-56). Model kayaks made of sea mammal skin were probably the first specially made souvenirs acquired from Alaska. In 1791 Alejandro Malaspina collected model kayaks at Prince William Sound; and in 1794 Peter Puget of George Vancouver's expedition, when at Yakutat Bay, obtained model kayaks and other objects, "which these people [from Cook Inlet and Kodiak Island], though at so great a distance from home, were well provided, in expectation of finding a profitable market before they returned." Earlier in the summer, Vancouver had also collected a number of model kayaks and decorated gutskin bags near Cape Elizabeth, opposite Shuyak Island (Feder 1977:80; Vancouver 1801, 5:255, 391-92).

American museums have model kayaks dated 1867 and later, but very few before, from various Alaskan Eskimo villages. On the other hand, the Museum of Anthropology and Ethnography, Leningrad, alone, has thirty-two model kayaks from southern Alaska dating before 1850. The Central Naval Museum, also in Leningrad, has nine, four of which were obtained in 1805 (Liapunova 1964:228-29). In 1887, only a few of the hundreds of Eskimo artifacts in the United States National Museum had been collected from the Aleut and Pacific Eskimo areas. Of these, there were more model kayaks than any other object, fifteen of the forty-nine models having come from Unalaska, and four from Kodiak. The rest had been collected at many different places along the coast as far north as Unalakleet.[3]

3. See the introduction to the illustrations for a summary of the Eskimo holdings of the United States National Museum in 1887. It should be noted that comparatively few baskets had been collected from Unalaska by that time: of a total of sixty-one baskets from sixty-six places in western Alaska, only seven were from Unalaska.

Model kayaks of skin—with or without the miniature model occupants and weapons—were apparently not traditional objects, although models made of wood served as shamans' charms or children's toys. Model umiaks of skin, however, were hung in ceremonial houses during hunting festivals, at least at Point Hope and on Kodiak Island.

The model kayaks of the Aleut and Pacific Eskimos are unusual because of the two- and three-cockpit variations and the fidelity of the tiny figurines. Details of clothing, weapons, and the boats themselves provide us with ethnological information of the past. Three of the model one-cockpit kayaks in the Museum of Anthropology and Ethnography, Leningrad, were made so faithfully to the original that the little sea otter amulets were included (fig. 33). A recent model kayak from Nikolski is a three-holer, which carries a priest reading his Bible in the middle cockpit (fig. 32).

BASKETRY

Basketry has been on the decline in the Aleutian Islands, especially since World War II, but in southwest Alaska it has steadily increased in quantity and quality. It has been assumed that the Aleut women ceased their basketry entirely when they were evacuated from the islands, and though the Attu women did not continue their work in Japan, several of the Atka women wove baskets of grass obtained around Killisnoo Harbor. The Alaska State Museum has two such baskets and a covered bottle (Keithahn n.d.:48; museum catalog data for the Killisnoo Aleut baskets: II-F-128 made by Jennie Golley; II-F-126 [bottle] and II-F-135 made by Mrs. Andrew Snigaroff).

At the height of Aleut basketry almost all women were involved in the activity of making baskets, but in 1971 when Raymond L. Hudson, an Unalaska teacher and student of basketry, endeavored to learn how many weavers were still producing Aleut baskets, he found that there were no weavers in Akutan, only three (who had only recently learned to weave) in Nikolski on Umnak Island, several weavers in Atka and Unalaska, and one in Anchorage. Since then, however, the interest in both Aleut and Eskimo basketry has grown through school and community programs. Anfesia T. Shapsnikoff (who died in 1973) and Sophia Pletnikoff of the Aleutians, Eunice Neseth and Hazel Jones of Kodiak, and Rita Pitka Blumenstein from Tununak have been active in teaching formal basketry classes. The students, who are both men and women, native and nonnative, usually substitute raffia and artificial straw for wild rye. Mrs. Neseth and Mrs. Blumenstein, however, try to use only wild rye in their classes (Chandonnet 1975:56, 58; *Tundra Drums,* 15 May 1976, p. 25; Mantzke 1978). On Kodiak Island in 1978, only a few women (most of whom had learned to weave in Mrs. Shapsnikoff's classes) made baskets when they needed a little money.

The current excellence in Eskimo coiled basketry from southwest Alaska is the result of personal encouragement, festival competition, and a growing awareness by the basketmakers themselves of basketry as an art form. The Alaska Festival of Native Arts has received hundreds of entries in the basket division, the majority of which are submitted by the Eskimo women of southwest Alaska. Only a few have been entered by Kodiak or Aleut women, who

were once the great basket artists of Eskimo Alaska. Since the juried festivals began in 1967, the only Aleut and Pacific Eskimos who have submitted baskets are Fedocia Inga, Hazel Jones, Eunice Neseth, Sophia Pletnikoff, and Anfesia Shapsnikoff. In 1968, Shapsnikoff gave a special exhibit lecture, and in 1970, both she and Parascovia Wright were special lecturers on basketry.

Even the southwest Eskimo entries come from a limited number of villages. In 1977, for example, of forty-four basket entries, all but six were made in the villages of Hooper Bay, Chevak, Kipnuk, Toksook Bay, and Tununak (Napakiak and Togiak had one entry each; there was none from the Aleutians or Kodiak). That year, for the first time in the history of the festival, a basket—made by Bertha Lincoln of Toksook Bay—won the Juror's Choice award (see catalog for illustration).

Another encouragement for basketry has been the annual basket sale for the benefit of the Alaska Treatment Center for Crippled Children and Adults, which has been coordinated since 1967 by Eleanor Klingel of Anchorage. Over the years she has received baskets from about two hundred women living between Scammon Bay and the lower Kuskokwim area, and in 1978, she estimated that there were as many as three hundred active basketmakers. For the 1977 bazaar, she received 322 baskets (mostly coiled baskets; only a few were twined), which were so popular that all were sold in forty minutes. For the 1978 bazaar on November 4, people had assembled in lines two hours before the 9 A.M. opening, and it would have taken less than an hour to sell the 434 items—mostly basketry—if the cashiers and baggers had been able to work faster. In 1978 Kipnuk sent 235 coiled baskets; Hooper Bay, 66; Kwigillingok, 17; Nightmute, 4; Tununak, 3; and Mountain Village, Goodnews Bay, and Kwethluk, 2 each. Chevak sent 33 coiled and 2 twined baskets and 3 braided objects; Toksook Bay, 14 basketry hand fans; and Bethel, 4 twined open-weave fish baskets. Only 15 poorly made or overpriced items on consignment did not sell.

According to Eleanor Klingel, the quality of Nelson Island basketry seems to be deteriorating, although overall the island is one of the largest producers in southwest Alaska. The above final tally of the bazaar sale, therefore, does not reflect the total quantity so much as the highest quality of baskets that she has kept from all that are sent to her for consideration year round. Many of the purchasers prefer the fine coiling done by the Hooper Bay women, but their production is not so large (Brennan 1977; E. Klingel, letters, 30 November 1977 and 8 November 1978, and interviews, July and August 1978).

Mrs. Klingel's dedicated volunteer work and close association with the selling of thousands of baskets has not only made her an expert in this field, but has piqued her curiosity as to what a basketmaker could do in response to a specific request. Accordingly, she sent illustrations of trays and baskets made by Arizona and New Mexico Indian women, as well as by Datsolali, the renowned Washo Indian basketmaker, to several women, who eagerly accepted the challenge of trying out new designs. The Eskimo talent for copying was evident by the superior work done on the very first attempts. A basket with one of the introduced southwest Indian designs, made by Cecilia M. Olson of Hooper Bay, won an award in the 1977 Alaska Festival of Native Arts (see catalog, 1977). The most interesting results, however, came from two separate interpretations of Datsolali's basket design, as seen in figure 93. These

first attempts show a remarkable imitative ability coupled with independent interpretation on the part of both women. (Four baskets by Datsolali, including the basket considered to be her "most perfect work," are illustrated in *Sacred Circles* [Coe 1977:figs. 585-88]; see also Dockstader [1961]:fig. 148 [in color].)

Each village has developed its own styles of coiling techniques, basketry shapes, and sometimes, designs. The basketry in figures 84-86 from Stebbins, Hooper Bay, and Scammon Bay is characteristic of each of these places. The Stebbins coiling is wider than that from Hooper Bay, which is among the finest coiling made today. Generally, baskets from Nelson Island are round or oval, and those from Kipnuk, crock shaped with a lip on the top (although I have seen a basket from Kwigillingok also with a similar lip). When a woman moves to another village after marriage, she takes her own basketmaking techniques with her. Nowadays, the designs of Hooper Bay and Nelson Island are generally made of colored grasses dyed from berries, colored crepe paper, or commercial dyes, but seal gut is usually used by women in Kongiganak, Kwigillingok, Quinhagak, and Kipnuk.[4]

The Eskimo women consistently attempt to make new objects of grass. As with the ivory carvers of the north, ideas or objects that prove salable (for instance, grass dance fans, yoyos, and dolls) are copied by other women. But they like variety, too, and some of their excursions into novelties have resulted from fertile imagination, sense of humor, and a feeling that almost anything now is suitable subject matter (for example, the snowmobiles on the basket in figure 87 and the grass doll and kerosene lamp in figures 75 and 95). In Hooper Bay, I saw Natalia Smith's "Santa Claus" yoyos (first made for Christmas 1975), which were cone-shaped with Santa's face on one side, and sequins on the bottom to "sparkle." Then, there was a basket made by Betty Smith with a surprising lid: a face with mouth, eyes, eyebrows, and hair woven into the coil with contrasting color, but the nose was the knob.[5]

Besides the new designs in coiled basketry, imported materials, such as raffia for both weft and overlay designs in coiled baskets, and nylon string for twined bags are used. Still, most women prefer native grass for both coiling and twining, even when they experiment with beads and sequins instead of grass, for example, in hot dish mats. Sometimes women must buy grass from other villages if growing or drying conditions have been poor in their own village, thus adding to the cost of a basket.

Almost all village women, who make coiled baskets, have one under construction at all times, working at it off and on between household chores. A hot pad like the one in figure 84 would probably take a day and a half of steady work to complete, but baskets often take weeks or months, and some women make only two or three a year. Yet, should a visitor go to one of the villages, it seems that every woman has a finished basket to sell as she suddenly materializes on a path or in a doorway with a new one in her parka pocket or in a well-worn paper bag.

4. Further information about dyes used in basketry is given in chapter 2.

5. Although the crustacean in figure 83 was made about 1941, and the kerosene lamp in figure 95, in 1976, imitating foreign objects in native techniques and materials is not a new practice. The grass teakettle in figure 82 was obtained in 1907, and the bentwood teakettle (fig. 179), even earlier. The Alaska State Museum has a pair of coiled basketry slippers (II-A-2386) modeled after Chinese shoes, from the Kuskokwim River, about 1910-15.

The development of Eskimo coiled basketry in southwest Alaska has followed the same path as Aleut basketry and early gold-rush coiled basketry—a response to growing markets, personal encouragement, and selection of the best baskets, which stimulated better and better products. Yet, unlike the northerners, many villagers continue to weave utilitarian objects of grass in the old twining technique—carrying bags, entrance and floor mats—as well as using the unwoven grass for rope or stuffing materials.[6]

IVORY CARVING

In the north a market art in ivory developed rapidly in response to the collecting habits of ships' crews, and later, gold miners and tourists in towns like Saint Michael, Teller, and Nome, where hundreds of Eskimo men turned out thousands of ivory cribbage boards, gavels, umbrella handles, and figurines for the local stores. Although the Eskimos of southwest Alaska did not develop a souvenir industry of that magnitude, there was never a time when ivory carving was not done to sell. Local markets always developed wherever there was a trader, teacher, or anyone else willing to buy. Most of the carved ivories went directly from carver to buyer, without benefit of a middleman.[7]

From the earliest days there has been a small, but steady, production of souvenir objects that were made in regional art styles, reflecting the current taste in Eskimoized foreign paraphernalia—ivory toothpicks, buttons, gavels, cigarette holders, candlesticks, napkin rings, pipes, cribbage boards, and models

6. In a study on Nunivak Island in 1972, Janice Gibson learned that, as a general rule, the old crafts were no longer made for native use, a conclusion that would probably hold true for the rest of southwest Alaska, except for certain types of basketry, as already noted. On Nunivak, some basketry and skin products were made for use, but not wooden ware or ivory objects. Of her sampling of one-fourth of the island's population, she learned that all the women over fifty could make baskets and sew furs. Of the women between twenty-six and forty-nine, 86 percent could do basketry and 70 percent could sew furs. Between the ages of fourteen and twenty-five, only 50 percent could make baskets and 13 percent could sew skins. Under fourteen, none could make baskets, and only 14 percent could sew. (I learned in 1976, however, that some of the Hooper Bay women over fifty-five had not learned to make baskets until they were fourteen.)

Although one-fourth of the men over fifty said they could make wooden dishes and utensils (as in fig. 192), 63 percent could make masks, "but there were no positive responses in any of the other age groups." Seventy-five percent of the men over fifty could carve ivory; 33 percent, between twenty-six and forty-nine; 50 percent, between fourteen and twenty-five; but only 20 percent under fourteen. Old masks were not recognized more readily by any one age group, and though 85 percent of all said that they had seen the half-man–half-fox mask (fig. 154), only 3 percent had seen such a mask in use, and only 15 percent (all were people over fifty) had ever seen a Nunivak mask dance. They could give her no specific knowledge about the meaning of any mask. All of the mask makers and ivory carvers agreed that the only reason they made what they did was to sell them. On the other hand, 71 percent cited skin sewing as having definite utilitarian value; only 9 percent cited it as having economic value. In response to her question as to why children should learn the crafts, especially in school, the ranking answer was so that they would not forget the old culture, and the second answer was to sell. Only one person said that it was because they could use it themselves (Gibson 1974:73, 82-83, 93, 95, 96).

7. Lest it be thought that the Alaskan Eskimos and Aleuts were the only ones to succumb to the lure of souvenir-making, there are many examples made by Canadian Eskimos. For example, Franz Boas illustrated a miniature ivory knife and spyglass, which were in the Museum für Völkerkunde in 1885 at the time of his report on the Central Eskimo, and E. W. Hawkes illustrated a number of small ivory models of knives, a powder horn, a gun, boots, and a bag, obtained on the coast of Labrador in 1914 (Boas 1888:pl. IX; Hawkes 1916:pl. XXVI). See also Blodgett 1979.

of native scenes, especially ceremonial or hunting activities (figs. 113-26). During the 1920s, however, a noteworthy art form developed, known as the "Nunivak tusk." We have no documentation as to the originator of this distinctive art, which is characterized by "deep carving" of animals and birds in complex relationships. There were two styles; one, of whole animals (figs. 127 and 128) and the other, entwined animals in a puzzle effect (figs. 129-31).

Although the Nunivak people always had walrus ivory, they did not begin carving tusks in this unique style until the Lomen Corporation established a reindeer herd on Nunivak Island in September 1920, and provided the Eskimos with quantities of ivory in an attempt to foster a souvenir business. In his memoirs, Carl J. Lomen does not explain how or when this unique art form originated, nor does Edward S. Curtis, who took the photograph of the man in figure 127, shortly after production had begun. The Lomens bought all of the "souvenir material" that the Eskimos made, including coiled baskets, which their Nunivak manager, Paul Ivanoff, taught them to make (Lomen 1954:175, 179-80).[8]

There are no known archeological antecedents for the deep carving or for the tusk form,[9] but there is evidence that this style had been evolving since the turn of the century on Nunivak Island and other southwest Alaska places from simple, low-relief carving. This kind of sculpture, illustrated in figures 117, 123-26, seems to be an unmistakable prototype for the Nunivak style. The authenticated dates of 1902 for the bas-relief style from Togiak (see caption to fig. 123) and 1910 (or before) for the Herrnhut cribbage board (fig. 125) indicate that the incipient elements were already present for reinterpretation into the Nunivak style of deep carving in the 1920s. The cribbage board in figures 126 a and b seems to be halfway between the fairly stiff bas-relief style and the fluid lines of the classic style, both of which are represented on this board.

Because there is no demonstrable antiquity anywhere for the carving of multiple animals as one unit, it is quite likely that the source of inspiration in the prototypes was an Eskimo innovator, or perhaps even a merchant. Small bas-relief figures—human or animal faces, and even an occasional whole animal, such as a whale—were made in Old Bering Sea and Dorset times as far apart as eastern Siberia and eastern Canada, but the time gap of almost fifteen hundred years to the late nineteenth century, and the disparate styles, preclude any direct relationship. It has been demonstrated repeatedly during the historical period that many objects were suggested by a trader or a collector, and that help was actively given to develop certain forms and styles (Ray 1961; 1977).

The earliest-known carvings with multiple animals in historic times were

8. In 1956, I asked Mr. Lomen about these tusks, but he did not provide any information. Neither Margaret Lantis nor Hans Himmelheber, both of whom were doing research on Nunivak in the 1930s and 1940s, has written about this art style. Himmelheber's oversight of this art form is puzzling: "As already said, the Nunivakers make a small number of functional objects as art works out of ivory, and indeed solely to make them pretty. Without exception these things are converted to animal. . . . On the whole island of Nunivak there were no more than three dozen such carvings. One can but wonder that such an obviously artistic talent does not seek a greater field of participation. Art in the esthetic sense is at the very least highly unimportant to the Nunivak" (1953:68).

9. Personal communications from Michael Nowak and James W. VanStone, 1977.

made on cribbage boards, a nonnative object that was introduced to the carvers during the 1880s and 1890s (figs. 123-26). By the 1920s, Labrador Eskimos were also carving multiple animals on tusks. The style of these carvings, which are illustrated by Frank G. Speck and Charles Martijn, suggests that they were inspired either by one of the above prototypes (which may have been taken to the Labrador Moravian missions by Alaskan Moravians) or the "Nunivak tusk" itself. The Lomens took the Nunivak tusk far and wide for the curio market, and it would not be surprising if a Canadian carver had been asked to make one like it. I know of a similar request in Alaska. Michael Kazingnuk, an ivory carver from Little Diomede Island, told me that he was asked to make such a cribbage board in 1928 by Ken Rank, a Nome merchant. Rank furnished the idea and the ivory, and Kazingnuk carved three cribbage boards with "all kinds of animals" for thirty-five dollars apiece (Martijn 1967:10-11; Ray field notes 1955; Speck 1927).

The unfortunate lack of information about the carvers and origin of the Nunivak tusks and cribbage boards might lead to the interpretation that the whole-animal style was the original one, from which the more complicated designs were derived. Careful analysis, however, shows that this was not the case. Several pieces with the complex intertwining of animals were collected about 1924, at the very beginning of their production (for example, see fig. 130). The whole-animal theme thus appears to have been an individual style concomitant with the intertwined animals. The tusks with the puzzle arrangements are no longer made, and only John Kusowyuk ("Uncle John") was carving the whole-animal style in the 1970s. (The tusk in figure 128, supposedly made by Kusowyuk, dates from the 1940s.) The ivory carvers of Nunivak Island now prefer to make miniature ivory masks and small figurines. Even Kusowyuk entered an ivory mask, not a carved tusk, in the twelfth Alaska Festival of Native Arts in 1977.

The carving of ivory is relatively unimportant in southwest Alaska today. Compared to the hundreds of carvers in the north there is only a handful of persons who produce on a more-or-less regular basis, but some have become well known for their specialties: Harry Shavings and Andrew Noatak of Nunivak Island, small sculpture and miniature ivory masks; George Williams and Olie Olrun, also of Nunivak, miniature ivory masks; Homer Hunter, Sr., Scammon Bay (formerly of Hooper Bay) and Peter Post, Tununak, ivory jewelry (figs. 133-40; Sam Fox of Dillingham and Tom Sunny and Cyril Chanar of Toksook Bay, cribbage boards and small carvings. Since 1956, Jonathan Johnson of Hooper Bay has specialized in ivory rings with tiny figures of cranes, seals, walruses, and foxes—very popular with young Eskimo girls—but in the past he also made delicate carvings of animals and souvenir figurines like the comic strip character, "Donald Duck." Several other persons from southwest Alaska have entered ivory carvings or jewelry in the Alaska Festival of Native Arts: Joe Seton, Hooper Bay; Olinka Jackson, Kwethluk; Louis Post, Nightmute; James Williams, Quinhagak; and George Nevak, Albert Therchik, and Bessie White of Toksook Bay. In 1975, the older carvers in Tununak were still giving instruction to the youngsters, as in the old days, but this is rare in southwest Alaska, except where school programs have instituted teaching of traditional arts by an older person (Anable 1973; catalogs, Alaska Festival of Native Arts, 1966-77; *Kalikaq Yugnek*, spring 1977 and fall 1977; Morgan 1975, 1978; D. J. Ray field notes).

GRAPHIC ART AND WOOD CARVING

For at least forty years the Eskimo artists of the Alaskan southwest have painted faithful copies of original ownership marks and stories on dishes for the market, but this geographical area has not produced the number of successful professional artists whose sole livelihood comes from drawing on paper, reindeer hide, and sealskin, as in the north. One of the most talented, productive, and best-known southwest artists in this genre is Milo Minock, a native of Pilot Station, whose drawings of Eskimo life on the Yukon and surrounding area are in the best tradition of illustrative art. He draws on paper, skin, or birchbark in various sizes (fig. 195), and has published a small book of his drawings with explanations, written in longhand, of such topics as "Making Yukon fish trap," "Fall fishing camp," or "Making Eskimo masks" (Minock 1971; *Alaska,* May 1972, p. 19; *Kalikaq Yugnek,* spring 1978). A compulsion to teach and to explain to others about Eskimo life is evident in almost every one of his pictures. Consequently, his drawings are highly detailed and realistic. During 1976, when he was a teacher in the Artists-in-Schools program at Kilbuck Elementary School, Bethel, he told me that he did not begin to draw commercially until the late 1950s when he retired from hunting. He had, however, acquired an early taste for drawing during his five school years as a child at Holy Cross Mission on the Yukon. Alaska Native Arts and Crafts, Inc., has handled his drawings since the 1960s. Minock's son, Pat Minock, was just beginning his own career in art in 1978 (fig. 196).

To this day, no women paint the traditional drawings on bowls and eyeshades made for sale (figs. 192 and 193). The women began to use representational subjects, however, during the 1930s in their coiled basketry, which had not been a traditional handicraft, and even earlier in a picture writing for remembering the scriptures. Although the original idea for pictographic writing on paper had been developed by a Kuskokwim River man, Uyakok, or Helper Neck, at the end of the nineteenth century, the women perpetuated it. Despite the precedence of Kuskokwim storyknife illustrations, fewer women from the Kuskokwim area used this picture writing than those from the Seward Peninsula-Kotzebue Sound area, who did not have the storyknife. The picture writing is rarely used today.

Uyakok, the son of an influential shaman, was himself a young shaman when Moravian missionaries visited his village, Akiachak, thirteen miles northeast of Bethel, in 1885. About 1894, a few years after his conversion to Christianity, he invented a picture writing similar to that in figure 191. Later, he devised a phonetic system with hieroglyphic-like symbols (Oswalt 1963:100; Schwalbe 1951:49, 69-71, 151). Uyakok, as a missionary, filled many notebooks with this shorthand, which he read to his fellow Eskimos, astounding them with his knowledge. In the University of Alaska Archives is a "Helper Neck Bible," an impressive ledger, twelve-by-seven and a half inches, filled with hundreds of lines of finely written script in his invented writing system.

His original picture writing apparently diffused to the Kotzebue Sound people, but we are not sure how or when. At any rate, Ruth Ekak, also the daughter of a shaman from Buckland, and the mother of Lily Savok, who gave me information about the Kotzebue Sound writing in 1968, invented a similar system around 1914 without knowing about the Kuskokwim writing; and

indeed the style and individual ideograms are different from its supposed proto-type. The example of Nunivak Island writing in figure 191 is in the Kotzebue-Seward Peninsula style, which was taken to Nunivak in 1932 by the first missionary, Jacob Kenick, originally of Golovin and Unalakleet. After Kenick's wife died, he married a Nunivak woman, Edna, who helped him in his mission-ary work and kept extensive notes in picture script. One of Edna Kenick's books, fifty-one pages long, is a log of Bible lessons that she recorded between 1944 and 1948, also deposited in the University of Alaska Archives.

The most interesting aspect of the Eskimo pictographic writing is not the pictures as they stand alone (the artistry depended upon individual skill), or a mere side-by-side comparison with the text, but the reason for using a particu-lar symbol. There was no "system"; that is, no single device, such as rebus, was used throughout. Instead, many kinds of symbols were used, although only one symbol applied to a specific word or phrase. Besides the rebus (a picture suggesting the sound of a similar word, for example, a hook for "reward" because hook and reward sound similar [in Inupiat]), at least eight other kinds were used: Christian symbols (crosses, etc.), realistic forms (such as houses), action figures (people in various postures), mnemonic motifs and mnemonic letters (these were more or less arbitrary, such as the first and second letters of the particular word or phrase in Eskimo), metonymy (words which suggest comparable attributes, for example, "towel" for "clean"), and synecdoche (part of an object to represent the whole, as a feather for angel). This analysis is based on Inupiat pictography (see Ray 1971a for other examples and explana-tions).

Women have lately been provided with greater freedom in the graphic arts through school and government programs in art, which, of course, are also untraditional. A generation of students has grown up with a different concept of art—art for art's sake, and for personal expression and enjoyment—and some of the best artists in the programs are female.

School programs have nurtured many an Eskimo child's latent creative talents. An unusual example, in the elementary school of Eek, a village of only 184 people in the latter 1960s, has been called an "explosion in art." Paul Forrer, a career teacher in the Bureau of Indian Affairs schools, began an unorthodox method of stimulating the pupils' imaginations through unstructured (but not unplanned) observations of everyday life and from pictures in books and maga-zines. There were no formal art classes, and teaching of art was often combined with another subject. If a pupil was in the midst of creating a painting, however, when, say, arithmetic class was approaching, he was not pulled off the project to attend. Since this happened only rarely, and then to only the most devoted artists, their other lessons did not suffer because their enthusiasm for art seemed to rub off onto their other subjects. Interest in painting and drawing was conta-gious in the Eek school, and new ideas were freely shared, discussed, and appraised. The students were permitted to choose their own subjects, and in the seventy-seven paintings in color illustrated in an article written by Forrer for *Alaska Journal* (1971), it is impressive to see how untraditionally "Eskimo" these colorful paintings are despite the isolation of Eek, and the inevitable inspiration that must have come from the surrounding environment.

This break with tradition was a result of free association with whatever struck the pupils' fancy and Forrer's innovative techniques, not formal direction.

Not one drawing or painting was a copy of the traditional graphics of the old wooden bowls and drumheads.[10] At least one of the pupils, Tom McIntyre, who now signs his prints and drawings "Chuna," hopes to make art his life's work (fig. 197). In an interview with Deloris Tarzan, a *Seattle Times* art critic in 1978, McIntyre had the highest praise for both Mr. and Mrs. Forrer, who inspired the Eek students. "When the teachers left," he told Tarzan, "the project collapsed" (Tarzan 1978).

Wood carving is almost entirely confined to the making of masks and copies of old ceremonial and everyday objects, although in the 1970s several persons in southwest Alaska made figurines, lamp bases, and three-dimensional scenes of Eskimo life in wood, bark, or synthetic materials. For example, John Williams of Napakiak was making large (eighteen inches long) wooden pieces, such as a man in a kayak spearing a walrus, stained brown and varnished to a high gloss. Others were making some very unattractive and gimmicky objects, especially styrofoam igloos representing the snow dwellings that were used only by the Canadian Eskimos.

In the 1970s the northern Eskimos carved masks for dancing performances, but ironically, in southwest Alaska where some of the most imaginative and complex performing masks had once been worn, the majority were made as sculpture to hang on walls. The "masks" made in 1976-77, and illustrated in figures 153-55, are flat, not concave, on the back, and do not have holes anywhere for viewing.

In 1976, the principal mask makers in southern Alaska were Nunivak Islanders living in Mekoryuk and Bethel, although a few masks were made in Chevak, Hooper Bay, Nunapitchuk, and Toksook Bay, and by art students interested in contemporary interpretations. The Aleuts and Pacific Eskimos gave up mask making long ago, but the recent work of Aleut artists, Fred Anderson and John Hoover, have included masks (fig. 53; also see *Alaskameut* 1978:figs. 1 and 2; Monthan and Monthan 1978:54; and Shalkop 1978:fig. 11). Despite the abandonment of traditional Eskimo ceremonials, there have always been other reasons for making masks during the past fifty years—to sell, to use in an occasional dance, and even for special events, such as the re-creating and photographing of traditional Hooper Bay dances by a Walt Disney photographer in the 1940s—thus maintaining a continuous production.[11]

10. Also see Frederick 1970. The Anchorage Historical and Fine Arts Museum, however, has several drawings with Eskimo subject matter, which were not included in the published articles. Some criticism has been leveled privately at Forrer by traditionalists because of his emphasis on nonnative inspiration.

Forrer later moved to Kotzebue where he had charge of a high school art class. *The Alaska Journal* also reported results of the work there, but it is difficult to compare the two because the Kotzebue class was a formal one, at a different grade level, and included some nonnative participants (*Alaska Journal* staff 1975). From examples of their work in the article, the students appeared to be slightly more preoccupied with traditional subjects and with the human face and figure than the Eek children. Yet, they had parted almost completely from the stereotyped "Eskimo" drawings, which have been the staple of northern Eskimo commercial artists for the past two generations. There were even a few abstract-nonrepresentational paintings, which the younger Eek pupils had not done.

11. In 1964, the principal mask-producing villages in southern Alaska were Chevak, Chefornak, Hooper Bay, Kipnuk, Mekoryuk, Nightmute, and Russian Mission (Don Burrus, ANAC, letter, 14 August 1964, Juneau). Only one old man, Walter Smith (Keowan) was carving at Goodnews Bay. In 1978 the Nightmute carvers were living in Toksook Bay. Collections of masks and other

On Nunivak Island in 1976, there were eleven mask makers in a population of about two hundred, which compared rather favorably with Hans Himmelheber's estimate in 1936 that there were about ten mask makers for each one hundred or one hundred and fifty persons in the Kuskokwim area (1953:76-77). But, in Hooper Bay, once a village of master mask makers, there were only three or four mediocre carvers in a population of about six hundred in 1976. All but one of the Nunivak carvers were over sixty years of age. This, however, does not mean that mask making is coming to an end, because many of the older men who are now carving turned to mask making only after they had retired from hunting and fishing or wage-earning work. Henry Bighead, a resident of Stebbins, who was born on Nelson Island in 1903, did not make masks until five years ago, at age seventy, although he had carved ivory in his youth. In 1978, along with Fred Anderson, the Aleut artist, Sam Fox of Bristol Bay, Rick Seeganna of King Island, and Joseph Senungetuk of Wales, he was chosen to participate in a two-week workshop "to encourage the traditional and emerging art of mask making among Alaska's Native cultures" at the University of Alaska (*Alaskameut* 1978:3, 7-11). Younger men in the general southwest Alaska area are now making masks with their own contemporary interpretations (figs. 157, 158), and some of the older men are deviating from what is considered to be traditional design (figs. 153, 155, 156).

The Nunivak men not only make more masks than any others in southern Alaska, but a greater variety. A popular mask is the traditional half-man–half-fox *(ixcit)*, but others are the musk ox (fig. 153), which has been carved—principally by Andrew Noatak—ever since the musk oxen were first put on Nunivak Island in 1936; and the loon, single walrus, double walrus, and puffin masks, especially by Peter L. Smith (fig. 155).

Most of the carvers use natural colors for their masks, as explained in the section on materials and coloring agents, and they rarely use ornamental appendages of materials other than wood. They can no longer use migratory bird feathers in the halos—having to substitute those from non-migratory birds instead—because stores are subject to a $500 fine if found selling masks or other products utilizing migratory bird feathers.

Nunivak Island masks have been the inspiration for two mask-like sculptures: a table-model mask of wood called a "ring sculpture," illustrated in figure 159, and the ivory "miniature mask" (figs. 136-38). The first miniature mask, a fox face, was said to have been made on request in 1952 by John Kusowyuk.[12]

Except for the painted dishes and masks, the only other ceremonial object of note now produced is the dance stick, made only by Kay Hendrickson of

Eskimo artifacts are constantly being offered for sale from family or attic collections, which were acquired during the twentieth century. A collection of about 350 objects was given to the Washington State Museum in 1978 by the family of the late Robert Gierke, a pioneer trader in Bethel, and another collection of more than two hundred pieces from the same area was recently offered for sale by the Walrus Gallery in Kennebunkport, Maine. The masks on pages 18 and 19 of the Walrus Gallery sale catalog are the same pieces that Hans Himmelheber illustrated in his *Eskimokünstler*, plates 15 and 20. They were still in Bethel when he left in 1936 (Emery 1978; Hans Himmelheber, letter, 6 March 1978, Heidelberg; Quevillon [1977]).

12. This information from Robert Gibson is in slight disagreement with that from Ethel Montgomery, a former employee of the Alaska Native Arts and Crafts, Inc., who said that she had seen miniature masks in the latter 1940s. They were never listed in the ANAC catalogs because of their rarity (E. Montgomery, letter, 31 December 1977, Juneau).

Nunivak Island (fig. 161). Hendrickson's sticks (all made for sale) have been simplified, and no longer operate as a shuttle, but he has retained the size of the stick, the harpoons stuck into the animals, and the "event" (a man in a kayak), which has always been placed on the handle. Drums are still used in local Eskimo dances, but some of the drumheads are now made of plastic instead of sea mammal membrane.

FUR AND SKIN SEWING

The Eskimo women of southwest Alaska still make mittens, mukluks, and parkas for everyday use, but commercially made wool and down garments are being purchased and worn with increasing frequency. Because of the scarcity of furs, however, they make very few large parkas for sale. Some, similar to the parka in figure 68, are made occasionally for competition, as are non-utilitarian forms—yoyos, copies of old ceremonial headdresses, ornamental bags, and dolls. With the exception of a few dolls, there is little skin, fur, or gut sewing south of Bristol Bay.

Most of the Eskimo bags, sewing pouches, and articles of clothing sold to nonnatives during the eighteenth and nineteenth centuries reflected the styles and designs current at that time. Human figurines clad in typical native clothing have been a mainstay of market art since Captain Cook's time in all of the southern area except the Aleutians and on Kodiak Island. Today's dolls are dressed in both contemporary and traditional garments, reflecting nostalgia and a pride in the old Eskimo way of life. In the nineteenth century, dolls that had removable clothing, or that had a hard torso and legs of skin or cloth, were usually made as playthings, and the unclothed figurines of wood or ivory were usually amulets or shamans' dolls. The majority of dolls today are soft-bodied, with clothing sewed on permanently; but there are exceptions, such as the "horn doll," a hard doll with slip-off parka from Shishmaref (see Ray 1977:50 and fig. 156).

In the last ten years, "activity dolls," also called "doll models" (to distinguish them from free-standing dolls) have been made to depict typical Eskimo pursuits—mending nets, fishing, chopping seal meat, making mats, dancing, etc. Some free-standing dolls, which are made as family groups, "doing things," should also be classed as activity dolls, although they are not mounted on a base. One of my favorite doll models is illustrated in figure 74. The two girls, who are dressed in modern *kuspuks* (cloth parkas), are engaged in the traditional pastime of telling a storyknife tale.

There is a poorly made doll for every good one, but each year, new and interesting dolls appear in the arts festivals and in the stores (figs. 70-72). Recently, the Eskimo woman's skill in this sphere has been challenged by Sam Fox, an Eskimo man from Dillingham, who has made some unusual dolls (Morgan 1978).[13]

13. For other twentieth century dolls from the southern area, see Alaska Festival of Native Arts catalogs; Frederick 1972:31; Frost 1970:frontispiece, 35, 74; Larsen [1974]; Lipton 1977:figs. 129, 158, 159; Quevillon [1977]:20-23.

PROJECTS AND PROGRAMS

In *Eskimo Art* I discussed the various projects that had been attempted in the north to give training in design and marketing and to encourage the Eskimo arts: the Indian Arts and Crafts Board (IACB) projects in jade and caribou hoof, the Manpower Development and Training Act (MDTA) project, and others. The Indian Arts and Crafts Board did not carry out projects south of Saint Michael because of a small budget and limited personnel. Only one person, Frank Long, was employed in the development of Eskimo arts and crafts in the field in all of Alaska during the 1950s, and since he was a specialist in lapidary work, projects such as jade and caribou hoof appeared to be the most economically feasible. The IACB, however, has given advisory assistance to the extension service program at the University of Alaska and the Visual Arts Center in Anchorage (both of which have had participants from southwest Alaska), as well as to the Toksook Bay pottery project (Myles Libhart, letter, 14 October 1976, Washington, D.C.).

No Eskimo artists from the area south of Saint Michael were enrolled in the MDTA program of 1964-65 (Ray 1977:60), but several men, including Kay Hendrickson, one of the foremost Nunivak artists, have taken advantage of the extension service program at the University of Alaska. Hendrickson developed his "ivory trees" while taking courses in design, and working in the shop in College (fig. 141).

In *Eskimo Art,* I discussed the work of the University extension service and the Visual Arts Center of Alaska. In 1978, both were thriving, although for a time it looked as if the Visual Arts Center would have to close in 1977 because of lack of financial support. In the summer of 1978, however, it was operating again at almost full capacity. Since it began in 1972, more than two hundred artists in the divisions of jewelry and metalsmithing, fiber, sculpture, and printmaking have participated in the program, which enables talented persons, both native and nonnative, to develop their skills in well-equipped studios. Before acceptance, an artist presents a portfolio, and upon successfully completing a three-month trial period, can remain as long as two years. The center also has permanent and temporary exhibits, which are the works of both participating and non-participating artists (Kes Woodward, letter and interview, August and November 1978).

Until the inauguration of the Artists-in-Schools program in the early 1970s, and the establishing of the University of Alaska extension program and the Visual Arts Center, the various arts in the south had grown and developed through the interest and sponsorship of individuals. The Toksook Bay pottery project started in this way when Carl and Nancy Wobser, the Bureau of Indian Affairs teachers at Nightmute, began the project as an adult education class in 1958. The clay was obtained locally, a ceramics workshop was set up, and a small electric kiln was purchased. A small business was formed, and a catalog printed. The project died, however, from lack of potters and experienced managers after many of the young participants left for boarding school, and the teachers went on to another teaching assignment.

When half of Nightmute moved to Toksook Bay in 1964, the inhabitants of the new village decided to form a cooperative (Toksook Bay Arts and Crafts Co-op, Inc.) and the Community Enterprise Development Corporation in An-

chorage sent Carol Kampert to investigate the possibilities of reviving the pot-tery project. Government funding was not forthcoming, however, because the cooperative was unable to specify what products were going to be made, or to show what orders had already been received. Funds were eventually obtained from several church groups and other private sources, and the "Nelson Island School of Design" began under the direction of David Stannard of the Univer-sity of Oregon's art department. The teachers and students cooperated in mak-ing a number of pottery jars (fig. 181), but when the ceramics project was finally put entirely into the hands of the Toksook Bay people, it faltered, and by 1979 was no longer operating. The cooperative itself, however, continued to operate as a retail store for selling general merchandise and arts and crafts products (*Alaska,* December 1972:15; Anable 1973; Janice Gibson, interview, May 1976, Bethel; Bernard F. McMeel, S. J., letter, 24 May 1978, Toksook Bay; Francis E. Mueller, S. J., 1 May 1978, Fairbanks; *Tundra Times,* 30 August 1972).

The demise of this project repeated the experience of similar local efforts, such as the northern projects, which introduced new and unfamiliar designs and materials to be used without supervision. The failure of these projects and the success of college-oriented or mixed native and nonnative urban pro-grams are the result of numerous factors. Contributing to a successful program are the younger age of the participants, the prospect of considerable economic reward as an *individual* artist, the fact that some of the teachers are natives themselves in an intensive one-to-one appraisal and instruction, and the vigor that new designs and materials create under a sustained goal.

A recent project that includes both northern and southern participants is the knitting of "qiviut" (musk ox underwool). Musk oxen, which became ex-tinct long ago in northern Alaska, were transplanted from Greenland to Fair-banks in 1931, but were transferred to Nunivak Island in 1936 at the suggestion of the Lomen Corporation, which had a reindeer business on the island. In 1954, a musk ox project, designed to explore the feasibility of domesticating the musk ox to provide a livelihood for Eskimos through herding and the making of wool products, was begun in Vermont under the direction of John J. Teal, director of the Institute of Northern Agricultural Research. In 1964, with the experiment proving a success, a number of Nunivak animals were taken to the University of Alaska at College where the project functioned until 1976 and 1977 when all of the musk oxen were removed to a new farm near Unalakleet. (Other animals from Nunivak Island had previously been relocated as wild animals to Brevig Mission, Cape Thompson, Nelson Island, and Barter Island.)

In 1966, Teal began to look for distinctive designs for the proposed knitted products, and the first one—a harpoon design from a kitchen midden on Nuni-vak Island—was developed under the tutelage of Ann Schell, a nonnative. The second was the "triple harpoon." (The hat of the naturally colored wool in figure 96 is the "star cap," designed by Esther Shavings of Mekoryuk.) The textile arm of the project, Musk Ox Producers' Cooperative, better known as "Oomingmak" ("the bearded one"), was located in College, and the first harvest of this exceedingly fine wool was sent to several villages in 1969. From then on, each participating village developed its own designs on scarves (the first item made for sale), hats, stoles, sweaters, tunics, "smoke rings" (worn

as cowls or scarves), and baby hoods from various dyed hues, as well as the natural gray brown color. For those persons who could not read written instructions for each item, symbols were devised.

In 1977, Oomingmak was moved from College to Anchorage. By 1979, one hundred and seventy-five women, and some men, had been trained to knit in week-long training sessions in the villages, and at least a hundred were still actively working. The villages that have participated in this program are Bethel, Marshall, Mekoryuk, Nightmute, Saint Marys, Shishmaref, Toksook Bay, Tununak, Unalakleet, and Wainwright. A head knitter in each village distributes the wool and suggests what a knitter might make. The final choice, however, is up to the individual. Pay is based on "actual average knitting time," and since the exact number of stitches is known in any one piece, beginners are assured of the national minimum wage (John J. Teal, interview, 15 December 1977, Bainbridge Island; Lomen 1954:180-81; Mathiessen 1967; *Oomingmak* brochure [n.d.]; Rearden 1975; *Tundra Times,* 19 May 1976; Wilkinson 1971).

The innovative turns that Eskimo art often takes are well demonstrated in the use of the musk ox as subject matter after they were placed on Nunivak Island in 1936, especially in masks, paintings, and basketry (figs. 153, 193). I do not know the exact date that this motif was adopted, but it probably was the day after the musk oxen arrived! The southerners have not made free-standing wood and ivory sculpture of the musk ox, however, as have the artists of the north, who copied from the animals relocated in the wild from Nunivak Island (Ray 1977:63 and figs. 174, 175).

The distribution of all native arts in this southern area was very much a local procedure until the Alaska Native Arts and Crafts Clearing House (ANAC) was established in 1937 in cooperation with the Bureau of Indian Affairs for sponsorship and marketing of native goods. In 1956, it separated from the BIA to become a private cooperative, Alaska Native Arts and Crafts, Inc., which has headquarters in Anchorage (Ray 1977:56). In contrast to the north, particularly at Nome, where several stores had huge supplies of native crafts on hand at all times, there were fewer outlets in the south. ANAC was therefore able to provide a central market for handicrafts from remote villages. In southwest Alaska, Bethel has been the most active local center for sales of arts and crafts since the early 1900s. Traders were always present to buy the products made in Bethel and nearby villages, and several crafts shops have opened over the years, but not all were successful. In 1976 the Moravian Book Store and the Yugtarvik Regional Museum had rather large inventories and selection of items for sale. In 1979 Martha Larson, the former director of the museum, opened her own shop, "Martha Larson's Native Arts and Crafts." Interest in the arts has developed through the Bethel Council of the Arts and its sponsorship of various events, such as annual native fairs. In the Aleutians and on Kodiak Island, native art products were usually sold to the old Alaska Commercial Company and other stores or offered to passengers and crews of ships, especially at Unalaska where women from all of the islands sent their baskets for sale. Although crafts shops in Kodiak were selling ivory carvings and other northern items in 1978, they had no local arts in stock.

5. "What Is Past Is Prologue"

Although there are numerous differences in art forms and styles in Eskimo-Aleut territory, there were many similarities in materials and objects and their uses during historical times. Everywhere, amulets and charms of ivory and wood were made in human and animal shapes, and placed in various structures or worn on the person. Furs were sewed into tailored garments, usually with some kind of ornamentation; and animal intestines were made into waterproof garments. All groups made masks and other wood sculpture, and practiced the technique of bending wood for buckets, boxes, and hunting hats. All used paint in varying degrees, especially the omnipresent red, and painted or incised some form of representational sketches. Certain birds, animals, and mythological beings were portrayed in sculpture by all, especially in masks.

All of these artifacts, furthermore, had in common the fact that they looked "Eskimo"; that is, they had characteristics that set them apart from Athabascan or Northwest Coast Indian art, except for those marginal objects that came from the Eskimo-Indian boundaries where traits were exchanged, or the simple ones that had counterparts everywhere.

Besides its universal uses in ceremonies, religion, and magic, art was employed as mnemonic devices, as a means of communication, and for the building of prestige. We do not know the meanings of innumerable designs that were undoubtedly used for such purposes, but we have enough examples to know that in all of western Alaska many of the geometric and representational designs applied to most materials were made for public display. The northern Eskimos engraved scenes and animal pelts on drill bows and bag handles. Marks were sewed into mukluks or tattooed on the hands and face to represent whales caught, and the caribou tooth belt publicized a caribou hunter's ability. The sea lion bristles of an Aleut hunting hat represented a hunter's skill, and the Aleut woman's tattooing told of a relative's hunting exploits. Among the southern Eskimos, spectacular events were recorded in dance sticks and on drumheads, dishes, and grave boxes. In both everyday life and on festive occasions, the eye constantly beheld great achievements of the past.

Similarities between north and south also extended to attitudes toward trade goods. From the date of first European contacts, no group turned down the opportunity to trade, and all eagerly exchanged their own goods (except certain religious objects) for the new, which they invariably added to their traditional arts in one way or the other. For instance, the Aleut women adopted embroidery thread and raveled cloth for intricate ornamentation of kamleikas and baskets (as did the northern women for souvenir pouches and welting designs on fur garments), and all Aleut and Eskimo men and women used trade beads in many imaginative ways.

In all areas, too, objects were made to sell whenever trading opportunities arose. There were no exceptions, north or south. The alacrity with which everyone accepted, and worked for, a souvenir market is directly related to the

Eskimo-Aleut ability to copy, which was mentioned repeatedly by the early explorers. This ability has been demonstrated many times by the immediate implementation of direct or indirect suggestions provided by nonnatives, and has resulted in many notable products of the nineteenth and twentieth centuries: the various Aleut basketry forms, skin kayak models, cribbage boards, gavels, and other foreign-inspired objects of the gold-rush period, contemporary ivory figurines, the Nunivak tusk and ivory masks from Mekoryuk, the representative designs on coiled basketry, and many others. The amazing results on first attempts and the short periods of time required to attain the pinnacles of success in a wide variety of forms have important implications for a study of development and retention of style and form in archeological art.

Historical and contemporary art spans, at the most, only two and a half centuries—and in some areas, much less time—yet in this comparatively short period, many changes in art styles occurred in the several cultural areas. Few styles or forms have remained stable long. Even the favorite staples, cribbage boards from the 1880s and 1890s and ivory figurines from the 1920s (both adopted first by northern carvers), have not escaped new subject matter and styles. In view of this, some revision of the time span thought to be necessary for the development of designs, styles, and forms, as well as the length of time these same designs and forms can remain unaltered, is in order.

Prehistoric reconstruction cannot be made in the same detail as that of the historical-contemporary period, but assuming that the Eskimos of a thousand or two thousand years ago had the same cognitive traits exhibited by the Aleut-Eskimo for the past two hundred and fifty years, and that the rate of change was similar—even considerably slower—the implication is that changes in style were quickly and easily adopted, and did not remain stable for long periods of time. The events that brought changes in prehistoric days were not the same as those since 1741 when Europeans and Alaskans met face to face, but it is known that the Bering Strait Eskimos of Okvik, Old Bering Sea, and Ipiutak times of fifteen hundred years ago did not live in isolation, and apparently were the recipients of many outside influences. They had iron for carving and incising, and many elements of design and various unidentified forms appear to have come from the far reaches of Siberia or even China.

The local or outside events responsible for change are seldom ascertainable for prehistoric times, but in the long history of Eskimo culture, art was always made for a specific purpose, and changes in art styles during the historical period were a result of outside stimuli in most cases. In other words, changes in art were directly related to changes in some other sphere of life. Art did not change for art's sake. It is reasonable to assume that all this was true during prehistoric times. The introduction of the unusual paraphernalia that characterizes the archeological remains of Okvik and Ipiutak cultures doubtless came about as a change in ceremonial practices, probably introduced from the outside, since derivative forms such as ivory chains were part of the assemblages.

There is another side to consider, however: the role that an innovator or an especially strong shaman-artist pattern might have played in a particular group or area. In historical times, this might explain the creation of hundreds of masks and figurines from the Point Hope area in the north, and the efflorescence of a larger variety and more unusual forms and styles in the Kuskokwim-

Yukon delta–Nunivak Island region than any other local area. In Okvik-Old Bering Sea-Ipiutak times, this, too, along with the introduction of certain ceremonial elements, could have been responsible for the distinctive objects from those periods.

The southwest Alaska Eskimos employed designs and developed styles during the nineteenth century, which were not used by either the Inupiat and Pacific Eskimos, or the Aleut. These included: a profusion of incised geometric designs on needlecases, snuff tubes, and bag and box handles (figs. 107, 108); the storyknife; paintings on wood of family stories, which were diagrammatic and impressionistic, with "X-ray" views, rather than the more photographic realism in ivory of the north or on wood in the Aleutians; surrealistic, composite, and complex masks; mask appendages of animals or human beings, whole or in part; wooden effigy monuments; and paintings on kayak and umiak covers, drumheads, and gut windows. A conventionalized element not known elsewhere was the upturned mouth to represent a human male; the downturned mouth, a female. Eyes of some human figurines and effigy monuments were made in crescent shape, usually of ivory, also a style unknown elsewhere. The conical hunting hat apparently originated in the southwest Alaska area, later spreading to the Aleutian Islands. In the early twentieth century, the Nunivak people used a comma-shaped design to represent animal whiskers, and only the Nunivak men made the "Nunivak tusk."

In the case of southwest Alaskan art, especially Nunivak Island, it appears that the unusual characteristics in form and style had developed internally during historic times, for the people did not live on the main routes for trade in early European goods (and possibly not in late aboriginal times as well) and were therefore not subjected to outside influences. But, saying that it "developed internally" is begging the question, for it does not explain the unknown factors that were establishing conditions for creating, say, extremely complicated masks in one area of the south, while in the north—where the Eskimos professed similar beliefs and religion—the masks were simple and straightforward, almost pedestrian at times. Such disparity, almost more than anything else, shows the delicate differences between the many Eskimo groups of Alaska. Trying to trace the development of art of any one area for unrecorded history is speculative at best.

In 1978, the first exhibition of contemporary Alaskan art was shown at the National Collection of Fine Arts of the Smithsonian Institution, giving viewers outside Alaska a glimpse of a fast-growing body of paintings, prints, and sculpture by Alaskan artists (*Contemporary Art from Alaska* 1978; McCollom 1978). In 1741, the first artistic objects, made by residents of what was to be called Alaska, were described and obtained from Aleuts in the Shumagin Islands. These two events have much in common despite the interval of almost 250 years. In both cases, the art works were taken to a nation's capital to display the handiwork of the residents of a remote and exotic region. In both cases, the objects were contemporary art: the graceful hunting hats, the tiny ivory amulets in human shape, and other objects traded from the Aleuts, were the work of that time, the mid-eighteenth century. The works in both displays were those of resident Alaskans, but in 1741 all were Eskimos (i.e., Aleut), whereas in 1978, only eight of the forty-two artists were native Alaskans. Most significant, however, is the fact that in the recent show, only the viewer

acquainted with specific styles could distinguish the works of the native artists from the nonnatives, because almost all had drawn their inspiration from "native" or "Alaskan" subjects. The exhibition represented a vigorous cross-fertilization of ideas and materials found in Alaskan art today.

Two of the native artists, Fred Anderson and Alvin Eli Amason, were Aleut, and the others were Inupiat Eskimos from northern Alaska. There were no Yupik participants, and no native women, although fifteen of the thirty-four nonnative artists were women. The Aleut and the Eskimo artists could not have come from more disparate artistic backgrounds. An identifiable, ethnically oriented art lay far behind the two Aleuts, while a thriving "Eskimo art" tradition, which had never been interrrupted, is still very much a part of the lives of the eight northern artists.

With the exception of James Kivetoruk Moses, who was about seventy-eight years old at the time of the exhibition, all of the native artists were born in the 1940s. All, except Kivetoruk, had formal art training at various institutions, such as the Institute of American Indian Art (Santa Fe), the San Francisco Art Institute, the Rhode Island School of Design, Arizona State University, the University of Alaska, and others; and several have college degrees.

The fact that there were no Yupik artists represented is not too surprising since fewer students, so far, have engaged in formal art or college studies from the southern area, and most of the local sculptors and painters have continued to turn out interpretations of traditional art. Very few consider their work a profession as do the eight artists whose works were chosen for the show. The absence of female artists can be explained in part by the still prevalent attitude that women should confine themselves to sewing and basketry, and also, in part, by the fact that women who do go to college choose more service-oriented courses, such as teaching, nursing, and business, rather than art. Even in the villages, workshops are designed for women's utilitarian handicrafts—basketry, knitting (qiviut wool), and sewing. Yet the girls in elementary school art programs have shown that they are equal to the boys.

The difference between the Smithsonian exhibition, which was limited to the fine arts, and an exhibition of contemporary native art at the Anchorage Historical and Fine Arts Museum during the summer of 1979, is reflected in the geographical distribution of exhibitors and the interpretation of art to include those objects that are more-or-less traditionally oriented. Of 158 objects (representing 115 Aleut, Eskimo, and Indian artists), there were 41 objects made by twenty-nine Yupik artists, nineteen of whom are women. Their twenty-one entries were those often placed in the category of cottage arts—dolls, qiviut knitting, basketry, dance fans, and the like (Anchorage Historical and Fine Arts Museum 1979).

Many of the younger artists at the present time are departing rather drastically from the market art that has dominated most of the previous production of the Eskimos; yet there will undoubtedly continue to be production of the handicraft arts that form an important cottage industry in many small villages. Despite their new directions, the native Alaskans will not forget that the inspiration for much of their art is still derived from their own culture. One indication is the founding of such groups as the Raven's Bones Foundation, a native artist-controlled collective, organized in 1976, which not only wishes to perpetuate the mystique of traditional art, but has a membership of the same persons

who are in the vanguard of the new fine arts. Several native artists have even talked about divorcing themselves entirely from white culture in their art: materials, teaching, role models, even selling. But they are 250 years too late. Their artistic productions have gone hand-in-hand with the white culture for generations, and realistically, they can never turn back on their nonnative inspirations any more than they can reject their own native background. They are indeed the new artists with many opportunities to capitalize on a rich and varied legacy.

PART TWO
Illustrations

Introduction

The 219 illustrations in this book and the 307 illustrations in *Eskimo Art: Tradition and Innovation in North Alaska* represent more than nine hundred objects in public and private collections and dozens more in sketches made by early artists between 1741 and 1979. This is but a sampling of the objects made—or even collected—since the beginning of the historical period; yet, even this comparatively small sample permits us to outline and interpret the content and course of Alaskan Eskimo art.

When comparing the objects in this book with *Eskimo Art,* there may be an impression that the Aleut and Pacific Eskimos did not produce as prodigiously as their Yupik or Inupiat relatives in either traditional or contemporary times. Except for women's basketry, this is true of today's production, but does not apply to traditional art, as is evident from archeological and early ethnological collections. Their creativity was as fully developed as that of their relatives to the north. This volume contains fewer illustrations because fewer objects have been preserved, and a large percentage of those are in hard-to-reach collections. For these reasons I have included several illustrations from published materials.

The drawings and paintings executed by the artists of the various expeditions to southern Alaska are invaluable because the traditional art of the Aleuts and Pacific Eskimos was abandoned early and quickly. John Webber of James Cook's expedition (1778), Ludovik Choris of Otto von Kotzebue's expedition (1816), and Mikhail Tikhanov of Vasilii M. Golovnin's expedition (1818) are well known for their painstaking records of Aleut and Eskimo people and places. Tikhanov's work has only recently become available in an English publication (Shur and Pierce 1976); I have reproduced all but his drawings from the original publications. Tikhanov's works, which he painted originally in color, are reproduced from the black and white versions in the 1965 edition of Golovnin's *Puteshestvie.*

I am also illustrating four plates of southwest Alaska Eskimo objects of wood and ivory from E. W. Nelson's *Eskimo about Bering Strait.* In 1954 I photographed the majority of ivory objects collected by Nelson and deposited in the United States National Museum, but only a few made of wood. Using these plates will present the maximum number of objects in their original condition—which was very good—shortly after they were collected between 1877 and 1881. Identification of the villages from which the objects came is given in the list of settlements in appendix B.

Most of the objects collected from south Alaska before the purchase of Alaska from Russia by the United States in 1867 were taken to Europe, where they remain, a treasure trove of beautiful clothing, masks, and sculpture. Some of the objects were collected as a sideline to maritime exploration, but in the 1840s, two large and important collections were made by Lavrentii Zagoskin and Ilia G. Voznesenskii, who were sent to Alaska specifically for collecting or exploring.

Zagoskin, who explored the Bering Strait and Bering Sea area for possible trade routes and sites for trading posts between 1842 and 1844, returned to Russia with a collection of ethnological objects from the Saint Michael and Kuskokwim River areas (Zagoskin 1956; 1967). Between 1839 and 1849, Voznesenskii made the most important early collections of Aleut, Eskimo, Athabascan, and California Indian materials now housed in Soviet museums; and, according to the authors of an article on the holdings of American artifacts in the Museum of Anthropology and Ethnography of the Academy of Sciences in Leningrad, these items represent more than two-thirds of the museum's American collections. Voznesenskii's Aleut materials are "most valuable" of their entire Aleut collection, and include "implements for fishing and sea animal hunting, weapons, kayaks (among these special attention is deserved by a one-man kayak with a two-bladed oar . . . as well as the collection of kayak models made by the Aleut as ordered by the collectors), articles of clothing, kamlejkas made from sealskin, and birdskin robes, as well as the collection of wooden and leather headgears, for hunting and dancing, respectively. It also contains carved bonework and funeral masks" (Zolotarevskaja et al. 1956:222, 224; Blomkvist 1951, 1972; Liapunova 1967a; Lipshits 1950; Pierce 1975; Stanyukovich 1970:7).

Voznesenskii also obtained several masks used in a "six-act mystery play" on Kodiak Island, which he attended in 1842. I am reproducing three of them. These are, however, only a small portion of the Koniag regalia that Voznesenskii took back to Russia, a sample of which can be seen in the photograph of a model dancer in the Museum of Anthropology and Ethnography, Leningrad (fig. 16).

A few Alaskan Eskimo objects in Russian museums have been described in papers and articles by Soviet ethnographers: Ivanov 1949a; Lipshits 1955; Stepanova 1949; Volkov and Rudenko 1910; and Zolotarevskaja et al. 1956. Some of the Aleut material has been described in several papers by Soviet ethnographers, but that from Kodiak Island has yet to be analyzed and published. The principal publications on the Aleut material are: Avdeev 1958 (in Russian, translated into German, 1964); Ivanov 1930, 1949b; Liapunova 1963, 1964, 1967b, 1975a, 1975b, 1976; and Orlova 1964.

Pacific Eskimo masks (especially from Kodiak Island) that were collected by Alphonse Pinart in the 1870s have been illustrated and discussed by Lot-Falck (1957). Kaj Birket-Smith described the Chugach and Kodiak holdings of the National Museum of Denmark in "Early Collections from the Pacific Eskimo." Some of these objects were purchased from Henrik Johan Holmberg, who had obtained them in Alaska in 1850. In his Chugach ethnography (1953), Birket-Smith also illustrated many of the Chugach objects collected by Johan A. Jacobsen for the Museum für Völkerkunde in Berlin.

American museums unfortunately have comparatively little pre-1867 material from the Aleut and Pacific Eskimo area, except from archeological sites. (See note 1, chap. 2, and note 17, chap. 3 for a list of monographs and papers dealing with prehistoric art of the Aleut and Pacific Eskimo areas.) Only a few of the unique Aleut hunting hats are in American museums, but a photograph in Lipshits' paper of 1955 shows that in one display case alone in the Museum of Anthropology and Ethnography in Leningrad there are nine Aleut hunting hats with closed, pointed tops, and three in the open style.

The paucity of ethnological objects from the Aleutian Islands and the Pacific

Eskimos after 1867 can be illustrated by the experience of Edward G. Fast, who, in ten months' time (October 1867 to July 1868) acquired more than six hundred Tlingit, Koniag, and Aleut objects while on duty as a member of Brevet Major General Jefferson C. Davis' staff in Sitka. Most of the collecting was done by "several intelligent and courageous natives [that is, Tlingits] who . . . scoured the country for hundreds of miles, obtaining many of the articles from ancient graves, to touch which is considered such a heinous sacrilege that their lives would have been sacrificed upon the spot had they been detected in the act" (Fast 1869:5-6).

Despite the diligence of Fast's assistants, only 37 of the 611 objects listed in his catalog that accompanied an exhibition and sale of his artifacts in New York's Clinton Hall in 1869 are from the "Aleut," who were "scattered over the Aleutian Islands, the islands of Kodiak, St. Paul, St. George, and the peninsula of Alaska" (ibid.:27). The thirty-seven pieces included two "models of skin canoes," fifteen "arrows with movable heads," two "bows," one "waterproof shirt" made of intestines, and a "cap made from same," three "bags," two "wooden hats," two "wooden caps," one "canoe [one-hatch] of seal-skin 13 feet long, with complete outfit," one harpoon, one dart "with movable head and swimming bladder," four darts "without swimming bladder," and two "darting-boards" (spear throwers). The Peabody Museum of Archaeology and Ethnology, Harvard University, purchased all of these objects in 1869; two are illustrated in *The Far North:* a spear thrower, and a "seal decoy helmet," which is probably one of the wooden hats listed in Fast's catalogue (1973:figs. 70 and 86). Fast did not list any ivory figurines, masks, or baskets from the Aleut-Eskimo area.

Another indication of the scarcity of early Aleut and Pacific Eskimo art in American museums is in a listing by T. D. Bolles of all Eskimo objects in the United States National Museum as of 1887 (1889). Bolles' article was written after E. W. Nelson's large collection had arrived at the museum.

In the list were 122 masks obtained from seventy-two places, but none from the Aleutian Islands or Kodiak. Nine are from Nuchek (Prince William Sound). In 1953, Kaj Birket-Smith wrote that "the only Chugach masks known to exist at the present day are seven specimens collected near Port Etches [Nuchek] for the United States National Museum in Washington, D.C." (1953:109).

Other information gleaned from Bolles' list is as follows:

Of 249 dolls (human figurines), none was from the Aleut or the Pacific Eskimo areas.

Of a total of 61 baskets from sixty-six places, 13 were from Saint Michael, 7 from Unalaska, and 6 from the Togiak River. One basket was from Kodiak Island.

Of 31 carved dogs, only 1 was made south of Koyuk on Norton Sound, and this came from Nunivak Island.

Of 84 carved seals, only 11 originated from south of Saint Michael; 1 was from Unalaska.

Of 45 carved whales, all were from Saint Michael or southward; 6 were from Koggiung, and 1 from Unalaska. (A number of carved whales, walruses, and bears were collected in 1881–83 at Point Barrow for the National Museum; apparently these were not yet catalogued.)

Of 39 carved walruses, 11 were from south of Saint Michael; 6 were from Cape Vancouver, 4 from Koggiung, and 1 from Unalaska.

Of 59 carved otter (land or sea not specified), all were from Saint Michael southward, 15 from Koggiung, and 14 from Unalaska.

Of 117 "miscellaneous carved animals," 68 were from Saint Michael, but only 22 others were from the area to the south, 5 of which were from Koggiung and 2 from Unalaska.

Of 115 carved birds, 73 were from Saint Lawrence Island, and of the 42 remaining, 22 were from the southern area: 15 from Saint Michael, 6 from Koggiung, and 1 from Unalaska.

Of 49 carved fish, all were from Shaktoolik on Norton Sound or southward. Of these, 31 were from Saint Michael, and 2 from Unalaska.

In the museum there was a total of 49 kayak models, presumably made of skin over wood frames. The largest number, 15, came from Unalaska; 5 were from Unalakleet, 4 from Kodiak, and 2 from Nunivak Island.

Much archeological material has since been obtained from the Aleutian Islands and Kodiak, from both scientific excavations and the looting of graves, caves, and old village sites, an active sideline to trapping, especially in the 1920s (letter, "Andrew" from Nick Bolshanin, 23 May 1923, Unalaska, Alaska State Museum files). Some post-1867 ethnological pieces are in museums throughout the United States. The entire small collection of Koniag objects in the Lowie Museum, Berkeley, collected in the 1880s and 1890s, has been described and illustrated by Robert F. Heizer (1952).

Besides the many illustrations of early traditional southwest Eskimo objects in Nelson's *Eskimo about Bering Strait,* others are to be found in Coe 1977; Disselhoff 1935, 1936 (Eskimo masks and finger masks collected by Johan A. Jacobsen); Himmelheber 1953; *The Far North;* Israel 1961, 1963, 1971; Jacobsen 1884, 1977; Zagoskin 1956, 1967; and the Russian sources already mentioned.

The objects illustrated in figures 111-12, 115, 116, 122, and 124-25 were collected during the last decade of the nineteenth century and the first decade of the twentieth, on the Kuskokwim River and Nunivak Island by Moravian missionaries, and taken to Germany. This is part of the collection described by Heinz Israel in his three papers. The objects are now in the Völkerkunde-museum Herrnhut/Oberlausitz. (Herrnhut or Herrnhuter means Moravian.)

The task of choosing illustrations of masks for this volume was difficult because of the wide variety and limited space. Since many masks have already been illustrated elsewhere, I decided to devote proportionately more space to those made by the Aleut and Pacific Eskimos and by contemporary (post-1940) artists than to the older masks. Thus, many unusual ones are necessarily omitted.

The first fifty-seven illustrations are Aleut and Pacific Eskimo objects or persons. The rest are Yupik. The objects are organized chronologically by material and form.

Abbreviated names of museums used in the text are:
Anchorage Museum: Anchorage Historical and Fine Arts Museum, Anchorage
Constantine Collection, Agnes Etherington: Agnes Etherington Art Centre,
 Queen's University, Kingston, Ontario
Dresden Museum: Staatliche Museum für Völkerkunde, Dresden
Herrnhut Museum: Völkerkundemuseum Herrnhut/Oberlausitz

IACB: Indian Arts and Crafts Board, Department of the Interior, Washington, D.C.

Lowie Museum: Robert H. Lowie Museum of Anthropology, University of California, Berkeley

MAE, or MAE, Leningrad: Museum of Anthropology and Ethnography, Academy of Sciences, USSR, Leningrad

Peabody Museum: Peabody Museum of Archaeology and Ethnology, Harvard University, Cambridge, Massachusetts

USNM: Smithsonian Institution, Museum of Natural History (U.S. National Museum)

Washington State Museum: Thomas H. Burke Memorial Washington State Museum, University of Washington, Seattle

Other museums that are cited are the Alaska State Museum, Juneau; American Museum of Natural History, New York; Baranof Museum, Kodiak; British Museum, London; Museo de America, Madrid, Spain; Museum of the Peoples of the USSR, Moscow; National Museum of Denmark, Copenhagen; National Museum of Finland, Helsinki; Sheldon Jackson Museum, Sitka; Übersee Museum, Bremen, Germany; University of Alaska Museum, College; Visual Arts Center of Alaska, Anchorage.

All photographs are mine unless credited otherwise. I photographed most of the contemporary art during 1976-78 in private and public collections in Seattle and Alaska, including Anchorage, Bethel, Hooper Bay, Juneau, Nunivak Island, and Sitka.

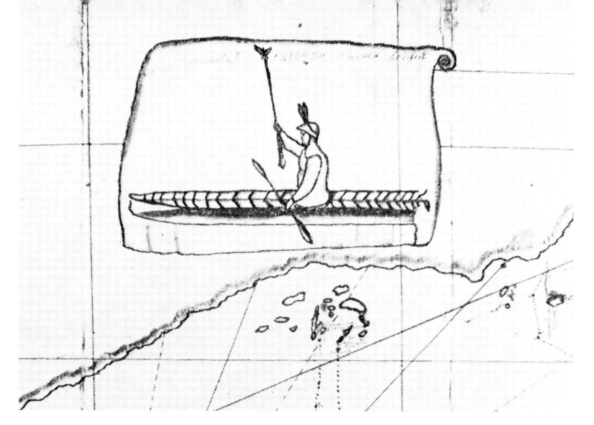

ALEUT AND PACIFIC ESKIMO

1. An Aleut in his kayak, the first drawing of any Alaskan native, by Sven Waxel of Vitus Bering's expedition, 1741. From a copy of Waxel's original map made by Sofron Khitrov, Fleet Master, in 1742 (Efimov 1964:map 101). The account of meeting this man near Bird Island is described in chapter 1. When I first saw this staff, with the two wings, the so-called "winged figures" of Old Bering Sea and Punuk periods immediately came to mind.

2. "Ritual Dance of the Aleuts," by an unidentified artist, drawn between 1769 (the end of Levashev's expedition) and 1775. From a map in the Central State Archives of the USSR Navy. The women are tattooed, and dance with "bladders," and the men wear labrets. The tall hat on the woman resembles the one in figure 18, which was the type worn in the western Aleutians. *Photograph courtesy Svetlana G. Fedorova and Richard A. Pierce*

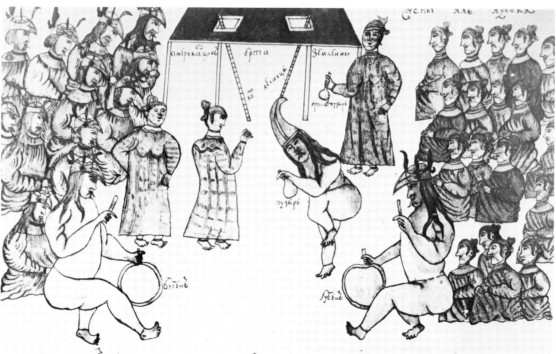

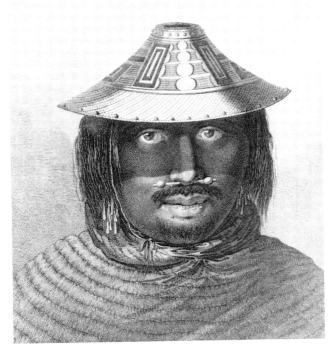

3. "A Man of Prince William's Sound," 1778, drawn by John Webber, artist of James Cook's expedition. From Cook's Atlas 1784:plate 46. This hat, probably woven of split roots, was trimmed with beads. The top was flat, perhaps to accommodate an additional section. Other Chugach spruce root hats are illustrated in Birket-Smith 1953:figure 35; Gunther 1972:figure 41; and Kaeppler 1978:figure 588.

4. "A Man of Kadiak," 1791, showing a round hat with designs similar to those used by Northwest Coast Indians. From Sauer 1802:plate VI, facing 176. Compare the facial ornamentation of this man with that of the Aleut woman in figure 14.

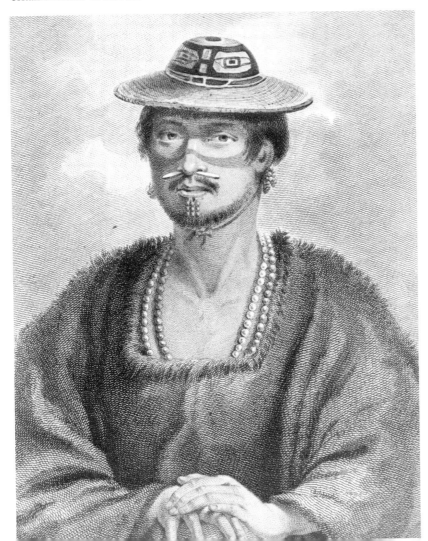

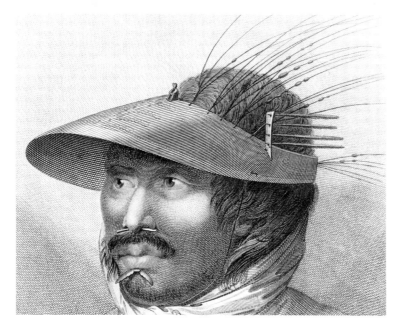

5. "A Man of Oonalashka," wearing a wooden hunting hat with a seated human figurine, 1778. Drawn by John Webber (pl. 48 in Cook's Atlas, 1784). The figurine is the kind of amulet that Steller described in 1741 (see chap. 1), and is still attached to this hat, which is in the British Museum (NWC2; 42.5 cms. long; blue, black, and red designs).

6. Man of Unalaska Island, wearing a hunting visor over the hood of his kamleika, 1791. From Sarychev's Atlas 1802, 2:16. Note the small figurine among the bristles. Compare this with an eyeshade from Kodiak, 1857 (Birket-Smith 1941:fig. 9).

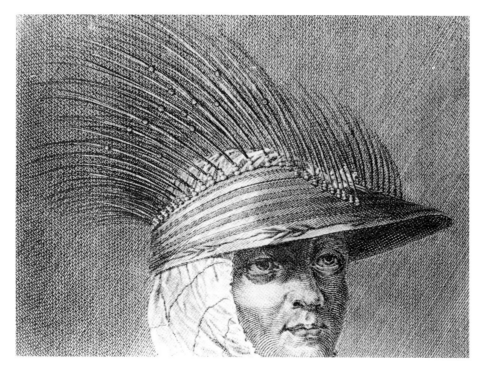

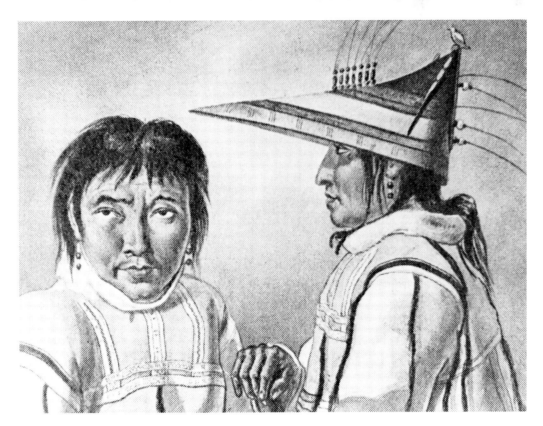

7. A man named Umasikh from Unimak Island, 1818, from a painting by Mikhail Tikhanov, artist of V. M. Golovnin's expedition in the *Kamchatka*. This excellent portrait clearly shows how the closed, pointed wooden hat was worn on the head. The hat is painted, and also ornamented with beads, sea lion whiskers, a long ivory ornament on the side, and a bird amulet on top. *Photograph courtesy Richard A. Pierce*

8. An Aleut hat, illustrated in color by Ludovik Choris, artist of Otto von Kotzebue's expedition, 1816 (Choris 1822: pl. V [VI]). The whales are black, and the other colors are gray, light green, light blue, and rose pink.

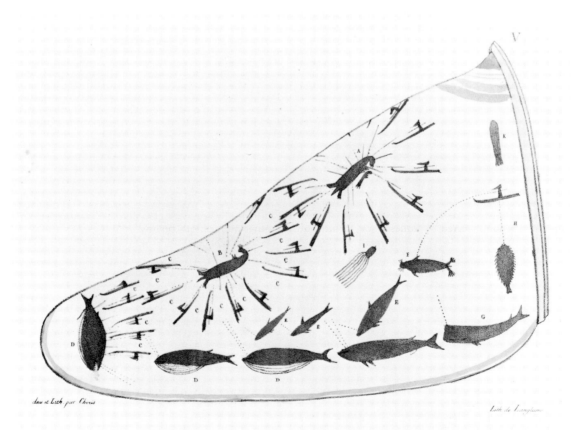

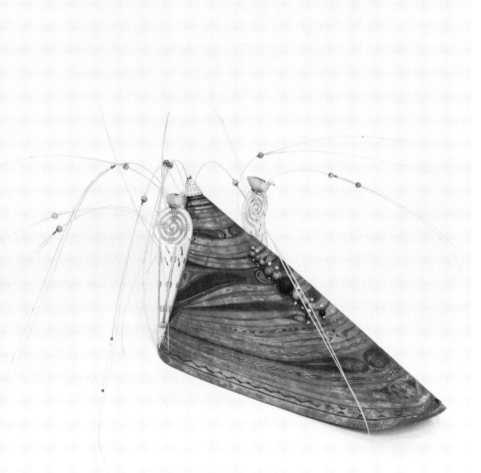

9. Hunting hat from Unalaska. Length: 15¾ inches (39.3 cm.). British Museum 2240, probably the 1830s (acquired in the 1860s). The surface is ornately painted in black and various shades of brown and tan. Three black beads, eight light blue beads, as well as smaller beads in red and white are attached to the middle front. Each of the two side pieces has an ivory bird on top. The beads on the bristles are light blue. This piece was not collected by James Cook, as attributed in other publications (Penny Bateman and Yvonne V. Neverson, letters, 1977, British Museum). Published in color in Fagg 1972:frontispiece. *Photograph courtesy Trustees of the British Museum*

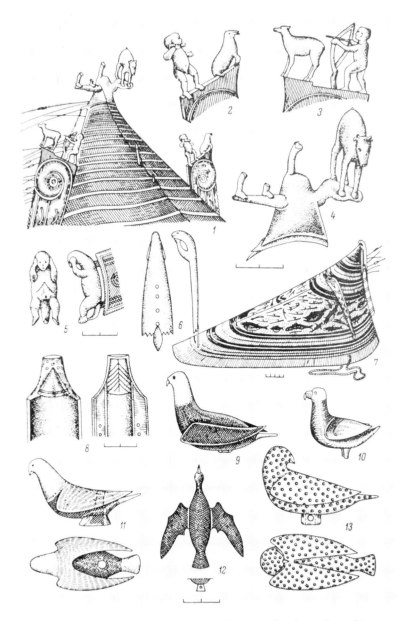

10. Ivory figurines, for ornamentation on Aleut hunting hats. From Liapunova 1967b:plate II:

(1-4) Hunting scenes on a hat, showing a man shooting a "deer," and another, who probably once had a spear in his hand, standing behind a walrus. Stumps on the left are remains of a man's legs. MAE 2868-84. This hat is also illustrated by Ivanov (1930:pl. IX), at which date the man behind the walrus (called a seal by Ivanov) did indeed have a club in his hand. Figure 11 *(below)* shows the ivory seam plate-whisker holder on the back of this hat. A similar ivory object is illustrated in *The Far North* (fig. 65).

(5) This is a small sea otter, placed on the upper side of a hunting hat. MAE 2868-80

(6-7) A linear interpretation of a sea otter in ivory used at the back of the hat to cover up the seam. Sea lion whiskers are stuck into the spine.

(8) A stylized figure of a sea otter, placed at the top of the back of hunting hat MAE 2868-39.

(9) An ivory bird, colored black. The eyes are large black dots. The beak is red. MAE 2937-6.

(10) A bird, colored black, with red beak and legs. Length (beak to tail): 2 inches (5.2 cm.). MAE 2937-8.

(11) The wing and back incisions are black, but the beak is uncolored. Length: 2³⁄₁₆ inches (5.7 cm.). MAE 2937-5.

(12) This bird has a black body. MAE 2937-7.

(13) Ivory bird with black dots. Height: 6 cm. MAE 2937-4.

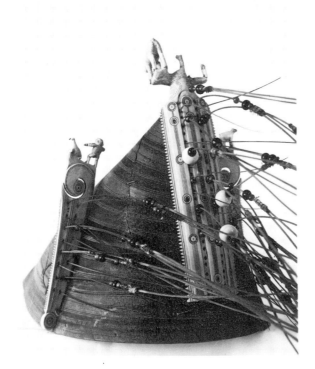

11. The back of an Aleut wooden hat, showing a fancy ivory seam plate. MAE 2868-84. *Photograph courtesy MAE, Leningrad*

12. "Toion, Alaska Peninsula, named Aiachunk, and baptized Andrei." Painting by Mikhail Tikhanov, 1818. This man appears to be wearing a finely woven garment, possibly of grass, although by 1818, it could well have been made of cloth. Although feathers were worn on the head for ceremonial occasions from the Aleutians to Point Barrow, the frame of this headdress is very unusual.

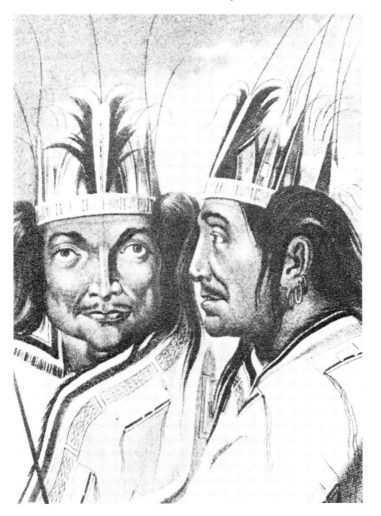

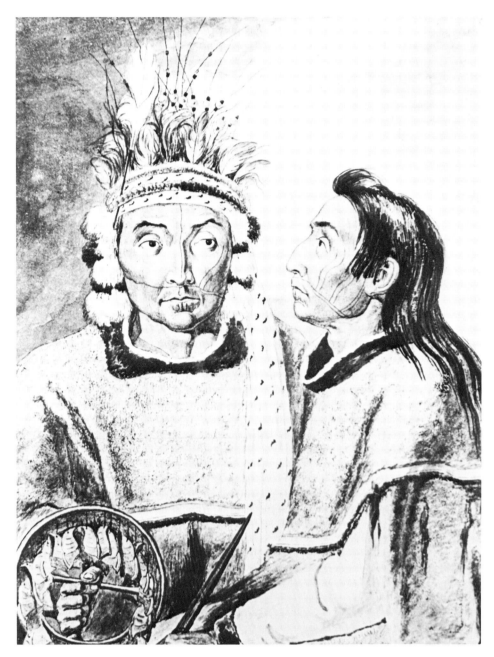

13. Another resplendent man, the "toion Nankok of Kodiak, baptized Martin," from a painting by Mikhail Tikhanov, 1818. This ceremonial headdress is decorated with feathers and fur as well as beads strung on bristles, as on Aleut hunting hats. Gavriil Sarychev said that in 1790, for ceremonial occasions, the Kodiak people "besmear their faces with various colours, marking them with lines and divisions of black, white, and red, according to their several tastes" (Sarychev 1806-7, 2:18). *Photograph courtesy Richard A. Pierce*

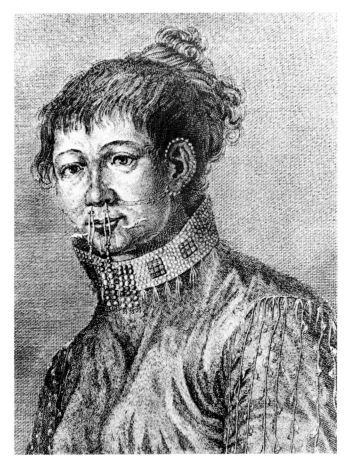

14. "Woman of Unalaska Island," drawn by the artist of Joseph Billings' expedition, 1790. From Sarychev's Atlas 1802, 2:18. The woman's ears are rimmed with beads, her cheeks and chin are tattooed, and she wears two labrets. The collar of beads was a Russian adaptation, and Sarychev said that such a standing collar was about two inches high, "enamelled in various patterns." The same ear ornaments and stiff collar were still in vogue when G. H. von Langsdorff visited the islands in 1805 (Sarychev 1806-7, 2:8; Langsdorff 1814, 2:40).

15. "Woman of 'Ukamok' Island, named Pameisinak, baptized Anna," a painting by Mikhail Tikhanov, 1818. Pameisinak appears to be wearing a beaded headdress, made similarly to that of the Kuskokwim hat in figure 61.

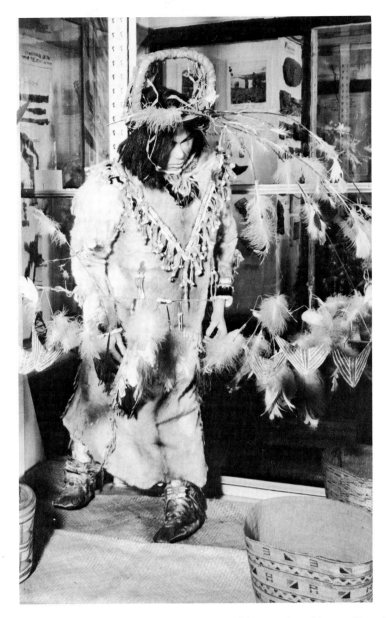

16. A model of a Kodiak dancer, with headdress and necklace collected in the 1840s, from an exhibit in the Museum of Anthropology and Ethnography, Leningrad. *Photograph courtesy MAE, Leningrad*

Facing page:

17. "Household Utensils and other objects from Alaksa [Alaska Peninsula], Oonalashka, and Kodiak," 1805. From Langsdorff 1814, 2:plate II. The information about these objects is quoted verbatim from "Explanation of the Plates," which is placed in Langsdorff's book before the table of contents, unpaged. I have supplied the italics.

(1) A bag made of fish skins from *Alaksa.*

(2) A leather finger-case, used as a shield by the women of *Alaksa* when they are sewing. [Notice the loops, which appear to be similar to those in the Aleut kamleika, figures 21 and 22.]

(3) A rattling sort of instrument from *Kodiak,* made of the beaks of sea-parrots [puffins], and used to beat the time in dancing.

(4) and (5). Ornaments for the ears, made of the shell called the sea-tooth [dentalium].

(6) A lip ornament of the *Aleutians,* of its natural size, made of pieces of bone and glass beads: it is ingeniously inserted into an opening made in the upper lip.

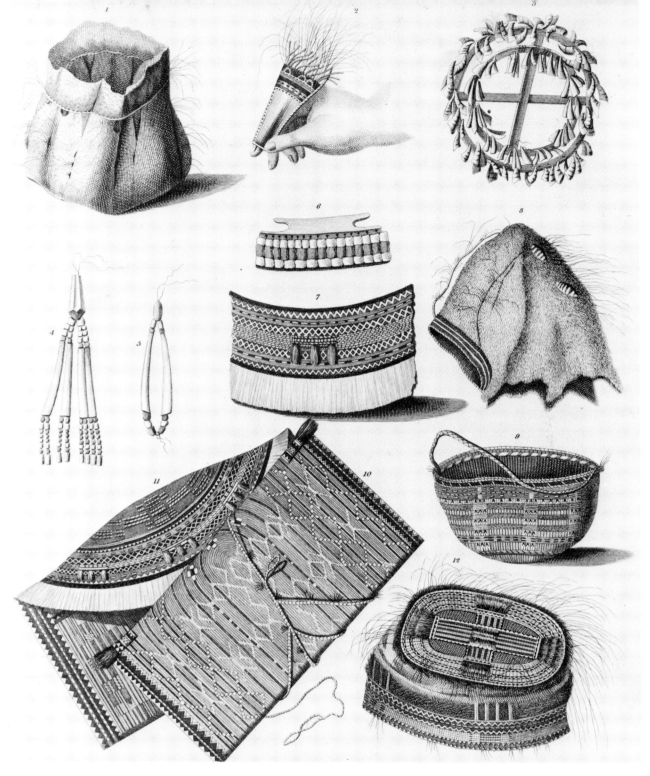

(7) Specimen of a sort of embroidery done by the women of *Oonalashka,* upon leather, with the hair of the rein-deer [caribou]. [The wristlet in figure 65, from Ikogmiut, 1878, was made of sealskin with white caribou hairs as design elements.]

(8) A head-dress, made of mole-skins from *Alaksa.*

(9) A basket made of straw from *Oonalashka.*

(10) and (11) Straw pocket-books from *Oonalashka.*

(12) A head-dress with a great deal of embroidery, only worn by the *Aleutians* at their dancing-festivals. The bunch of goats-hair flying about is considered as extremely ornamental.

Other objects observed in 1805 from Kodiak by members of the Krusenstern-Lisianskii expedition are illustrated in Lisianskii 1814:plate III and Lisianskii 1947:171, 178.

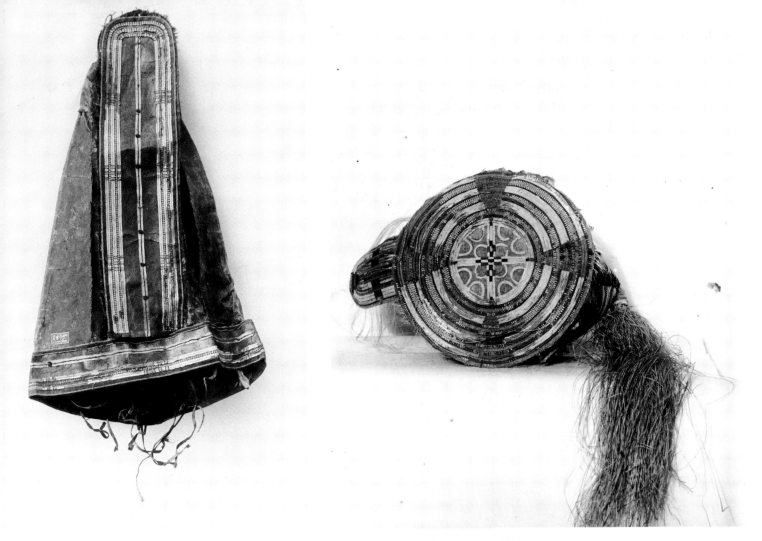

18. Conical Aleut headdress of fur and skin. Height: 14¹³⁄₁₆ inches (38 cm.). MAE 536-22. One of two types made by the Aleuts: this one is said to be typical of the western Aleutians, and a round shape (fig. 19), of the eastern Aleutians (also see Liapunova 1976:pl. 2; Liapunova 1975a:fig. 31; Birket-Smith 1941:fig. 6; and Zerries 1978:fig. 47). *Photograph courtesy MAE, Leningrad*

19. Aleut headdress in round shape. Diameter: 7¾ inches (20 cm.). MAE 536-14. This hat, of skin and caribou hair, has a wide band of delicate designs all around the side. Three other hats, with different designs, are illustrated in Liapunova 1976:pl. 3. The very fine white designs are similar to those on a waterproof cape obtained on the Pribilof Islands before 1847 (*The Far North*:fig. 62; see also Lisianskii 1947:171 [Kodiak] and James Cook's Atlas 1784:pl. 56 [Unalaska]). *Photograph courtesy MAE, Leningrad*

Facing page:

20. Puffin-skin garment, collected before 1847 by A. A. Etolin on Kodiak Island. Length: 48½ inches (124.5 cm.). National Museum of Finland K 85. *Photograph courtesy the National Museum of Finland, Helsinki*

21. An Aleut gut parka with delicate designs made of caribou hairs, yarns, and quills placed in alternating seams, 1911. Length (not including hood): 34⅓ inches (88 cm.); bottom circumference: 61⅝ inches (158 cm.). Weight: 10 ounces. Washington State Museum 4832. See chapter 3 for description. See also two gut garments in Russian style, collected before 1847, in *The Far North* (figs. 61 and 62); a similar one from Kodiak (Birket-Smith 1941:fig. 4); and an elaborate one in Eskimo style from the Kuskokwim, with the strips placed vertically (Zagoskin 1967:fig. 10).

22. Close-up of the extremely small designs on the Aleut parka, figure 21. The width of the widest hanging braid strand is only a tenth of a centimeter. For another very finely braided ornament, see Hrdlička 1945:figure 234.

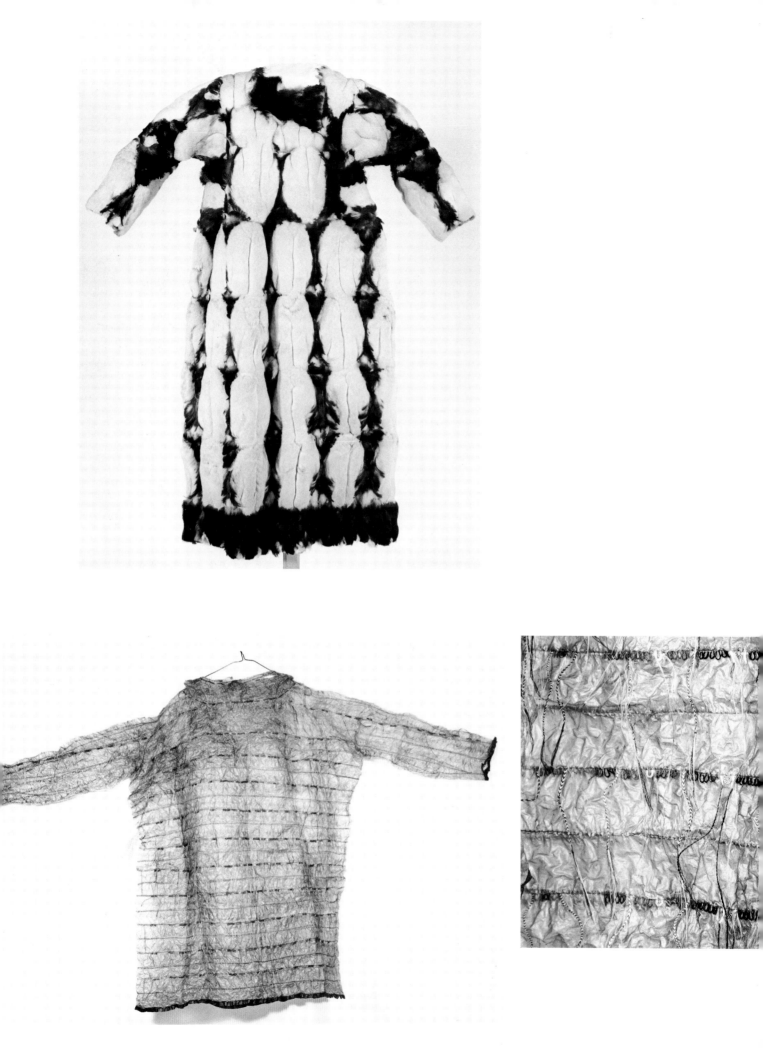

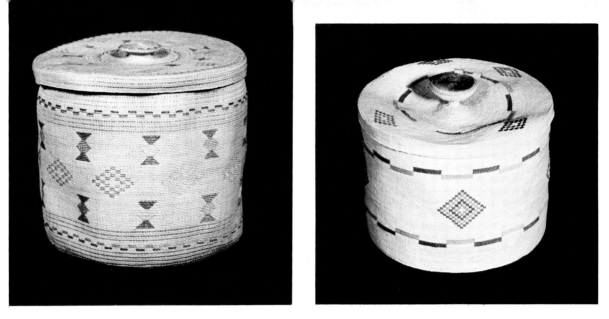

23. Aleut basket with a lid, probably from Unalaska. Height: 4 inches (10 cm.); diameter: 5 inches (12.5 cm.). Private collection. According to Raymond Hudson, who has made a study of Aleut basketry, the open work (fish-basket stitch) at the top and bottom of this basket is characteristic of the eastern Aleutians. An Atka or Attu weaver would probably not place the open work as close to the edge as in this basket, since it would weaken the corner (letter, 15 March 1978, Unalaska). Embroidery thread colors are light and dark blue, dark red, lavender, pink, orange, yellow, and rust in symmetrical placement; for example, the hour-glass figures alternate between the combinations of dark blue-orange-dark blue and dark red-light blue-dark red. See similar designs on the Eskimo coiled basket in figure 81.

24. A delicate basket, said to come from Atka, but in Attu style, about 1920s or 1930s. Height: 3 inches (7.5 cm.). Collection of Jeannette and Alan Backstrom. The top and bottom border designs are purple and light blue. Other colors used are red, rose, lavender, and green. See similar tetragon designs on the Eskimo coiled basket in figure 81.

25. A "May basket," probably from Attu, early twentieth century. Height: 6 inches (15 cm.). Collection of D. J. Ray. Some of these flared baskets had a handle, but this one does not. Repairs to the basket can be seen at the bottom. The grass is dark tan; the top and bottom designs are red and green, and the middle row has lavender and red flowers with yellow centers and green leaves. The majority of May baskets had similar floral designs, but occasionally one had geometric elements. Such a basket, in the Baranof Museum, Kodiak, is illustrated by Lucy McIver, but is not identified as such in the article (1937:37). The Alaska State Museum has a basket with two rows in the Greek-key motif (ASM II-F-285), illustrated in Lee 1979:89.

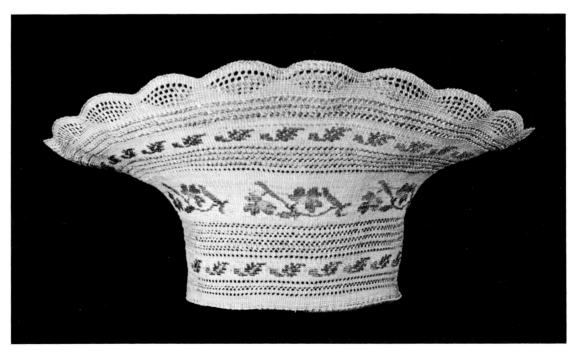

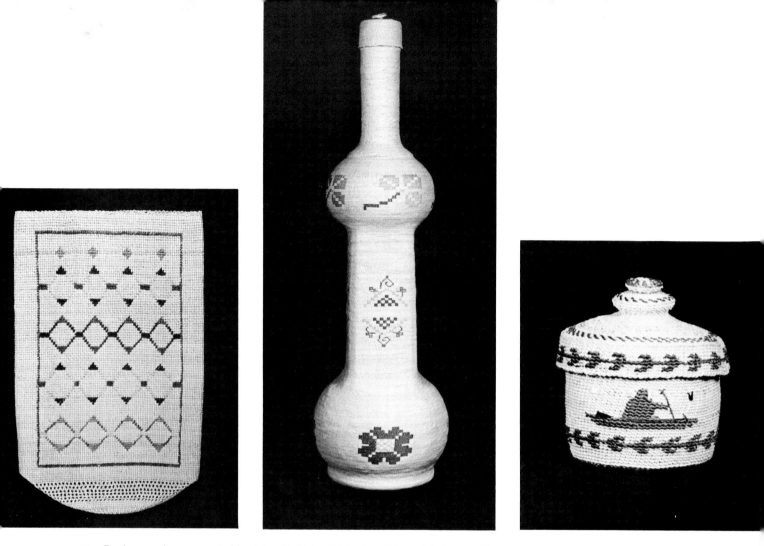

26. Card case of grass, probably Attu. Height: 4⅜ inches (11 cm.). Private collection. This tan case has 1,216 meshes to the square inch. The geometric designs are embroidered in orange, rose, blue, red, and gray threads. No element of design is composed of just one color; for example, the darkest row of tetragons is embroidered in red, blue, and rose. Illustrated here is only one-half of a card case; usually another half is slipped into the top. Jochelson illustrated nine cases, all different designs (1933:fig. 22). (Other examples are found in *Arizona Highways* 1975:20; Coe 1977:fig. 232; Keithahn n.d.: 47; Keithahn 1959:unpaged; Miles 1963:no. 4.70; Miles and Bovis 1969:fig. 83; Sheldon Jackson Museum 1976:78; Thiry and Thiry 1977:28; Wardle 1946:pl. VIII.)

27. A superb example of a basketry-covered bottle, probably Attu, about 1890 (the barbershop bottle shape dates from the 1890s). Height: 13½ inches (33.8 cm.). Collection of Mr. and Mrs. R. T. Ohashi. The lavish use of colors is illustrated again in this bottle. The top flowers are rose colored with green stems. The middle design is purple, gold, blue, and red, and the bottom flower, which has a pink center, is edged in a light rose.

28. A tiny twined basket with a lid by Tatiana Zaochney, Atka, about 1975. Height: 2¼ inches (5.5 cm.). Private collection. The illustration shows a man in a blue parka and a brown boat. On the other side there is a man in a white parka in a brown boat. The border motif, apparently a modification of the Aleut floral design, is green and brown. (For a photograph of Mrs. Zaochney, see Morgan 1974:580).

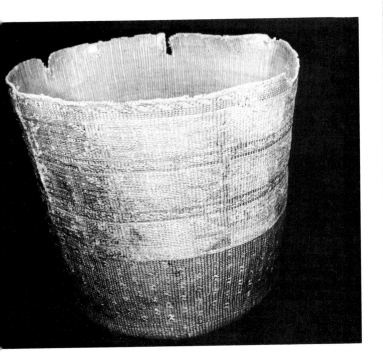

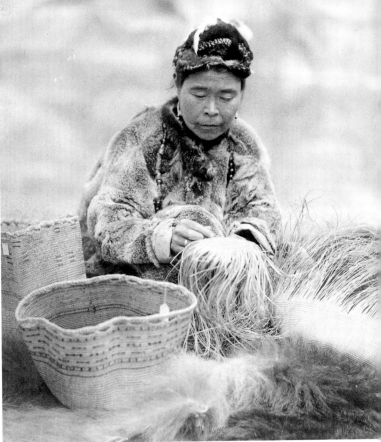

29. Spruce root basket, Chugach, found in a cave on Knight Island, Prince William Sound. Height: 10¹⁵⁄₁₆ inches (28 cm.). Alaska State Museum II-B-370. The false embroidery is of yellow grass. Two baskets in similar style and design are illustrated by Gunther (1972:fig. 42, bottom) and Kaeppler (1978:fig. 595). *Photograph by Richard S. Lee, courtesy the Alaska State Museum*

30. Aleut woman weaving a basket, date unknown, probably 1890s. This photograph, which was set up in a museum or studio, illustrates the open basket from Unalaska, made in the traditional "fish-basket" weave. *Photograph courtesy the Field Museum of Natural History*

31. Eunice Neseth, Kodiak Island, 1978. Mrs. Neseth, of Aleut-Koniag ancestry, teaches basketry in the local community college, having taken over the duties of Anfesia Shapsnikoff, her Aleut teacher. *Photograph from a color slide by Nancy Kemp, courtesy the Kodiak Historical Society*

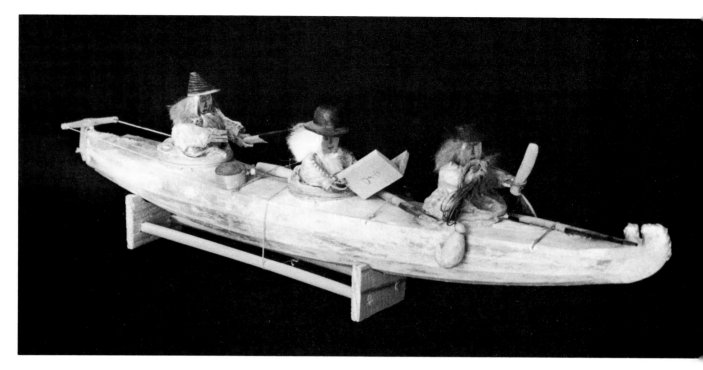

32. A baidarka of sealskin made by Sergie Sovoroff, Nikolski, 1972. Length: 17½ inches (43.8 cm.). Private collection. An unpainted wooden fish is opposite the club at the front of the boat. The priest in the middle is reading the Lord's Prayer. Mr. Sovoroff included the following "Story of the Aleutian Bidarky" with the model:

Before the year of 1910, Aleuts use their skin boat and travel all over via sea.
This is how they travel the Russian Orthodox priest from villiage to villiage along the entire Aleutian chain.
Transportation was available once a year in this type of bidarky. The one boat makes round trip to the Aleutian villiage. This was a long voyage for the strong bidarky crew.
The Russian Orthodox priest is holding his Bible in his hand and praying. The men were never to hunt seal's, only fishing was award to bidarky crew. Not aware of any big game killing on this journey. The end, made by Sergie Sovoroff, Nikolski, Alaska 99638.

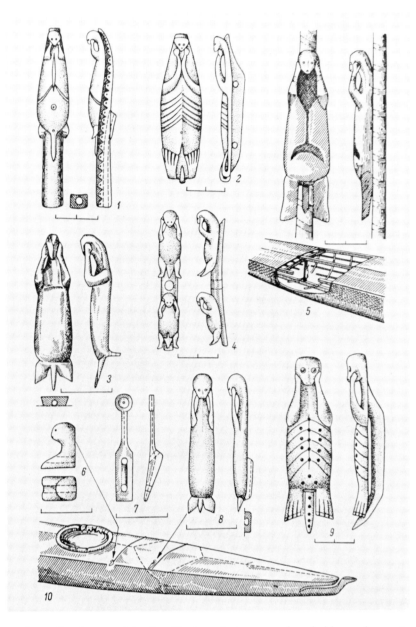

33. Ivory figurines used by the Aleuts as fasteners, and probably as charms in their baidarkas. This plate, with a few brief explanations, is reproduced from Liapunova 1967b:plate I.

(1) MAE 4507-14. (2) MAE 2438-17; height: $2^{11}/_{16}$ inches (7 cm.). (3) MAE 4104-33, from a model of a one-cockpit baidarka. (4) MAE 4507-16. (5) MAE 593-76; wood, 3 inches (7.5 cm.) high, for a one-hatch kayak. (6, 8, and 10) figures placed on a model one-cockpit baidarka for holding weapons. (7) MAE 4104-38; supposedly a stylized figure of a sea otter on a model one-cockpit baidarka. (9) MAE 162-1/19; 7.5 cm. high; originally erroneously entered in the museum catalog as being from the "Far East," since it was in the collection of I. S. Poliakov, who obtained it at a Nagasaki bazaar in 1881 (Liapunova 1967b:43n). See also figures 10 and 34. Other sea otters in Soviet museums are also illustrated in ibid.:plate III and Orlova 1964:figures 52 and 55.

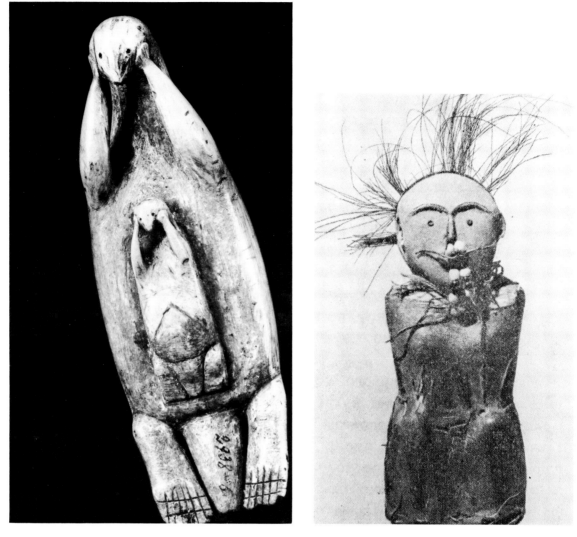

34. Ivory sea otter holding a baby. Aleut. Length: 6½ inches (16.8 cm.). MAE, Leningrad 2938-6. Also illustrated in line drawing in Liapunova 1967b:plate III. *Photograph courtesy MAE, Leningrad*

35. Aleut ivory carving of a female shaman wearing a mask, about 1816. Height: 4¾ inches (12 cm.). Museum of the Peoples of the USSR, Moscow, IV-496 (copied from Ivanov 1949b:fig. 2). Another photograph of the same figure, illustrated by Orlova (1964:fig. 54) shows a round, open mouth behind the beads. A "bone" figurine, with similar features and body, 19 cm. high, was collected by James Cook in Prince William Sound in 1778. It is clothed in white fur and apparently has human hair, as does this figurine (Kaeppler 1978:fig. 592). Another similar figure of wood, 15.5 cm. high, and two of ivory were collected by Yuri Lisianskii on Kodiak Island in 1805 (Ivanov 1949b:199; Lisianskii 1814:pl. III-a and b; Lisianskii 1947:171).

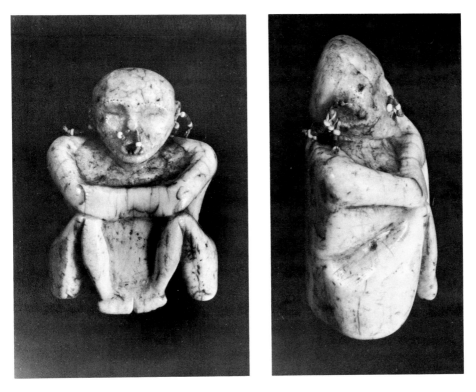

36 a and b. Seated human figurine of walrus ivory, from "Northwest America," but undoubtedly Aleut. Height: 3$\frac{11}{16}$ inches (9.5 cm.). MAE 699-1). There are three incisions on the lower lip. The beads, which hang from the nose and ears, are blue and white. Also illustrated and described in Ivanov 1949b:198. A similar figurine is located in the Museum of the Peoples of the USSR, Moscow (ibid.:fig. 1). *Photographs courtesy MAE, Leningrad*

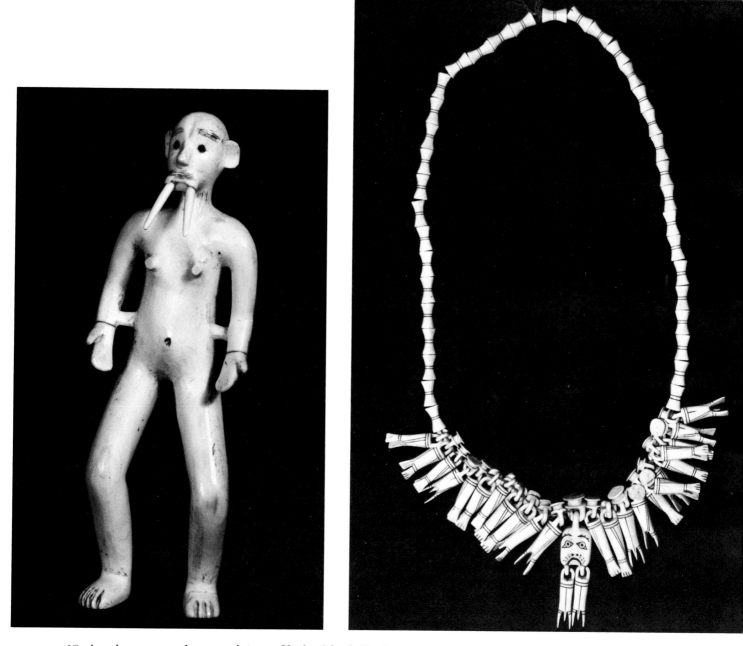

37. A walrus person of mammoth ivory, Unalga Island. Height: 5½ inches (14.2 cm.).
Alaska State Museum II-F-74. Obtained in the 1920s by Nick Bolshanin, apparently
from a cave. The eyes are baleen. The right foot has five toes; the left, four. This
figurine may represent a shaman or a transvestite because of the exaggerated nipples
and lack of sexual organs. A line at the wrists indicates mittens, which all Alaskan
Eskimo men wore while dancing, unless they held feather ornaments. *Photograph by
Alfred A. Blaker*

38. A unique ivory necklace from the Aleutian Islands, made before 1878. Length:
32⅜ inches (83 cm.). Übersee Museum, Bremen, Germany, C281. Each hanging piece
is the rear half of a seal. This piece was donated to the Übersee Museum by Albrecht
Poppe about 1878, according to a catalog of that date. Poppe was a private scholar
and collector of ethnographic objects, and was "Assistant für Ethnographie" at the
museum in 1878-79. The Übersee Museum has a collection of about fifty-five Aleut
pieces, including tools, weapons, basketry, and clothing (information from Corinna
Raddatz, Übersee Museum). *Photograph by H. Jaeger, courtesy the Übersee Museum, Bremen*

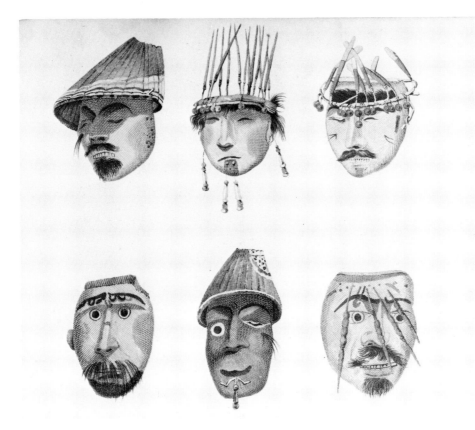

39. Aleut masks observed in 1790 by the Billings expedition, and illustrated by Martin Sauer in 1802 (pl. 11). All of these masks represent human faces, although the bottom middle one apparently depicts the half-man–half-animal being. Gavriil Sarychev, of the same expedition, also illustrated nine different masks, rather faintly drawn (Atlas 1802, 2:136). They, too, are human faces, all with flaring nostrils, reminiscent of noses representing whales' tails on certain Point Hope masks and the noses on small carvings from the Chaluka site, possibly three thousand years old (VanStone 1968/69; Aigner 1972:48). Two are plain portraits of men, and two are women. Two others are asymmetrical faces. A seventh appears to have a growth on the forehead; an eighth has an animal coming out of its mouth (see also a similar mask from Point Hope in Ray 1977:fig. 24); and the ninth is a face with a realistic beard and the wings of a large bird projecting out from either side of the upper half of the face. A retouched reproduction of these masks is illustrated in Avdeev 1958:figure VIII.

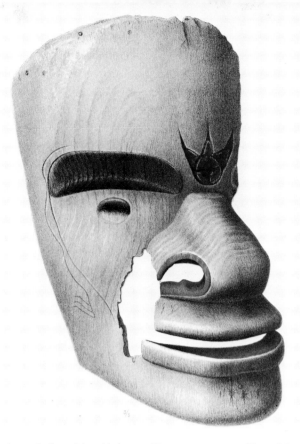

40. A mask found by Alphonse Pinart in 1871 on Unga Island. Height: 14 inches (36 cm.). From Pinart 1875:plate III. Similar masks are illustrated in Lot-Falck 1958:plate IX; Ray and Blaker 1967:plate 70; and Pinart 1875:plates I, II. Pinart's plates IV-VII illustrate wooden attachments for the masks.

41. A unique Aleut mask, from Atka, supposedly from a cave, collected by Illarion Arkhimandritov, and taken to Russia in 1857 by L. I. Schrenk. Height: 12 inches (31 cm.). MAE, Leningrad 538-1. Traces of red paint remain, especially around the eyes and eyelids. A similar mask (MAE 538-2) was acquired at the same date, but does not have the helmet-like frame around the face. It has, however, holes for attachments, and an object in the mouth, which may represent a straw wad used for breathing in a sweat bath. The two masks are illustrated in Avdeev 1958 and 1964, and in *The Far North* (fig. 53). This mask, though from the western Aleutians, has several stylistic similarities to the eastern Aleut mask in figure 40. *Photograph courtesy MAE, Leningrad*

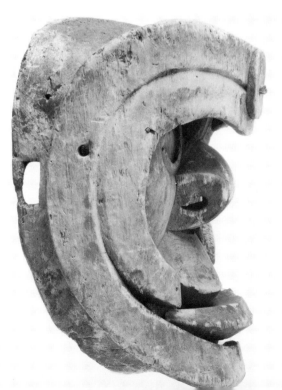

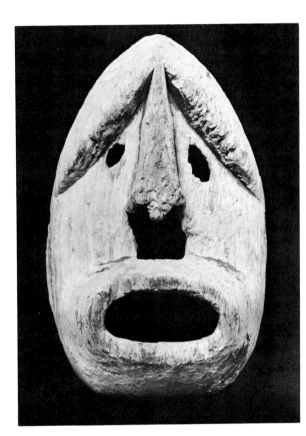

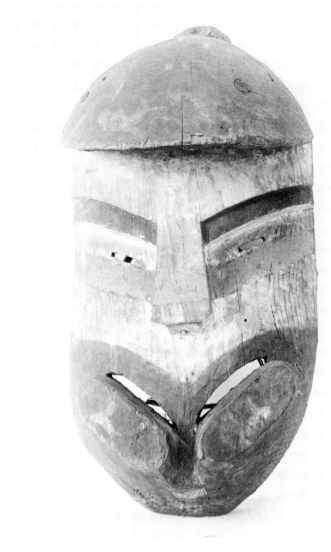

42. Mask from Kodiak, now bleached, but with traces of red color remaining. From a burial on Kodiak Island, excavated in the 1930s. Height: 11 inches (27.5 cm.). Washington State Museum 10.0/37. The black area under the nose is not a shadow, but a broken area. A mask collected by Ilia Voznesenskii in the 1840s also has the inverted V-shape forehead (Lipshits 1955:pl. 4), as does one from Prince William Sound, figure 46. An unusual mask with a serrated top border, found on Shuyak Island, is illustrated in Chaffin 1967:11.

43. A mask used in the "Six-Act Mystery" on Kodiak Island, collected by I. G. Voznesenskii in 1842, and called the "sick one." MAE 571-4. *Photograph courtesy MAE, Leningrad*

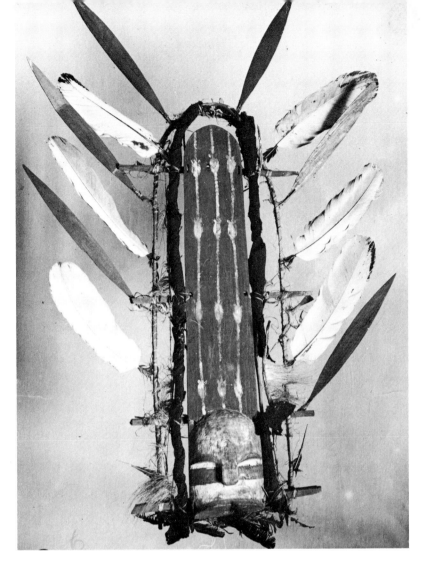

44. Another mask from the "Six-Act Mystery," Kodiak Island, 1842, called the "happy fellow." MAE 571-6. *Photograph courtesy MAE, Leningrad*

45. Mask from the "Six-Act Mystery," 1842. Height: 9½ inches (25 cm.). MAE 571.9. This mask is not illustrated in B. A. Lipshits' article of 1955, as are those in figures 43 and 44. *Photograph courtesy MAE, Leningrad*

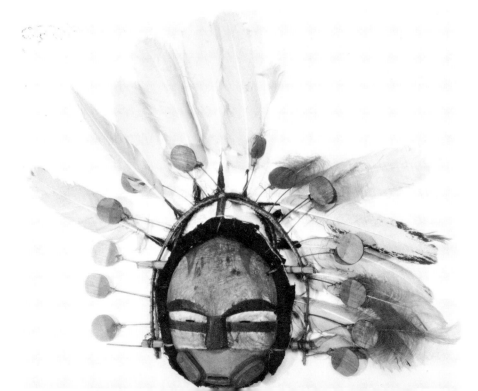

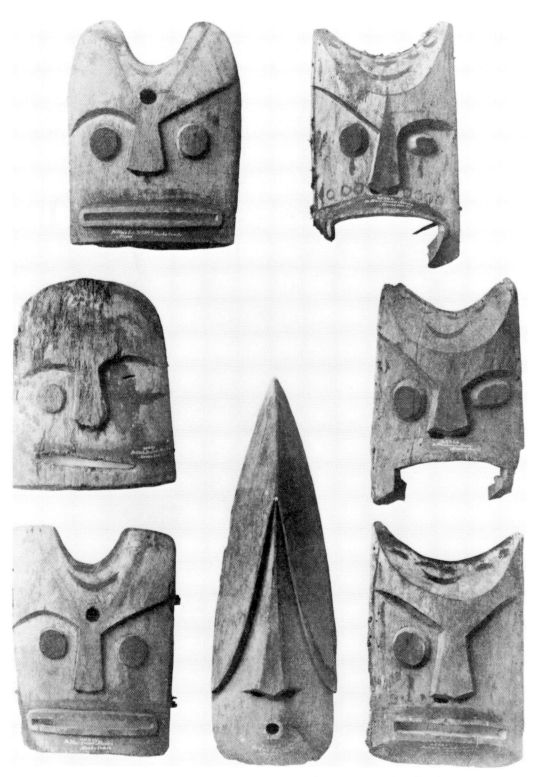

46. Masks from Prince William Sound, from *The Chugach Eskimo* by Kaj Birket-Smith
(1953:fig. 41). These are also illustrated as drawings in Dall 1884, but Birket-Smith
said that some of the drawings were "slightly incorrect."

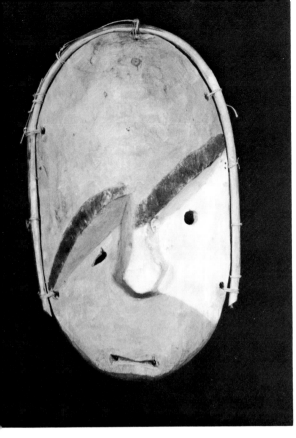

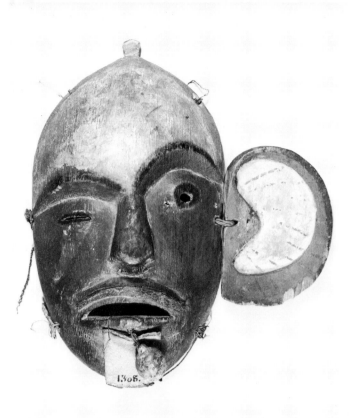

47. A mask in Chugach style obtained "near Yakutat" in the 1890s by Sheldon Jackson. Height (including hoop): 14¼ inches (35.6 cm.). Sheldon Jackson Museum II.CC.4. The right forehead of the mask (with the slanting eye) is blue, with a black eyebrow and with red color on the cheek, under the eyebrow, on the side of the nose, under the nose, and on most of the left side of the chin. The left forehead and under the chin are also red. The nose, left cheek, and area under the eyebrow are washed with white. The hoop was once painted red. The back is unpainted.

48. Chugach mask from Prince William Sound, collected by the Malaspina expedition about 1791. Height: 10½ inches (26.3 cm.). Museo de America (Madrid) 1308. Colors are white, blue, black, and red. This was originally catalogued as Nootka, but there is no doubt that it is from Prince William Sound (see also Feder 1977:fig. 1). *Photograph by Arthur Taylor, the Museum of New Mexico*

49. Wooden bowl, in shape of a merganser, from Chenega, Prince William Sound. Length from tip of beak to end of the tail: 14³⁄₁₆ inches (36.3 cm.). This bowl is dark from grease. The small white beads are set in so that the hole of each is visible. Another dish is illustrated in Birket-Smith 1953:figure 30. Northwest Coast Indians made similar dishes. *Photograph by Alfred A. Blaker*

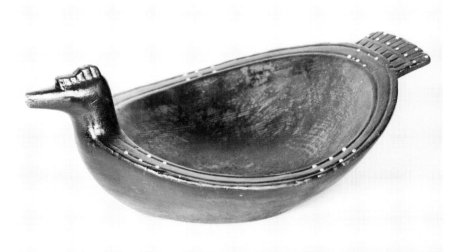

50. A wooden arrow case from Kodiak Island, 1851. Length: 37⅞ inches (93.6 cm.).
National Museum, Copenhagen Ib 174. Collected by H. J. Holmberg. The case is painted
red with black designs. Also see Birket-Smith 1953:figure 13 for a similar quiver from
Prince William Sound. The Pacific Eskimos used this kind of quiver for sea hunting
in a kayak, but a skin quiver for land hunting (Birket-Smith 1941:145-46). This case,
which is also illustrated in the *Far North,* figure 69, was copied almost exactly for a
two-story post in the lobby of the new Calista Sheraton Hotel in Anchorage (see photo-
graph in the *Tundra Drums,* 20 September 1979, p. 21). Native motifs are used throughout
the $40,000,000 hotel, which was built by the Calista Corporation, a native regional
corporation of southwest Alaska. *Photograph courtesy the National Museum of Denmark*

51. A print by Alvin E. Amason, Kodiak, 1976. Dimensions: 11⅛ by 9¼ inches (27.8
by 23.1 cms.). Alaska State Museum. The otter is white on a blue background, which
is framed in green, orange, and red. Orange and yellow shades appear under the lettering.

52. "Papa's Duck," painting by Alvin E. Amason, Kodiak, 1978. Height: 5 feet 7 inches; width: 4 feet 3½ inches. The duck, made of cork, sits in a galvanized bucket, which protrudes from the painting. Colors are mainly blue and green, with some white, red, and yellow. For more of Amason's works, see Paine 1979. Photographed by D. J. Ray at Alaska Native Arts and Crafts, Inc., Anchorage.

53. Mask of alder wood, acrylic paint, ivory, human hair, and feathers, by Fred Anderson, Aleut, 1974. Height: 9¾ inches (24.3 cm.) IACB W.75.17. *Photograph courtesy Indian Arts and Crafts Board*

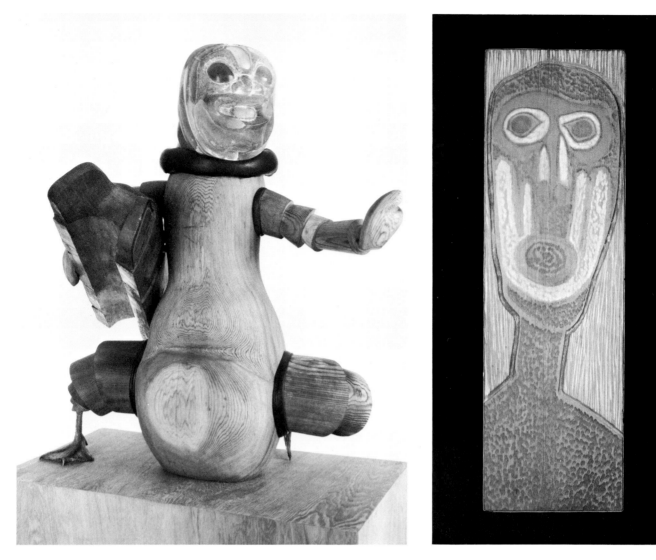

54. "Native Craft," by Fred Anderson, Aleut. Height: 34 inches (85 cm.). The body is made of cedar, and the head, of black alabaster. The feet are from a real goose. This sculpture was exhibited in the eleventh annual Alaska Festival of Native Arts in 1976 in Anchorage, and won the Alaska State Council on the Arts' Alaska Contemporary Art Bank purchase award. It was also included in the Smithsonian Institution show, "Contemporary Art from Alaska," in 1978. *Photograph by Sam Kimura, courtesy the Alaska State Council on the Arts*

55. "He who got Supernatural power from his little finger," wood plaque by John Hoover, Aleut, 1965. Dimensions: 36 by 11¼ inches. Collection of Verne F. Ray. The colors are whites, tans, deep rust, and brown.

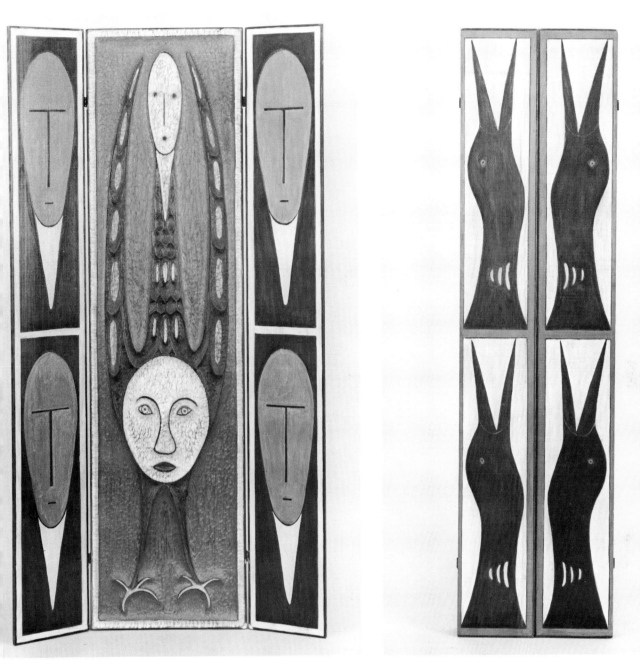

56a. "Loon Spirit," a triptych in wood by John Hoover, Aleut, 1971. Height: 44½ inches (111.2 cm.). IACB W-71.29. Red cedar, polychromed. This is the inside view. The following illustration shows it closed. For more of Hoover's works see Monthan and Monthan 1978. *Photograph courtesy Indian Arts and Crafts Board*

56b. "Loon Spirit," closed. *Photograph courtesy Indian Arts and Crafts Board*

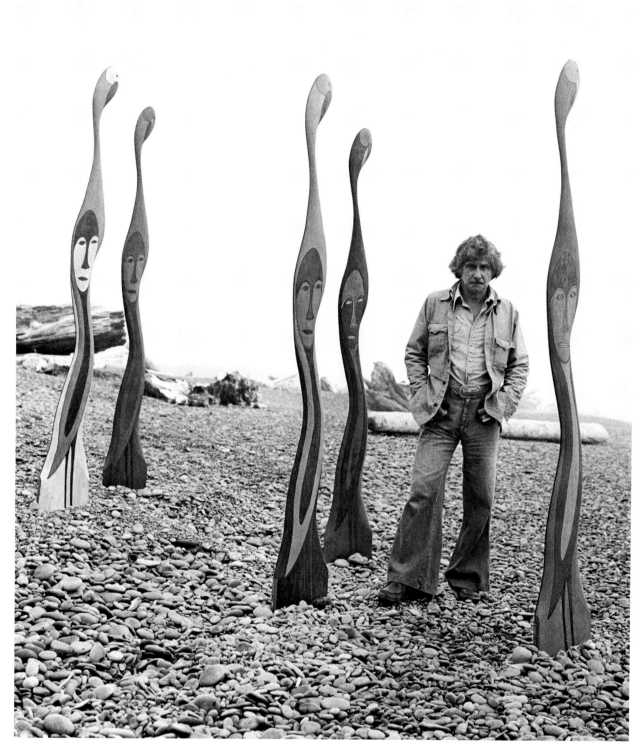

57. John Hoover in a forest of sculpture. *Photograph by Mary Randlett*

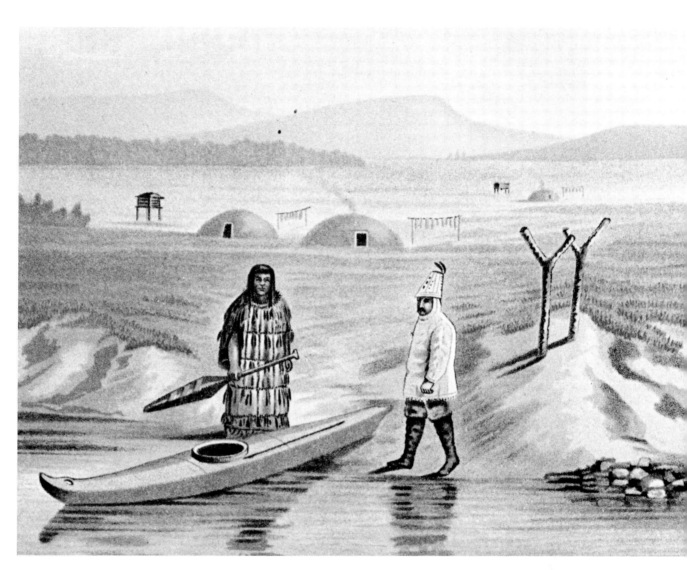

YUPIK

58. "Beluga hunter and dwellings—lower Kuskokwim River," published in color in the 1880 census report, showing typical clothing and headgear (Petroff 1884:pl. III). The hat worn by the man on the right is similar to one from Katmai, illustrated in Hoffman 1897:plate 53. The three stripes on the paddle are red.

59. Wooden hunting hats from the lower Yukon or Kuskokwim, collected by Johan Jacobsen in 1882. Length of bottom hat: 13½ inches (34 cm.). From a line drawing in Jacobsen's book (1884:217). The top hat is similar to ones from Norton Sound illustrated by Fagg (1972:pl. 7) and Nelson (1899:pl. LXIV-18). A hat in the Museum of Anthropology and Ethnography, Leningrad (593-51), collected in 1843 and illustrated in Ivanov 1930:plate II-2 and *The Far North,* figure 71, is also similar, except for a closed pointed top. Although Ivanov said that the provenience was unknown, it undoubtedly came from the Kuskokwim River, since the Sheldon Jackson Museum has three very much like them. *The Far North* erroneously attributed the hat to Saint Lawrence Island, where such hats were not made.

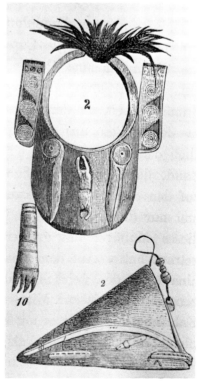

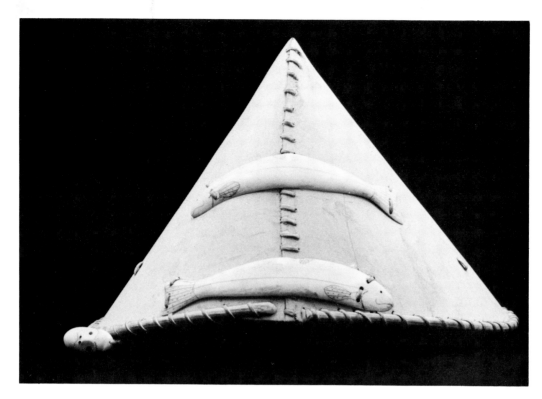

60. Hat of wood from the coastal delta between the Yukon and Kuskokwim rivers, 1960s. Height: 8⅜ inches (20.9 cm.). Anchorage Museum 71.82.1. This hat, which is a replica of an old hunting hat, is very well made. The little ivory head at the left is an amulet, attached to a short thong. This hat is also illustrated in *An Introduction to the Native Art of Alaska* (1972:72), but the amulet is not visible. Hats of this kind are no longer made for the Eskimo's own use, and only rarely for sale. In Hooper Bay in 1976, I saw one made of linoleum and painted with a pancake flour paste.

61. Cap made of small beads and sealskin, presumably from the lower Kuskokwim River, about 1930s. Height, excluding bottom fringe: 5¼ inches (13.1 cm.). Washington State Museum 10.0/199. A brass button on the top is sewed into the middle of the clock wheel. The beads are purple, light blue, medium blue, pink, red, green, and white. Originally the cap had two long suspensions of four strings of seed beads interspersed in a regular design with dentalia, big blue beads, and brass beads. The horizontal strips are of heavy hide. Compare with the Aleut headdress in figure 15.

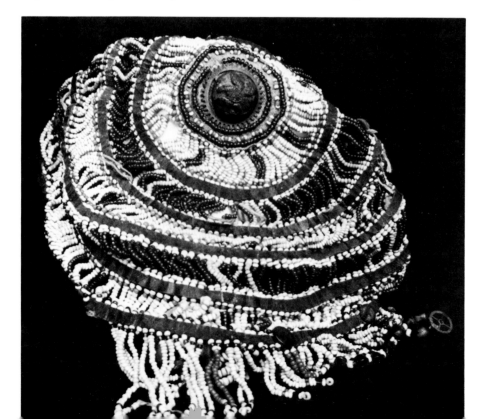

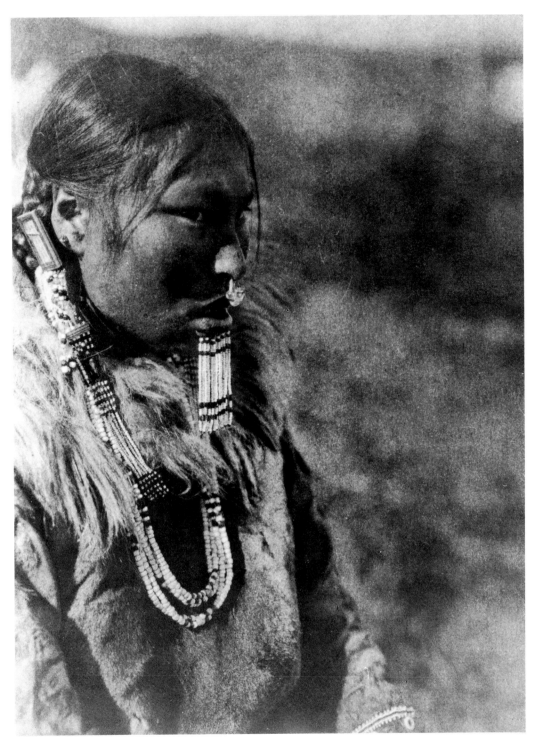

62. "Kenówŭn, Nunivak," wearing the fine beadwork and typical oblong hair ornament of Nunivak Island, 1927; photograph by Edward S. Curtis (Curtis 1930:opposite 66).

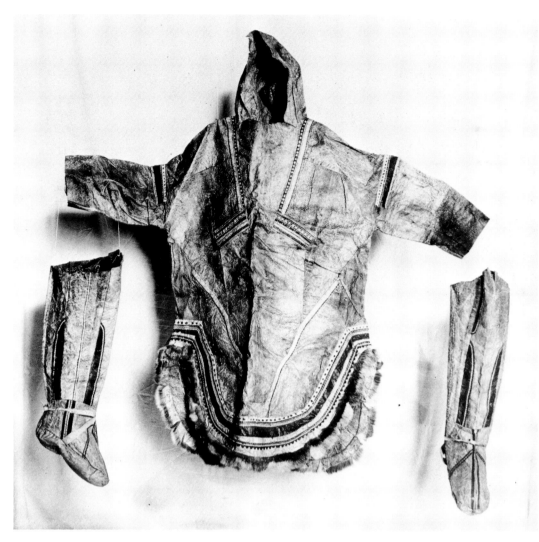

63. "Woman's Fishskin clothing" in traditional style from Saint Michael or the lower Yukon, 1890s. From a snapshot in H. M. W. Edmonds' manuscript on the Saint Michael and Yukon Eskimos in the University of Washington Library, Manuscript Division (Ray 1966).

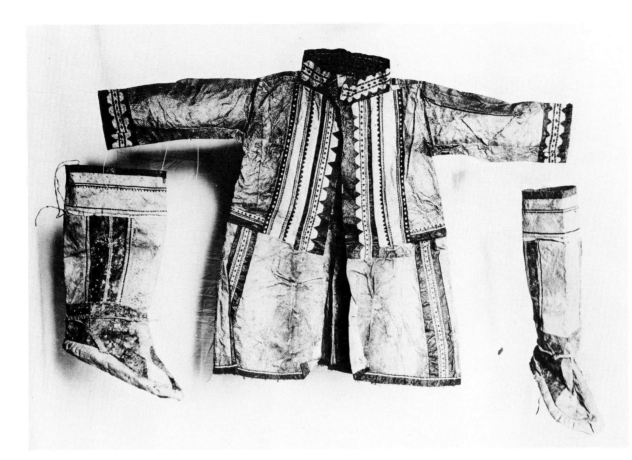

64. "Fish skin jacket and boots, tanned yellow, with trimmings of pale straw color and dark brick red," from Edmonds' manuscript. The cut of the jacket is adapted from the Russian style and the ornamentation is a combination of Russian designs and traditional welted strips. The stiff collar is characteristic of the Russian influence in clothing (see also fig. 14 and garments from Kodiak Island and the Pribilofs in *The Far North*:figs. 61, 62, 79; and Holtved 1947:57).

65. "Wristlet from Ikogmut," used in dancing, from a drawing in Nelson 1899:figure 148. Length of side: 3⅞ inches (9.6 cm.). This exquisite work consists of nine horizontal strips of alternating yellowish white and reddish brown tanned sealskin sewed onto a large piece of sealskin. The oblique stitches are white caribou hair, as are the X-shaped figures, which are made by tying the hairs in the middle with sinew.

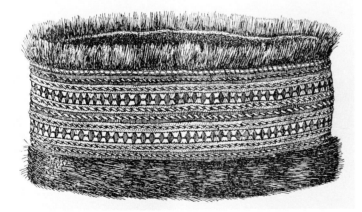

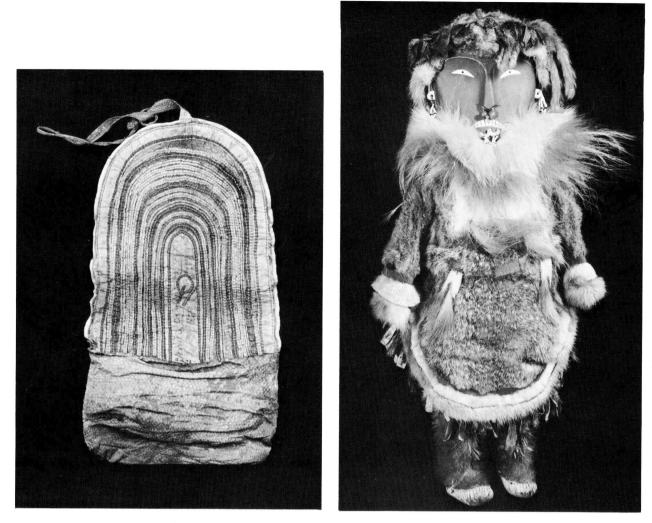

66. A "housewife," for storing a woman's sewing equipment, Andreafsky, probably 1890s. Height: 13¾ inches (34.3 cm.). Sheldon Jackson Museum II.B.78. The basic material is fish skin, with each parallel strip of white and brown-dyed intestine sewed on with an angled running stitch on the front side over a straight running stitch on the back. The fifth and tenth lines from the edge are of blue thread. A small design of a drum and baton is in the center, but is not visible when the equipment is inserted. This object is called *imguyutuk* in the Yukon-Saint Michael dialect, a name that was adopted for a twisted and folded rock formation on an ocean cliff near Unalakleet. The unique formation is explained by a folktale in which a woman ran away after her husband beat her, and in despair threw her sewing kit against the cliff, at which time the rocks immediately took on the shape of a huge *imguyutuk*.

67. Doll from the mouth of the Kuskokwim River, probably the 1890s. Height: 18 inches (45 cm.). Alaska State Museum II-A-2666. Collected by George T. Emmons as a child's doll. The face and body are carved of one piece of wood, and the ivory eyes and mouth are similar to those on the grave monument, figure 164. The main part of the parka is ground squirrel. The beads are white and blue. For information about Emmons' collecting of native artifacts, see Low 1977. *Photograph by Alfred A. Blaker*

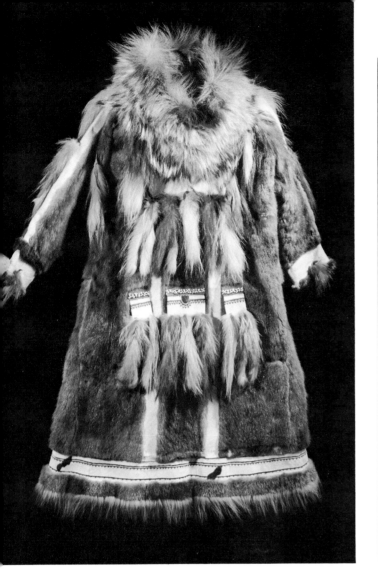

68. Parka from Kwethluk, 1950s. Length from top of ruff to bottom fringe: 6 feet. University of Alaska Museum UA68-8. It is made of mink trimmed with white calfskin. The middle squares are decorated with red, blue, and white beads and strips of wolverine fur. Below the bottom welted design is a strip of plucked beaver and a fringe of wolverine fur. The designs on the back are almost identical to those on the front. In earlier days, this woman's parka would have been rounded at the bottom as in figure 67. An ornately decorated squirrel parka, and a competition winner, made by Sassa Nick of Togiak, is illustrated in *Alaska* (February 1975:73). *Photograph by Barry McWayne*

69. A fur wall hanging by Marthalee Orock Lonsdale, Yukon River, 1976. Height: 15 inches (37.5 cm.). Collection of D. J. Ray. This innovative fur stitchery shows the "modern" cut of parka, a straight bottom edge rather than the traditional rounded flap, as illustrated in figure 67. This article is made of ground squirrel, beaver, calfskin, and soft tanned sealskin on a background of white rabbit, and is ornamented with red yard and blue, red, and yellow seed beads. Mrs. Lonsdale was born on the Yukon of Inupiat parents.

70. A "shaman doll" by Mary Nash, Chevak, 1969. Height: 14½ inches (36.3 cm.). Private collection. This sumptuous doll is dressed in an eider duck frock and seal mukluks, and holds a piece of bone in the left hand. The back of the parka is made of green eider duck heads. The face is wood. Exhibited in the 1969 Alaska Festival of Native Arts.

71. "Chinguruk," a seal hunter, by Anna Kungurkak, Toksook Bay, 1971. Height of doll: 18½ inches (46.3 cm.). Anchorage Museum 71.97.30. The body is stuffed, and wears a hooded feather parka with ermine ruff. The hat is made of muskrat fur, hair seal, otter, and yarn, and the mittens and high mukluks are of hair seal. The face is wood with black features. The seal on the sled has an ivory harpoon in it. This doll was exhibited at the 1971 Alaska Festival of Native Arts with the following story: "As usual this doll is a hunter who hunts seals. His Eskimo name is 'Chinguruk.' He used to hunt pulling his sled. The whole village long ago depended on him for food. He loved the people & he never did like to see them suffer from hunger. His story isn't long but he was known as a good hunter & a pitiful man."

72. "The Poor Man" by Mary Nash, Chevak, 1969. Height: 14 inches (35 cm.). Private collection. This figure has a wooden face, painted rust, a red mouth, and black eyes. He wears a gut parka, seal boots, has a grass basket on his back, and carries a staff of wood. This doll is illustrated, front and back, in color in Frederick 1972:31.

73. "Eskimo Drummer" by Rosalie Paniyak, Chevak, 1977. Height: 9¼ inches, including base (23.8 cm.). This model has fish skin boots, moose skin face and hands, and a cloth parka. The drum is made of wood and seal intestine. The eyes are three beads set in a row, a green bead for the pupil, with a white one on each side. Mrs. Paniyuk's dolls, while not especially well-made, have endeared themselves to collectors because of a rather macabre awkwardness. See also Shalkop 1978:fig. 7. Photographed by D. J. Ray at Snow Goose Associates, Seattle.

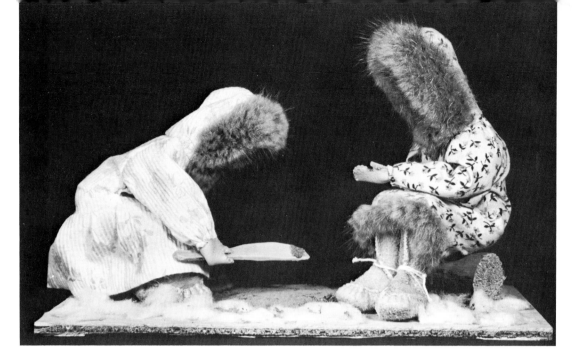

74. Two girls telling a story with a storyknife, by Lucy Berry, Napakiak, 1972. Height of right figure: 6 inches (15 cm.). Collection of D. J. Ray. The dolls are dressed in cloth parkas, and their boots, faces, and hands are of leather. The knife is made of wood. A square, representing a house, is drawn in the mud between the figures. Mrs. Berry died in 1977. See also figure 109 and section, "The Storyknife."

75. Doll of coiled grass by Viva Wesley, Mekoryuk, 1978. Height: 7½ inches (18.8 cm.). Collection of D. J. Ray. Each eye is a blue bead, and the blue and purple grass globe is hung around the neck with blue and white seed beads. The fur hat is made of ground squirrel, white calfskin, and otter, and the mittens are of otter, seal, and squirrel. The straw object at the feet is another hat, in the same colors as the necklace. The figure is mounted on a round coiled mat.

Grass dolls did not appear on the market until about 1975 when Hooper Bay women began to make them. Ethel Montgomery, formerly of Alaska Native Arts and Crafts told me, however, that in 1949 she saw two grass dolls, which were sent to the East coast, but she did not see any others until 1976. Some dolls are much larger than this one—over a foot tall with corresponding girth—and retail for $400-$500.

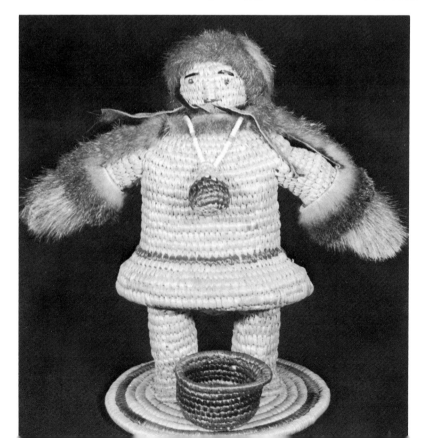

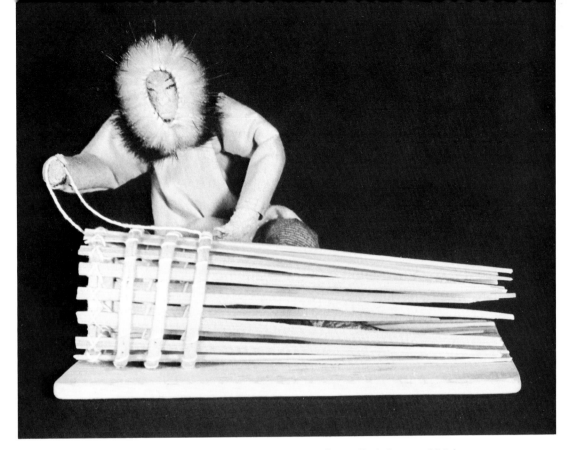

76. A man making a fish trap, an activity doll by Martina Oscar, Bethel, 1976. Height of man: 4½ inches (11.3 cm.). Collection of D. J. Ray. The man wears a blue parka and green pants, but his ruff is made of wolverine, and his hands and boots are of skin. The base, trap, and a model knife at his side are of wood. In 1977, a group of Mrs. Oscar's dolls won a Chevron U.S.A., Inc. award in the twelfth annual Alaska Festival of Native Arts.

77. Model umiak with happy rowers, made by Katie Kernak, Napaskiak, about 1970. Length: 16 inches (40 cm.). Anchorage Museum 70.41.17. The boat is made of fish skin and the little people are dressed in various kinds of fur. The one at the right wears a gut parka. A grass mat is on the bottom of the boat.

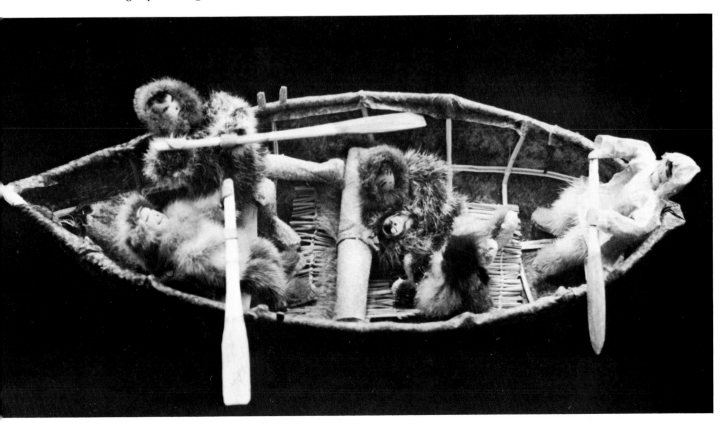

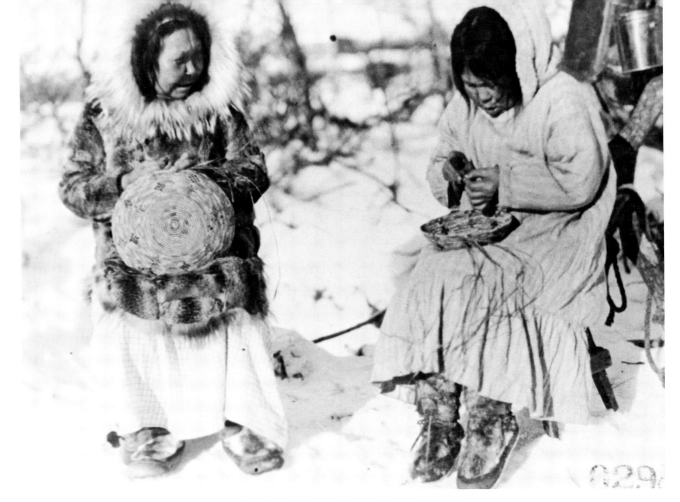

78. "Making Baskets on the Yukon," 1925, from the Archives of Sacred Heart Cathedral, Fairbanks, Alaska.

79. Coiled grass basket ornamented with birds' feet, collected before 1927-28 from "Chinick." Height: 5½ inches (14 cm.). Alaska State Museum II-A-2360. Sixteen birds' feet are sewed with a dark thread around the basket, and eight on the lid. The word *chinik* (or *singik* in the north) is a much-used term meaning "point." The best-known *chinik* was Golovin, but E. L. Range, who gave this basket and two boxes of specimens to the Alaska State Museum in 1927-28, had lived in Kanakanak on Nushagak Bay. This "Chinick" may be the one located on the Alaska Peninsula. *Photograph by Alfred A. Blaker*

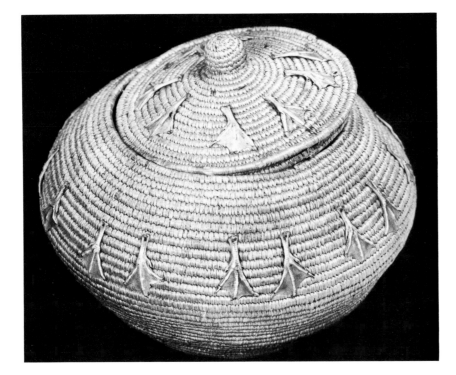

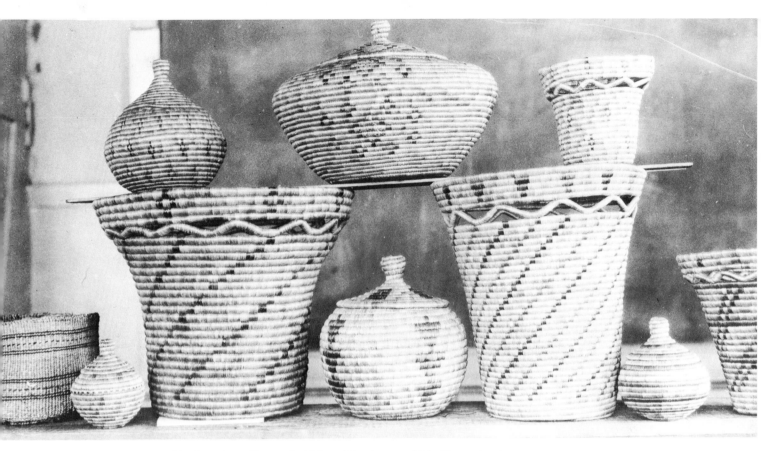

80. A collection of baskets from Tununak, Nelson Island, 1932. This illustration is taken from a photograph in Clark M. Garber's school superintendent's report of 1932. All are coiled baskets except the one on the left, which is twined. Garber's caption reads: "Baskets like those illustrated above bring an average price of two dollars from the Traders who turn at five hundred to one thousand percent profit" (1932:pl. 2). E. S. Curtis illustrated lidded baskets in similar style from Nunivak Island in 1928 (1930:78).

81. Basket made in the style of commercially produced sewing baskets, from Quinhagak, late 1940s. Outside width: 9¼ inches (13.8 cm.). Collection of Lucy and John Poling. These introduced designs are similar to the Aleut baskets in figures 23 and 24. The designs on the lid are of grass dyed red, purple, and green; but on the inside bottom of the basket, they are imbricated of bird leg skin dyed black, red, blue, purple, and blue green.

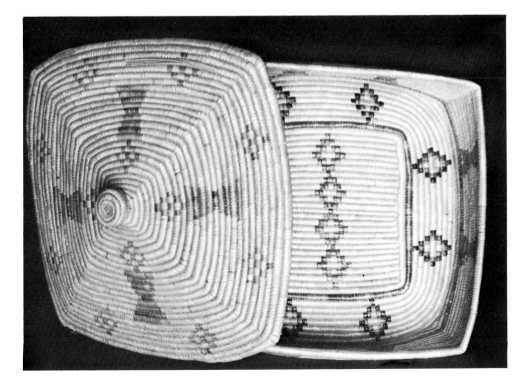

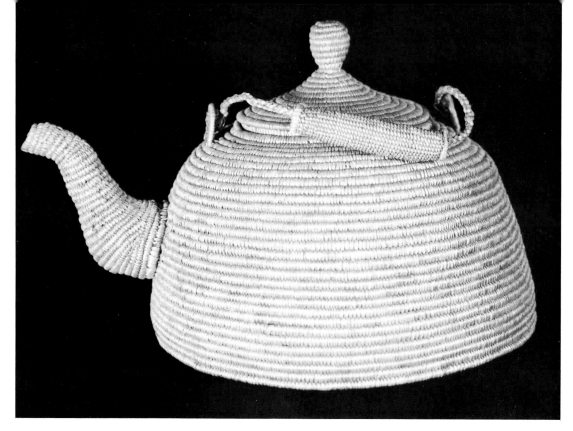

82. A teakettle made of grass, from Nushagak, 1907, collected by Alaska governor, Thomas Riggs. Height, including lid: 7⅘ inches (20 cm.). Alaska State Museum II-A-2370. A photograph of a similar teakettle, ornamented with typical Northwest Coast Indian designs, made by a Tlingit woman, is located in the Photography Collection, University of Washington Library (Nowell photograph No. 2367). *Photograph by Alfred A. Blaker*

83. Basket in the shape of a crustacean with raffia design, Nunivak Island, before 1941. Length, including the feelers: 7½ inches (18.8 cm.). Height: 2 inches (5 cm.). University of Alaska Museum 4050. The designs are blue and red, and the handle of the lid is braided grass. This was purchased by Henry Wolking (b. 1781, d. 1941) who had collected Indian baskets as a hobby since 1905. *Photograph by Barry McWayne*

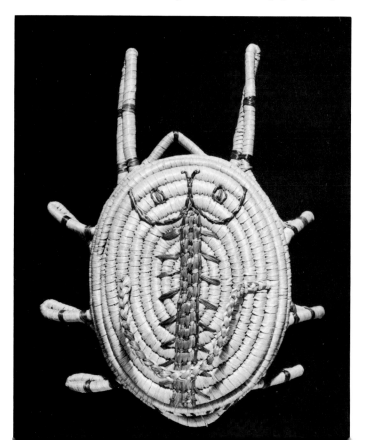

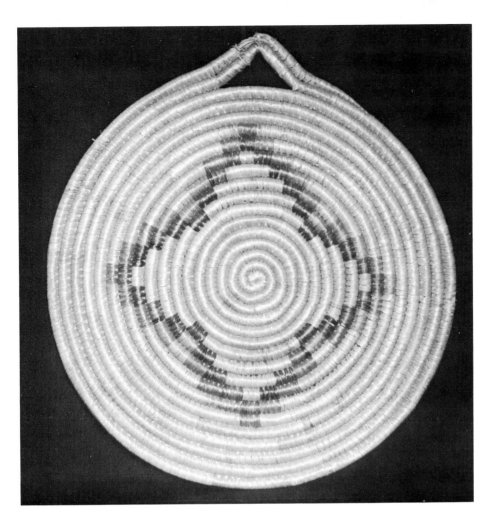

84. Mat of coiled grass, Stebbins, 1945. Diameter: 8¼ inches (21.3 cm.). Collection of D. J. Ray. The colors of the center design are red and black.

85. This fine basket was made in Hooper Bay in 1960. Height: 7½ inches (18.8 cm.). Collection of D. J. Ray. The colors are browns and tans. The lid fits very snugly.

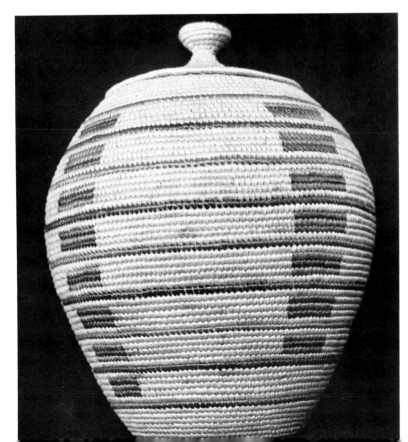

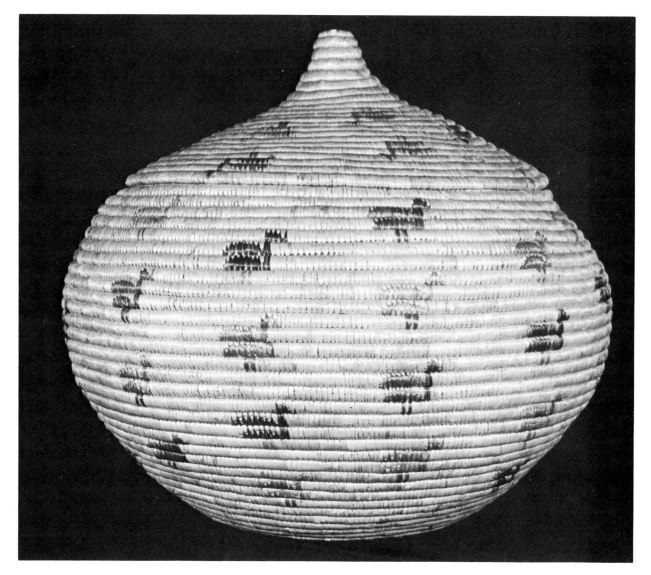

86. A large basket with a lid, from Scammon Bay, 1960. Total height: 13 inches (32.5 cm.). Circumference: 49 inches (112.5 cm.). Collection of D. J. Ray. The "knob" is an open-ended cone. The geese are portrayed by grass, now faded, dyed red, purple, and blue.

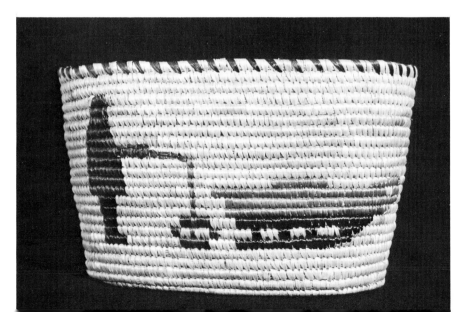

87. A basket with designs of snowmobiles and houses, Nelson Island, early 1960s. Height: 9½ inches (13.8 cm.); no lid. Collection of Mary Kroul. The designs are lavender, purple, blue gray, and red. Possible proveniences: Nightmute, Toksook Bay, Tununak. The first snowmobile arrived in Tununak in 1964 (Angaiak 1974:84). *Photograph by Barry McWayne*

88. Basket made by Mary Sundown, Scammon Bay, 1974. Height: 4¼ inches (10.6 cm.). Collection of D. J. Ray. The same design of dyed grass (a person fishing through the ice near a sled) is on both sides of this oval basket. Parka, boots, fishing rod, ice hole, sled runners, and top binding are purple; parka trim, fishing line, and kayak on top of the sled are rose.

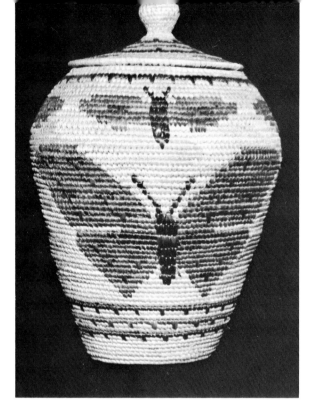

89. Basket with butterflies from Hooper Bay, about 1975. Height, including knob: 7 inches (17.5 cm.). Private collection. The colors are green and light and medium brown.

90. A triangular basket with three equal sides, embroidered with raffia, by Maria Lincoln, Tununak, 1971. Height: 9 inches (22.5 cm.). Collection of Rae and Sera Baxter. A fanciful basket: the side shown in the photograph has a leaping brown animal with green horns; the grass is green, the butterfly, purple, and the insect on the right, red; the second side depicts yellow animals, a red bug and flowers, a brown tree, a purple and yellow butterfly, and green grass; the third side has the same motifs as the second, but in different arrangement. It is thought that Mrs. Lincoln originated the three-sided basket.

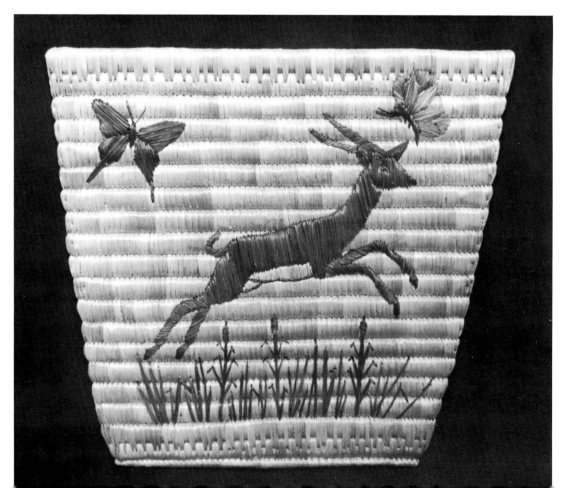

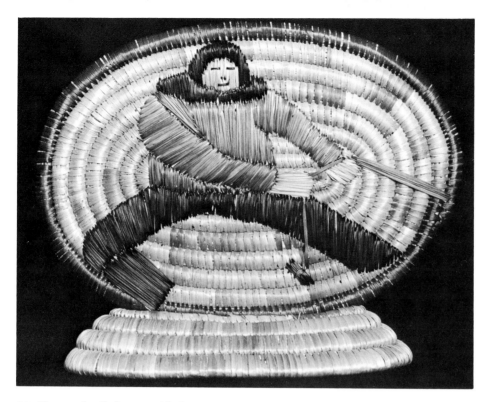

91. Plaque of coiled grass with finer grass overlay design by Mary Tom, Newtok, 1976. Width: 9½ inches (23.8 cm.). Collection of D. J. Ray. The figure is sewn over a paper pattern, still in place. The border is red, the jacket, green, the pants and hair, black, and the rope, brown. The plaque is made to stand upright in an oval slotted base.

92. Yoyos woven of grass by Helen H. Smith, Hooper Bay, about 1975. Diameter: 2½ inches (6.3 cm.); thickness: ⅞ inches (2.1 cm.). Collection of Mary and John Young. The colors are red, blue, and natural tan. The so-called "dance fans," patterned after the traditional finger masks, are also made of grass in this shape, with the addition of a loop for grasping and a fringe of reindeer hair all around, as on the grass mask (fig. 94). *Photograph by Ed Tate*

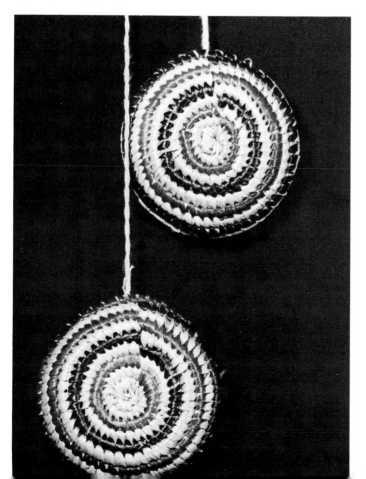

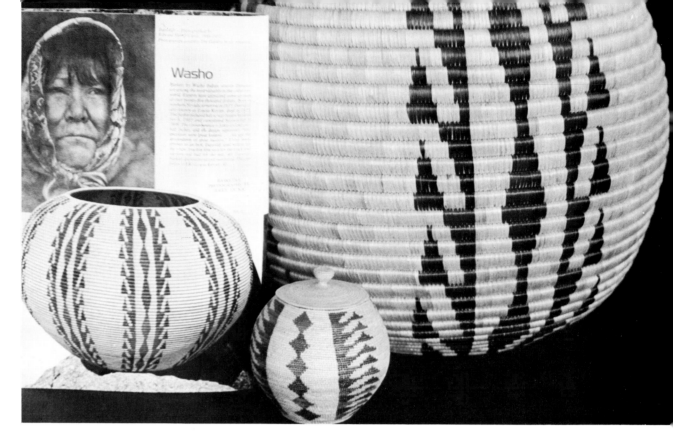

93. Two baskets copied after a photograph of a basket by the renowned Washo Indian artist, Datsolali. Illustration on the left is from *Arizona Highways* 1975:26. Height of the larger Eskimo basket on the right: 21 inches (52.5 cm.), and of the smaller basket: 4¾ inches (11.8 cm.). Private collection. The larger basket was made by Barbara Albert of Tununak in 1976, and the smaller one by Cecilia Olson of Hooper Bay, also in 1976. Although Datsolali's basket did not have a lid, the two Alaskan basket makers, independent of each other, and without request, made lids for their baskets. See discussion of this experiment in chapter 4. *Photograph by Jerry Jacka,* Arizona Highways

94. Mask of coiled basketry by C. Tinker, Hooper Bay, 1974. Height of face: 7 inches (17.5 cm.). Collection of D. J. Ray. The mouth is red; the eyes, eyebrows, and forehead are purple. There are holes for the eyes and nostrils, and the lips are slightly parted.

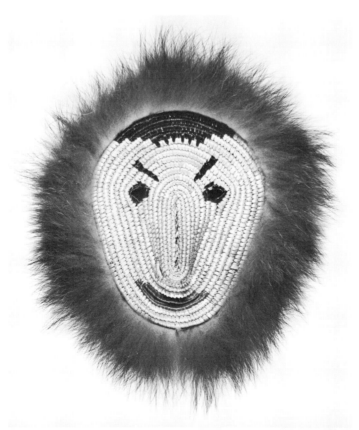

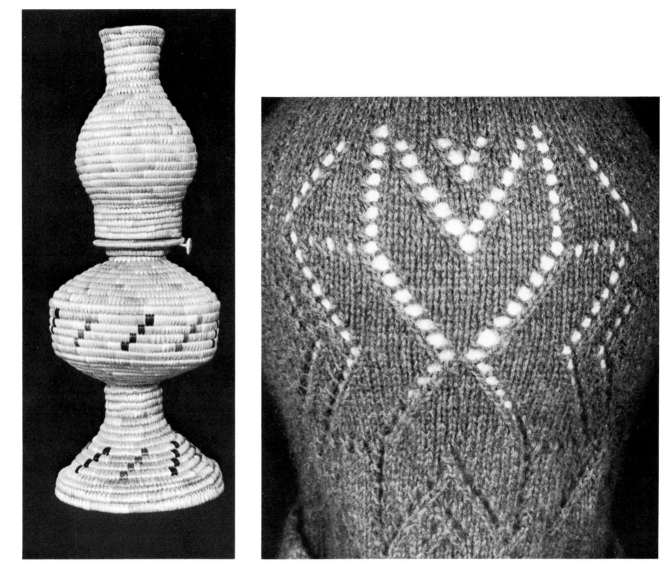

95. Replica of a kerosene lamp in coiled basketry, made by Susie Chanigkak, Kongiga-nak, 1976. Height: 14 inches (35 cm.). Collection of D. J. Ray. The squares are purple and green. The lamp is made in three parts: chimney, shallow wick section, and base.

96. "Qiviut" (musk ox down) hat with star design, knit by Nan Kiokan, Mekoryuk, 1975. Collection of Verne F. Ray. This design was developed by Esther Shavings, and, according to the label that accompanied the hat, is exclusive to Mekoryuk.

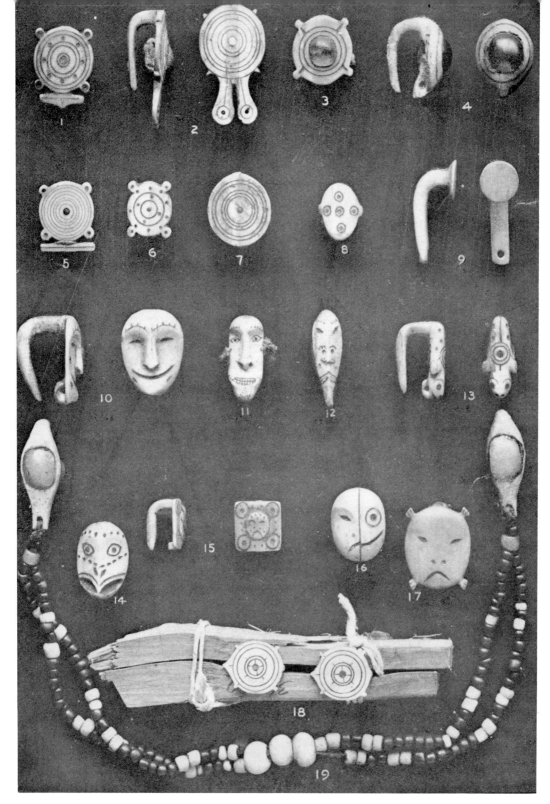

97. Earrings of ivory, with additional ornamentation of beads, 1877-81. Collected by E. W. Nelson, except number 9, which was collected by Lucien M. Turner. Number 10 is ⅞ inches (2.1 cm.) long. All are from southwest Alaska, except number 19 from Sledge Island. From Nelson 1899:plate XXIV. Nelson describes the earrings on pages 54-56.

(1) Cape Vancouver. (2) Nunivak Island. (3) Nulukhtulogumut. (4) Kaialigamut. (5) Cape Vancouver; similar earrings from Big Lake and Nulukhtulogumut are illustrated in Hoffman 1897 (pl. 48 [8 and 10]). (6) Chalitmut; there is a similar earring from the Yukon River in Hoffman (pl. 48 [5]). (7) Cape Vancouver. (8) Chalitmut. (9) Saint Michael; Nelson said that these were "the only earrings of this description that were seen" (p. 56). (10) Nulukhtulogumut. (11) Cape Vancouver. (12) Cape Vancouver. (13) Kushutuk. (14) Cape Vancouver; described as a "short-ear owl." (15) Chalitmut. (16) Cape Vancouver; a "tunghak," or spirit. (17) Cape Vancouver; a seal. (18) Askinuk.

142

98 a and b. A caribou tooth belt, collected by L. A. Zagoskin between 1842 and 1844 at Norton Sound. Length: 35½ inches (91 cm.). MAE 537-26. This belt has seventy-nine sets of caribou teeth. The ivory buckle, which is slightly convex, is unusual in that the thong, which is pulled through a hole in the center of the buckle, has four tiny well-carved bird heads at the end. This buckle and belt are discussed in Stepanova 1949. (See other buckles in Nelson 1899:pl. XXVII.)

A double belt in the Alaska State Museum (II-A-5018) has 131 sets of teeth in one row and 127 in another, with the rows separated by a row of 81½ blue trade beads. Another double belt, in a private collection, has 140 sets of teeth in one row, and 148 in the other. Since these belts were worn by a woman primarily to show off her husband's hunting skills, the owners of belts with three rows must have been very proud indeed! Three-row belts are known from both the Kuskokwim River and Port Clarence: a Kuskokwim belt, collected by Johan Jacobsen, probably had a total of 350 sets of incisors at one time, and another obtained by Miner Bruce at Port Clarence, had at least 600 (Jacobsen 1884:217; 1977:108; VanStone 1976:pl. 28). *Photographs courtesy MAE, Leningrad*

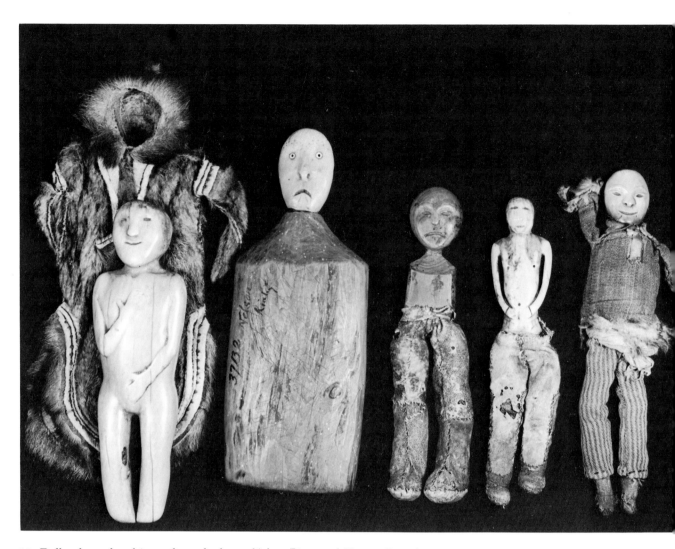

99. Dolls of wood and ivory from the lower Yukon River and Norton Sound, 1877-81. Collected by E. W. Nelson for the Smithsonian Institution.

From left to right: 48712. From Rasboinsky, this doll (6½ inches high) is of deeply yellowed ivory. I have seen several dolls with arms in this position, or that in figure 86 (far right), but have been unable to learn the meaning. The parka (no. 38695) was on the doll.

37132. This doll, 7½ inches high, has a wooden block body and a double face of ivory. The opposite side of this head has a face with a turned-up mouth and no tattooing.

No number. The wood has been painted red. The eyebrows, eyes, and mouth are incised. The pants are made of sealskin around grass fibers.

32914. A doll from Norton Sound. The difference in the northern style of face and torso is evident in comparison with the three dolls flanking it, with their broader faces, block-like bodies, and crescent-shaped mouths. This doll has a groove for a backbone, and a hole in the top of the head with an inset of wood.

48858. This doll from the lower Yukon River is made from a split walrus tusk, the back being entirely flat. The eyebrows are lightly incised, and three holes under the mouth are rather deeply dug out.

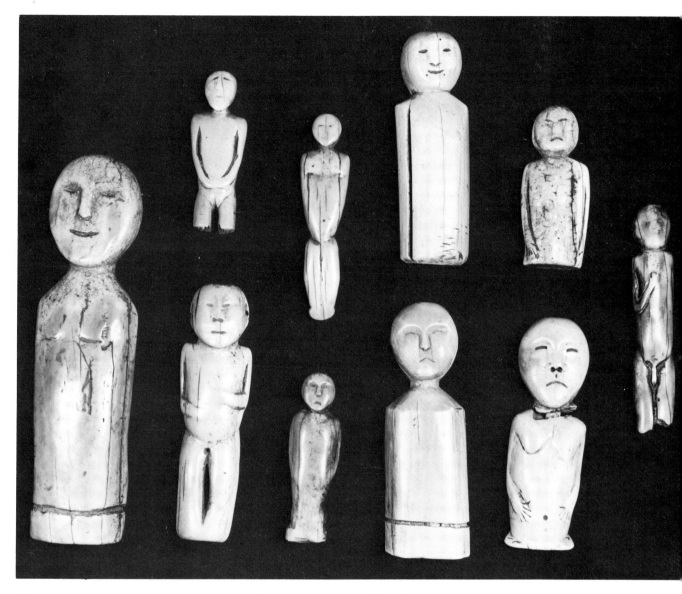

100. Human figurines of ivory from the old villages of Rasboinsky (Pilot Village) and Sabotnisky (Marshall), collected by E. W. Nelson, 1878-81. The doll on the left is 7¹⁵⁄₁₆ inches (20.2 cm.) high, and on the right, 4¾ inches. The description of each of these figurines is in appendix A.

Nelson did not illustrate any of the human figurines in figures 99-102 in *The Eskimo about Bering Strait.* Therefore, when S. V. Ivanov wrote a paper in 1949 about two ivory dolls that were very similar to the female figure in the lower right, he thought that they were unique, without parallel in Eskimo art (1949a). There are actually quite a few such figurines in American collections, but the ones in Ivanov's paper are among the earliest collected—in the 1840s by I. G. Voznesenskii, from Norton Sound.

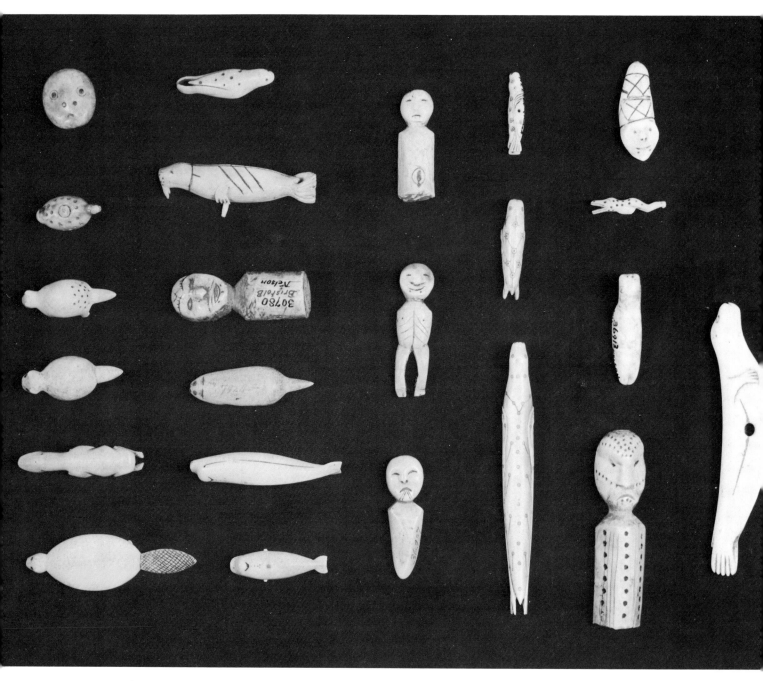

101. Ivory objects collected from the area between Bristol Bay and the Kuskokwim River, most of them in 1878-79. The human figure, bottom right is 3⅓ inches (8.5 cm.) high. All are in the U.S. National Museum. The descriptions of these figures are in appendix A.

146

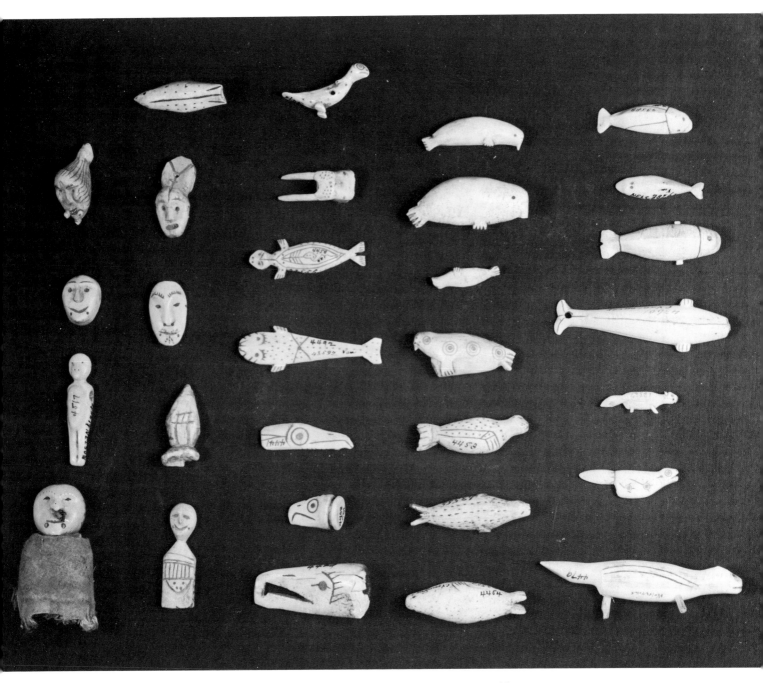

102. Ivory figurines obtained from Cape Vancouver by E. W. Nelson, presumably on his winter trip, 1878-79. Length of the lower right figure: 3½ inches (9 cm.). All are in the U.S. National Museum. A trader was living at Cape Vancouver at the time these were collected. Information about each figurine is in appendix A.

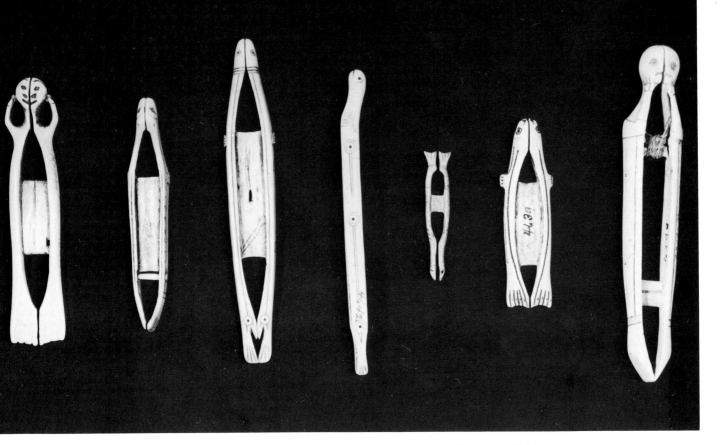

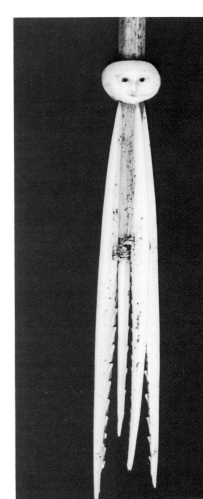

103. Shuttles made of ivory, all from Nunivak Island, except the third from the left, which is from Big Lake, 1878-81. Length of left shuttle: 4⅓ inches (10.9 cm.). Collected by E. W. Nelson. All are in the U.S. National Museum. Although a number of objects from Nunivak Island are illustrated in Nelson's *Eskimo about Bering Strait,* they were collected by other persons, particularly William H. Dall. The objects, *left to right:*
 (43740) The divisions of the flippers are marked on the back side.
 (43741) The characteristic "Nunivak" eye—a circle with two opposing triangles—is colored red. (176239) The sides are engraved with a flipper at the forward end and two circle-dots, each with a spurred line, all connected with a straight line. (43742). (48278) Only 2⅛ inches (5.4 cm.) long. (43789). (43261) Small incised "paws" are placed on the neck, and two double nucleated circles with spurred lines are incised on the sides. The eyes are inset.

104. Fish spear of ivory, probably from the lower Yukon River. Length: 5⁷⁄₁₆ inches (13.8 cm.). Peabody Museum, Cambridge, 64241. The head has a face on both sides.

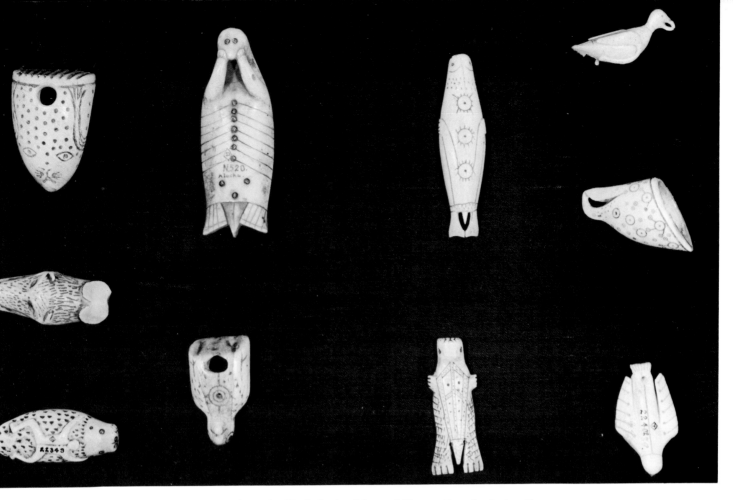

105. Ivory objects collected from the Kuskokwim delta and Norton Sound, nineteenth century. Length of upper left figure: 1⅞ inches (4.4 cm.). American Museum of Natural History. One object, a "duck" *(extreme top right),* is from Kodiak Island, collected in 1882. The details are in appendix A.

106. Two kayak guards from Kaialigamut, reproduced from line drawings in *The Eskimo about Bering Strait* (Nelson 1899: figs. 72 and 73). The bottom one is 1¾ inches (4.3 cm.) high. These are described in chapter 3 under "Sculpture as Amulets and Charms."

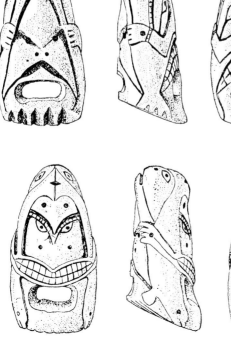

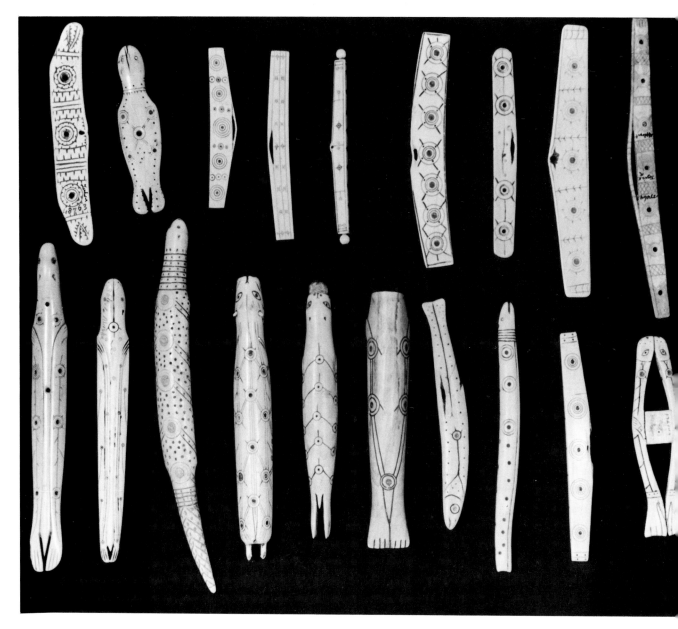

107. Ivory bag handles with black designs from southwest Alaska; collected by E. W. Nelson and Mr. Applegate, 1878-81. The top left handle is 4¹⁄₁₆ inches (10.5 cm.) long. All are in the U.S. National Museum.

Top, left to right: (48763) Yukon. (48869) A seal from the lower Yukon. (127469, five pieces with the same number) From Togiak, collected by Applegate. (37748) Chalitmut. (127469) Made of old ivory, also collected by Applegate from Togiak.

Bottom, left to right: (48860) Lower Yukon; the eyes and two holes forward have inlays. (36479) Kuskokwim River. (48867) Yukon River; the large inlays are lead. (38128) Nulok; most of the centers have inlays; the tiny ears are pegged in, and the mouth has carved teeth. (27443) Togiak River. (43697) Nunivak Island; the inlays are brown. (35972) The eye of this fish and center of the circle have inlays. (38367) Big Lake; the eyes are lavender beads. (127469) Togiak; collected by Applegate. (176142) Cape Vancouver; the center of the two circles behind the head are inset with ivory.

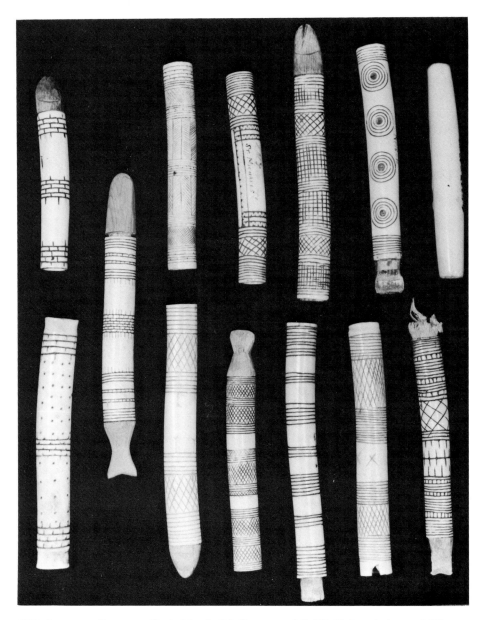

108. Ivory needlecases collected by L. M. Turner and E. W. Nelson between 1874 and 1881, mainly from southwest Alaska. The sixth from the right is 4 inches (10.3 cm.) long. These are in the U.S. National Museum. The museum numbers and proveniences are as follows:

Top row, left to right: (48328) Nunivak Island. (36736) Needlecase with wooden head and tail from Big Lake. (48807) Yukon River. (129231) Saint Michael. (37802) Cape Vancouver. (49028) Rasboinsky. (45337) Cape Nome.

Bottom row, left to right: (48604) Rasboinsky. (38184) Needlecase with Y-figures from the Yukon River. (36781) Provenience unknown. (24492) Saint Michael. (48803) Rasboinsky. (36763) Big Lake.

109. Ivory storyknife from the lower Yukon River. Length: 12¾ inches (31.8 cm.). Collection of D. J. Ray. The same design is on both sides. Nelson illustrated thirteen storyknives from the lower Yukon, Big Lake, Cape Vancouver, Chalitmut, Ikogmiut, Kashunuk, Koñigunugumut, Nulukhtulogumut, Togiak River, and the lower Kuskokwim. Eight were made of ivory, and four were of bone or horn. Two had a salmon head carved at the handle end (1899:pl. XCIV). See also Lipton 1977:fig. 163.

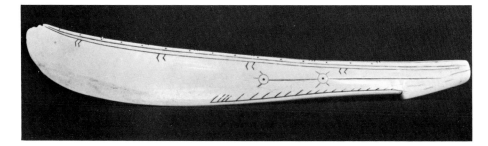

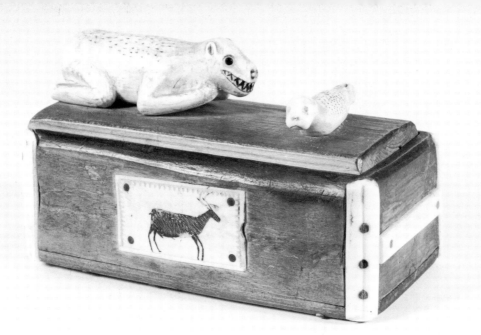

110. Percussion cap box of wood with a carved ivory animal (bear?) and a seal on a sliding lid, Saint Michael, 1884. Length: 4⁷⁄₁₆ inches (11.2 cm.). Lowie Museum UCLMA 2-4547. The same humorous attitude of the bear is repeated in the seal carving, figures 111a and b. This box does not show the care in construction evident in the tool and tobacco boxes in figures 174-78. *Photograph by Eugene R. Prince*

111a. Reclining figure, probably a seal, with a composite creature engraved on its back. Provenience unknown, but probably collected from the lower Kuskokwim by a Moravian missionary in the early twentieth century. Length: 2⅛ inches (5.5 cm.). Dresden Museum 57487. The figure on the back is colored black, and has a triangular head, two front animal paws, and two human legs. Two seal-like flippers are engraved under the rear end of the piece as if the body of the creature were carried on under the edge (Israel 1971:132). See also figure 105, lower left. *Photograph by Sieglinde Weidel, courtesy Dresden Museum*

111b. Close-up of face of figure 111a. *Photograph by Eva Winkler*

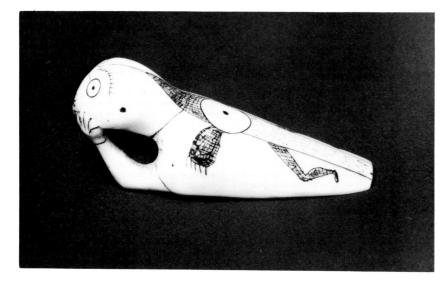
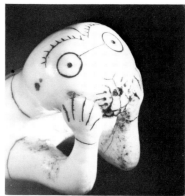

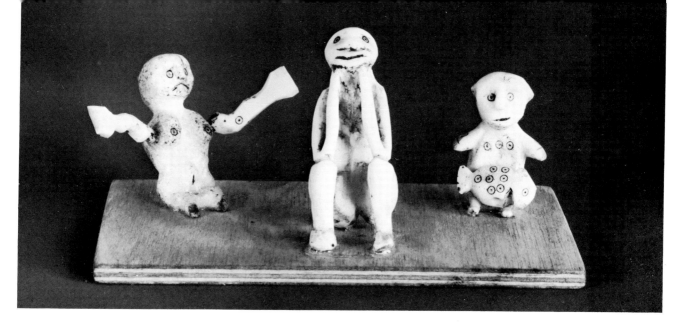

112. Three sitting figurines of ivory, collected in 1896 by the Moravian missionary, J. H. Romig, probably from the Kuskokwim River. Height of middle figure: 1⅝ inches (4 cm.). Herrnhut Museum 3527a-d. These figurines, which were originally catalogued as "idols," are in a collection made in Alaska by Moravian (Herrnhut) missionaries between the 1890s and 1910s, and taken to Germany. The figure on the left has large breasts, disproportionately long arms, and stubby legs. There is a hole in the lap, probably for attaching a figure like the fish in the lap of the figure on the right. The middle figure also has extremely long arms. The figure on the right has a deep longitudinal indentation in its back (Israel 1971:131-32, and figs. 44 and 45). *Photograph by Sieglinde Weidel, courtesy Dresden Museum*

113. Dance scene in ivory, probably Kuskokwim River, before 1898. Height: 7½ inches (19 cm.). Lowie Museum 2-4573. Hanging from the top of the model are two "bladders" made of wood, and an ivory bird. Another model in the Sheldon Jackson Museum (II.S.1), and collected on the Kuskokwim River by Adolph Neumann in 1890, was probably made by the same man. The model II.S.1 is illustrated in *The Far North* (fig. 132) and the Sheldon Jackson Museum catalog 1976:88. The Lowie Museum model was obtained from the Alaska Commercial Company, with which Neumann was associated. *Photograph by Eugene R. Prince*

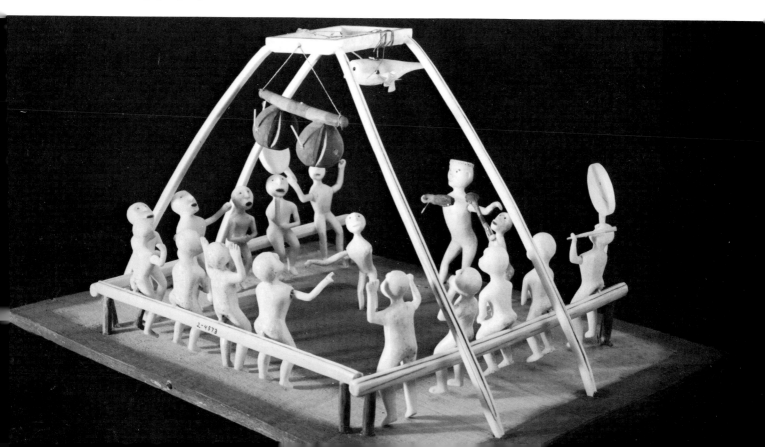

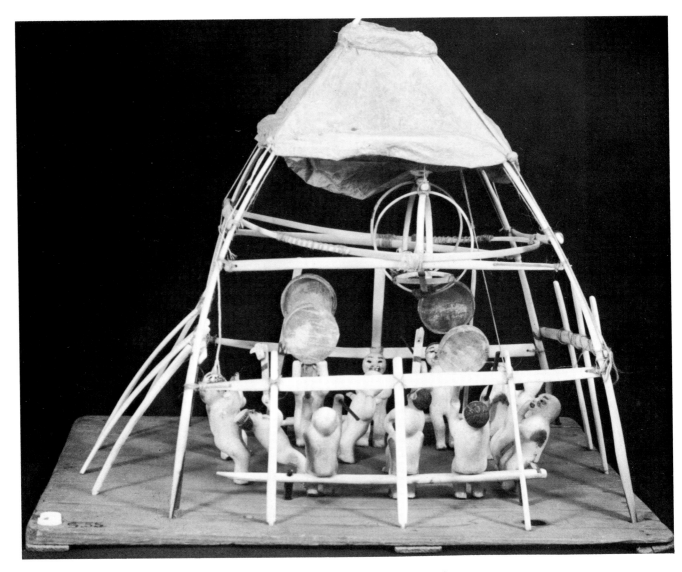

114. Dance scene, probably from the Kuskokwim River, 1890s, all of ivory. Height: 11¼ inches (28.1 cm.). Alaska State Museum II-A-5350. Of the fourteen ivory figures, five are dancers and four are drummers. The handle of one of the drums is in the shape of a puffin; the other, a fish. One of the dancers holds a flat ivory stick with a small carved bird pegged in. The two round objects toward the top are probably lamp frames, connected at the top by a bar, in the middle of which is a tiny ivory bird.

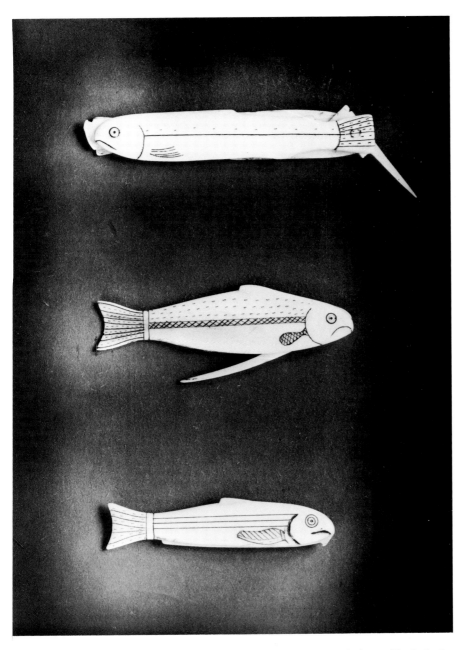

115. Ivory models of pocket knives in the shape of fish, probably lower Kuskokwim, before 1911. Herrnhut Museum 5020-5022. Length: between 2 and 2½ inches (5 and 6.5 cms.). These were given to the Herrnhut Museum in 1911 by G. Adolph Stecker, who was a missionary in Bethel between 1901 and 1910. In 1913, after a trip to Germany, he returned to Quinhagak. These were entered in the museum catalog as "toothpicks." *Photograph by Sieglinde Weidel, courtesy Dresden Museum*

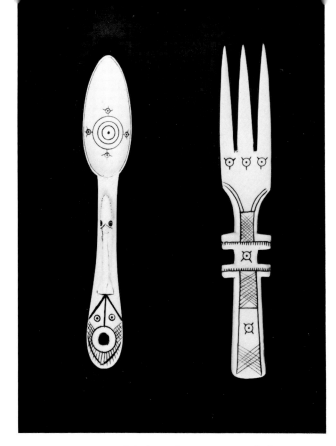

116. Ivory spoon and fork made as souvenirs before 1906, probably Kuskokwim area. Collected by G. Adolph Stecker and Joseph Weinlick. Length of fork: 5½ inches (14 cm.). Herrnhut Museum 3520 and 3529. Black geometric designs are found on both sides of the spoon and the fork. The handle end of the spoon appears to be a face, with open mouth. The round hole is cut through. These objects are illustrated and discussed by Heinz Israel (1971:125 and plates 28-31). *Photograph by Sieglinde Weidel, courtesy Dresden Museum*

117. Gavel or hammer made of walrus ivory. Collector and date unknown, but probably by G. A. Stecker from Quinhagak in 1927. Length: 5¹¹⁄₁₆ inches (22 cm.). Herrnhut Museum 5617. The incised dots and other markings are black, red, and green. The Herrnhut Museum accessions catalog interprets the figure on the handle as a snake. It probably represents one of the worms or serpents that prevailed in western Eskimo mythology, since there are no snakes in Alaska. This gavel is illustrated and discussed in Israel 1971:123-24 and pl. 25. *Photograph by Sieglinde Weidel, courtesy Dresden Museum*

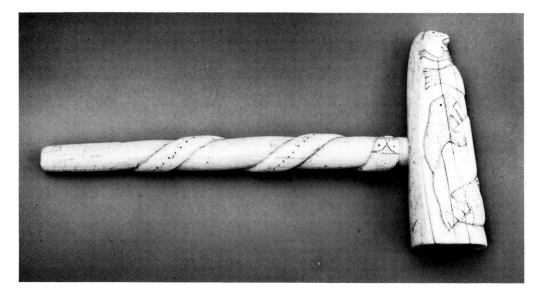

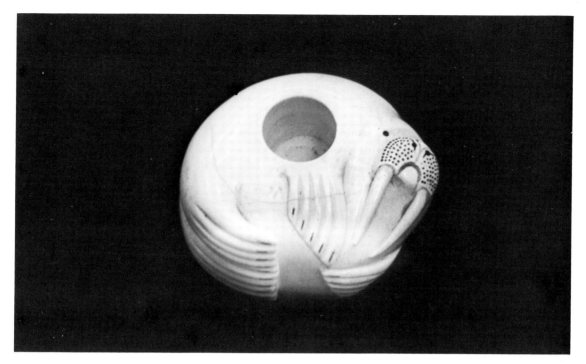

118. A candlestick holder of elephant or mastodon ivory, collected in the 1920s by George Gasser, probably Nunivak Island. Widest diameter: 2½ inches (6.2 cm.). University of Alaska Museum 900-167. The walrus head has black whiskers, eyes, and nose, and a red mouth.

119. Inkwell of ivory, probably Nunivak Island. Length: almost 4 inches. Private collection. All markings are black, and the eyes are inset with black baleen. The center animal covers the opening to the inkwell.

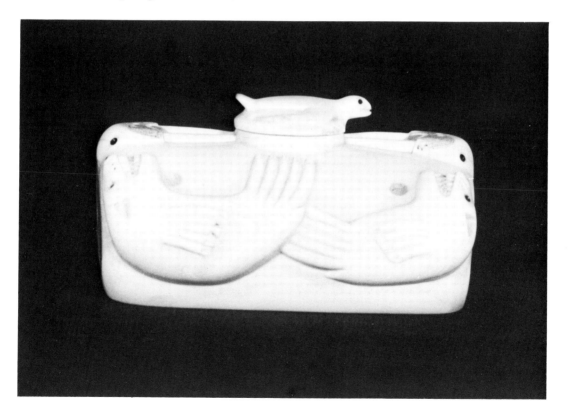

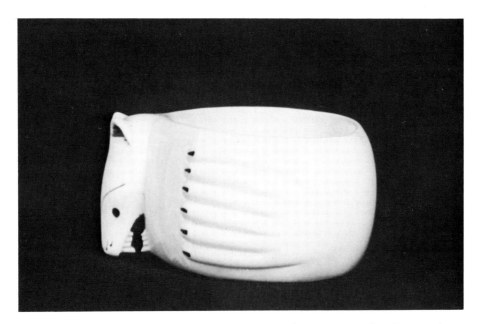

120. Ivory napkin ring from Nunivak Island. Circumference: 7¼ inches (18.1 cm.); inside diameter: 1¾ inches. Private collection. This apparently is a bear, and the design on the side, a paw. On the opposite side, the paw is turned down. The ears, mouth, and nostrils are red; the nails, black; and the eyes are black insets.

121. Needlecase of ivory from Mekoryuk, 1939-40. Length: 5½ inches (13.8 cm.). Washington State Museum 2-1233. Collected by Margaret Lantis. The head detaches, and the ears are separate pieces of ivory. The eyes and nostrils are inset with baleen. A geometric design of dashes and spurred lines is incised on the under side, and filled with a brown color.

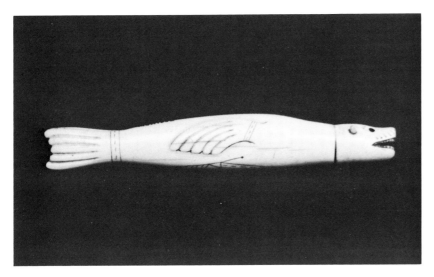

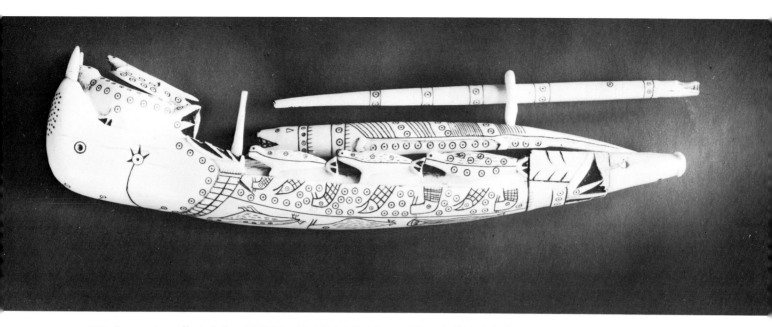

122. Ivory pipe collected about 1906 by G. Adolph Stecker and Joseph Weinlick, lower Kuskokwim area. Length: 10½ inches (27 cm.). Herrnhut Museum, no catalog number. The geometric designs and engraved animals are in alternating red and black color. The bottom of the pipe has outline sketches of three land animals and three sea mammals. All sides of the pipe are illustrated by Heinz Israel (1971:figs. 18-21). *Photograph by Sieglinde Weidel, courtesy Dresden Museum*

123. An ivory cribbage board, possibly from Togiak, about 1902. Length: 13⅞ inches (34.6 cm.). The date and provenience of this piece have been established on the basis of a very similar board in the Washington State Museum (2-4416), known to have come from Togiak in 1902. Photographed by D. J. Ray at The Legacy, Ltd., Seattle.

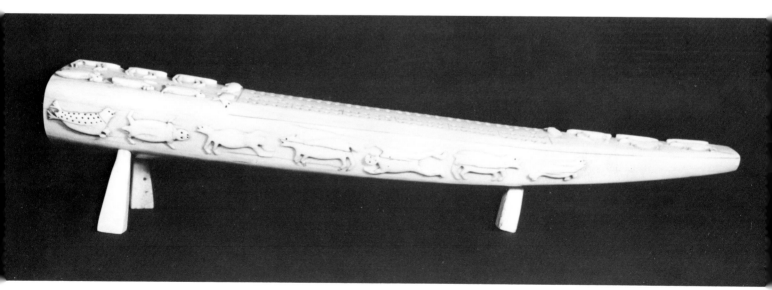

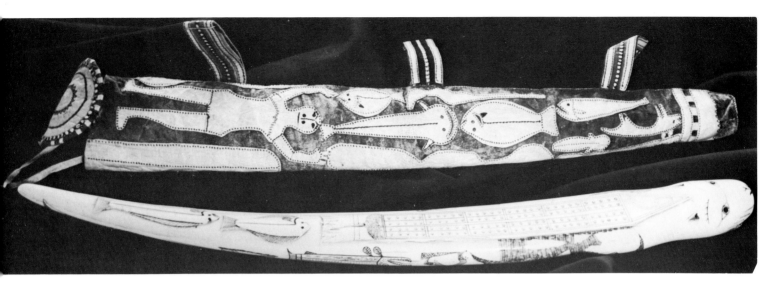

124. Ivory cribbage board and carrying case made of skin with appliquéd figures, collected by G. Adolph Stecker, 1910, probably Nunivak Island. Length: 20½ inches (52 cm.). Herrnhut Museum 4987. Marie Drebert, Mr. Stecker's daughter, wrote to Heinz Israel, Dresden, that most of the cribbage boards made in her father's missionary territory during the early twentieth century came from Nunivak Island (1961:309). The large animal head with mouth and tongue painted red supposedly represents a polar bear. The eyes are black. On the sides and bottom are incised a number of figures in black and reddish brown: a fish, an elongated walrus, a kayak, a man shooting a bow and arrow, another shooting a gun, two large birds, a polar bear eating a seal, two men, and several other small sketches (Israel 1961:306-7 and fig. 9). *Photograph by Sieglinde Weidel, courtesy Dresden Museum*

125. Top and bottom of a cribbage board from Nunivak Island, collected by G. Adolph Stecker in 1910. Length: 23¼ inches (57 cm.). Herrnhut Museum 4986. This cribbage board has been squared off on all sides in the peg section. On both sides there are carved foxes or wolves in bas-relief. The carving of the bird on the left is similar in style and design to the tail of the cribbage boards in figures 129 and 130. Both ends are carved animal heads. *Photograph by Sieglinde Weidel, courtesy Dresden Museum*

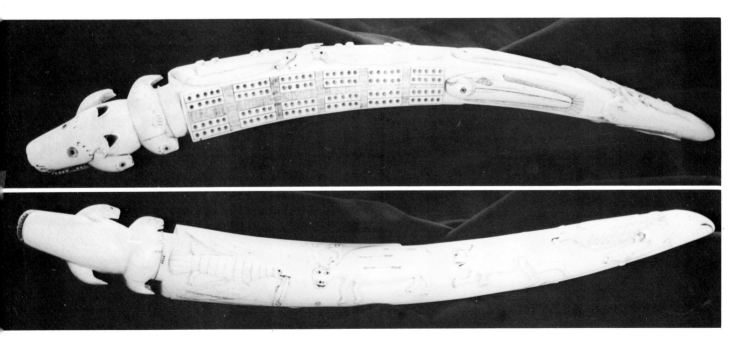

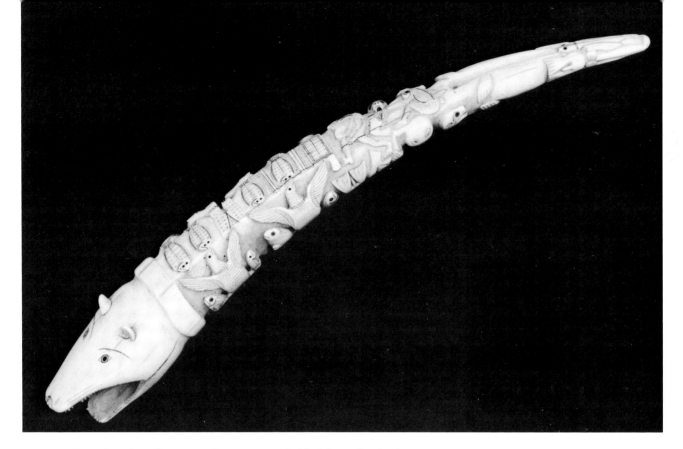

126a. Cribbage board, early twentieth century, probably Nunivak Island. Length of outer curve: 18 inches (45 cm.). Constantine Collection, Agnes Etherington M69-26. This intriguing piece appears to be a step toward the fully developed "Nunivak tusk," intermediate between the one collected in 1910 (fig. 125) and those made after the 1920s. The information in the Agnes Etherington catalog that it was collected at Nome "ca. 1895" is erroneous since Nome did not exist until 1898. It was acquired by Queen's University in 1930. *Photograph by Frances K. Smith*

126b. Reverse side of the cribbage board in figure 126a. *Photograph by Frances K. Smith*

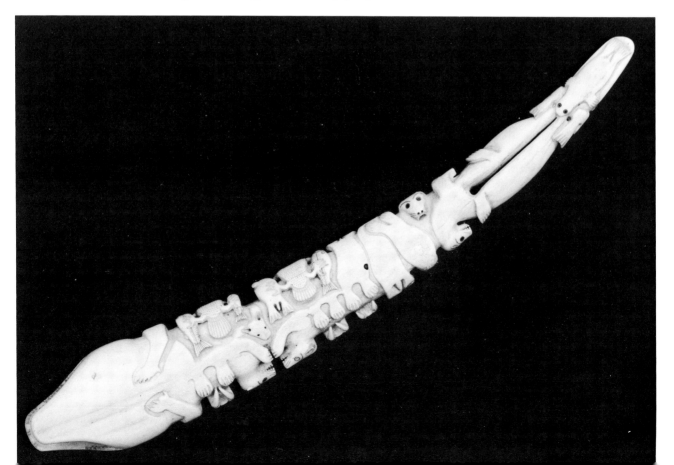

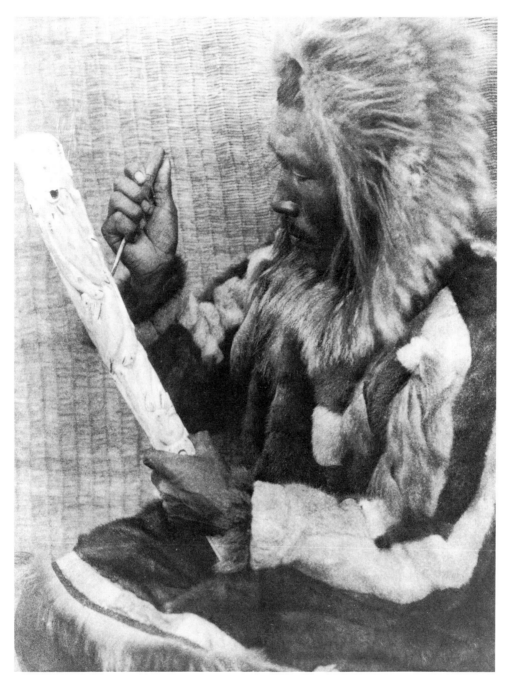

127. "The Ivory Carver, Nunivak," photograph by Edward S. Curtis, 1927 (Curtis 1930:facing p. 86). This photograph shows a carved tusk in the elongated-animal style.

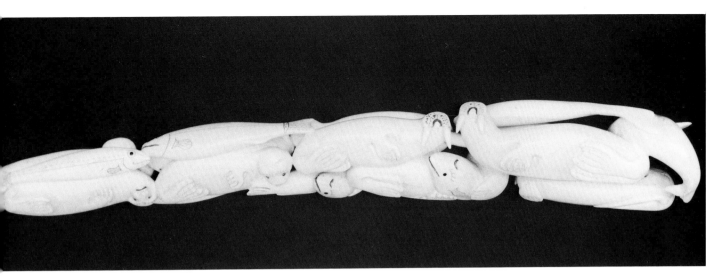

128 a and b. Front and back of a carved ivory tusk, from Nunivak Island, 1940s. Length: 14½ inches (36.3 cm.). Collection of Robert A. Henning. In Mekoryuk in 1976, John Kusowyuk ("Uncle John"), the only person still carving these tusks, identified this to me as his work.

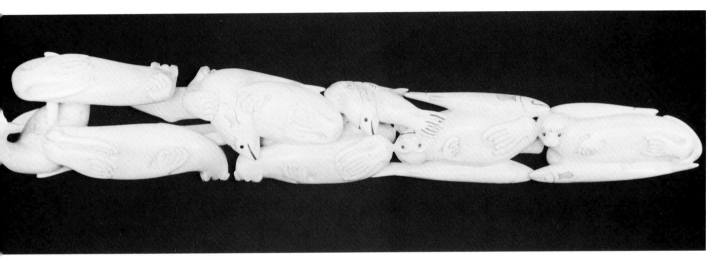

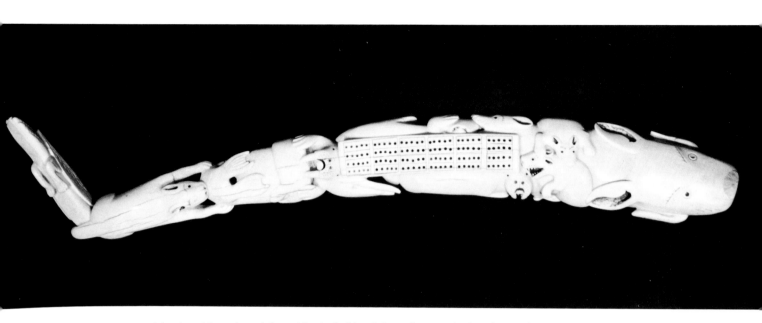

129 a and b. A cribbage board from Nunivak Island. Length: 29¼ inches (73 cm.). Private collection. The markings are black and red. The bird at the end is made a chain link. This is one of the longest cribbage boards in this style that I have seen, although carved tusks without the peg holes have been made from longer tusks. One in the U.S. National Museum (332,176), and illustrated in Ray 1961 (fig. 74), is almost thirty-four inches long.

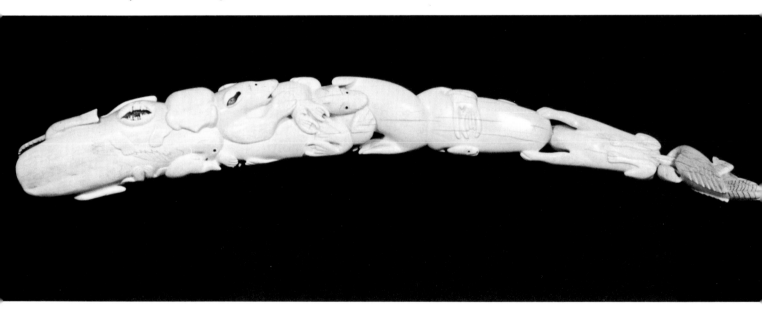

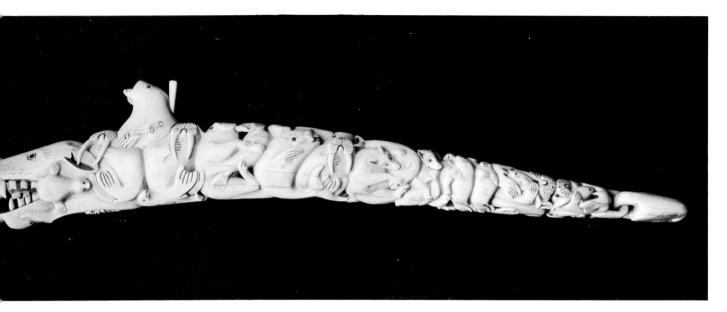

130 a and b. Walrus tusk carved on Nunivak Island, about 1924, and collected by
Knud Rasmussen. Length: 27 inches (69 cm.). The National Museum, Copenhagen,
P.1333. A black mineral serves as pupils of all the eyes, which are ringed with red.
The "whiskers" are black. The tail end is also a chain link, like the cribbage board in
figure 129. Notice the small fish or animal emerging from the mouth of the topmost
seal. *Photograph courtesy the National Museum of Denmark, Copenhagen*

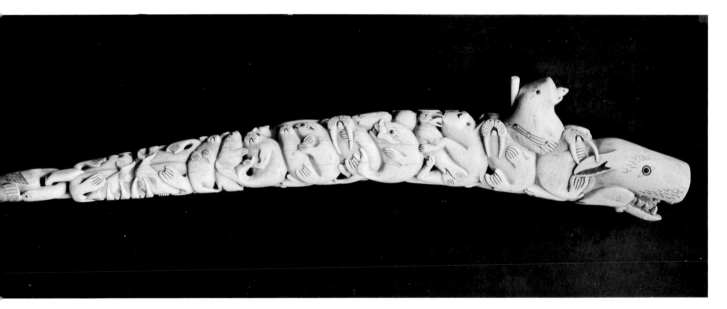

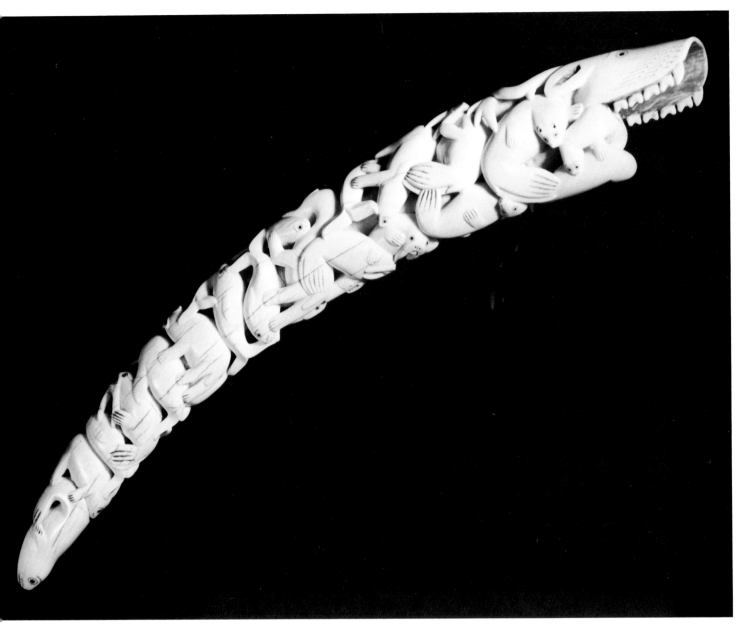

131. Another example of a carved tusk from Nunivak Island, 1930s. Length: 27 inches (69 cm.). Alaska State Museum, II-A-2789. This tusk was once broken into three parts, but has been skillfully repaired. Like many of the carved tusks, it has small lengthwise cracks. This piece has thirty-one entwined animals—foxes, seals, walruses, whales, and polar bears. The larger end of the tusk terminates in a caribou (or reindeer) head, and the smaller, in a sea mammal. Mouths, flippers, and ears are red, and eyes are inset. *Photograph by Alfred A. Blaker*

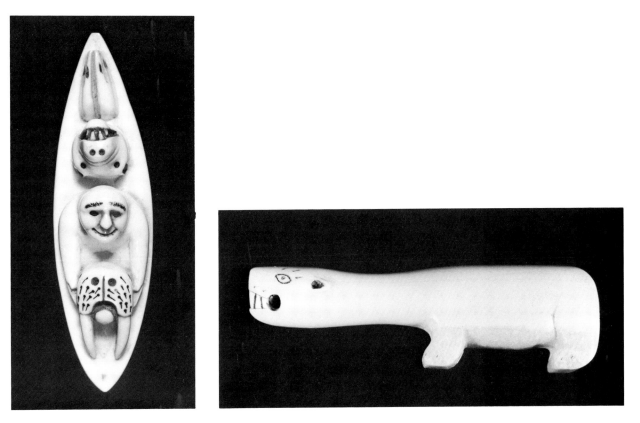

132. A small carving (only 2⅛ inches long) of walrus ivory, which represents a man in a boat with a walrus head and a bear head. Private collection. This is said to have come from Nunivak Island about 1936, but is in somewhat atypical Nunivak style, except for the whiskers. The mouths of the figures, the animals' nostrils, and the ears of the bear are red. All other markings are black.

133. A small bear of walrus ivory made by Andrew Noatak, Mekoryuk, 1974. Length: 2⅞ inches (7.1 cm.). Private collection. The ears and mouth are red, and the eyes and eyebrows are black. The hole at the end of the mouth is cut through.

134. Ivory bird made of walrus tooth, by Andrew Noatak, Mekoryuk, 1976. Length: 2 inches (5 cm.). Private collection. The mouth is red, the other markings are black.

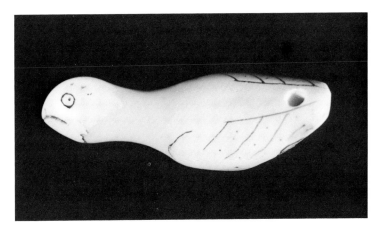

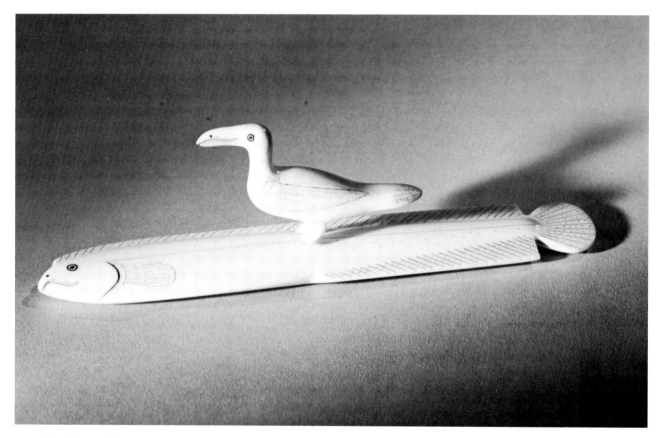

135. A bird on a fish, an ivory sculpture by Harry Shavings, Mekoryuk, about 1960.
Length: 6⅛ inches (15.3 cm.). IACB W/X.118 *Photograph courtesy Indian Arts and Crafts
Board*

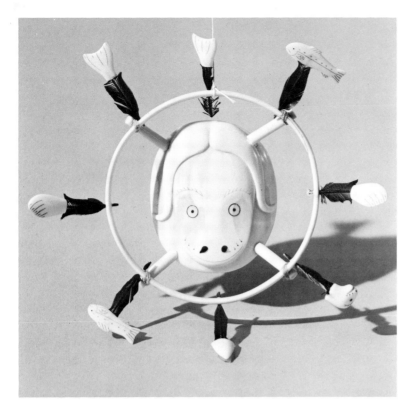

136. Miniature ivory mask, which represents a musk ox, Nunivak Island, about 1960. Diameter of hoop: 6½ inches (16.3 cm.). IACB W/X.119. *Photograph courtesy Indian Arts and Crafts Board*

137. Miniature ivory mask depicting the half-man–half-animal, by Andrew Noatak, Mekoryuk, 1973. Overall height, including appendages: 7⅞ inches (19.6 cm.). Private collection. Mouth and nostrils are colored red; all other markings are black.

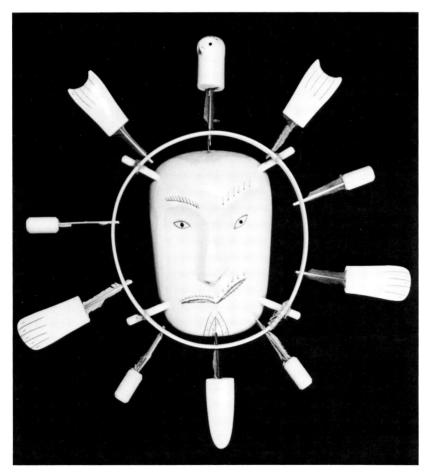

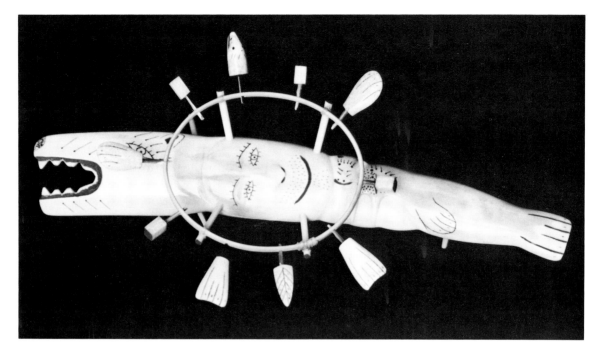

138. Miniature ivory mask sculpture by George Williams, Mekoryuk, 1976. Length: 9⅝ inches (24 cm.). Private collection. Mouths are painted rust, as are the ears and tail. Other markings are black. This sculpture is not made to hang on the wall as are the two preceding miniature masks, but stands on four ivory pegs. This was the first or second one of this kind that Williams had made, and is reminiscent of the "ring sculpture" in wood, figure 159.

139. Bracelet of engraved walrus ivory with mammoth ivory links, by Homer Hunter, Scammon Bay, 1975. Dimensions of engraved links: ¾ by ¹¹⁄₁₆ inches (1.9 by 1.7 cm.). Collection of Pam Tate. Besides the goose, other subjects on the links are a village scene, a killer whale, a seal, a whale, all colored black. Hunter, who was born in Hooper Bay, found the mammoth ivory near Dall Point in 1946. By 1976 he had almost exhausted his supply. *Photograph by Ed Tate*

140. A wafer-thin earring of walrus ivory, only one inch high, made by Peter Post, Tununak, 1975. Collection of Pam Tate. The fin and dots are green, the mouth and nose are red, and the eye is black. *Photograph by Ed Tate*

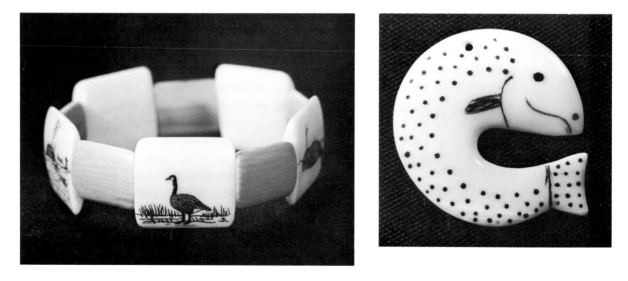

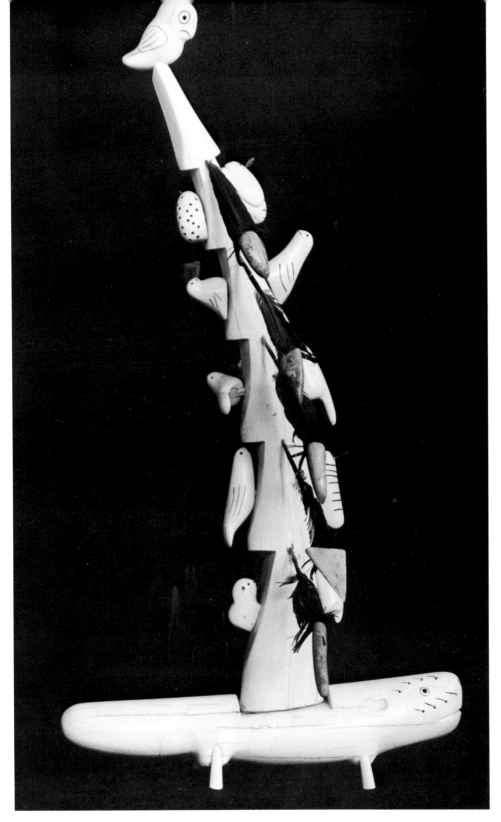

141. An ivory tree, by Kay Hendrickson, Mekoryuk and Bethel, 1970s. Height: 18½ inches (46.3 cm.). Collection of Rae and Sera Baxter. This tree rests on an ivory animal with pegged-in legs. The birds are ivory, and bits of soapstone are attached to raven feathers. Black is the principal color, except for red in the ears. Hendrickson created three styles of ivory trees while participating in classes of the Extension Service for Arts and Crafts at the University of Alaska in 1970. Each of his trees has an ivory bird at the top, but the other two styles are much simpler than this one, consisting mainly of ivory leaves placed at regular intervals on the ivory trunk. In 1978, Hendrickson was making similar trees of wood, two feet high, and painted black and white.

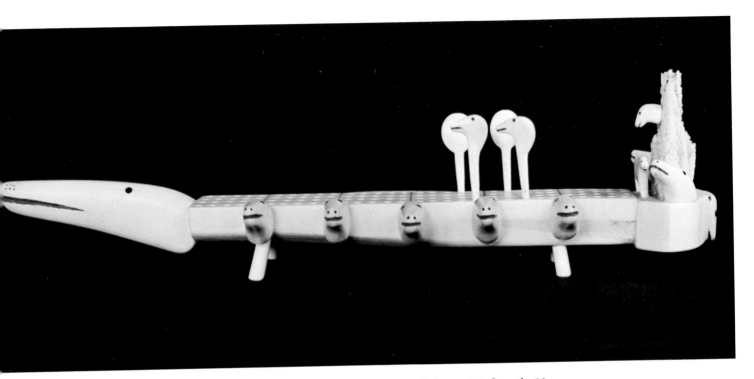

142. Cribbage board of walrus ivory, by Tom Sunny, Toksook Bay, 1973. Length: 13 inches (32.5 cm.). Collection of Rae and Sera Baxter. This is a simple board made interesting by the addition of numerous small attached carvings. Most of the sculptural forms of Eskimo-made ivory cribbage boards are made of the same piece of ivory as the board. This is an innovative treatment, but Sunny, as an older man in 1973, also made copies of old masks, seal harpoons, and throwing sticks of wood for sale (Anable 1973).

143. A small mask, only 5¾ inches high from the Kuskokwim River, probably early twentieth century. Washington State Museum 4516. There is a blackish wash on the mask, but the teeth and area around the animal's eyes were not painted. The back of the mask is unpainted. This mask is a great contrast in size to that in figure 144a, which is 49½ inches high.

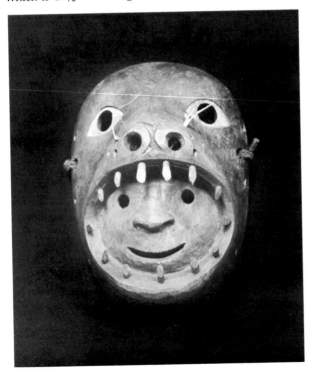

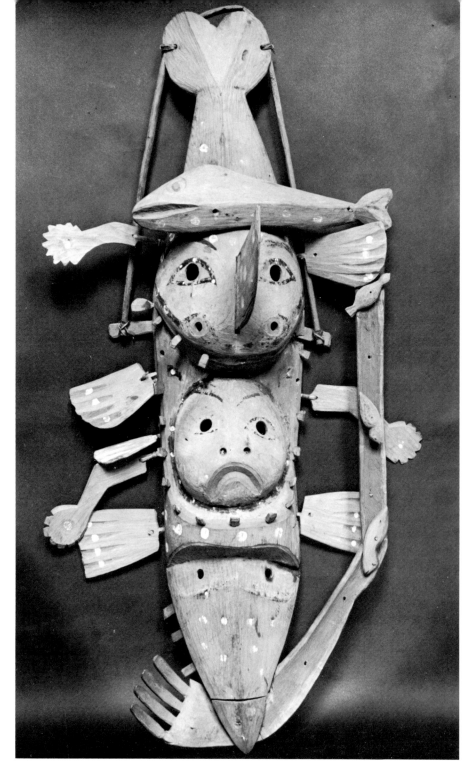

144a. A large and complex mask from Goodnews Bay, obtained in 1912. Height: 49½ inches (123.8 cm.). Washington State Museum 4528. (The mask in figure 144b, though of unstated provenience, was probably made by the same person.) The main part of this huge mask probably represents a whale because of the large blue fin that serves as a nose on the upper face. This mask apparently represents a very complicated dream or vision; at least the carver made it seem so. A unique part of this mask is the long arm-like appendage, painted red, which extends three-fourths of the way down the side and under the bottom chin. On the vertical part of the arm are a number of holes, with carved birds pegged into three of them. The body of the "whale" and the fish at the top once had a bluish wash, although the two round faces were unpainted, with black and red markings. The hoop at the top is red. All appendages were left a natural color with white spots on blue interstices. Most of the mask is held together with root lashings, but the bottom beak is nailed on. This mask was hung from the roof and held steady with a projection for the mouth behind the beak; therefore, the dancer looked out the bottom set of eyes.

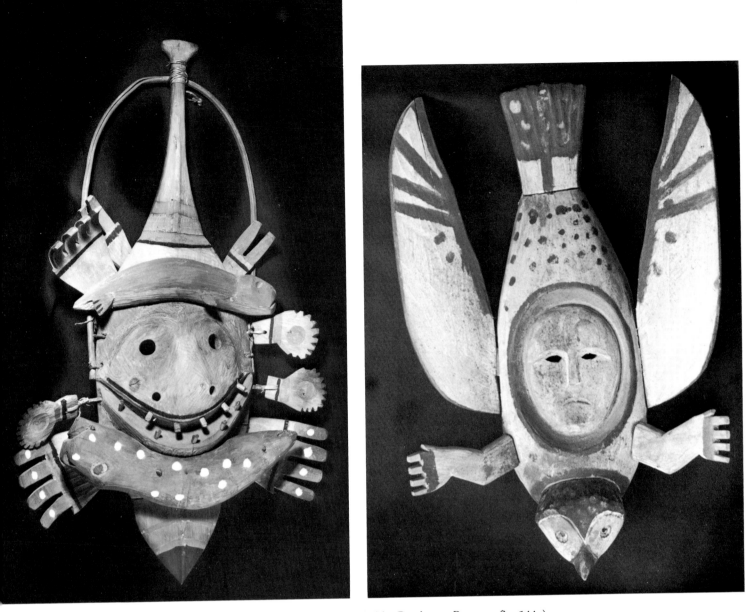

144b. A large mask from the Bering Sea coast (probably Goodnews Bay, see fig. 144a). Height: 37 inches (94.7 cm.). Alaska State Museum II-A-1454. The central part of the face is natural color, but the forehead and the areas at the temples and under the red mouth are bright blue. The animal on the forehead is painted blue, and the one beneath the chin, reddish with white spots. Outlines are black. *Photograph by Alfred A. Blaker*

145. A mask from Kashunuk, made in the 1940s, representing an owl with its *inua* (human spirit of the mask) on its back. Height: 18 inches (45 cm.). University of Alaska Museum 314-4354. The basic color is a whitewash. The tail, the framing of the human face, the top of the bird's head, the beak, and the strip on the hands are black. Other colors are red. This is one of ten well-made masks that Frank Waskey, a former prospector from Dillingham, collected from Kashunuk in the 1940s, but there is no record of who made them. Another of the masks is illustrated in figure 151.

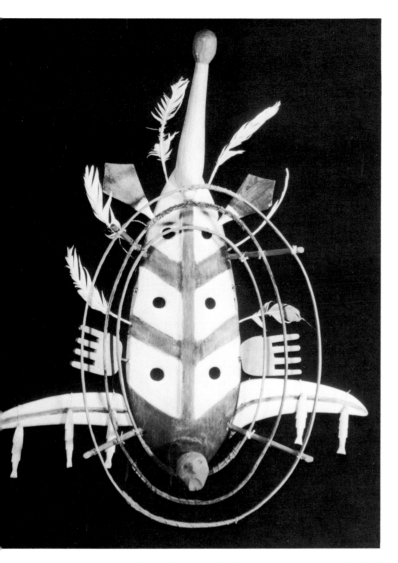

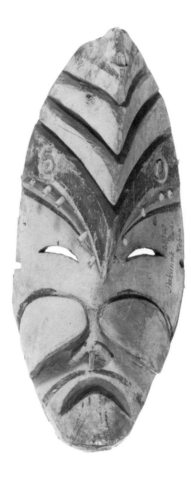

146. Mask from Saint Michael, representing some kind of bird, collected about 1915 by D. S. Neuman. Height without ring: 16½ inches (42.3 cm.). Alaska State Museum II-A-1505. The principal colors are black and white, but the outer and inner hoops and the human face at the bottom are red. The six holes are cut through. *Photograph by Alfred A. Blaker*

147. Mask, collected by E. W. Nelson, from Askinuk (Hooper Bay) in 1878. Height: 11¼ inches (28.2 cm.). USNM 48,700. Colors are a white-tan background with red and black markings. A bird beak is carved on the forehead. This mask was worn at one of the feasts for the dead. *Photograph from the Smithsonian Institution*

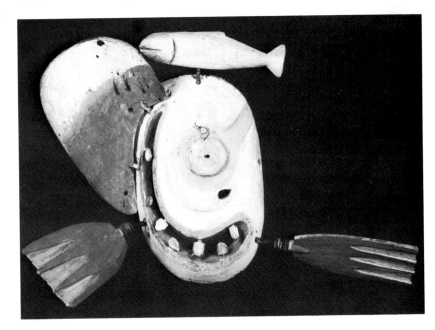

148. Mask, probably from the lower Yukon or Kuskokwim, 1880s or 1890s. Collected by the Alaska Commercial Company. Height: 9½ inches (23.8 cm.). Lowie Museum 2-5851. This is an example of the surrealistic images often experienced by the shaman in his visions. The principal colors are white, reddish brown, and gray green. A groove was made round the mask, probably for a halo of caribou hair, a decorative device illustrated in many of the drawings of masks in *The Eskimo about Bering Strait* (Nelson 1899). The wearer of this mask looked through the nostril. *Photograph by Alfred A. Blaker*

149. Dance mask from the Kuskokwim River, collected by E. W. Nelson. Height: 21 inches (52.5 cm.). USNM 64,257. This mask apparently represents a sea mammal, since the face at the bottom looks something like that of a seal. Colors are black and white except for the interior of the holes on the sides, which is red. The eyes of the bottom head are wooden pegs, as are the teeth in the large mouth. *Photograph from the Smithsonian Institution*

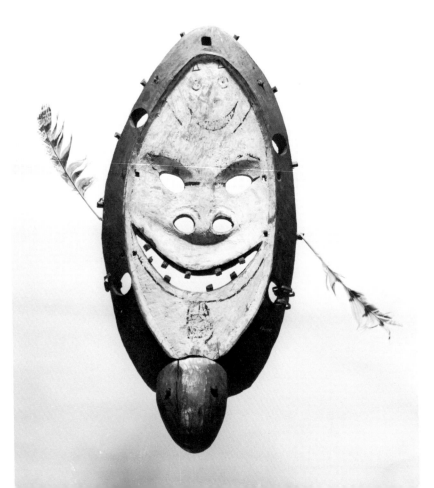

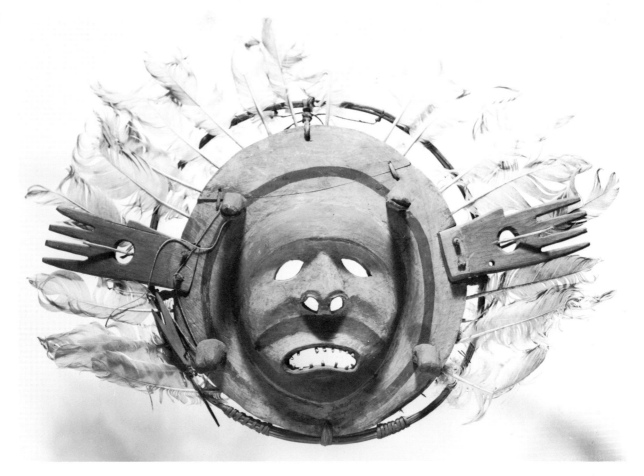

150. Kuskokwim River mask, collected by E. W. Nelson. Width with hands: 28½ inches (71.3 cm.). USNM 64,241. The mask is white with green and black markings. The hands are reddish, and the teeth in the mouth are real animal teeth. Four animal heads project from the mask. The feathers are goose. *Photograph from the Smithsonian Institution*

151. Mask of a man, Kashunuk, 1940s. Height: 9 inches (22.5 cm.). University of Alaska Museum 314-4352. This mask is unpainted except for the facial features in black. The straightforward simplicity of this mask is in marked contrast to the surrealistic mask in figure 148. Even in traditional days of the nineteenth century, Eskimos of the Yukon-Kuskokwim area made simple human face masks for certain purposes.

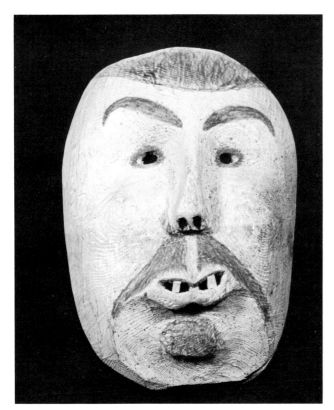

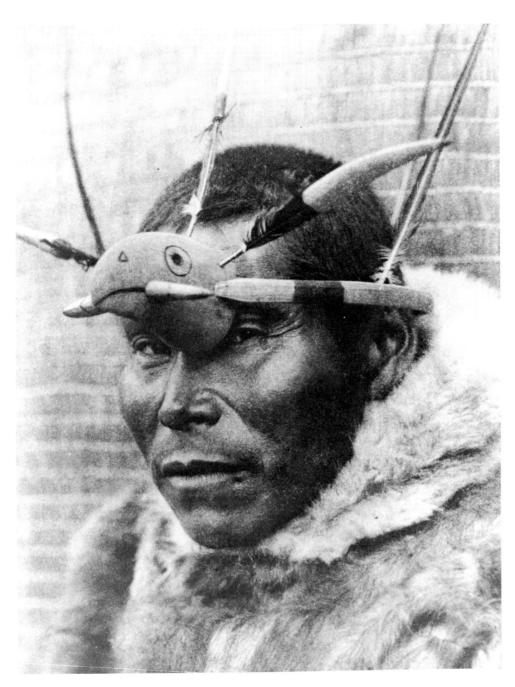

152. Photograph of a Nunivak Island man wearing a "maskette," or forehead mask. Photograph by E. S. Curtis (1930:opposite p. 82).

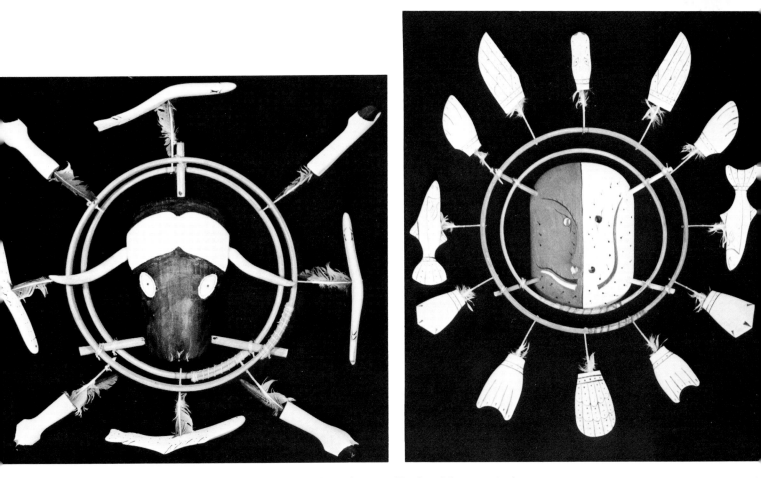

153. Musk ox mask by Andrew Noatak, Mekoryuk, 1975. Height of face: 6⅝ inches (16.5 cm.). Collection of D. J. Ray. The four hoof and four fish appendages are wood, painted white with black and red markings, and attached with murre feathers. The musk ox face is black with a white forehead. The two hoops are red, and the horns are made of bone.

154. A contemporary mask sculpture of the half-man–half-animal by Edward Kiokan, Mekoryuk, 1976. Height from top to bottom of outer ring: 11¼ inches (28.1 cm.). Collection of D. J. Ray. The red side with black markings is human; the white side is a wolf. It has a long red gash for a mouth, and black "whiskers." All appendages, which are fastened to the ring with quills, are white with black markings, except for the fish, which have red mouths and gills, and the head at the top, with a red mouth. The appendages represent the following, top to bottom: pintail duck, wings, front seal flippers, salmon, duck feet, back seal flippers, and tail feathers of the bird. The eyes are not cut through. In earlier days, this kind of mask was also made in a small size to wear on the forehead, as in figure 152. Kiokan began making masks when he grew older and no longer hunted.

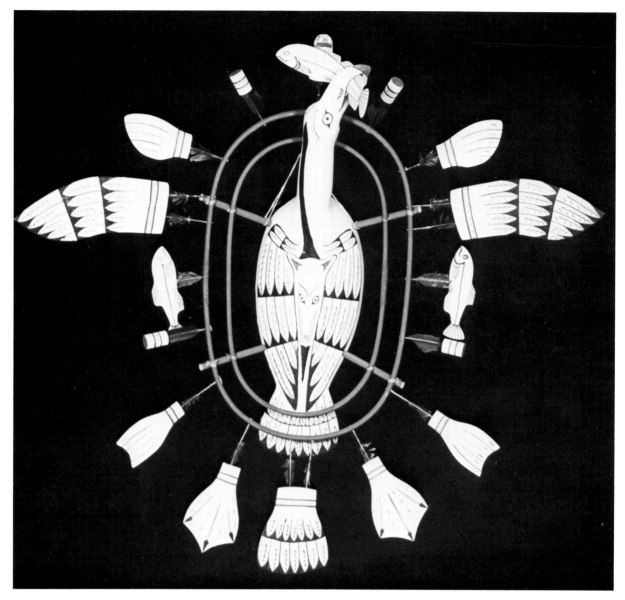

155. A very large loon-mask sculpture by Peter L. Smith, Mekoryuk, 1977. Height from tip of tail to beak: 28 inches (70 cm.). Collection of D. J. Ray. The bird and the appendages are basically white with black and red markings. The hoops are red. There are no eye holes in the mask, which is made to hang on a wall. (See "Peter Smith," *Kalikaq Yugnek,* spring 1975, pp. 41-44.)

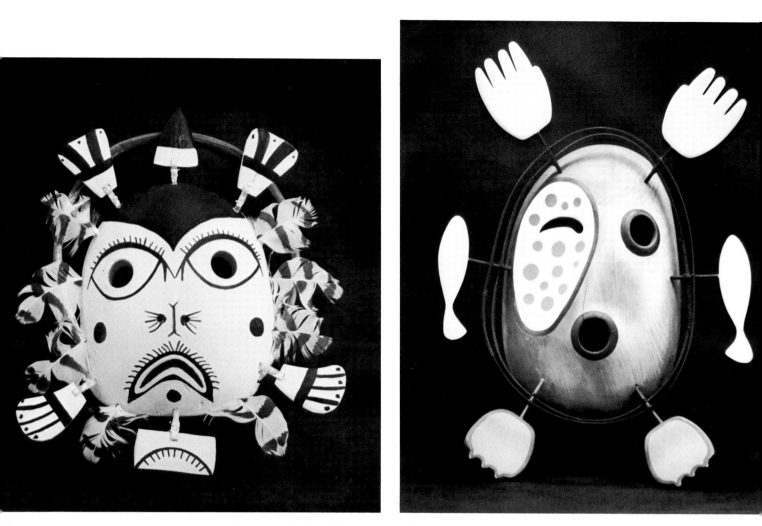

156. Seal spirit mask made by Joseph Friday, Chevak, 1974. Overall height, including appendages: 13¼ inches (33 cm.). University of Alaska Museum 74-77-1, purchased from his grandson, John Pingayak. The white and black colors are from commercial paints, but the red nose, mouth, and the three-fourths ring are colored with local earth pigments.

157. A modern interpretation of a nineteenth-century mask, by Edward E. Hofseth, Napaimiut, 1973. Height: 16½ inches (41.3 cm.). Anchorage Museum 73.22.9. This mask, which was displayed on the cover of the 1975-76 Anchorage telephone directory, combines features of two kinds of masks: the simple face mask of the mainland of southwest Alaska (as illustrated in Nelson 1899:pl. XCV-4) and hoops and appendages arranged in Nunivak style. The mask is painted in vivid colors: a greenish face with red cheeks, and red dots on pure white. The inside of the mouth and eyes are red with black and blue trim. The four upper appendages are white; the bottom two are red with blue trim. The hoops are black.

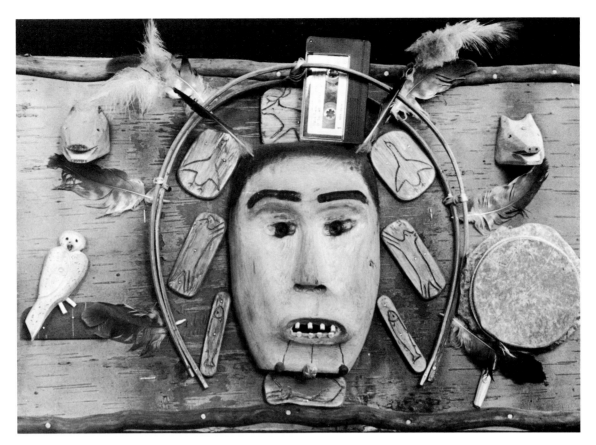

158. A mask sculpture, "Upisṅga," by Noel Polty, Pilot Station, 1975. The background board of birch is 28½ by 25½ inches (71.3 by 63.8 cm.). Collection of Rae and Sera Baxter. The various objects of wood (and a gut drum) are nailed to the board. The story of Upisṅga is recorded on tape, which I inserted into the top hoops for the photograph.

159. A "ring sculpture" made of wood by Edward Kiokan, Mekoryuk, probably 1950s. Length of the wood ermine: 11½ inches (28.8 cm.). Diameter of rings: 8½ inches (21.3 cm.). Anchorage Museum 72.63.24. Viewed from the top, this looks like a traditional Nunivak mask with two rings and appendages, except for the whole animal sculpture instead of a face. The fish is glued into the mouth. The Anchorage Museum has a similar sculpture by Harry Shavings, also of Mekoryuk.

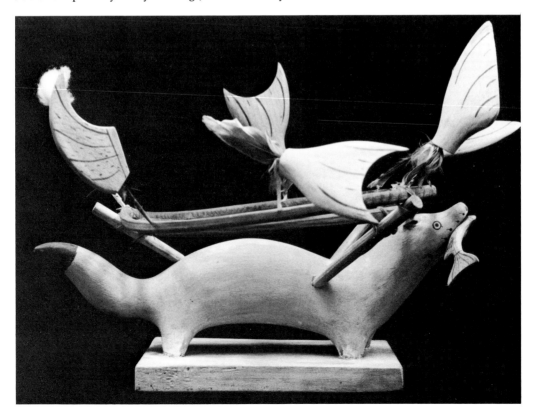

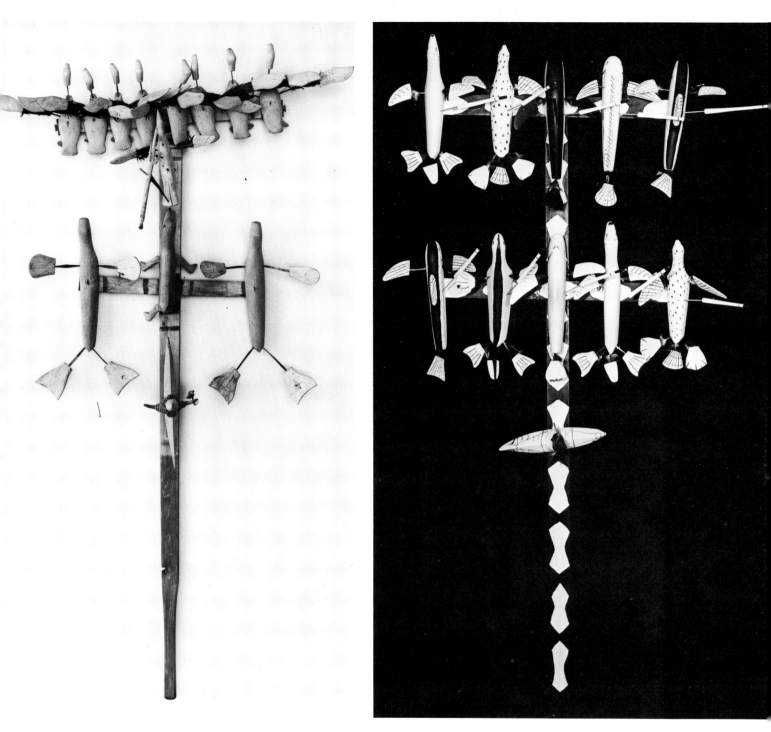

160. Dance stick of wood from Nunivak Island, 1924. Length: 57⅛ inches (145 cm.). National Museum, Copenhagen P.33.127. Collected by Knud Rasmussen. *Photograph courtesy National Museum of Denmark, Copenhagen*

161. A modern interpretation of a dance stick, made by Kay Hendrickson of Nunivak Island, while living in Bethel, 1976. Length: 51¾ inches (129.3 cm.). Length of crosspiece: 24 inches (60 cm.). Private collection. The carvings represent various kinds of whales, birds, and seals, and are predominantly white with black markings, although the top right two figures, and bottom left, have a red line and red dots on their sides. All wings and flippers are attached with quills. The figure is pegged through the kayak to the handle. Hendrickson made his first dance stick in 1961 (when he was fifty-two years old), the most elaborate one consisting of three crossbars, a handle length of 69¼ inches, and fifteen birds and one seal. Spears were always stuck into the animals or birds. For further information see "Masks and Other Wood Sculpture." The appendages of a dance stick illustrated in Davis 1949:figure 175 are attached with full feathers instead of quills.

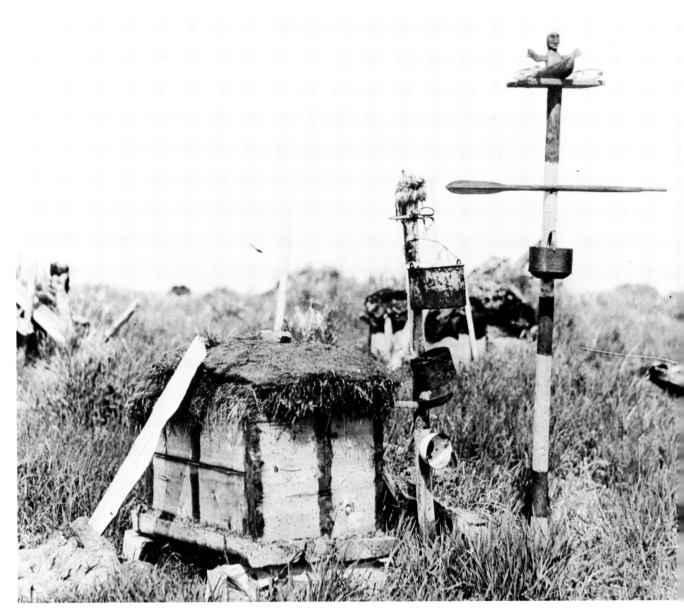

162. Effigy monument, Hooper Bay, photographed in July 1921 by Seymour Hadwin. Photography Collection, University of Washington Library, V. Garfield notebooks (Miscellaneous). This pole is probably the same one that E. S. Curtis photographed six years later (Curtis 1930:98). By then, the paddle, bucket, and one of the animal figures at the top were gone. There are several other photographs of graveyards and effigy monuments by Hadwin in the University of Washington collection.

163. Effigy monuments at Kinak on the Kuskokwim River, 1932. This is photograph number 8 in Clark Garber's manuscript report in the U.S. National Archives (1932), and is published as figure 10 in his article on mortuary customs (1934). The monuments have eaves-like projections.

164. Close-up view of the monument third from the right in figure 163. This figure wears her cherished ceremonial beaded cap and belt. The eyes and mouth of the face are inlaid with ivory. This face is similar to that illustrated in Lipton 1977:figure 182. For a close-up view of a different board monument, see Garber 1934:figure 9.

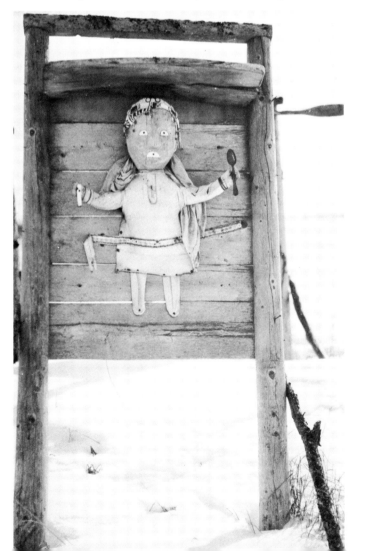

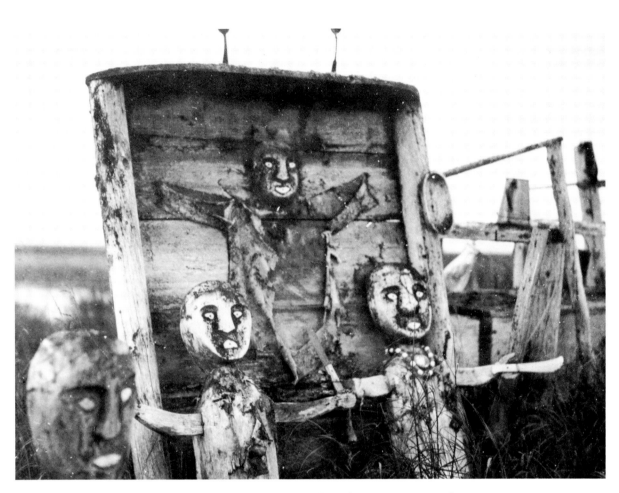

165. Effigy monuments at Nunachuk, 1932. The figure on the right wears a string of large beads, and what appears to be a brooch. It holds a butcher knife in the right hand and a storyknife in the left. A wooden bowl is hung above. The eyes and mouths of all faces are inset with ivory, and the hands on the two right figures are similar to the appendages on the old masks. (This is plate 19 in Clark M. Garber's report of 1932; also illustrated in his mortuary paper, 1934:fig. 11. For similar objects see *The Far North*:vii and fig. 160; Feder 1971:fig. 68; and Himmelheber 1953:pls. 24 and 26).

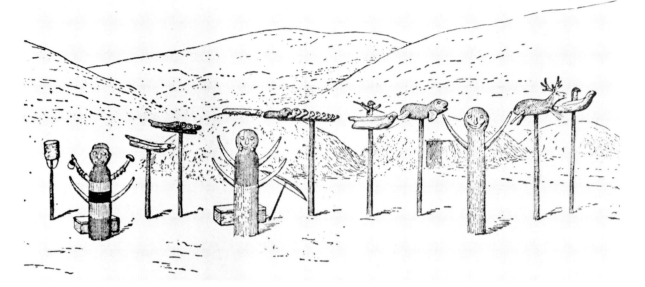

166. "Memorial Images at Cape Vancouver," 1878-79 (fig. 104 in Nelson 1899). Nelson saw these images at Tununak, where they were placed about twenty yards in front of the *kazgi* entrance, parallel to the ocean. The three largest were drift logs, six or seven feet high, and twelve to fifteen inches in diameter. Johan Jacobsen, who also saw these monuments in 1882, said that the tallest ones were twenty or thirty feet high. This height is not apparent in Nelson's sketch, but they may have been as tall as the pole at Hooper Bay in figure 162 (Jacobsen 1884:208-9; 1977:111).

The first post, which represented a woman, was painted *(from top to bottom):* red, white, black, white, red. The face had ivory eyes and mouth. An old fur hood clung to the head. Two walrus tusks, notched to hold objects, represented arms. The "arms" wore a number of iron bracelets, and on the tip of one was an *ulu* ("woman's knife") and on the other hung a small wooden dish. Another pair of tusks was attached near the "hips" to represent legs. The box behind the figure contained her clothing and a workbag. Near this was an iron bucket on a pole.

The middle large post represented a man whose arms and legs were also walrus tusks. The eyes and mouth were ivory, and the labrets, beads. The box behind him contained his clothing and small tools. A bow and quiver of arrows were fastened to the base of the post.

Wood carvings on four posts behind him gave a capsule biography of the man represented in the post. It was explained to Nelson that the models of the umiak and the four kayaks (to his right) meant that he had made and owned them. The nine wooden models of the seals (to his left) represented the result of his best day's hunting; and the kayak with the man in it "showed that he had been a hunter at sea."

The third post with a human head was very old and dilapidated. It, too, had facial features inset with ivory, and had two tusks for arms, but no legs. On the poles behind him were a large seal, a caribou, and a man in a kayak, all of which meant he was a good hunter on both land and sea, "especially at sea" (Nelson 1899:317-18). These images, as discussed in chapter 3, "Effigy Monuments," were erected in memory of persons whose bodies had not been recovered.

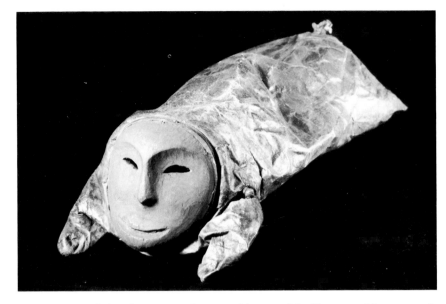

167. A shaman's hand puppet, a fox pup skin turned inside out, with a rust-colored face made of wood, probably Yukon River, early twentieth century. Collected by George T. Emmons. Length: 14 inches (35 cm.). Alaska State Museum II-A-3070. Feathers of old squaw duck tipped with swan's down were once attached around the face. According to Emmons' notes in the Alaska State Museum, this object was "carried in the hand and could be inflated or deflated at will." Accordingly, the right rear leg has an inserted plug. *Photograph by Alfred A. Blaker*

168. Two human faces in wood, used as protective spirits in a Nunivak Island kayak. Height of each: about 6¾ inches (16.8 cm.). USNM 340,373 (Stewart and Collins collection). Two somewhat similar faces were recently made as port and starboard cockpit coaming stanchions, and illustrated by David W. Zimmerly. The port *(left)* side was associated with bad luck and femaleness (downturned mouth), but the starboard *(right)* side was connected with good luck and maleness (Zimmerly 1979:85). *Photograph from the Smithsonian Institution*

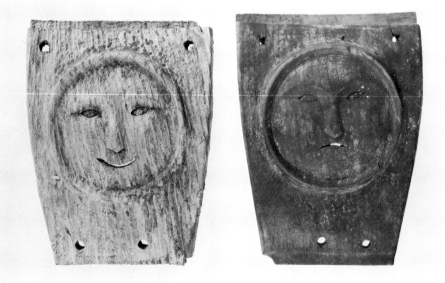

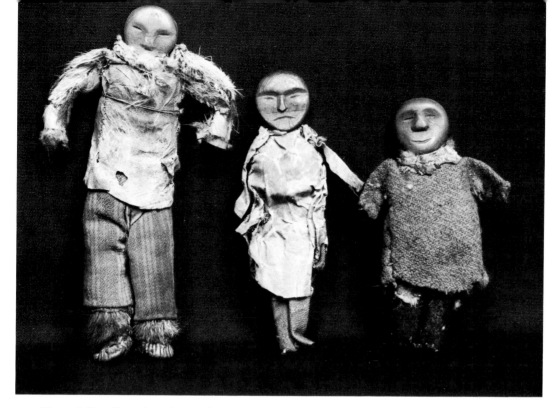

169. Three dolls collected on the Kuskokwim River before 1915. Height of left figure: 6½ inches (16.3 cm.). Washington State Museum *(left to right)*: 4838, 4837, 4839. All have wooden faces. The two on the left have fish skin coats.

170. Human head and torso of wood, Hooper Bay. Height: 5½ inches (14 cm.). USNM 390,554. Although this was collected by Aleš Hrdlička in 1937, it undoubtedly dates from an earlier time. This may have been a shaman's figurine since the chin and face up to the cheekbones, and above the eyes, have been painted red. The eyes are uneven, and there is a hole on both sides of the head.

171. Wood float for a fish net, Kuskokwim River, 1907, collected by G. B. Gordon. Length of base: 9⅜ inches (23.5 cm.). University Museum (University of Pennsylvania) NA-1504.

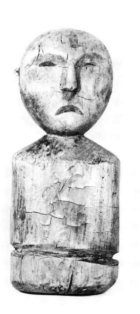

172. Wooden net float in shape of a seal from Nash Harbor, Nunivak Island. Length: 24 inches (60 cm.). University of Alaska Museum 2-396. A white rock is set into the bottom, possibly as an amulet.

173. Drum handle in shape of a puffin's head, Nunivak Island. Collected in 1952 by James W. VanStone. Length: 10¾ inches (26.8 cm.). University of Alaska Museum 554-5448b. The handle is wood, and the beak is painted red and the head, black. One of the drum handles in the model dance scene, figure 114, is a puffin head.

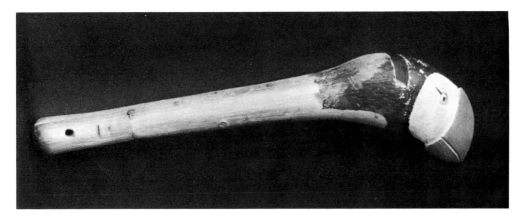

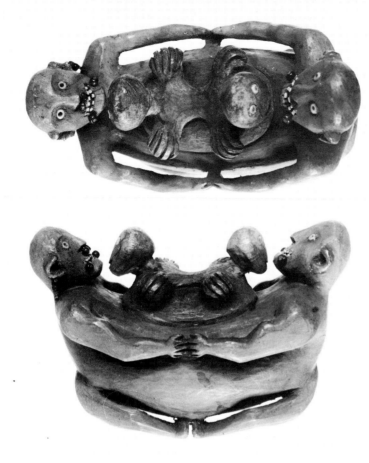

174. Wooden snuff box from the Yukon River, collected by L. Zagoskin in the early 1840s. Length: 4¹¹⁄₁₆ inches (12 cm.). MAE 537-46. Carved in one piece, the body of the box is formed by two persons facing each other. The heads and arms of two children form the lid. Small beads are used as eyes and facial ornaments (Zagoskin 1956:451). A dish collected by I. G. Voznesenskii on the lower Yukon River in 1845, and illustrated in *The Far North* (fig. 112, MAE 493.45), undoubtedly came from the same village, and might have been made by the same man. In that carving (which is about twice the length of this box), two figures, in similar position to these, are holding a wooden bowl between them. *Photograph courtesy MAE, Leningrad*

175. Wooden snuff box made of three cylinders with the portrait of a man and a woman in bas-relief on each part. Collected by L. Zagoskin on the Yukon River in the early 1840s. Height: 2 inches (5 cm.). MAE 537.42. The faces are red, edged with a black line. The man wears labrets, has a turned-up mouth, and oval eyes. The woman has a downturned mouth and thick crescent-shaped eyes, probably of ivory. *Photograph courtesy MAE, Leningrad*

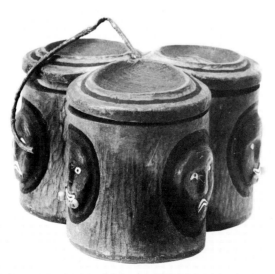

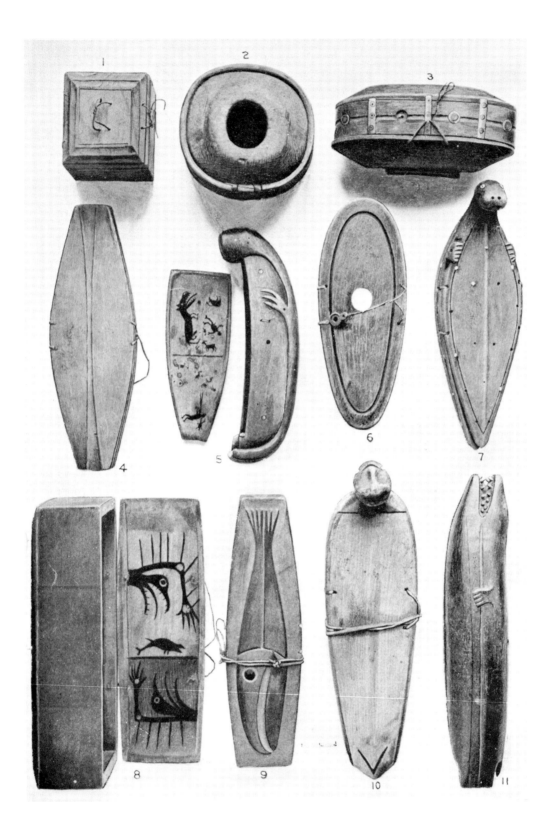

Facing page:

176. "Tool and Trinket Boxes," collected by E. W. Nelson, 1877-81. Length of number 7: 12 inches (31 cm.). All are in the U.S. National Museum. This is Nelson's plate XLII in *The Eskimo about Bering Strait.* All are made of wood, and are from southwest Alaska with the exception of numbers 1 and 2, which are from Sledge Island and Saint Lawrence Island. Nelson describes these boxes on pages 94-100:

(3) Sfugunugumut; woman's workbox. (4) Askinuk; tool box; inside the cover are men, sledges, wolves, caribou, and other animals painted red and black. (5) Ikogmiut; woman's workbox; a "semihuman face" is carved in relief on the lid, and the inside is painted with an assortment of human figures and mythical animals. (6) Anogogmut; tool box, painted red with black grooves; a piece of white porcelain is set into the cover. (7) Sfugunugumut; tool box; see figure 177. (8) Koñigunugumut; woman's workbox; the sides of the box are red, and the drawings inside the cover are black. (9) Sabotnisky; woman's workbox. (10) Sfugunugumut; tool box; representing a mythical being with the body of a seal, but a human head. (11) Pastolik; tool box.

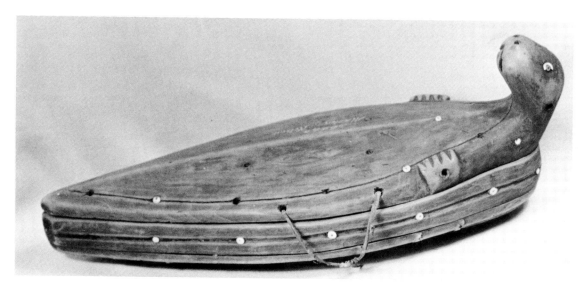

177. A different view of number 7 in figure 176.

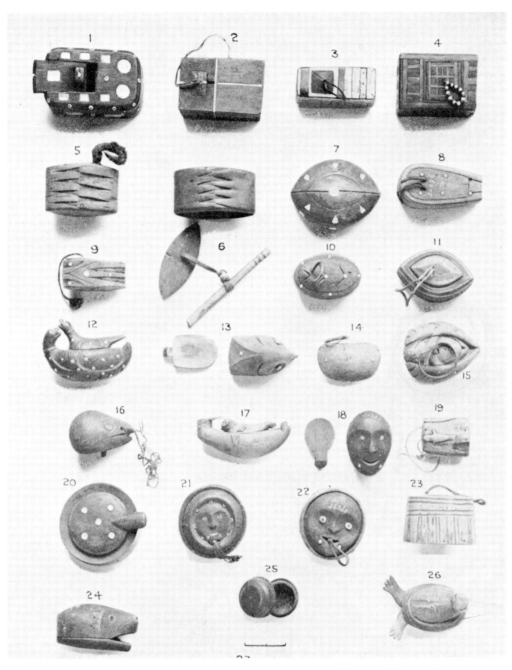

178. "Tobacco and Snuff Boxes," 1877-81, collected by E. W. Nelson and deposited in the U.S. National Museum (Nelson 1899:pl. LXXXVI). All are from southwest Alaska with the exception of 1, 19, 23, and 25. All are made of wood except 3, 19, and 23, which are ivory; number 5, which is birchbark; and number 6, which is leather and baleen. Nelson called numbers 8-10, 13, 14, 16-18, 22, 24, and 26 quid boxes. The rest are snuff boxes.

(2) Nulukhtulogumut; the lid is on the left, and is black; the right side is red, and the white strips are inlaid pieces of ivory. (3) Nunivak; made of ivory and brass. (4) Nunivak; wood with many pieces of inlaid brass. (5) Kashunuk; birchbark with wooden top and bottom. (6) Saint Michael; leather covered with baleen. (7) Kashunuk; white crockery insets. (8) Chalitmut; inset with many ivory pegs. (9) Anogogmut; birch wood, with pieces of crockery and beads. (10) Kashunuk; with ivory pegs; the box is bluish with red grooves. (11) Kashunuk; alternating black and red stripes are on the sides

194

and the top and bottom are a dull blue. (12) Lower Yukon; two seals with pieces of ivory and white beads imbedded; bird quill is around each neck. (13) Kulwoguwigumut; supposed to be "a grotesque figure of a porcupine"; eyes and pegs are ivory. (14) Kashunuk; each end has incised features of an animal's face, with white beads as eyes and nostrils. (15) Chalitmut; two seals, joined at the tails and painted red, are carved in high relief on either side of the box. (16) Nunivak; represents a murre's head; the cover, which is the jaw and throat, is lifted by the mandible. (17) Askinuk; a young walrus forms the lid of this box in the shape of an adult walrus; both walruses have tusks of bone, although one tusk of the larger animal is wood; the large walrus has red bead eyes; the small one, white. (18) Chalitmut; the face is red, and the cover, which is at the back of the head, is bluish. (20) Kaialigamut; with five ivory plugs. (21) Anogogmut; both the top and bottom of this red box are human faces with eyes and mouth of ivory. (22) Kashunuk; with eyes and labrets of ivory. (24) Chalitmut; a bear's head; one eye is an incised circle, and the other, an incised oval with a piece of glass set in; the cover is taken off by means of the lower jaw. (26) Askinuk; a seal, the head of which is used to lift the lid.

179. A well-made bentwood container in imitation of a Russian copper kettle, from the lower Kuskokwim River, possibly late nineteenth century. Height: 15 inches (38.5 cm.). Alaska State Museum II-A-4102. The kettle is painted black with red bands, and is fastened together with split root strips and wooden pegs. The top and the lid have insets of small round pieces of ivory. *Photograph by Alfred A. Blaker*

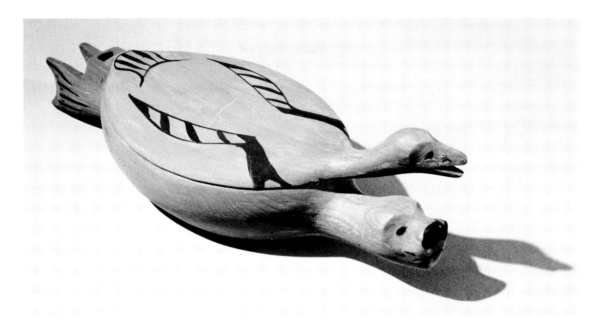

180. A modern interpretation of a lidded box in animal shape, from Nunivak Island, about 1960. Length: 9 inches (22.5 cm.). IACB W/X.120. This quid box is made of driftwood, painted red with black. *Photograph courtesy Indian Arts and Crafts Board*

181. A pottery jar made in Toksook Bay, 1974, with a carved wood and ivory knob on the lid. Height: 7 inches (17.5 cm.). IACB W-76.3.2. These pots were made in various sizes, and like the baleen baskets of the north, have a variety of carved handles on the lids. *Photograph courtesy Indian Arts and Crafts Board*

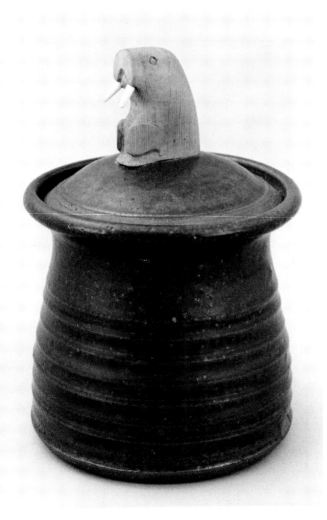

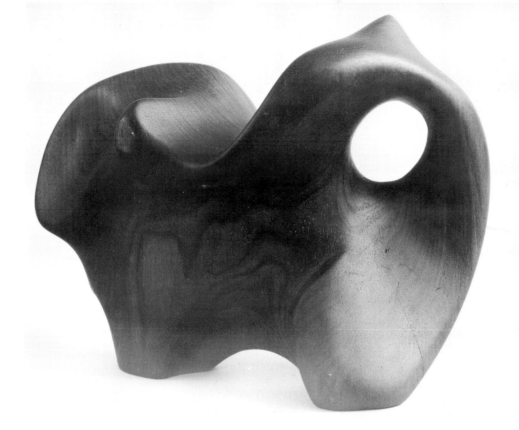

182. An untitled rosewood sculpture by Edward E. Hofseth, Napaimiut, 1973. Height: 7 inches (17.5 cm.). IACB W-73.29.1. *Photograph courtesy Indian Arts and Crafts Board*

183. "The Hunter's Story," a soapstone sculpture by Louis Chikoyak, Tununak, entered in the tenth Alaska Festival of Native Arts, 1975. Height: 7½ inches, including base. Collection of Kenneth M. Petersen. *Photograph courtesy the Anchorage Historical and Fine Arts Museum*

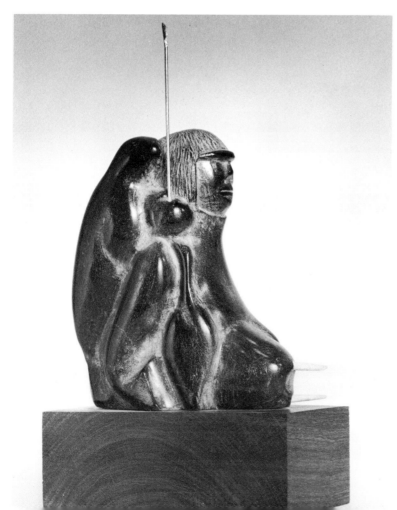

184. "The Story," a sculpture in alabaster, photographed with the artist, John Kailukiak, when he was an intern at the Visual Arts Center in 1974. Height: about 21 inches (52.5 cm.). See also Shalkop 1978 (fig. 2) for a sculpture in ivory by Kailukiak. *Photograph courtesy the Visual Arts Center of Alaska*

185. Wooden spoon from the Kuskokwim River, late nineteenth century. Overall length: 17½ inches (43.8 cm.). Length of the animal is five inches. Collection of D. J. Ray. The bowl, the back and sides of the entire spoon, and part of the handle, are painted a rust color. The designs are black. There are two sets of "X-s" on the handle against a tan background.

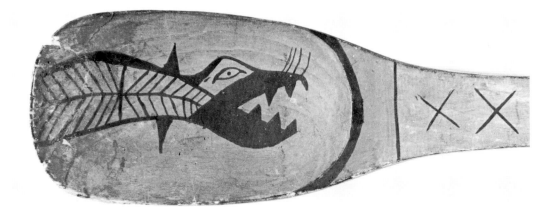

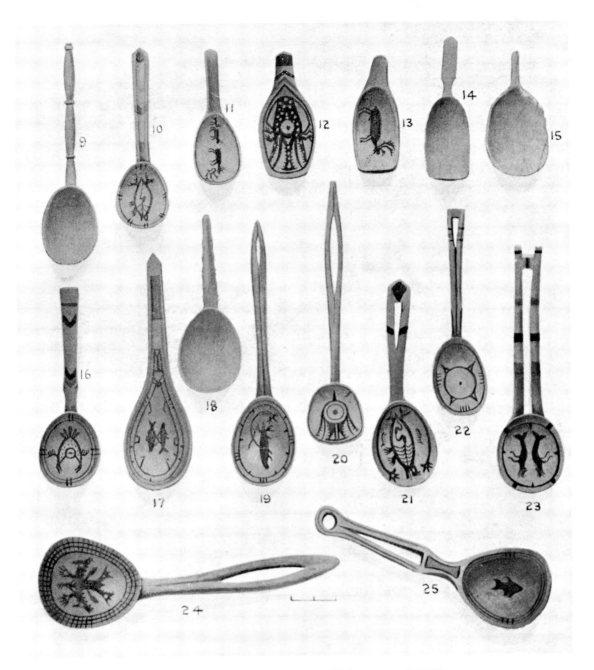

186. "Spoons and Ladles," from *The Eskimo about Bering Strait* (Nelson 1899:pl. XXX). Numbers 1-8 are mostly plain, undecorated spoons, and numbers 15 and 18 are from Saint Lawrence and Sledge islands. Described by Nelson, pages 65-70. Number 25 is about 10½ inches (26.2 cm.) long.

(9) Koñigunugumut. (10) Chalitmut; X-ray view of a seal painted black. (11) Kulwogu-wigumut; three caribou and a pair of antlers are on the bowl. (12) Kaialigamut; "a conventional representation of a wolf-like animal." (13) No provenience. (14) Kashunuk. (16) Kuskokwim; a two-headed mythical creature. (17) Sabotnisky; two fish, painted black, are in the bowl. (19) Lower Kuskokwim; a seal with a spear in its back. (20) Cape Vancouver; a mythological animal in black. (21) Sfugunugumut; X-ray view of a seal, almost surrounded by a U-shaped line, which terminates at either end in a hand with a hole in the palm. (22) Sfugunugumut; a design similar to those used on women's earrings. (23) Chalitmut; the twin figures represent the "hybrid animal known in Eskimo mythology as the metamorphosis of the white whale into a combination of wolf and whale." (24) Chalitmut. (25) Paimut; very deep bowl, black designs.

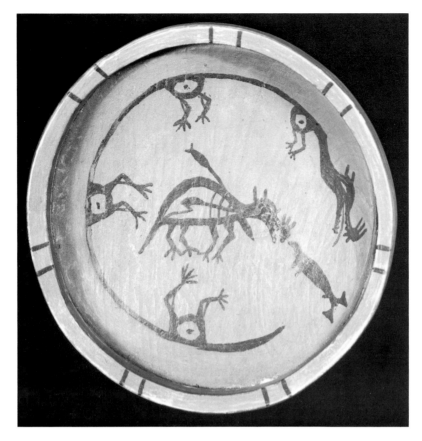

187. A small shallow dish with the *palraiyuk* and other mythological creatures, from the mouth of the Kuskokwim River, late nineteenth century or early twentieth century. Collected by George T. Emmons. Diameter: 5 inches (12.6 cm.). Alaska State Museum II-A-1824. The figures are black on a rust-colored background. *Photograph by Alfred A. Blaker*

188. Wooden scoop, probably from the Kuskokwim River, early twentieth century. Length: 19½ inches (48.8 cm.). Alaska State Museum II-A-1803. The figures, which are an incongruous mixing of traditional subjects and playing-card designs, are painted in black and red. The handle is a bird's head. A black hand, twelve inches long, with a hole in the palm, is painted on the reverse side. *Photograph by Alfred A. Blaker*

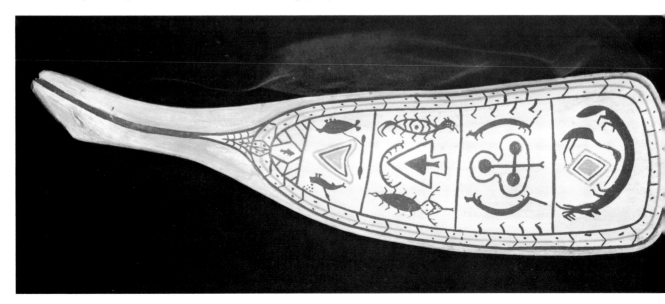

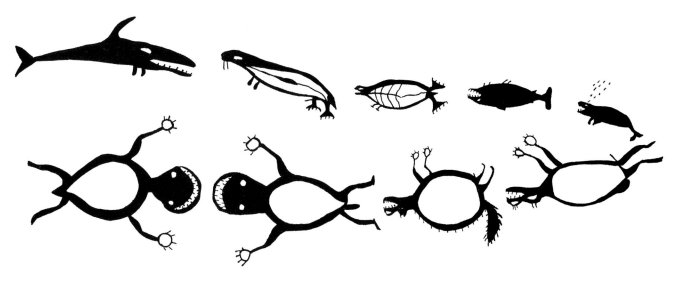

189a. Designs taken from a wooden paddle, Kuskokwim River, 1890s. Collected by Sheldon Jackson. Length of the paddle: 21⅝ inches (54.9 cm.); length of the "fish," upper left: 3¹⁄₁₆ inches (8 cm.). Sheldon Jackson Museum II.S.3.

189b. Photograph of the broad tip end of figure 189a, showing the character of the painted objects on wood. *Photograph by Alice Postell*

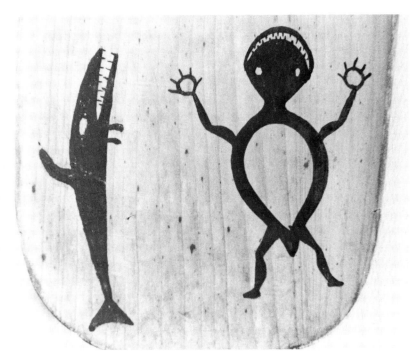

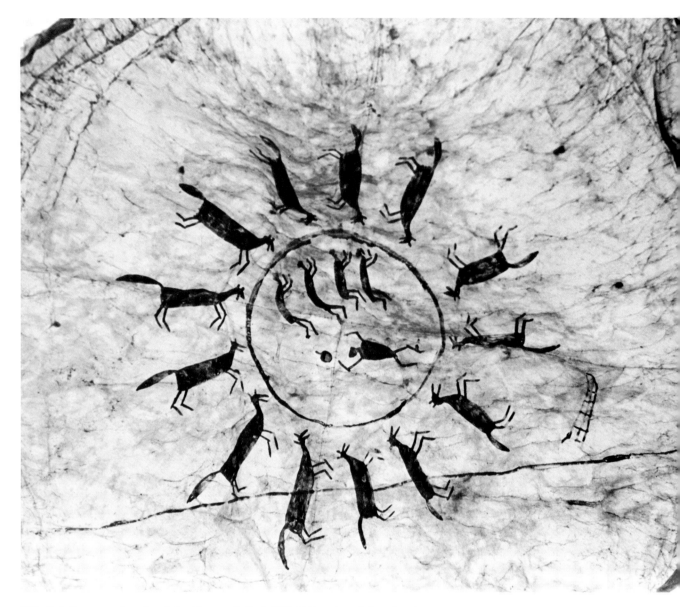

190. Painting on a drumhead, by Gusma, Bethel, 1937. Diameter of drumhead averages 25½ inches (63.8 cm.). Widest diameter of the circle: 6½ inches. University of Alaska Museum 67-293. Collected by Hans Himmelheber during the course of his research at Bethel and Nunivak Island. Another photograph of this drumhead is illustrated in his *Eskimokünstler* (1953:pl. 12) with the caption, "Dreadful experience of a widow with a pack of wolves." The "dreadful experience" is drawn with black paint. *Photograph by Barry McWayne, courtesy University of Alaska Museum*

191. "On Zion's Hill," a hymn in picture writing, by Katherine Toots, Nunivak Island, explained by Hilma Shavings.

1. *On Zion's hill* (a hill) *a mansion stands* (a house) *for all* (loons, which mean "all" because loon means the same in Eskimo), *the pure* (towel, "to clean") *and blest* (two men are "blest"). *We know it was not made* (small man and object, "something made") *with hands* (first hand). *Up there* (hand pointing up, and a dot means there) *the soul may rest* (man sitting).

Chorus: *On Zion's blessed hill* (two hills) *the soul's eternal* (a "V" on its side, "the ends go on forever") *home; God's voice* (face speaking) *is softly calling still* ("perhaps something at rest, standing still") *to rest beneath that dome* (house with people in it).

2. *No sun or moon is shining there* (a sun, a moon, and a dome with a dot inside—"not shining— hiding") *to light the streets of gold* (a circle for a light; lines for the street; and coins, i.e., "gold"). *The Lamb's* (a reindeer) *own light* (a moon, "because light sounds like moon in Eskimo") *so wondrous fair* (a person with raised hand) *the saints* (figures in supplication) *with joy* (arms upraised) *behold* (an eye).

3. *To meet you* (people) *there* (hand and a dot, "not up but there") *I mean to live* (a person) *while here on earth I stay* (a man on a line representing the ground), *There Christ* (figure with cross on his head) *a welcome* (a kayak bow, "to welcome; when come by kayak to a strange place, are pulled up to shore by the hole, and welcomed") *sweet will give for one eternal* ("the ends go on forever") *day* (sunrise).

The Bible verses, Philippians 4:4-7, written by Lily Savok of Buckland and Nome, are illustrated in Ray 1977:fig. 277, and, with a complete explanation of the symbols, in Ray 1971a.

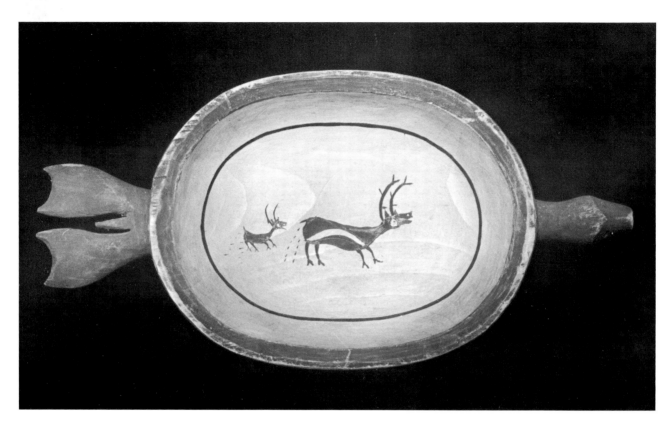

192. Wooden dish representing the body of a seal, with head and rear flippers on
opposite ends, and drawings of caribou in the bowl, Nunivak Island, probably 1940s.
Overall length: 10⅜ inches (25.9 cm.). Private collection. Black on rust background.

193. Wooden eyeshade from Nunivak Island, 1960s, with drawings of a musk ox head
and two caribou or reindeer with diagrammatic ribs and stomach. Length: 6 inches
(15 cm.). Private collection. When the eyeshade is worn, the painted figures are in a
horizontal position, since the eyes look out of an open slit between the top rim and
a parallel piece of wood. The depth is 1⅜ inches (3.4 cm.). The figures are black on
an off-white background, and the border is rust.

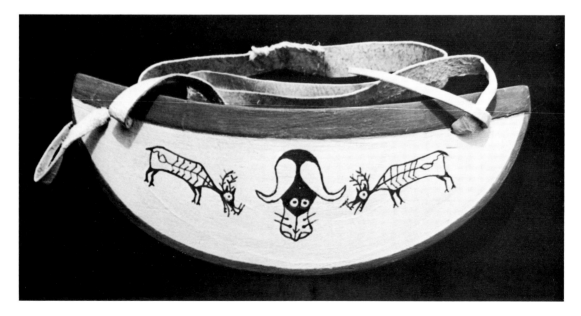

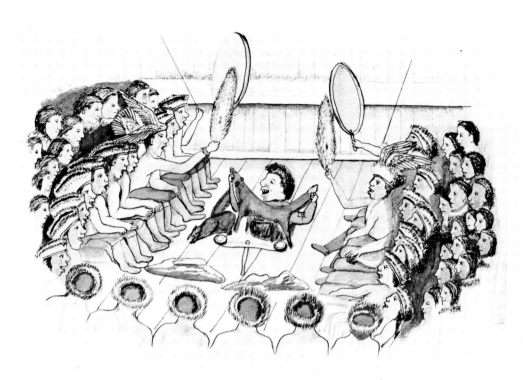

194. A drawing in watercolor and crayon by Guy Kakarook, Saint Michael, 1903. Dimensions: 9¾ by 9 inches (24.3 by 20 cm.). Office of Anthropology, Smithsonian Institution 316702. See "Kakarook, Eskimo Artist" (Ray 1971b) and Phebus 1972, for drawings by Kakarook's Eskimo contemporaries. *Photograph by Smithsonian Institution*

195. Drawing on birchbark by Milo Minock, Pilot Station and Bethel, 1976. Dimensions overall, including plywood background: 9½ by 5¾ inches (23.8 by 14.3 cm.). Collection of D. J. Ray. The pieces of wood are glued on.

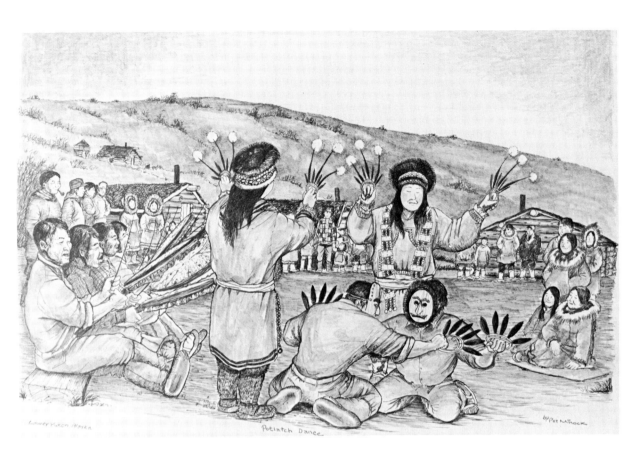

196. "Potlatch Dance," lower Yukon River, an ink drawing by Pat Minock, Pilot Station and Anchorage, 1978. Dimensions: 14 by 11 inches (35 by 27.5 cm.). Collection of D. J. Ray.

197. "Yaqulget," a print in yellow, black, and white by Chuna (Tom McIntyre), 1978. Dimensions: 12½ by 10 inches (31.3 by 25 cm.). Collection of D. J. Ray.

198. Peter L. Smith making a loon mask, Mekoryuk, May 1976. He is drawing the chisel toward him. It takes him three or four days to make this kind of mask.

199. Kay Hendrickson of Mekoryuk carving an animal for one of his dance sticks, photographed in Bethel, 1976.

200. Andrew Noatak, ivory carver and mask maker, Mekoryuk, 1976.

201. Edward E. Hofseth with a painting, "The Eskimo Dancers and Masks," post office, Fairbanks airport, 1975. *Photograph by Lens Unlimited, courtesy Edward E. Hofseth*

202. Peter L. Smith's pile of driftwood, used for making masks, Mekoryuk, 1976.

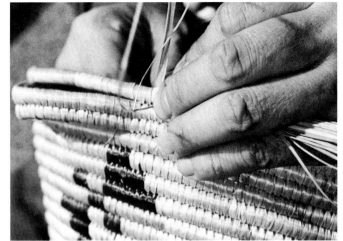

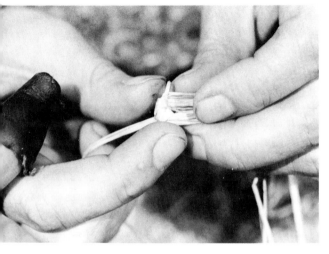

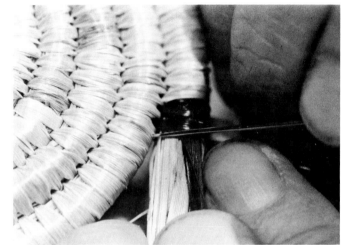

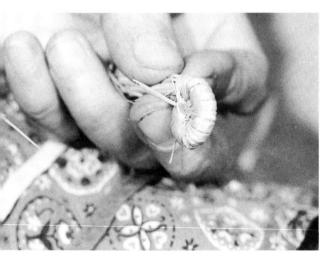

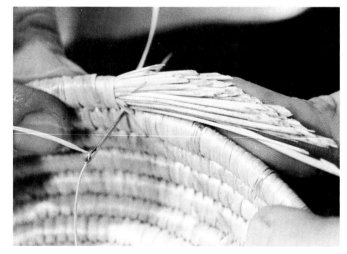

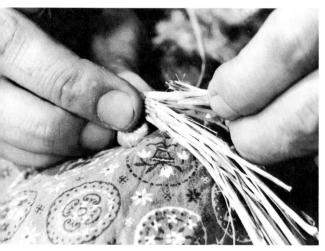

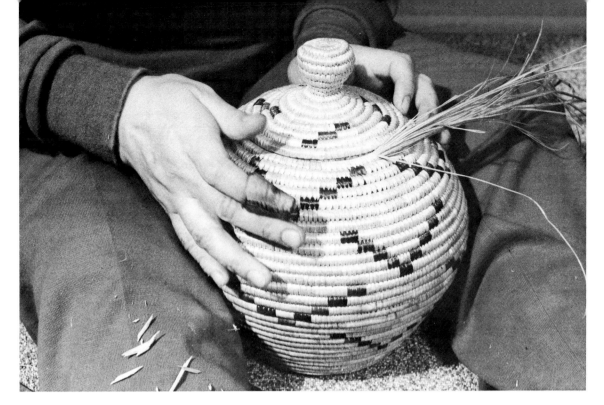

203-10. Steps in making a coiled basket, selected from a traveling photographic exhibit in 1973-74, "Eskimo Coiled Basketry," sponsored by the University of Alaska Museum with a grant from the Alaska State Council on the Arts. The original exhibit consisted of thirteen large black and white photographs of a Stebbins woman making a basket, taken by Barry McWayne, which were mounted on large cardboard panels with explanatory captions. In this text, the original captions to the selected photographs are quoted verbatim, while some of the captions to the photographs not used are paraphrased for continuity.

The first panel lists the materials needed for making a coiled basket: a steel needle with a large eye, a container of water for dampening the grass from time to time, and a steel or leather thimble.

Facing Page:

(203) "Several pieces of grass are selected and then split with the needle and dampened." After that, a piece of sewing grass is split down the middle, the rib being discarded.
(204) "A bundle of four or five pieces of split grass are wrapped with a piece of sewing grass and bent into a rough coil. The coil is known as the 'foundation.'" The needle is then threaded with a piece of sewing grass, and pushed through and around the foundation, bending it to the inside, forming an almost complete coil, with the ends of the foundation grass protruding from the open end.
(205) "The end of the sewing grass is inserted on the exact spot where the first ended. The sewing grass is kept untwisted so that it will lie flat over the foundation."
(206) "Two or three pieces of foundation grass are split and added to the coil from time to time when it begins to thin out."
(207) The foundation grass is bent out and wrapped with a piece of sewing grass when handles are added to a basket. "Another handle coil is sewn to the first and then the body of the basket is continued."
(208) "Dyed grass is added three or four stitches at a time, depending on the design planned by the maker. The dyed grass is bitten off with the teeth."
(209) "When a basket is ready to be finished, the ends of the foundation grass are tapered off with a pair of scissors or a knife."

Above:

(210) "When a lid is completed, it is fitted on to the uncompleted basket so that the maker can insure a perfect fit when the basket is done." (See also fig. 84 for Stebbins basketry.)

Appendix A

Additional Captions to Illustrations

Figure 100. Top, left to right: (48711) Rasboinsky; the legs have been broken off, and there is a hole in the top of the head with a piece of wood inserted; similar to number 32914 from Norton Sound in figure 99. (47040) Rasboinsky; a groove is made all around behind the face, and another from the neck to the bottom in the back, which is flat. (48710) Rasboinsky, black incised eyes, nostrils, mouth, and labrets. (49005) Sabotnisky; arms and fingers are carved; there is a groove behind the face and down the back, and a hole in the top of the head. (49006) Sabotnisky; of dark brown ivory; the right hand is placed at the middle of the chest, and the left one, to the back; the face is almost obliterated.

Bottom, left to right: (48709) Rasboinsky; slightly hollowed out at the bottom. (48713) Rasboinsky; with incised facial features; there is a hole at the genitals, one beneath each ear, and a slight depression on the top of the head. (69067[?]) Rasboinsky; like numbers 47070, 49005, 48907, and 48908, it has a groove all around behind the face, but has a blue string in the groove and wound around the neck. (48907) Sabotnisky; flat on the back with a groove made around the face. (48908) Sabotnisky; with a face much larger in proportion to the body or bust than most; there is a groove round the head, and the navel is inlaid with some substance; the figurine has been broken and repaired with a piece of wood.

Figure 101. Left row, top to bottom: (127374) Togiak River; face with inset eyes; the mouth is not colored. (56055) Bristol Bay; bird with a hole in each side and at the top of the head; a hole from top to bottom is filled with cork. (55909-A) Bristol Bay; two beavers (?), collected by C. L. McKay, 1882. (55909-C) Bristol Bay; frog. (55909-A) Bristol Bay; beaver (?) with pegged-in legs; the tail has cross-hatching on both sides.

Second row, top to bottom: (127451) Togiak; seal, probably used as a button since there is a small knob underneath for fastening; the holes are filled with dirt. (72902) Nushagak walrus. (30780) Bristol Bay; human bust. (7929[4?]) Bristol Bay; an animal that stands on four tiny legs. (55909-B) Bristol Bay; two whales, collected by McKay; both have a black line incised on each side.

Third row, top to bottom: (38357) Big Lake; with incised "eyebrows," and two tattoo marks; the design on the front may indicate female genitalia. (36229) Big Lake. (36227) Provenience unknown; behind this face is another one with an open slanting mouth, a slanting slit for the right eye, and an oval for the left eye.

Fourth row, top to bottom: (36892) Lower Kuskokwim River; seal with a characteristic long double side "fin" terminating in front and back fins. (38143) Yukon River; seal with a hole through the sides and through the front of the mouth and under the chin; the design is carried onto the reverse side. (36480) Kuskokwim River (?); seal, collected by E. W. Nelson, 12 cm. long; the tiny face has an incised mouth, nose, nostrils, and the nucleated circles are made like a necklace round the neck.

Fifth row, top to bottom: (36895) Kashunuk; head with unusual headdress. (36880) Provenience unknown; frog with dirt-filled dots. (36913) Kashunuk; walrus with inlaid eyes; scooped out beneath. (36225) Kashunuk; bust, triangular in cross section; there is a wooden plug in the top of the head, and the dots are blackened.

The seal on the right (37975, and 12 cm. long) is from Kashunuk. It has inlaid eyes, a hole through the sides, a well-defined face, and a piece cut out of the back.

Figure 102. All are from Cape Vancouver (Tununak). *Left row, top to bottom:* (43572) This small sculpture of a face, only 3.8 cm. high, has very noticeable labrets with a hole in the center of each; what appears to be a topknot is actually an animal's head (also illustrated in *The Far North,* fig. 94). (43571) This face is made from a walrus tooth.

(43617) The hole at the armpits go through; eyes, nostrils, and ears are merely dots, and legs are indicated only by an incised line. (43517) All facial features are incised except the nose, which is carved with green beads hung from the nostrils; cloth is wrapped around the block body, which is flat on the back.

Second row, top to bottom: (43576) Bird with black incised lines. (43570) Four parallel lines are made as tattoo marks on the chin, and a hole is in the middle of the headdress. (43671) A face with prominent eyebrows, a carved nose with what appears to be both lip and chin tattooing, and labrets; the head is hollowed out lengthwise. (43573) This is the side view of a man's head. (43574) Bone figure with black incisions.

Third row, top to bottom: (43575) This highly polished bird of very yellow ivory will stand up; the outside circles of its eyes are blue, the pupil is of inset brown ivory, and behind each eye is a red curved line; a hole passes through the body. (60381 [36081?]) Walrus head. (43556) Seal with ribs and stomach incised on the top. (43592) Mythic creature (?). The incisings on the side photographed are red; but on the reverse side, ribs are incised along the entire length in black. (43541) Head of a bird, with incised lines colored blue; the pupil of the eye is wood, colored red; and on the reverse side, six chevrons are placed on a line, all black. (43508) Bird head, with both sides alike, black lines, and brown ivory insets in the eyes. (43529) Head of a bird with brown insets; although I have called these objects bird heads, one or more may represent a salmon, as indicated by Nelson on storyknives (1899:pl. XCIV).

Fourth row, top to bottom: (43563) Walrus, with its face and six dots on each cheek incised in black. (176148) Undecorated walrus face. (4459?) Seal with well-carved flippers, and a mouth hole that goes through to underneath the chin. (43564) An ornamented walrus lying on an object that has a design on the front similar to the circles on the walrus; all centers of circles, including three on the top, are inlaid with a brown substance; the face has four dots on the right side of the mouth, and two on the left. (43553) Seal with row of dots down the center of the back and round the neck, and many other dots placed indiscriminately on the face and sides, all colored black. (43555) Seal; mouth is a big hole that comes out under the chin. (43445) Seal.

Fifth row, top to bottom: (43568) Whale, with three rows of black dots underneath. (38762) Whale. (43589) Beluga (white whale). (43601) Whale, with a wooden plug in the mouth. (43581) Mink, with legs and ears inserted; a hole is pierced through the cheek, and a blue substance is in the eyes, ears, and mouth. (43585) Otter; the centers of the circles (including one under the chin) are wood, painted red, as are the circular lines; the straight lines are green. (43579) Wolverine, with legs inserted into the holes.

Figure 105. *Top row, left to right:* (60.1-4080) Kuskokwim delta; kayak guard, with black markings, collected by G. T. Emmons in 1916; other kayak guards are illustrated in figure 106. (N520) Norton Sound; "from Gen. Lyons' collection, 1866," called a "mythological seal" (this is a sea otter, not usually found in Norton Sound); the holes are inlaid; there are no ears, and the reverse side is excavated, leaving a longitudinal ridge with two holes in it for fastening. (60-5829f) Button from "Alaska"; the face has dots, apparently to represent whiskers. (T22765) Kodiak Island; "duck," collected in 1882 by William J. Fisher; the curved wing design is unusual; a triangular piece is cut out of the tail. (60-5824) "Gun charger of ivory representing eagle's head," received from G. T. Emmons, 1906.

Bottom row, left to right: (T22348) Norton Sound; wolf head (?), with deep, blackened eyes, and said to be a toggle, collected by William J. Fisher, 1880; the gashes on the muzzle apparently were once colored red. (T22349) Norton Sound toggle; a man in low relief on the back of a seal, collected by Fisher in 1880; the seal's face has dashes for "whiskers," and the eyes, nostrils, and ears have inlays (see also figure 111; Nelson illustrated an ivory sculpture of a man lying face down on the top of a bear, his feet in the bear's mouth, and his arms around its rear legs, also from Norton Sound [Nelson 1899:346-47]). (60.1-4721) The catalog states that this figure was from "Etah, Comer, Crocker Land Expedition, 1917," but is included in this photograph because of its similarity to objects from southwest Alaska, especially the "X-ray view" of ribs and stomach on the reverse side. (T22402) Norton Sound bird, collected by Fisher in 1880, which has feet, but will not stand up; there is a hole through the tail, and a simple design of a straight line and two parallel dotted lines on the reverse side.

Appendix B
Village Identification

ISLANDS

Aleutian Islands. The Aleutian Islands extend from the Alaska Peninsula (a long extension of the mainland into the Bering Sea) to Attu Island, a distance of 1,100 miles. Attu, 1,800 miles from Anchorage, is almost 1,200 miles southwest of Nome. Aleuts also live on the Alaska Peninsula as far east as Port Moller, where Eskimo territory begins. The Shumagin Islands, south of the Alaska Peninsula, are also occupied by Aleuts. Unga Island, where Alphonse Pinart found the mask in figure 40, is only forty miles northwest of Bird Island, where Bering's expedition first saw Aleuts.

There are two Aleut dialects, the eastern and the western, with the division between the Fox and the Andreanof islands. These two principal divisions also reflect cultural differences.

Immediately to the west of the Alaska Peninsula is the Fox Island group of the Aleutians, which extends for a distance of about 290 miles from Unimak Island to Umnak Island, the westernmost of the group. The Fox Islands also include Unalaska Island and the seven Krenitzin Islands, which lie immediately to the east of Unimak. Akutan, Akun, and Tigalda are the best-known islands of the Krenitzin group. The Islands of Four Mountains. are usually not included in the Fox group, but in 1770, an Aleut chief, who was visiting Saint Petersburg, divided the archipelago into four general groups and names, and at that time included the Four Mountains group in the Fox Islands (Masterson and Brower 1948:39). Kagamil Island, where Aleš Hrdlička examined the cave remains, is the most famous of the Four Mountains group.

To the east of the Islands of Four Mountains are the Andreanof Islands (named after Andreian Tolstykh), which are (east to west): Amlia, Atka, Adak, Great Sitkan, Kanaga, and Tanaga, plus several smaller islands. At the east end of the Andreanofs, and sometimes included in that group, are nine small islands known as the Delarof Islands. Tiny Unalga Island, from which the walrus person in figure 37 is said to have come, is in the Delarofs.

Amchitka Pass separates the Delarof Islands from the Rat Islands, which are made up of numerous islets, and include the well-known Amchitka, Kiska, and Semisopochnoi islands.

The westernmost group of islands is called the Near Islands, or "Blishnie Ostrova," thus named by the early Russians because of the proximity to Kamchatka where the early fur-hunting expeditions to the Aleutians originated. The principal islands of this group are Attu, Agattu, and Shemya, none of which has been reinhabited since their evacuation in 1942 at the beginning of World War II. There are now five active villages on the islands proper: Akutan, Atka, False Pass, Nikolski, and Unalaska (verbal information, Aleut Corporation, 21 July 1978).

Kodiak. The Kodiak group includes Kodiak, Afognak, Shuyak, Trinity, and several smaller islands. The principal towns are now Kodiak, Port Lions, Ouzinkie, Old Harbor (near Three Saints Bay, the first permanent European settlement in Alaska), Akhiok, Larsen Bay, and Karluk. In all, there are twenty-five villages.

Nelson Island. This island is located at the edge of the Yukon-Kuskokwim delta across from Nunivak Island on Etolin Strait. Its four principal settlements today are Newtok, Nightmute, Toksook Bay, and Tununak. A number of masks in the Alaska State Museum are said to be from "Katalac Island," which is probably this island, "Qaluuyaq" (small dip net).

Nunivak Island. A large island opposite the Yukon-Kuskokwim delta. Only one village, Mekoryuk, is now inhabited.

Pribilof Islands. Located approximately 240 miles southwest of Nunivak Island and approximately the same distance north of the Aleutians. Saint George and Saint Paul, which are the two "Pribilofs," were uninhabited in 1786 at their discovery by Garasim Pribylov. In 1788, the Russians colonized the islands with Aleuts to hunt fur seals and walrus tusks.

VILLAGES

Akiachak ("little other side"). A village, thirteen miles northeast of Bethel on the right bank of the Kuskokwim River.

Andreafsky. This probably was named from the possessive case, "Andrei's house." There were two settlements by this name, "Old Andreafsky" and "New Andreafsky." Old Andreafsky was located on the right bank of the lower Yukon River at about 62° 03' N. latitude and 163° 22' W. longitude, and had been established as a fort and trading post by the Russian-American Company in 1853 upon Lieutenant L. A. Zagoskin's recommendations in the 1840s (Dall 1870:230, 231; Zagoskin 1967:278-79). This post, which was about five miles downstream from the mouth of the Nygyklik River (Andreafsky River, "negeqliq," or "northern one"), was unoccupied at the time of Charles·W. Raymond's visit in 1869, but the Alaska Commercial Company, successor to the Russian-American Company, apparently reactivated it later because one of their agents was using it as Yukon River trading headquarters when Frederick Schwatka arrived in 1883 (Raymond 1870:6; Schwatka 1885:109 and sheet no. 19).

New Andreafsky, which was located five miles upstream on the right bank of the Andreafsky River, was said to have been established in 1898 or 1899 as a depot and winter quarters for the Northern Commercial Company, successor to the Alaska Commercial Company (Orth 1967:76). New Andreafsky was located at the site of an Eskimo village, "Negokligamut," according to a map "drawn by a native" in the Governor of Alaska's report for 1899-1900 (Brady 1901:end map). It grew into a substantial Eskimo village, and during July and August 1951, Saint Mary's Mission of Akulurak was moved to Andreafsky. The main move was made on August 3 when 126 children, and the nuns, priests, and brothers, landed at Andreafsky at 10:30 P.M. (Sister Scholastica Lohagen, O.S.U., 13 July 1977, Saint Marys; "The News-Letter" of Fr. John Fox, S. J., dated 23 August 1951, Oregon Province Archives of the Society of Jesus, Crosby Library, Spokane). On 1 January 1955, the official post office name was changed from Andreafsky to Saint Marys (Ricks 1965:55).

The objects collected and tagged "Andreafsky" in the 1880s and 1890s are probably from Old Andreafsky, having been taken there by the Eskimos of Negokligamut or from a settlement, "Negoklimpaenaramut," which was located at Pitkas Point (Brady 1901:end map). According to L. Zagoskin, only one family was living in a winter camp at the point in 1842-44, but nearby were remains of a once large village that had been destroyed thirty years before by the Magemiut (a group living inland about twenty miles south of Mountain Village) (Zagoskin 1967:278; Oswalt 1967:6; a settlement called "Illinoromeut" was located at the site of Old Andreafsky on the native map of 1899-1900). In the 1890s, Sheldon Jackson, the first agent of education for Alaska, apparently obtained the Andreafsky masks (now in the Sheldon Jackson Museum) from Alaska Commercial Company traders in Saint Michael, and during a trip up the Yukon in 1898.

Anogogmut (Anogok). A settlement visited by E. W. Nelson in 1878, located on the north shore of Kuskokwim Bay, about 105 miles southwest of Bethel.

Askinuk. The name of a village, at or near the site of present Hooper Bay. At the time of Nelson's visit in December 1878, the population was two hundred.

Big Lake or Nunvogulukhlugumut. A settlement on what is now called Nunavakanukakslak Lake on United States Geological Survey map, "Baird Inlet," Alaska topographic series of 1954 (1966 edition). It would be rendered more accurately as Nanvarnarrleq in Yupik phonemes. People from this village moved to Nunapitchuk in the 1940s and then resettled in Atmauthluk in the 1970s (Phyllis Morrow and Chase Hensel, letter, 6 January 1979, Groton, N.Y.). E. W. Nelson's map of 1882 located the village

on what is now called Qyigayalik Lake. There are dozens of "big" lakes in the Kusko-kwim area, so Nelson's confusion is understandable in the days before aerial surveys.

Cape Vancouver. See Tununak.

Chalitmut (Chalit). A settlement located on the Kugaklik River, twelve miles northeast of Anogok.

Chenega. A village located on the west side of Prince William Sound, which was abandoned after the 1964 earthquake.

Chevak ("passage, canal"). A village located seventeen miles east of Hooper Bay, and the same distance north of the abandoned village of Kashunuk, which Nelson visited during his trip of 1878-79. The inhabitants formerly lived in Old Chevak, and before that, in Kashunuk. Old Chevak was located between new Chevak and Kashunuk.

Eek ("two eyes"). Located on the Eek River, about forty miles southwest of Bethel.

Hooper Bay. Situated in the northwest part of the body of water named Hooper Bay, at or near the old village of Askinuk, which Nelson visited in 1878. The post office of Hooper Bay was established in 1934 (Ricks 1965:27). The present Eskimo name of this village is Naparamiut.

Ikogmut (Ikogmiut, Russian Mission). See Russian Mission.

Kaialigamut. This is probably Old Kealavik, eight miles west of present-day Newtok, where some of the residents of Kealavik have moved. In December 1878, there were one hundred persons in Kaialigamut.

Kashunuk. An old village site at the mouth of the Kashunuk River on the coast between Hooper Bay and Hazen Bay, but Nelson, who visited "Kushunuk" in 1878, mistakenly placed it on a tributary upstream on his maps. The village, which was "large . . . between 100 and 200 people" at Nelson's time, was later moved to Old Chevak and then to Chevak (Nelson 1882:661, 666; Barker and Convert 1979).

Katmai. An old settlement on the south shore of the Alaska Peninsula opposite Kodiak Island.

Kinak. A village of 175 inhabitants in 1879 when Nelson visited it. Located on the right bank of the Kuskokwim River, about thirty miles southwest of Bethel (Nelson 1882:669).

Kipnuk ("twist, or bend"). A village about a hundred miles southwest of Bethel, and about sixty miles east of the south end of Nunivak Island.

Koggiung. An old Eskimo settlement, nine miles north of Naknek on the Alaska Peninsula.

Kongiganak. A village on Kuskokwim Bay, eighty miles southwest of Bethel. Nelson visited this village in January 1879, calling it Koñgiganagamiut in his article of 1882 and Koñigunugumut in his text of 1899.

Kulwoguwigumut (Kulvagavik). This settlement, which was visited by Nelson in 1878-79, was located on the northwest shore of Kuskokwim Bay, fifteen miles northeast of Kongiganak and about seventy-two miles southwest of Bethel.

Kushutuk. On the left bank of the Yukon River, about twenty miles downstream from Old Andreafsky.

Kwethluk ("strange river"). About eight miles northeast of Bethel on the left bank of the Kwethluk River.

Lomavik. A village of ten cabins when Aleš Hrdlička visited it in 1930; located fourteen miles southwest of Bethel on the left bank of the Kuskokwim River.

Marshall. See Sabotnisky.

Mekoryuk ("more people"—Lantis 1946:162). The only inhabited village on Nunivak Island today, located on the north side of the island near Cape Etolin, with a present population of less than two hundred.

Mumtrak ("caches"). An abandoned village a short distance from the present village of Goodnews at the head of Goodnews Bay, an indentation of Kuskokwim Bay.

Napaimiut ("people of the trees"). A small Eskimo-Indian village on the Kuskokwim River, twenty-eight miles east of Aniak.

Napakiak ("small posts or trees"). A village across the Kuskokwim River from Napas-kiak, about seven miles south of Bethel.

Napaskiak. Located on the left bank of the Kuskokwim River, about seven miles south of Bethel.

Newtok ("rustling of grass"). Located opposite the north end of Nelson Island on the mainland, this village came into being when Old Kealavik was relocated about eight miles to the east in the 1940s.

Nightmute (pronounced nik-miut; "people of the pressed down [by the wind] place"). Located on Nelson Island. See Toksook Bay.

Nikolski. A village of ninety-two persons in the 1970 census, on Umnak Island.

Nuchek. An abandoned village on Hinchinbrook Island, Prince William Sound.

Nulok or Nulukhtulogumut. An old settlement on the southeast shore of Nelson Island, near the present village of Nightmute, which Nelson visited in 1878.

Nunachuk ("little land"). A village, now abandoned, thirty miles northwest of Bethel and about five miles north of the present village of Kasigluk. Many inhabitants of present-day Kasigluk came from Nunachuk.

Nunvogulukhlugumut. See Big Lake.

Nushagak. A village at the mouth of the Nushagak River. This was the site of Alexander Redoubt, the first Russian-American Company post built (1819) on the west coast of Alaska north of the Aleutians.

Pastolik. A settlement on the Pastol River, fifty-five miles southwest of Saint Michael.

Pilot Station. An Eskimo village on the right bank of the lower Yukon River. Also see discussion of Rasboinsky.

Quinhagak ("new river"). Located on the Kanektok River near Kuskokwim Bay, seventy-five miles south of Bethel.

Rasboinsky (also spelled Razboiniksky, Rasboinski, etc.). The Eskimo name of this village, which was located near present-day Pilot Village, was Angkachagmiut. "Razboinik" means "robber" in Russian; Razboinskii is the adjectival form. According to Zagoskin, the village was so named because "of the insolent acts of the inhabitants," who numbered about 120 at the time of his visit in the early 1840s (1967:278).

Rasboinsky, that is, Angkachagmiut, or Pilot Village, apparently has been confused with Zagoskin's "Kanygmyut," or Pilot *Station*, twelve miles southwest of Rasboinsky. *The Dictionary of Alaska Place Names* (Orth 1967:80) identifies Rasboinsky as "Kinegnaguk," or Zagoskin's Kanygmyut, and "Anakhchagmyut" as Pilot Station, but Zagoskin definitely said that Angkachagmiut was called "Razboynichiy." In 1929, the anthropologist Aleš Hrdlička searched for old "Razboiniki" in the vicinity of "Old Pilot Village," not Pilot Station. He said that Mountain Village was made up of people who had settled there from the "former Razboiniki and Old Pilot villages" (Zagoskin 1967:278; Hrdlička 1943:238, 246). I have been told that the present Eskimo name of Pilot Station is *tutalixaq* ("man has labrets"), but another name obtained is *tautalgarmiut,* or "labret people."

Russian Mission. There are two Russian Missions. The one where a number of artifacts were collected by nineteenth-century travelers was located at Ikogmiut on the Yukon, where the first Russian Orthodox mission of the Alaskan interior was established in 1844. The other one, usually called Little Russian Mission, is located on the upper Kuskokwim River, about ten miles from Aniak and more than a hundred miles northeast of Bethel.

Sabotnisky (Marshall). According to Nelson, this village was also called Uglivia (or Ouglovaia [1899:map; 1882; map]), located near present-day Marshall. Donald Orth states that this name is the "Russianized Eskimo name" for the village, but it is a purely Russian word, *uglovaia,* meaning "the corner one." Sabotnitzkii probably was a Russian surname. The Eskimo name for Marshall is *masučaleq* ("old fish turning calico color"). Marshall came into being after gold was discovered in July 1913 on Wilson Creek (named after the president of the United States). Its name, Marshall, after the then-vice-president, has been used interchangeably with Fortuna Ledge, the post office that was established in 1915 (D. Ray field notes; Ricks 1965:21; Stuck 1917:197).

Saint Marys. See Andreafsky.

Scammon Bay. A settlement twenty-seven miles northwest of Hooper Bay and seventeen miles east of Cape Romanzof.

Sfugunugumut (spelled variously, including Sfaganugamute on Nelson's map of 1882). This long-abandoned village on the Yukon-Kuskokwim delta was located about six miles east of Nelson Island, and was visited by Nelson in 1878.

Stebbins. The nineteenth-century Eskimo name for this village on Saint Michael Island, approximately nine miles northwest of Saint Michael, was Atuik. Many of the inhabitants of the village, which is now called Tapkak in Eskimo, are descendants of immigrants from Nelson Island about 1915. The name Stebbins is probably a corruption of Stephens (Cape Stephens and Stephens Passage).

Togiak ("sending something [as present or payment]"). A settlement on the left bank of the Togiak River, about seventy miles west of Dillingham.

Toksook Bay. In 1964, many of the inhabitants of Nightmute on Nelson Island moved to Toksook Bay, about fifteen miles to the west. The 1970 census reported 257 people in Toksook Bay, and 127 in Nightmute.

Tununak ("back"). This settlement is located on Nelson Island near Cape Vancouver, which has sometimes been used as a provenience designation for Tununak. This small village of only eight persons in 1878 was the home of a "half-breed" fur trader "with a small stock of goods" (Petroff 1884:16; Nelson 1882:668).

Glossary of Words of Non-English Derivation

BAIDAR. The Russian word for umiak, a large skin boat.

BAIDARKA. The Russian word for kayak.

BELUGA. In Russian, *beluga* means sturgeon, and *belukha,* the white whale *(Delphinapterus leucas),* which is found in abundance in the waters of western Alaska. In Alaska, however, the white whale has always been called "beluga," when properly, it should be "belukha." (I am grateful to Erna Siebert, Leningrad, for bringing this difference to my attention.)

CEREMONIAL HOUSE. See KAZGI.

INUA (in Inupiak; YUA, in Yupik). The "person," or human counterpart, of a being or object; consequently, the human aspect of a mask representing a spirit, an animal, or an inanimate object.

INUPIAK (pl., INUPIAT). The language and name of Eskimos living north of Norton Sound.

KAMLEIKA. A term applied by the Russians to the native waterproof parka made of intestines. It is said to have been derived from the Chukchi word, *kemliyun* (Zagoskin 1967:330).

KAYAK. A slender decked boat, with one, two, or three cockpits. The three-cockpit style was introduced by the Russians for transporting Russian officials, traders, and priests.

KAZGI. A ceremonial house, usually used by the men for their daytime occupations and leisure; and by both men and women for festivals and special occasions. The word has been transcribed variously from different dialects—kazigi, karigi, qalegi, kazhim, etc. The often-used "kazhim" was said by Zagoskin to be derived from the Koniag language (1967:115).

KAZHIM. See KAZGI.

KUSPUK. A Yupik term for the outer cloth parka.

MUKLUK. A generic name for Eskimo footwear, applied by the Russians from *maklak* (bearded seal), from which many of the soles are made.

SUGPIAQ. The Kodiak Eskimo language.

TOION. A Yakut term, meaning "princeling," which was introduced by the Russians to designate chiefs or headmen (Tokarev and Gurvich 1964:246).

UMIAK. The Eskimo term for a large open boat, usually made of split walrus hide.

YUA. See INUA.

YUPIK. The language and name of Eskimos living in southern Alaska between Norton Sound and the Alaska Peninsula.

Acknowledgments

The research for this study, the compiling of illustrations, and the taking of photographs has been a cooperative venture with persons from many places. I have interviewed contemporary artists and examined as many objects as possible at first hand, including those in the British Museum and the National Museum of Denmark. I am very grateful to Svetlana G. Fedorova, Academy of Sciences, Moscow; Rosa G. Liapunova and Erna V. Siebert, the Museum of Anthropology and Ethnography, Leningrad; Penny Bateman, Yvonne V. Neverson, and J. C. H. King, the British Museum, London; Poul Mørk, the National Museum of Denmark, Copenhagen; Heinz Israel, Staatliche Museum für Völkerkunde, Dresden; and Dieter Heintze and Corinna Raddatz, Übersee Museum, Bremen, Germany; and to the museums concerned, for correspondence, information, and photos.

In earlier publications I have acknowledged the valuable assistance of many persons whose aid has contributed also to the present venture, and I have revisited or visited a number of museums for further data and photographs. I wish to thank the following persons, and the museums, galleries, libraries, and archives for their help in this project:

Frances K. Smith, Agnes Etherington Art Centre, Queen's University, Kingston, Ontario; Mary Lou Lindahl, Alaska Native Arts and Crafts, Inc., Anchorage; Molly B. Jones, Alaska State Council on the Arts; Phyllis DeMuth, Alaska State Library; Laura Bracken, Bette L. Hulbert, and Mary Pat Wyatt, Alaska State Museum; M. Diane Brenner, John Carnahan, Bill Pedrick, Robert Shalkop, and Walter Van Horn, Anchorage Historical and Fine Arts Museum; Marian Johnson and Eunice Neseth, Baranof Museum, Kodiak; Carolyn R. Shine, Cincinnati Art Museum; James W. VanStone, Field Museum of Natural History, Chicago; Myles Libhart, Indian Arts and Crafts Board, U.S. Department of the Interior; Mardonna Austin-McKillop, The Legacy, Ltd., Seattle; Michael Weber, Museum of New Mexico; Annette M. Clark, Donald W. Clark, and David Zimmerly, National Museums of Canada, Ottawa; Robert Elder, Natural History Museum, Smithsonian Institution; Clifford Carroll, S. J., Oregon Province Archives of the Society of Jesus, Spokane; Edmund Anable, S. J., and Francis E. Mueller, S. J., Sacred Heart Cathedral, Fairbanks; George E. Shaw, Shaw Indian Art, Aspen, Colo.; Peter L. Corey and Alice Postell, Sheldon Jackson Museum, Sitka; Jane Schuldberg, Snow Goose Associates, Seattle; James Nason, Thomas H. Burke Memorial Washington State Museum; Beverly Davis and Paul McCarthy, University of Alaska Archives; Dinah Larsen and Ludwig Rowinski, University of Alaska Museum; Dennis Andersen, Richard Berner, Andrew F. Johnson, Ruth Kirk, Anna McCausland, Robert Monroe, Betty McWilliams, and Carol Parker, University of Washington Library; Gordon A. Smith and Kes Woodward, Visual Arts Center of Alaska; and Martha A. Larson, Yugtarvik Regional Museum, Bethel.

And equal thanks to these individuals who gave unselfishly of their time, photographs, information, transportation, or hospitality: Jean S. Aigner, Alan and Jeannette Backstrom, James Barker, Sandra B. Barz, Rae Baxter, Joan Bell, Kirt Bell, Lydia Black, Alfred A. Blaker, Betty Bockstahler, Everett Bracken, Mrs. George Butler, Connie Dickman, Barbara and Leonard Douglas, Ferdinand Drebert, Susan Fair, Norman Feder, Nora Opanuk Fisher, Janice Gibson, Robert Gibson, Walter E. Gnagy, Dagmar Gundersen, Kay Hendrickson, Chase Hensel, Hans Himmelheber, John Hinsvarck, Edward Hofseth, John Hoover, Raymond Hudson, Mabel Johnson, Doris E. Jones, Rhea Josephson, Eleanor and Terry Klingel, Mary Kroul, John Kusowyuk, Margaret Lantis, Molly Lee, Richard S. Lee, Barbara Lipton, Sister Scholastica Lohagen, OSU, Bernard F. McMeel, S. J., Milo Minock, Mrs. I. J. Montgomery, Phyllis Morrow, Flora Nanuk, Andrew Noatak, Michael Nowak, Paul C. O'Connor, S. J., Mr. and Mrs. R. T. Ohashi, Kenneth M. Petersen, Richard A. Pierce, Lucy and John Poling, Rosemary Porter, Mary Randlett,

Louis L. Renner, S. J., Antoinette Shalkop, Hilma and Henry Shavings, Helen H. Smith, Natalia Agnes Smith, Peter L. Smith, Sr., Gary C. Stein, Pam and Ed Tate, John J. Teal, Eric S. Thompson, Linda Yarborough, and Mary and John Young.

Last, but not least, I wish to thank Verne F. Ray for reading the manuscript.

References Used

Ackerman, Robert E.
 1967 "Prehistoric Art of the Western Eskimo." *The Beaver* (Autumn), pp. 67-71.

Ager, Lynn Price
 1971 "The Eskimo Storyknife Complex of Southwestern Alaska." Master's thesis, University of Alaska.

Aigner, Jean S.
 1966 "Bone Tools and Decorative Motifs from Chaluka, Umnak Island." *Arctic Anthropology* 3 (no. 2):57-69.
 1972 "Carved and Incised Stones from Chaluka and Anangula." *Anthropological Papers of the University of Alaska* 15 (no. 2):39-51.

Aigner, Jean S., ed.
 1976 "Papers from a Symposium on Aleutian Archaeology Presented at a Meeting of the Society for American Archaeology, Bal Harbour, Florida, May, 1972." *Arctic Anthropology* 13 (no. 2):31-131.

Alaska Journal Staff
 1975 "Kotzebue School Art." Photographs by Richard Montague. *The Alaska Journal* 5 (no. 2):89-103.

Alaskameut
 1978 Catalog of an exhibition of masks made in a two-week mask-making workshop at the Native Arts Center, University of Alaska. Alaskaland-Bear Gallery, 15 November-14 December 1978.

Anable, Edmund
 1973 "A Real Opportunity." *The Alaskan Shepherd,* vol. 11, no. 3, whole issue.

Anchorage Historical and Fine Arts Museum
 1979 *Contemporary Native Art of Alaska from the Collection of the Anchorage Historical and Fine Arts Museum.* Catalog for an exhibition, 8 July-23 September 1979, Anchorage.

Angaiak, Hubert M.
 1974 "1965: The Intrusion of the Snowmobile." *Theata* 2:84-87.

Arizona Highways
 1975 *American Indian Basketry.* Special edition, vol. 51, no. 7.

Arutiunov, S. A., and D. A. Sergeev
 1975 *Problemy Etnicheskoi Istorii Beringomor'ia* (Problems in ethnic history of the Bering Sea). Moscow: Akademiia Nauk SSSR.

Athearn, Robert G., ed.
 1949 "An Army Officer's Trip to Alaska in 1869." (Visit to Sitka, Kodiak Island, the Aleutians, and the Pribilofs by Captain Alfred Lacey Hough.) *Pacific Northwest Quarterly* 40 (no. 1):44-64.

Avdeev, A. D.
 1958 "Aleutskie maski v sobraniiakh Muzeia antropologii i etnografii Akademii nauk SSSR." (Aleut masks in the collections of the Museum of Anthropology and Ethnography of the Academy of Sciences, USSR). Leningrad: *Sbornik* MAE 18:279-304. (Translated into German in *Jahrbuch des Museums für Völkerkunde zu Leipzig,* vol. 20, pp. 413-33. Berlin: Akademie-verlag, 1964.)

Barker, James H., and Jules Convert, S. J.
 1979 "Kashunuk to Chevak." *Tundra Drums,* issues of 8 and 15 March.

Beaglehole, J. C., ed.
 1967 *The Journals of Captain James Cook on his Voyages of Discovery,* vol. 3: *The Voyage of the Resolution and Discovery, 1776-1780.* Cambridge: Published for the Hakluyt Society, Cambridge University Press.

Berreman, Gerald D.
 1953 "A Contemporary Study of Nikolski: An Aleutian Village." Master's the-
 sis. University of Oregon.
Birket-Smith, Kaj
 1941 "Early Collections from the Pacific Eskimo." *Etnografisk Raekke* 1:121-63.
 Nationalmuseets Skrifter, Copenhagen.
 1953 *The Chugach Eskimo. Etnografisk Raekke* 6 (whole issue). Nationalmuseets
 Skrifter, Copenhagen.
Birket-Smith, Kaj, and Frederica de Laguna
 1938 *The Eyak Indians of the Copper River Delta, Alaska.* Copenhagen: Levin and
 Munksgaard.
Black, Lydia T., ed. and trans.
 1977 "The Konyag (the Inhabitants of the Island of Kodiak) by Iosaf [Bolotov]
 (1794-1799) and by Gideon (1804-1807)." *Arctic Anthropology* 14 (no. 2):79-
 108.
Blaker, Alfred. See Ray, Dorothy Jean, and Alfred Blaker
Blodgett, Jean
 1979 "The Historic Period in Canadian Eskimo Art." *The Beaver* (Summer), pp.
 17-27.
Blomkvist, E. E.
 1951 "Risunki I. G. Voznesenkogo" (Drawings of I. G. Voznesenskii). *Sbornik*
 MAE 13:230-303.
 1972 "A Russian Scientific Expedition to California and Alaska, 1839-1849."
 (Translation of 1951 by Basil Dmytryshyn and E. A. P. Crownhart-
 Vaughan). *Oregon Historical Quarterly* 73 (no. 2):101-70.
Blomkvist, E. E. See Zolotarevskaja, I. A.; E. E. Blomkvist; and E. V. Zibert
Boas, Franz
 1888 *The Central Eskimo.* Sixth Annual Report of the Bureau of Ethnology, pp.
 399-669. Washington, D.C.
Bockstoce, John R.
 1977 *Eskimos of Northwest Alaska in the Early Nineteenth Century.* University of Oxford,
 Pitt Rivers Museum, Monograph Series No. 1. Oxford.
Bolles, T. Dix
 1889 "A Preliminary Catalogue of the Eskimo Collection in the U.S. National
 Museum, Arranged Geographically and by Uses." U.S. National Museum
 Report for 1887, pp. 335-65.
Bovis, Pierre. See Miles, Charles, and Pierre Bovis
Brady, John G.
 1900 *Report of the Governor of the District of Alaska to the Secretary of the Interior, 1900*
 (for the year 1899-1900). Washington, D.C.: U.S. Government Printing
 Office.
Brennan, Marnie
 1977 "Buying Eskimo Baskets Can be Difficult for Uninitiated." *The Anchorage
 Times,* 30 October.
Brower, Helen. See Masterson, James R., and Helen Brower
Cantwell, J. C.
 1902 *Report of the Operations of the U.S. Revenue Steamer* Nunivak *on the Yukon River
 Station, Alaska, 1899-1901.* Treasury Department Document No. 2276.
 Washington, D.C.: U.S. Government Printing Office.
Chaffin, Yule
 1967 *Koniag to King Crab.* [Kodiak]: Chaffin, Inc.
Chandonnet, Ann
 1975 "Sophia Pletnikoff's Cloth Made of Grass." (Photographs by Carol Grand-
 Montagne.) *The Alaska Journal* 5 (no. 1):55-58.
Choris, Ludovik
 1822 *Voyage Pittoresque Autour du Monde.* Paris.
Clark, Austin H. See Collins, Henry B., Jr.; Austin H. Clark; Egbert H. Walker

Clark, Donald W.

 1964 "Incised Figurine Tablets from Kodiak, Alaska." *Arctic Anthropology* 2 (no. 1):118-34.

 1970 "Petroglyphs on Afognak Island, Kodiak Group, Alaska." *Anthropological Papers of the University of Alaska* 15 (no. 1):12-17.

 1974 *Contributions to the Later Prehistory of Kodiak Island, Alaska*. National Museum of Man Mercury Series, paper no. 20. National Museums of Canada, Ottawa.

 1976 "The Pacific Origins of Eskimos." Typescript.

Coe, Ralph T.

 1977 *Sacred Circles: Two Thousand Years of North American Indian Art*. North American edition, published in connection with an exhibition at the Nelson Gallery of Art-Atkins Museum of Fine Arts, Kansas City, Missouri.

Collins, Henry B., Jr.

 1929 *Prehistoric Art of the Alaskan Eskimo*. Smithsonian Miscellaneous Collections, vol. 81, no. 14. Washington, D.C.

Collins, Henry B., Jr.; Austin H. Clark; and Egbert H. Walker

 1945 *The Aleutian Islands: Their People and Natural History*. Smithsonian Institution War Background Studies, no. 21. Washington, D.C.

Contemporary Art from Alaska

 1978 (Catalog of an exhibition at the National Collection of Fine Arts.) Washington, D.C.: Smithsonian Institution Press.

Convert, Jules, S. J. See Barker, James H., and Jules Convert, S. J.

Cook, James

 1784 *A Voyage to the Pacific Ocean*. Vol. 2 and Atlas. London: W. and A. Strahan.

Cook, Warren L.

 1973 *Flood Tide of Empire: Spain and the Pacific Northwest, 1543-1819*. New Haven and London: Yale University Press.

Coxe, William

 1780 *The Russian Discoveries between Asia and America*. (Readex Microprint Corporation, 1966.)

Curtis, Edward S.

 1930 *The North American Indian*. Vol. 20. Chicago.

Dall, William Healey

 1870 *Alaska and Its Resources*. Boston: Lee and Shepard.

 1878 *On the Remains of Later Pre-Historic Man Obtained from Caves in the Catherina Archipelago, Alaska Territory, and Especially from the Caves of the Aleutian Islands*. Smithsonian Contributions to Knowledge, vol. 22, publication 318.

 1884 "On Masks, Labrets, and Certain Aboriginal Customs . . ." Third Annual Report of the Bureau of Ethnology, 1881-82, pp. 67-203. Washington, D.C.: U.S. Government Printing Office.

Davis, Robert Tyler

 1949 *Native Arts of the Pacific Northwest*. Stanford: Stanford University Press.

Davydov, Gavriil I.

 1810,

 1812 *Dvukratnoe puteshestvie v Ameriku morskikh ofitserov Khvostova i Davydova, pisannoe sim posliednim* (Two voyages to America by the naval officers Khvostov and Davydov, written by the latter). Parts 1 (1810) and 2 (1812). Saint Petersburg.

 1977 *Two Voyages to Russian America, 1802-1807*. (Translation of above by Colin Bearne; edited by Richard A. Pierce.) Kingston, Ontario: Limestone Press.

Disselhoff, H. D.

 1935 "Bemerkungen zu einigen Eskimo-masken der Sammlung Jacobsen des Berliner museums für Völkerkunde." *Baessler-Archiv* 18:130-37.

 1936 "Bemerkungen zu Fingermasken der Beringmeer-Eskimo." *Baessler-Archiv* 19:181-87.

Dockstader, Frederick J.

 [1961] *Indian Art in America*. Greenwich, Conn.: New York Graphic Society.

Dumond, Don E.
 1964 "A Note on the Prehistory of Southwestern Alaska." *Anthropological Papers of the University of Alaska* 12 (no. 1):33-45.
 1969 "The Prehistoric Pottery of Southwestern Alaska." *Anthropological Papers of the University of Alaska* 14 (no. 2):19-42.
 1977 *The Eskimos and Aleuts.* London: Thames and Hudson.

Dumond, Don E.; Winfield Henn; and Robert Stuckenrath
 1976 "Archaeology and Prehistory on the Alaska Peninsula." *Anthropological Papers of the University of Alaska* 18 (no.1):17-29.

Efimov, Aleksei V., ed.
 1964 *Atlas geograficheskikh otkrytii v Sibiri i v severo-zapadnoi Amerike XVII-XVIII vv.* (Atlas of geographical discoveries in Siberia and northwestern America in the seventeenth and eighteenth centuries.) Moscow: Akademiia Nauk SSSR.

Emery, Julie
 1978 "Eskimo artwork: February display of a spirited Alaska." *The Seattle Times,* 30 December.

Fagg, William, ed.
 1972 *Eskimo Art in the British Museum.* London: British Museum.

The Far North. See National Gallery of Art

[Fast, Edward G.]
 [1869] *Catalogue of Alaskan Antiquities & Curiosities.* New York: Leavitt, Strebeigh and Co.

Feder, Norman
 1971 *Two Hundred Years of North American Indian Art.* New York: Praeger Publishers, Inc.
 1977 "The Malaspina Collection." *American Indian Art* 2 (no. 3):40-51, 80, 82.

Forman, Werner. See Siebert, Erna, and Werner Forman

Forrer, Paul
 1971 "The 'Happening' Art of Eek." Photographs by Richard W. Montague. *The Alaska Journal* 1 (no. 2):25-37 and cover.

Frederick, Saradell Ard
 1970 "Paul Forrer and Children of Eek." In *Cross-Cultural Arts in Alaska,* edited by O. W. Frost, pp. 57-63. Anchorage: Alaska Methodist University Press.
 1972 "Alaskan Eskimo Art Today." *The Alaska Journal* 2 (no. 4):30-41 and cover.

Frost, O. W., ed.
 1970 *Cross-Cultural Arts in Alaska.* Anchorage: Alaska Methodist University Press.

Garber, Clark M.
 1932 "District Superintendent's Report on Eskimos of Yukon-Kuskokwim Delta Coastal Section." Manuscript, National Archives, Record Group 75, Alaska Division Correspondence 1908-35. Washington, D.C.
 1934 "Some Mortuary Customs of the Western Alaska Eskimos." *Scientific Monthly* 39:203-20.

Gibson, Janice Ingram
 1974 "Eskimo Identification with Eskimo Arts and Implications for Curriculum Development: Interviews with Nunivak Islanders." D. Ed. thesis, Teachers College, Columbia University.

Giddings, J. L.
 1964 *The Archeology of Cape Denbigh.* Providence, R.I.: Brown University Press.

Glushankov, I. V.
 1973 "The Aleutian Expedition of Krenitsyn and Levashov." Translated by Mary Sadouski and Richard A. Pierce. *The Alaska Journal* 3 (no. 4):204-10.

Golder, Frank A.
 1914 *Russian Expansion on the Pacific 1641-1850.* Cleveland: Arthur H. Clark Co.
 1922 *Bering's Voyages.* Vol. 1. New York: American Geographical Society.
 1925 Ibid. Vol. 2.

Golovnin, Vasilii M.

1965 *Puteshestvie vokrug sveta, sovershennoe na voennom shliupe "Kamchatka" v 1817, 1818 i 1819 godakh flota Kapitanom Golovninym.* (Round-the-world voyage performed by the military sloop "Kamchatka" in 1817, 1818, and 1819.) Moscow.

Gordon, G. B.

1917 *In the Alaskan Wilderness.* Philadelphia: John C. Winston Co.

Gunther, Erna

1972 *Indian Life on the Northwest Coast of North America.* Chicago and London: University of Chicago Press.

Gurvich, I. S. See Tokarev, S. A., and I. S. Gurvich

Hawkes, Ernest W.

1913 *The "Inviting-In" Feast of the Alaskan Eskimo.* Canada Department of Mines, memoir 45 (no. 3), Anthropological Series. Ottawa.

1916 *The Labrador Eskimo.* Canada Department of Mines, memoir 91 (no. 14), Anthropological Series. Ottawa.

Heizer, Robert F.

1947 "Petroglyphs from Southwestern Kodiak Island, Alaska." *Proceedings of the American Philosophical Society* 91 (no. 3):284-93.

1952 "Notes on Koniag Material Culture." *Anthropological Papers of the University of Alaska* 1 (no. 1):11-24.

1956 *Archaeology of the Uyak Site, Kodiak Island, Alaska.* Anthropological Records 17, no. 1. Berkeley: University of California Press.

Henn, Winfield. See Dumond, Don E.; Winfield Henn; and Robert Stuckenrath

Himmelheber, Hans

1953 *Eskimokünstler.* 2d edition. Eisenach, Germany: Erich Röth-Verlag.

Hoffman, Walter James

1897 "The Graphic Art of the Eskimos." U.S. National Museum Report for 1895, pp. 739-968. Washington, D.C.

Holtved, Erik

1947 *Eskimokunst.* Foreningen for Ung Dansk Kunst. Copenhagen.

Hooper, C. L.

1897 *A Report on the Sea-Otter Banks of Alaska.* Treasury Department Document no. 1977. Washington, D.C.: U.S. Government Printing Office.

Hough, Alfred Lacey. See Athearn, Robert G., ed.

Hrdlička, Aleš

1943 *Alaska Diary, 1926-1931.* Lancaster, Penn.: Jaques Cattell Press (second printing of 1944 used).

1944 *The Anthropology of Kodiak Island.* Philadelphia: Wistar Institute of Anatomy and Biology.

1945 *The Aleutian and Commander Islands and Their Inhabitants.* Philadelphia: Wistar Institute of Anatomy and Biology.

Hudson, Raymond L. See Shapsnikoff, Anfesia, and Raymond L. Hudson

Hulbert, Bette, ed.

1976 *Alaska State Museum Bicentennial Catalog.* Photographs by Alfred A. Blaker. Anchorage: Northern Printing.

Illarion, Hieromonk

1861-63 "Travel Journal of the assistant of the Kwihpah missionary, Hieromonk Illarion, June 21, 1861-January 1, 1863." *Documents Relative to the History of Alaska.* Vol. 2, Alaska History Research Project (1936-38). (Copies in Library of Congress and University of Alaska Library.)

An Introduction to the Native Art of Alaska

1972 Published by the Anchorage Historical and Fine Arts Museum, Anchorage.

Israel, Heinz

1961 "Bemerkungen zu einigen verzierten Walrosszähnen aus Südwest-Alaska." *Beitrage zur Völkerforschung,* Museum für Völkerkunde, vol. 11, pp. 303-12 and plates 65-70. Berlin: Academie-Verlag.

1963 "Alaskische Spielbretter aus Walrosszähnen." *Abhandlungen und Berichte des Staatlichen Museums für Völkerkunde Dresden* 22:15-20 and illustrations 1-8. Berlin.

1971 "Beinschnitzerei der Eskimo." *Abhandlungen und Berichte des Staatlichen Museums für Völkerkunde Dresden* 33:113-40 and illustrations 1-46. Berlin.

Ivanov, S. V.
1930 "Aleut Hunting Headgear and Its Ornamentation." Proceedings of the Twenty-third International Congress of Americanists, 1928, pp. 477-504. New York.

1949a "O znachenii dvukh unikalnykh zhenskikh statuetok amerikanskikh eskimosov" (On the significance of two unique Alaskan Eskimo female statuettes). *Sbornik* MAE 11:162-70. Leningrad.

1949b "Sidiachie chelovecheskie figurki v skul'pture Aleutov" (Seated human figurines in Aleut sculpture). *Sbornik* MAE 12:195-212.

1954 *Materialy po izobrazitel'nomu iskusstvu narodov Sibiri XIX—nachala XX v* (Materials on the pictorial art of the Siberian peoples in the nineteenth and beginning of the twentieth centuries). Trudy Instituta Etnografii, n. s. vol. 22. Moscow-Leningrad: Izdatel'stvo Akademii Nauk SSSR.

Jacobi, A.
1937 "Carl Heinrich Mercks Ethnographische Beobachtungen über die Völker dés Beringsmeers 1789-91." *Baessler-Archiv* 20 (pt. 3-4):113-37.

Jacobsen, Johan Adrian
1884 *Capitain Jacobsen's Reise an der Nordwestküste Amerikas, 1881-1883.* Edited by A. Woldt. Leipzig.

1977 *Alaskan Voyage, 1881-1883.* Abridged translation by Erna Gunther of Jacobsen 1884. Chicago and London: University of Chicago Press.

Jaggar, T. A., Jr.
1908 "Journal of the Technology Expedition to the Aleutian Islands, 1907." *The Technology Review* 10 (no. 1):1-37.

Jochelson, Vladimir (Waldemar) I.
1923 *Materialy po izucheniiu Aleutskogo iazyka i fol'klora* (Materials for investigation of the Aleut language and folklore). Vol. 1. Petrograd.

1925 *Archaeological Investigations in the Aleutian Islands.* Washington, D.C.: Carnegie Institution.

1933 *History, Ethnology and Anthropology of the Aleut.* Washington, D.C.: Carnegie Institution.

Kaeppler, Adrienne L.
1978 *"Artificial Curiosities."* Honolulu: Bishop Museum Press.

Keithahn, Edward L.
1959 *Native Alaskan Art in the State Historical Museum, Juneau, Alaska.* Juneau: Alaska Historical Association.

n.d. *Descriptive Booklet of the Alaska Historical Museum.* Juneau: Alaska Historical Association.

King, Jonathan C. H.
n.d. *Artificial Curiosities from the Northwest Coast of America.* London: The British Museum, forthcoming.

de Laguna, Frederica
1934 *The Archaeology of Cook Inlet, Alaska.* Philadelphia: The University Museum.

1956 *Chugach Prehistory: The Archaeology of Prince William Sound, Alaska.* University of Washington Publications in Anthropology, vol. 13. Seattle: University of Washington Press.

de Laguna, Frederica. See Birket-Smith, Kaj, and Frederica de Laguna

Langsdorff, G. H. von
1814 *Voyages and Travels in Various Parts of the World, during the years 1803, 1804, 1805, 1806, and 1807.* Part II. London: Henry Colburn.

Lantis, Margaret
1946 *The Social Culture of the Nunivak Eskimo.* Transactions of the American Philosophical Society, N.S., vol. 35 (part 3), pp. 153-323. Philadelphia.

1947 *Alaskan Eskimo Ceremonialism.* American Ethnological Society, Monograph no. 11. Reprint, 1966. Seattle: University of Washington Press.

1950 "Mme. Eskimo Proves Herself an Artist." *Natural History* 59 (no. 2):68-71.

1954 "Edward William Nelson." *Anthropological Papers of the University of Alaska* 3 (no. 1):5-16.

Larsen, Dinah W.

[1974] *Eskimo Dolls in the Collection of the University of Alaska Museum.* Poster-pamphlet. College, Alaska.

Larsen, Helge

1950 "Archaeological Investigations in Southwestern Alaska." *American Antiquity* 15 (no. 3):177-86.

Larsen, Helge, and Froelich Rainey

1948 *Ipiutak and the Arctic Whale Hunting Culture.* Anthropological Papers of the American Museum of Natural History, vol. 42. New York.

Laughlin, W. S.

1963 "The Earliest Aleuts." *Anthropological Papers of the University of Alaska* 10 (no. 2):73-91.

Laughlin, W. S. and G. H. Marsh

1951 "A New View of the History of the Aleutians." *Arctic* 4 (no. 2):75-88.

Laughlin, W. S. and W. G. Reeder, eds.

1966 "Studies in Aleutian-Kodiak Prehistory, Ecology and Anthropology." *Arctic Anthropology* 3 (no. 2), whole issue. (There are many references to publications before 1966.)

Lee, Molly

1979 "Native Baskets: From Housewares to Souvenirs." *The Alaska Journal* 9 (no. 4):87-90. Photos in color of six Aleut and Eskimo baskets.

Levin, M. G. and L. P. Potapov, eds.

1964 *The Peoples of Siberia.* Translation from the Russian. Chicago and London: University of Chicago Press.

Liapunova, Rosa G.

1963 "Muzeinye materialy po Aleutam: orudiia okhoty Aleutov (po materialam MAE)." (Museum materials for the Aleut: hunting weapons of the Aleut [in the MAE collections]). *Sbornik* MAE 21:149-71.

1964 "Aleutskie baidarki" (Aleut baidarkas). *Sbornik* MAE 22:223-42.

1967a "Ekspeditsiia I. G. Voznesenskogo i ee znachenie dlia etnografii Russkoi Ameriki" (The expedition of I. G. Voznesenskii and its importance for the ethnography of Russian America). *Sbornik* MAE 24:5-33.

1967b "Zoomorfnaia skul'ptura Aleutov" (Zoomorphic sculpture of the Aleut). *Sbornik* MAE 24:38-54.

1975a *Ocherki po etnografii Aleutov* (Essays on the ethnography of the Aleut). Akademiia Nauk SSSR. Institut etnografii im. N. N. Miklukho-Maklaia, Leningrad.

1975b "Pletenye izdeliia Aleutov" (Aleut basketry). *Iz Kul'turnogo naslediia narodov Ameriki i Afriki. Sbornik* MAE 31:36-51. Leningrad.

1976 "O Proiskhozhdenii obriadovykh golovnykh uborov Aleutov" (On the origin of ceremonial headdresses of the Aleut). *Pervobytnoe Iskusstvo* (Primitive Art). Novosibirsk: Izdatelstvo Nauka.

Lipshits, B. A.

1950 "Etnograficheskie materialy po severo-zapadnoi Amerike v arkhive I. G. Voznesenskogo" (Ethnographic materials for northwest America in the archives of I. G. Voznesenskii). Geograficheskoe obshchestvo SSSR. *Izvestia* 82:415-20.

1955 "O kollektsiiakh Muzeia antropologii i etnografii . . . na Aliaske i v Kalifornii" (On the collections in the Museum of Anthropology and Ethnography . . . from Alaska and California). *Sbornik* MAE 16:358-69.

Lipton, Barbara, ed.
1977 *Survival. Life and Art of the Alaskan Eskimo.* The Newark Museum and the American Federation of Arts. Dobbs Ferry, N.Y.: Morgan and Morgan, Inc.

Lisianskii, Yuri F.
1814 *A Voyage Round the World in the Years 1803, 4, 5, & 6 . . . in the Ship* Neva. London: John Booth, and Longman, Hurst, Rees, Orme, and Brown.
1947 *Puteshestvie vokrug sveta na korable "Neva" v 1803-1806 godakh.* Gosudarstvennoe izdatel'stvo. Geograficheskoi literatury. Moscow. (Abridgement of the 1812 edition).

Litke, Frederic
1835 *Voyage autor du monde . . . 1826, 1827, 1828 et 1829.* 3 vols. and Atlas. Paris.

Lomen, Carl J.
1954 *Fifty Years in Alaska.* New York: David McKay Co., Inc.

Lot-Falck, Eveline
1957 "Les masques eskimo et aléoutes de la collection Pinart." *Société des Américanistes, Journal* (N.S.) 46:5-43.

Low, Jean
1977 "George Thornton Emmons." *The Alaska Journal* 7 (no. 1):2-11.

McCartney, Allen P.
1969 "Prehistoric Aleut Influences at Port Moller, Alaska." *Anthropological Papers of the University of Alaska* 14 (no. 2):1-17.
1977 "Prehistoric Human Occupation of the Rat Islands." In *The Environment of Amchitka Island, Alaska,* M. L. Merritt and R. G. Fuller, eds., pp. 59-113. Technical Information Center, Energy Research and Development Administration, TID-26712.

McCollom, Pat
1978 "The Smithsonian Show." *The Alaska Journal* 8 (no. 3):232-49, 280-85.

McElwaine, Eugene
1901 *The Truth about Alaska.* Chicago: Regan Printing House.

McIver, Lucy
1973 "Attu Basketry." *Handweaver and Craftsman* 24 (no. 1):35-37.

Mantzke, Carolyn
1978 "Local Resident Restores Ancient Art." *Kodiak Daily Mirror,* 27 February.

Marsh, G. H. See Laughlin, W. S., and G. H. Marsh

Martijn, Charles A.
1967 "A Retrospective Glance at Canadian Eskimo Carving." *The Beaver* (Autumn), pp. 5-19.

Mason, Otis T.
1904 *Aboriginal American Basketry: Studies in a Textile Art without Machinery.* Smithsonian Institution Publication, no. 128. Reprinted from U.S. National Museum Report for 1902, pp. 171-548. Washington, D.C.

Masterson, James R., and Helen Brower
1948 *Bering's Successors 1745-1780.* Seattle: University of Washington Press.

Matthiessen, Peter
1967 *Oomingmak: The Expedition to the Musk Ox Island in the Bering Sea.* New York: Hastings House.

Merck, Carl Heinrich. See Jacobi, A.

Miles, Charles
1963 *Indian and Eskimo Artifacts of North America.* Chicago: Henry Regnery Co. (Bonanza Books edition)

Miles, Charles, and Pierre Bovis
1969 *American Indian and Eskimo Basketry.* New York: Bonanza Books.

Minock, Milo
1971 *Drawings and Stories by Milo Minock.* Bethel, Alaska: Bethel Council on the Arts.

Monthan, Guy, and Doris Monthan
1978 "John Hoover." *American Indian Art* 4 (no. 1):50-55.

Morgan, Lael

 1974 "Atka, Rugged Home of my Aleut Friends." *National Geographic* 146 (no. 4):572-83.

 1975 "Cultural Heritage Versus Welfare: The Crunch on the Western Coast." *Alaska* 41 (no. 10):44-47, 70-71, 74-75, 78.

 1978 "Bristol Bay Artists." *The Alaska Journal* 8 (no. 1):15-17; photographs on inside and back covers.

National Gallery of Art

 1973 *The Far North, 2000 Years of American Eskimo and Indian Art.* Washington.

Nelson, Edward W.

 1882 "A Sledge Journey in the Delta of the Yukon, Northern Alaska." *Proceedings, Royal Geographical Society* (N.S.) 4:660-70, 712.

 1899 *The Eskimo about Bering Strait.* Annual report, Bureau of American Ethnology, vol. 18, pt. 1. Washington, D.C.

 n.d. "List of Ethnological Specimens obtained in Alaska with notes." Manuscript. Office of Anthropology, Smithsonian Institution, Washington, D.C.

Nowak, Michael

 1970 "A Preliminary Report on the Archeology of Nunivak Island, Alaska." *Anthropological Papers of the University of Alaska* 15 (no. 1):19-32.

Oomingmak

 n.d. (Brochure of the Musk Ox Producers' Cooperative)

Orlova, E. P.

 1964 *Chukotskaia, Koriakskaia, Eskimosskaia, Aleutskaia Reznaia kost'.* Novosibirsk: Akademii Nauk SSSR.

Orth, Donald J.

 1967 *Dictionary of Alaska Place Names.* Geological Survey Professional Paper 567. Washington, D.C.: U.S. Government Printing Office.

Osgood, Cornelius

 1940 *Ingalik Material Culture.* Yale University Publications in Anthropology, no. 22. New Haven and London: Yale University Press.

Oswalt, Wendell H.

 1952 "The Archaeology of Hooper Bay Village, Alaska." *Anthropological Papers of the University of Alaska* 1 (no. 1):47-91.

 1963 *Mission of Change in Alaska.* The Huntington Library, San Marino, California.

 1964 "Traditional Storyknife Tales of Yuk Girls." *Proceedings of the American Philosophical Society* 108 (no. 4):310-36.

 1967 *Alaskan Eskimos.* San Francisco: Chandler Publishing Co.

Oswalt, Wendell H. and James W. VanStone

 1967 *The Ethnoarcheology of Crow Village, Alaska.* Bureau of American Ethnology, Bulletin 199. Washington, D.C.: U.S. Government Printing Office.

Paine, Jocelyn

 1979 "Alvin Eli Amason." *The Alaska Journal* 9 (no. 3):6-11.

Petersen, Lance

 1971 "Ancient Aleut Rock Painting." *The Alaska Journal* 1 (no. 4):49-51.

Petroff, Ivan

 1884 *Report on the Population, Industries, and Resources of Alaska.* Tenth Census. Washington, D.C.

Phebus, George, Jr.

 1972 *Alaskan Eskimo Life in the 1890s as Sketched by Native Artists.* Washington: Smithsonian Institution Press. (Contains errors of fact and identification.)

Pierce, Richard A.

 1975 "Voznesenskii, Scientist in Alaska." *The Alaska Journal* 5 (no. 1):11-15.

Pierce, Richard A. See Shur, L. A., and R. A. Pierce

Pinart, Alphonse Louis

 1875 *La Caverne d'Aknañh, Ile d'Ounga (Archipel Shumagin, Alaska).* Paris: E. Leroux.

Porcher, C. Gadsden

 1904 "Basketry of the Aleutian Islands." *The Craftsman* 5 (no. 6):575-83.

Potapov, L. P. See Levin, M. G., and L. P. Potapov, eds.

Quevillon, Greg

[1977] *Quevillon Collection.* (Kuskokwim and other southwest Alaskan objects collected by Mrs. Flo Hurst, 1935-38.) Catalog, Walrus Gallery, Kennebunkport, Maine.

Quimby, George I.

1948 "Prehistoric Art of the Aleutian Islands." *Fieldiana: Anthropology* 36 (no. 4):77-92. Chicago: Field Museum of Natural History

Rainey, Froelich. See Larsen, Helge, and Froelich Rainey

Ray, Dorothy Jean

1954 "Analysis of an Aleut Waterproof Parka." Manuscript.

1961 *Artists of the Tundra and the Sea.* Seattle: University of Washington Press.

1966 *The Eskimo of St. Michael and Vicinity as Related by H. M. W. Edmonds* (editor). *Anthropological Papers of the University of Alaska* 13 (no. 2).

1971a "The Bible in Picture Writing." *The Beaver* (Autumn), pp. 20-24.

1971b "Kakarook, Eskimo Artist." *The Alaska Journal* 1 (no. 1):8-15 and cover.

1975 *The Eskimos of Bering Strait, 1650-1898.* Seattle and London: University of Washington Press.

1977 *Eskimo Art: Tradition and Innovation in North Alaska.* Seattle and London: University of Washington Press.

Ray, Dorothy Jean, and Alfred A. Blaker

1967 *Eskimo Masks: Art and Ceremony.* Seattle and London: University of Washington Press.

Raymond, Charles W.

1870 *Youkon River and Island of St. Paul.* 41st Congress: 2nd session, HR Ex. Doc. 112 (serial 1417).

Razumovskaia, R. S.

1967 "Pletenye izdeliia severo-zapadnykh Indeitsev" (Northwest Indian basketry). *Sbornik* MAE 24:95-123.

Rearden, Jim

1973 "The Federal Marine Mammal Act of 1972." *Alaska* 39 (no. 6):9-13, 51, 53-56.

1975 "The Musk Ox—an Overview." *Alaska* 41 (no. 12):28, 70-75.

Reeder, W. G. See Laughlin, W. S., and W. G. Reeder, eds.

Reger, Douglas R.

1977 "An Eskimo Site near Kenai, Alaska." *Anthropological Papers of the University of Alaska* 18 (no. 2):37-52.

Ricks, Melvin B.

1965 *Directory of Alaska Postmasters and Postoffices, 1867-1963.* Ketchikan: Tongass Publishing Co.

Riggs, Anna E.

1980 "Finger Masks: Vivid Symbols of Eskimo Spirits." *The Alaska Journal* 10 (no. 1):88-90. (Photographs in color)

Rudenko, S. I. See Volkov, F. K., and S. I. Rudenko

Sarychev, Gavriil

1802 *Puteshestvie flota Kapitana Sarycheva . . .s 1785 po 1793 god.* Parts 1 and 2 together, and Atlas. Saint Petersburg.

1806-7 *Account of a Voyage of Discovery to the North-East of Siberia, the Frozen Ocean, and the North-East Sea.* (Vol. 1 is 1806; Vol. 2, 1807, bound together.) London: Richard Phillips.

Sauer, Martin

1802 *An Account of a Geographical and Astronomical Expedition to the Northern Parts of Russia . . . in the Years 1785 etc. to 1794.* London: T. Cadell.

Schwalbe, Anna Buxbaum

1951 *Dayspring on the Kuskokwim.* Bethlehem, Penn.: Moravian Press.

Schwatka, Frederick

1885 *Report of a Military Reconnaissance in Alaska Made in 1883.* Washington, D.C.: U.S. Government Printing Office.

Sergeev, D. A. See Arutiunov, S. A., and D. A. Sergeev.

Shalkop, R. L.

1978 "Contemporary Alaskan Eskimo Art." *American Indian Art* 4 (no. 1):38-47, 68-69, and cover.

Shapsnikoff, Anfesia T., and Raymond L. Hudson

1974 "Aleut Basketry." *Anthropological Papers of the University of Alaska* 16 (no. 2):41-69.

Sheldon Jackson Museum

1976 *A Catalogue of the Ethnological Collections in the Sheldon Jackson Museum.* Text by Erna Gunther, with the assistance of Esther Billman. Sitka.

Shur, L. A. and R. A. Pierce

1976 "Artists in Russian America: Mikhail Tikhanov (1818)." *The Alaska Journal* 6 (no. 1):40-49.

1978 "Pavel Mikhailov: Artist in Russian America." *The Alaska Journal* 8 (no. 4):360-63.

Siebert, Erna, and Werner Forman

1967 *North American Indian Art.* London: Paul Hamlyn.

Siebert, Erna V. See Zolotarevskaja, I. A.; E. E. Blomkvist; and E. V. Zibert

Spaulding, Philip T.

1955 "An Ethnohistorical Study of Akutan: an Aleut Community." Master's thesis, University of Oregon.

Speck, Frank G.

1927 "Eskimo Carved Ivories from Northern Labrador." *Indian Notes and Monographs,* Heye Foundation, Museum of the American Indian, vol. 4 (no. 4), pp. 309-14. New York.

Stanyukovich, T. V.

1970 *The Museum of Anthropology and Ethnography.* Leningrad: Academy of Sciences, USSR. (In English)

Stein, Gary C.

1977 *Cultural Resources of the Aleutian Region.* 2 vols. Anthropology and Historic Preservation, Cooperative Park Studies Unit, University of Alaska, Fairbanks, Occasional Papers, no. 6.

Stepanova, M. V.

1949 "Dva Eskimosskikh poiasa iz sobraniia MAE." (Two Eskimo belts from the collection of the [Museum of Anthropology and Ethnography]). *Sbornik MAE* 11:62-72.

Stevens, Edward T.

1974 "Alaskan Petroglyphs and Pictographs." Master's thesis, University of Alaska.

Stuck, Hudson

1917 *Voyages on the Yukon and its Tributaries.* New York: Charles Scribner's Sons.

Stuckenrath, Robert. See Dumond, Don E.; Winfield Henn; and Robert Stuckenrath

Tarzan, Deloris

1978 "Eskimo artist from Eek combines the old and new." *The Seattle Times,* 13 October.

Thiry, Paul, and Mary Thiry

1977 *Eskimo Artifacts Designed for Use.* Seattle: Superior Publishing Co.

Tokarev, S. A. and I. S. Gurvich

1964 "The Yakuts." In *The Peoples of Siberia,* Levin and Potapov, eds., pp. 243-304. Chicago and London: University of Chicago Press.

Townsend, Joan B., and Sam-Joe Townsend

1961 "Archaeological Investigations at Pedro Bay, Alaska." *Anthropological Papers of the University of Alaska* 10 (no. 1):25-58.

Vancouver, George

1801 *Voyage to the North Pacific Ocean and Round the World.* Vol. 5. London: John Stockdale.

VanStone, James W.

1957 "An Archaeological Reconnaissance of Nunivak Island, Alaska." *Anthropo-*

logical Papers of the University of Alaska 5 (no. 2):97-117.

1968/69 "Masks of the Point Hope Eskimo." *Anthropos* 63/64:828-40.

1976 *The Bruce Collection of Eskimo Material Culture from Port Clarence, Alaska. Fieldiana: Anthropology* 67 (whole issue). Chicago: Field Museum of Natural History.

VanStone, James W. See Oswalt, Wendell H., and James W. VanStone.

Veniaminov, Ivan

1840 *Zapiski ob ostrovakh Unalashkinskago otdela* (Notes on the Unalaska Islands district). Parts 2 and 3. Saint Petersburg.

Volkov, F. K., and S. I. Rudenko

1910 "Etnograficheskiia kollektsii iz byvshikh' rossisko-amerikanskikh' vladenii" (Ethnographic collections from the former Russian American possessions). *Materialy po etnografii Rossii* 1:155-200.

Walker, Egbert H. See Collins, Henry B., Jr.; Austin H. Clark; and Egbert H. Walker

[Wardle, H. Newell]

1946 "Attu Treasure." *Bulletin,* University Museum, (University of Pennsylvania) vol. 11, no. 4, pp. 23-26.

Waxel, Sven

1962 *The Russian Expedition to Alaska.* M. A. Michael, ed. New York: Collier Books.

Wilkinson, Paul F.

1971 "Musk Ox, Misunderstood Animal." *Tundra Times,* five-part article in the 8, 15, 22, 29 September and 6 October issues.

Zagoskin, Lavrentii A.

1956 *Puteshestviia i issledovaniia leitenanta Lavrentiia Zagoskina v russkoi Amerike, v. 1842-1844 gg.* Gosudarstvennoe izdatel'stvo geograficheskoi literatury. Moscow.

1967 *Lieutenant Zagoskin's Travels in Russian America, 1842-1844.* Translated by Penelope Rainey; edited by Henry N. Michael. Toronto: University of Toronto Press. (Translation of 1956 edition)

Zerries, Otto

1978 *Die Eskimo.* Catalog of the Eskimo collection of the Staatliches Museum für Völkerkunde München. With the assistance of Jean-Loup Rousselot. Munich. (Photographs of Aleut woven wallets, baidarka model, wooden hats, conical fur hat, and fur and gut clothing from the nineteenth century.)

Zimmerly, David W.

1979 *Hooper Bay Kayak Construction.* National Museum of Man, Mercury Series. Canadian Ethnology Service, no. 53, Ottawa.

Zolotarevskaja, I. A.; E. E. Blomkvist; and E. V. Zibert (Siebert)

1956 "Ethnographical Material from the Americas in Russian Collections." *Proceedings of the 32nd International Congress of Americanists* 32:221-31. Copenhagen.

ADDITIONAL REFERENCES

Besides the references used directly for this study, the following sources contain either bibliographic information or occasional articles pertaining to Alaskan Aleut and Eskimo arts.

Alaska (monthly magazine), Anchorage, 1969-. Two separate magazines are issued each month: one with a large section, "Alaska-Yukon Magazine," for northern subscribers, and another, lacking the section for other readers.

Alaska Festival of Native Arts (catalogs of exhibitions), Anchorage, 1967-77.

Alaska Journal (quarterly), Anchorage, 1971-.

Alaska Native Arts and Crafts Cooperative Association, Inc. (catalogs), Juneau and Anchorage, 1940-.

Alaska Sportsman (monthly magazine), Ketchikan, Juneau, and Anchorage, 1935-69.

Arctic Bibliography (16 volumes to date), Arctic Institute of North America, 1953-.

Arts & Culture of the North (quarterly), New York 1976-.

The Arts in Alaska (newsletter of the Alaska State Council on the Arts), Anchorage.

Clark, Donald W., *Koniag-Pacific Eskimo Bibliography.* National Museum of Man, Mercury

Series. Archaeological Survey of Canada, no. 35, Ottawa, 1975.

Elwani ("Inside the Life and Culture of Kodiak"), published by the students of Kodiak Aleutian Regional High School, Kodiak, 1976-.

Jones, Dorothy M., and John R. Wood, *An Aleut Bibliography*. Institute of Social, Economic and Government Research, University of Alaska, 1975 (distributed by University of Washington Press, Seattle and London).

Kalikaq Yugnek, published by the students of Bethel Regional High School, Bethel, 1974-

Kwikpagmiut, published in Emmonak by high school students of Alakanuk, Emmonak, and Mountain Village, 1976-

Oswalt, Wendell H., "The Kuskokwim River Drainage, Alaska: An Annotated Bibliography," *Anthropological Papers of the University of Alaska* 13 (no. 1), 1965.

St. Mary's Yesterday and Today, published by the students of St. Mary's High School, St. Marys, Alaska, 1975.

Theata (annual publication by native students of the University of Alaska), Fairbanks, 1973-.

Tundra Drums (weekly newspaper), Bethel, Alaska, 1974-

Tundra Times (weekly newspaper), Fairbanks and Anchorage, 1962-.

Uutuqtwa, published by the students of Bristol Bay High School, Naknek, 1976-.

VanStone, James W., "An Annotated Ethnohistorical Bibliography of the Nushagak River Region, Alaska," *Fieldiana: Anthropology* 54 (no. 2):149-89. Chicago: Field Museum of Natural History, 1968.

Zimmerly, David W., "An Annotated Bibliography of Kayaks," Ottawa, 1978 (typescript, in press).

Index

The names of collectors, museums, and photographers in the captions have not been indexed.

Golovin, 51, 68, 132
Golovnin Bay, 15
Golovnin, Vasilii M., 83, 92
Goodnews, 217
Goodnews Bay: masks of, 27, 69n, 173, 174; basketry of, 62; mentioned, 217
Gordon, G. B., 38, 189
Gorgets, 43
Governor of Alaska report, 216
Graphic art, 58, 67-69. *See also* Drawing; Drumheads; Representational painting
Grass: Dyes for, 19, 20; in Kodiak festivals, 28; hand fans of, 29; hats of, 32; uses of discussed, 46, 64, 131; substitute materials for, 52, 61, 63; mentioned, 17. *See also* Basketry; Rye grass
Grave boxes, 42, 75
Grave monuments. *See* Effigy monuments
Great Sitkan Island, 215
Greek-key motif, 102
Greenland, 73
Guises: of animals and birds, 23
Gulf of Alaska, 11, 12n
Gusma, 202
Gut, 71, 77; clothing, 12, 28, 34, 52, 85, 100, 101; windows, 40; uses for, 55-56; material in illustrations, 89, 90, 91, 101, 129, 131. *See also* Kamleika
Gvozdev, Mikhail, 12n

Hadwin, Seymour, 184
Half–man—half–animal masks, 19, 26, 64n, 70, 169, 170
Halibut hooks, 19
Hamilton Inlet, Labrador, 51n
Hand fans, 29, 139
Hats: Aleut, 13, 14, 54-55, 91, 92; Koniag, 13-14; Eskimo, 14; of wood, 19, 43, 85; of roots, 32, 35, 36, 43-44, 90; of qiviut, 141. *See also* Dancing hats; Hunting hats
Hawkes, E. W., 26, 51n, 64n
Hazen Bay, 217
Headdresses. *See* Hats
Heizer, Robert F., 86
Helper Neck (Uyakok), 67
Helping spirits. *See* Tutelaries
Hematite, 20, 23
Hendrickson, Kay, Sr., 70, 71, 72, 171, 183, 207
Herrnhut, 65; meaning of, 86. *See also* Moravian missionaries
"He who got Supernatural power from his little finger," 118
Himmelheber, Hans: quoted on souvenirs, 5; quoted on mythical origin of goethite, 20; quoted on amulets and charms, 21-22, 25; quoted on animal figures, 23, 42-43; quoted on tobacco tins, 32; quoted on pole monuments, 37, 38; and representational painting, 41, 202; quoted on storyknives, 45; quoted on masks, 70 and n; mentioned, 40, 65n
Hinchinbrook Island, 218
Hoffman, W. J., 43n
Hofseth, Edward E., 181, 197, 208

Holmberg, Henrik Johan, 84, 116
Holy card cases. *See* Card cases
Holy Cross Mission, 67
Hooper Bay: effigy monuments of, 36, 37n, 184, 187; storyknives of, 44; basketry of, 62, 63, 64n, 135, 138, 139, 140; masks and hats of, 69, 70, 122, 175; wood sculpture from, 189; location of, 216, 217; mentioned, 66, 170, 218. *See also* Askinuk
Hoover, John, 60, 69, 118, 119, 120
Horn: as material, 17; doll, 71
Hot pads: grass, 63
Housewife (bag): illustrated, 126
Hrdlička, Aleš, 36, 38, 189, 215, 217, 218
Hudson, Raymond L., 47, 48, 61, 102
Human faces: as oracles and charms, 22, 24, 25, 37; on boxes, 31, 191, 194, 195; on effigy monuments, 36, 37, 38; in ivory, 36n, 142, 146, 147, 148, 213, 214; on armor, 44n; drawing of, 69n; used in kayaks, 188
Human figurines: Aleut (1741), 13, 22, 91; on stone lamps, 17; at Prince William Sound (1778), 22; discussed, 23; from Chaluka, 24; as kayak guards, 25; models of, in *kazgi*, 29; of ivory, 32, 64, 66, 94, 107, 108, 109, 144, 145, 146, 147, 153, 154, 213, 214; of grass, 46; in effigy monuments, 185, 186, 187. *See also* Activity dolls; Amulets; Charms; Dolls
Hunter, Homer, Sr., 66, 170
"The Hunter's Story," 197
Hunting hats, 21, 75, 77, 84, 91-95, 121, 122; ivory attachments for, 25, 32-35 *passim;* discussed, 32-36; paintings on, 42, 43-44
Hurst, Flo, 51n

IACB, 72
Ikogmiut (Ikogmut): Russian post established at, 15; doll festival of, 22; storyknife of, 45, 151; wristlet from, 99, 125; boxes from, 193; location of, 217, 218. *See also* Russian Mission
Illarion, Hieromonk, 55
Illinoromeut, 216
Imguyutuk, 126
Implements. *See* Tools
Indian Arts and Crafts Board (IACB), 72
Influenza epidemic (1918), 50, 51
Inga, Fedocia, 62
Ingalik Indians, 53, 57
Inkwell: ivory, 157
Inlays, 31, 38, 39, 214. *See also* Ivory: inlays of
Innovator: role of, 76
Inogos: of Nunivak Island, 21, 22, 23, 42
Institute of American Indian Art, 78
Institute of Ethnography, Leningrad, 48
Institute of Northern Agricultural Research, 73
Intestine. *See* Gut; Kamleika
An Introduction to the Native Art of Alaska, 122
Inua: defined, 221